Chinese Pottery and Porcelain

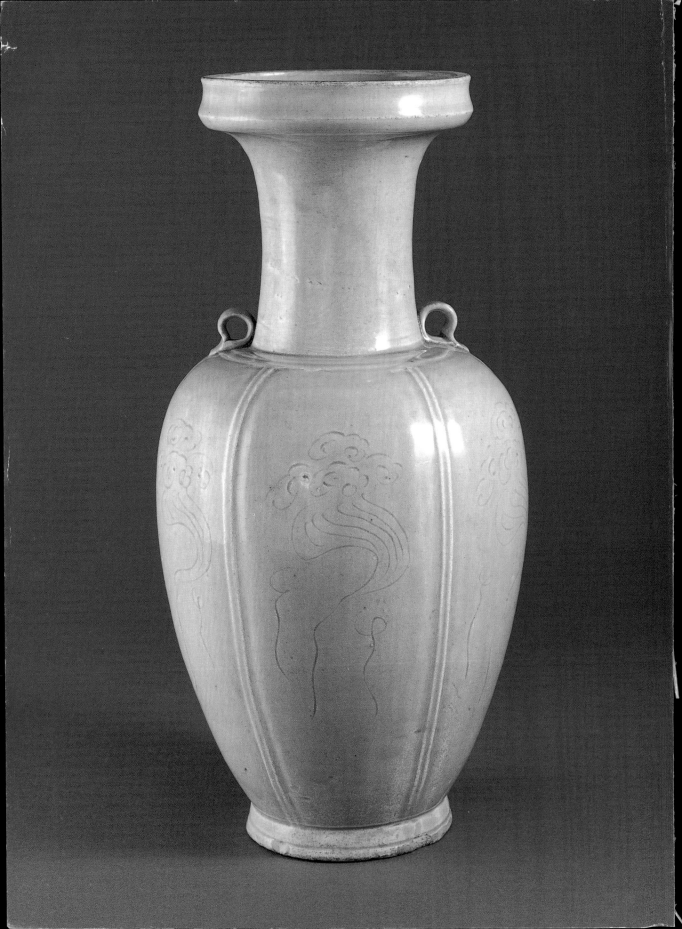

Chinese Pottery and Porcelain

Shelagh Vainker

THE BRITISH MUSEUM PRESS

FRONTISPIECE: Vase, Longquan ware, with green glaze (see fig. 52).
Early 10th century. HT 33cm. OA 1924.6-16.1

© 1991 The Trustees of The British Museum

First published in 1991 by The British Museum Press
A division of The British Museum Company Ltd
38 Russell Square, London WC1B 3QQ

www.britishmuseum.co.uk

First published 1991
First published in paperback 1995
Reprinted 1997
Second edition 2005

A catalogue record for this book is available from the British Library

ISBN-13: 978-0-7141-2432-2
ISBN-10: 0-7141-2432-X

Designed by Behram Kapadia
Cover design by John Hawkins Book Design
Photography by British Museum Department of Photography and Imaging

Typeset in Bembo by Rowland Phototypesetting Ltd, Bury St Edmunds, Suffolk
Printed in Italy by Milano Stampa

CONTENTS

Acknowledgements 7

Introduction 9

1 CERAMICS IN THE NEOLITHIC AND THE BRONZE AGE 12

2 FUNERARY ART AND FUNCTIONAL VESSELS 38
The Han and Six Dynasties

3 FOREIGN INFLUENCES AND CHINESE TRADITIONS 60
The Tang Dynasty

4 THE CLASSICAL PERIOD 88
The Song Dynasty

5 THE WORLDWIDE EXPORT OF PORCELAIN 134
The Yuan, Ming and Qing Dynasties

6 LATER ARCHITECTURAL AND POPULAR CERAMICS 160
1500 Onwards

7 IMPERIAL PORCELAINS FROM JINGDEZHEN 176
The Yuan, Ming and Qing Dynasties

Map 217

Appendix I: *Clays* 218

Appendix II: *Glazes* 220

Appendix III: *Kilns and Firing* 222

Glossary 224

Chronology 226

Bibliography and Site Reports 228

List of Illustrations 233

Index 236

Dedicated to
William Watson

ACKNOWLEDGEMENTS

My foremost debt is to William Watson, who laid the foundation of my understanding of Chinese art and archaeology and whose work continues to inspire many scholars. My own approach to the subject has benefited from many stimulating discussions with Jessica Rawson, Keeper of Oriental Antiquities at the British Museum, and to her I am also deeply grateful. In China, much important work has been carried out in recent decades by Li Jiazhi and other ceramic specialists, and I should like to thank particularly Zhang Fukang for his advice on technology and Wang Qingzheng and Liu Xinyuan for their opinions on objects in the British Museum's collection.

Rose Kerr, Rosemary Scott and Nigel Wood all undertook to read the manuscript and I am grateful for their comments and advice. For further comments on the text I should like to thank John Rawson, Paul Dean and Philip Vainker. Colin Mackenzie read Chapter 1 and Michael Rogers and Venetia Porter read Chapter 5 and directed me to source material; Neil Stratford, Stephen Green and Dorothy McPherson all provided information on particular export porcelains. Iurek Freundlich, Carol Michaelson and William Wong kindly assisted with the translation of certain quotations and inscriptions. Ian Freestone of the British Museum Research Laboratory checked the appendices and answered technological queries. I am grateful to David Gowers of the British Museum Photographic Service for providing fine illustrations at great speed, and to Ann Searight for the maps and line drawings. The Asian Art Museum of San Francisco, Ashmolean Museum, Burrell Collection, MCC Museum and the Percival David Foundation of Chinese Art all kindly permitted reproduction of items in their collections.

Within the Department of Oriental Antiquities, I should like to thank Anne Farrer for help in the final stages of the book's production, and my colleagues Richard Blurton, Jane Portal and Rachel Ward for their continued support and encouragement. I am indebted to Lay Goh, who typed the entire manuscript, and to Claire Randell for her generous assistance. Finally, I should like to express my special thanks to Philip and François Vainker for their affectionate tolerance throughout the writing of *Chinese Pottery and Porcelain*, and to Nina Shandloff, my editor at British Museum Press, without whose unfailing energy, enthusiasm and good nature the book would never have been produced on time.

Shelagh Vainker
London, 1990

INTRODUCTION

China's long and successful ceramic history is rooted in the high quality and wide distribution of an impressive range of raw materials. The skill of Chinese potters in exploiting those raw materials, and the high degree of organisation which prevailed in manufacturing industries from the earliest periods onwards, have ensured China's constant position as the world's foremost producer of ceramic artefacts. The function and status of the resulting earthenwares, stonewares and porcelains varied from dynasty to dynasty, so that they may be utilitarian, burial, trade, collectors' or even ritual objects, according to their quality and their era.

Amidst this wealth of regional and physical types, three broad traditions may be discerned: stonewares, porcelains and religious sculpture. Stonewares have the longest and most complex history, beginning in the fifteenth century BC and concluding, effectively, in the Song dynasty some two and a half thousand years later when porcelain was first produced in quantity. The stoneware tradition is dominated by greenwares, and the earliest were made in east China in the present-day provinces of Zhejiang and Jiangsu. During the Six Dynasties period kilns in north China also began producing high-fired ceramics of good quality, and the various major wares such as Yaozhou, Ru, Jun and Cizhou, which date from the succeeding Tang and Song dynasties, are all northern products. Within the stoneware sphere, seventh- to tenth-century white wares from Hebei and Henan provinces are of such pure kaolinitic clay that they may be regarded as porcelains, but they nonetheless lie outside the mainstream of porcelain manufacture.

Porcelains proper are the product of south China's abundant porcelain stone deposits. These were first exploited in the tenth century AD, and although porcelain wares were made in increasing quantity throughout the eleventh, twelfth and thirteenth centuries, it appears that the material was not greatly appreciated within China, other than as an export commodity, until the fourteenth century. The Song dynasty (AD 960–1279), long regarded as the high point in China's ceramic history, thus owes some of its richness to the overlapping of two major traditions.

The tradition of religious sculpture pervades most historical periods but is less neatly identified in physical terms than the other two types, for it embraces the old custom of earthenware burial ceramics together with later stonewares in the form of Buddhist images and architectural ornaments. In this category belong lead-glazed tomb models of the Han dynasty, three-colour lead-glazed vessels and figures of the Tang dynasty, and Ming three-colour and *fahua* type temple ornaments, as well as the many burial ceramics produced in imitation of vessels in materials of higher intrinsic value.

The first ceramics, produced around ten or eleven thousand years ago, were without doubt utilitarian wares, and this early role has never diminished. Ceramic vessels are widely used in everyday life now, just as they must have been in the Neolithic period, and the same low-fired red earthenware type is still produced in some rural areas of China. Before the Bronze Age, thin-walled, polished earthenwares of intricate shape were used as ritual vessels, particularly in the eastern seaboard cultures of Dawenkou and Longshan, yet once the crafting of bronze, lacquer and precious metals had been mastered, the status of ceramic artefacts declined. Only rarely in China's imperial history do stonewares or porcelains assume a ritual role. Notable exceptions are the Yue greenwares of the Tang dynasty and certain monochrome porcelains of the Ming and Qing periods.

Ceramic shapes imitated those of metal almost as soon as the latter appeared and some early earthenwares are clearly cheaper versions of precious objects. For less obvious reasons many later wares, beginning principally with Song dynasty Ding porcelain, were influenced by silver in particular, and the question of the relationship between ceramic and metalwork in terms of shapes and decoration is far-reaching and highly complex. To a lesser degree, ceramics were influenced by lacquer in shape, by jade in surface texture and by silk and most other precious media in their ornament. It is perhaps this very versatility which has led some scholars to place ceramics at the head of China's traditions in the applied arts.

From the Song dynasty onwards, porcelain was collected by emperors, men of learning and the well-to-do, and as a result much was written on the subject during the Ming and Qing dynasties. It was also during the Song dynasty that ceramics were established as a major commodity, and since then porcelain has almost constantly been one of China's most important exports. Within the country, silk alone could be said to match the long history, physical quality, craftsmanship and the multifarious roles of ceramics; internationally, the influence of Chinese porcelain on the material cultures of other nations is unrivalled.

The British Museum collection
The British Museum houses more than eight thousand Chinese ceramics. The collection includes Neolithic earthenwares and all the major types from that period until the present day: Shang and Zhou dynasty imitations of bronze vessel forms, Han dynasty burial ceramics and high-fired wares, funerary sculpture of the Han to Tang dynasties, green, white, black and blue glazed stonewares of the third to thirteenth centuries, and innumerable painted and enamelled porcelains of the Ming and Qing dynasties. Modern ceramics, ancient folk wares and glazed architectural and religious ceramics fill out the sequence, and it is probably true to say that with each new advance in the understanding of China's ceramic history, at least one old mystery is solved among the reserve collections.

A collection of such breadth can only be built over a long period, and with the expertise and generosity of generations of curators and collectors. Sir Augustus Wollaston Franks, Keeper of the Department

of British and Medieval Antiquities from 1866 until 1896, collected Asian material on such a scale as to make viable the eventual establishment of a separate department for oriental antiquities. Together his acquisitions for the Museum and the gift of his personal collection in 1876 include almost a thousand Chinese ceramics. The Franks pieces comprise a collection extraordinary for its time, for Franks sought to represent the length of China's ceramic history, and this he achieved as far as was possible at a time when the early wares were scarce outside China.

During the first three decades of the twentieth century, several comprehensive ceramic collections were formed in Britain, and these included quantities of early pieces and former imperial wares. R. L. Hobson was the foremost specialist in the subject and he assumed responsibility for the Museum's Asian ceramics in 1921, the year in which the Oriental Ceramic Society was founded. His great expertise and his friendship with leading members of the Society resulted in the acquisition of many fine ceramics for the Museum, including the donation of entire collections, or parts thereof, from his contemporaries. One of the most important of these was the collection of George Eumorfopoulos, who in the 1930s was not in a position to donate it, but offered many hundreds of items to the British Museum at a very advantageous price. This established the Museum's collection at a stroke as the broadest in London, for Eumorfopoulos had chosen pre-Ming porcelain and burial ceramics with particular success. Five years later, in 1941, a group of early Ming wares came to the Museum as the bequest of A. D. Brankston, who had acquired his small but choice collection of imperial porcelain while visiting Jingdezhen in south China. In 1947, a bequest of several hundred items dating from all periods was received from Harry Oppenheim, and subsequently the gifts of Mrs Brenda Seligman, Sir Harry Garner, Alfred Clark and Mrs Walter Sedgwick have greatly enriched the Museum's holdings of Song and Ming wares.

The most recent major gift is that of Sir John Addis, former Ambassador to China and Trustee of the British Museum, whose collection included twenty-two Yuan and early Ming wares from the imperial factories at Jingdezhen chosen expressly for the Museum, making the collection the strongest outside China for this period. His work on ancient Chinese porcelain, and his organisation in 1982 of the first of what was to become a series of international conferences on Chinese ceramics, make Sir John Addis a pioneer in the field. Without the wealth of interaction with Chinese scholars which he generated, the subject today would be much the poorer. The scientific analysis which dominated the 1982 conference is today carried out in Britain at the research laboratories of both the British Museum and Oxford University, and the dissemination of the results to a wide audience owes much to the potter and ceramic technologist Nigel Wood. The present book seeks to incorporate this technological work in addition to the archaeological and textual evidence, and to provide an accompaniment to the exhibition of two hundred of the Museum's major pieces which coincided with its original publication.

I

CERAMICS IN THE NEOLITHIC AND THE BRONZE AGE

1 OPPOSITE Earthenware
bowl and amphora
excavated at Banpocun,
Shaanxi province.
Yangshao culture. The
bowl bears traces of
painted decoration while
the amphora has an
impressed design probably
produced by rope. The
pointed base of the
amphora implies that it
was used for fetching
water. *c.* 4500 BC. Bowl:
HT 10.9cm, D 20.3cm. OA
1959.2–6.3,4, acquired by
exchange with the Institute
of Archaeology,
Academy of Sciences,
Beijing.

The first Chinese official to oversee pottery production burnt to death in a kiln, according to Gan Bao, a fourth-century AD writer. His name was Ning Feng and he was appointed by the Yellow Emperor (Huangdi) in China's legendary prehistory. He is recorded as being so thorough in his duties that he frequently entered the kiln to check the progress of a firing. On one occasion, he evidently ventured too far.

Ning Feng is mentioned in the standard history of ancient China, compiled in the first century BC by the grand historian Sima Qian, as well as by Gan Bao writing four centuries later. He belongs to Chinese mythology rather than history, yet his story and its association with the Yellow Emperor proclaim the importance of pottery even in the early periods of China's history, for the famous Emperor is credited with such fundamental achievements as the invention of writing, wheeled vehicles and ships.

Clay, then, should not be underestimated. In the form of pottery and porcelain, it has played an important role throughout Chinese history. Indeed, the invention of the potter's wheel during the fourth millennium BC must rank as one of China's greatest achievements in industry and the applied arts.

Clay fashioned into pots provides some of the earliest Chinese arte-facts. The only worked objects which have survived in the archaeological record and predate pottery are stone and bone implements. Turning clay into objects is more complicated than fashioning tools from stones; a stone already exists and can be carved, but the body of a pot must be created before it can be modelled. Nonetheless, as the basic material of an object, clay requires much less alteration from its natural state than

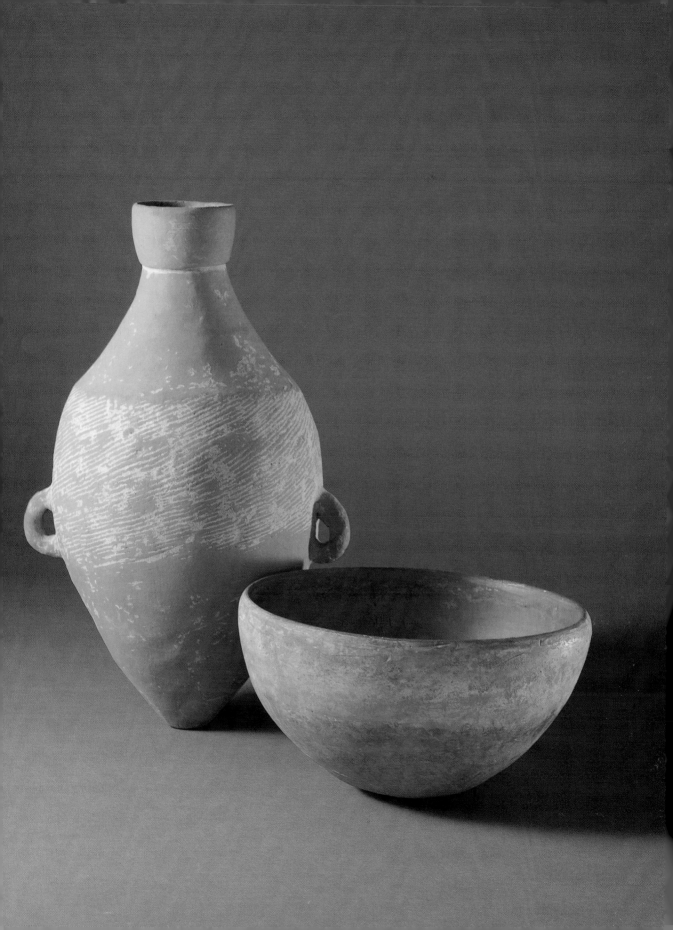

do many other media such as bronze, lacquer or textiles. This is why pottery appears before bronze.

The history of ceramics can be identified because pottery survives even when it is broken. Other materials such as wood and textiles simply disintegrate, leaving only scant evidence that they were used at all. Thus pots, stones and bones are the main sources of information about very early settlements. Within these limited means of assessing early cultures in China, the pottery finds are judged as accurately by their appearance as by their context, so the following account of Neolithic pottery in its surprisingly numerous variations is art historical as well as archaeological and regional.

It seems that clay was first turned into pottery in China almost nine thousand years ago. The radiocarbon dating of the cave site at Guangxi Guilin Zengpiyan is much debated, but it is clear that the earliest pottery comes from this south-western area of China, embracing present-day Guangxi and Guizhou. Of a coarse gritty paste, loose brittle texture and uneven thickness, it is limited to one shape and two colours – a round-based jar in either red or grey. It has some impressed decoration.

The earliest identified pottery in north China occurs about a thousand years later at four clusters of sites grouped loosely together under the term Peiligang culture, so called after the site at Henan Xinzheng Peiligang. The Peiligang sites occur in central Henan, southern Hebei, eastern Shaanxi and southern Shanxi. The number of common character-

2 Four Peiligang vessels. Figures **a** and **b** were excavated at Hebei Wu'an Cishan, **c** and **d** at Henan Xinzheng Peiligang. All *c.* 5000 BC. Approx. HT 35cm; 20cm; 5cm; 9cm.

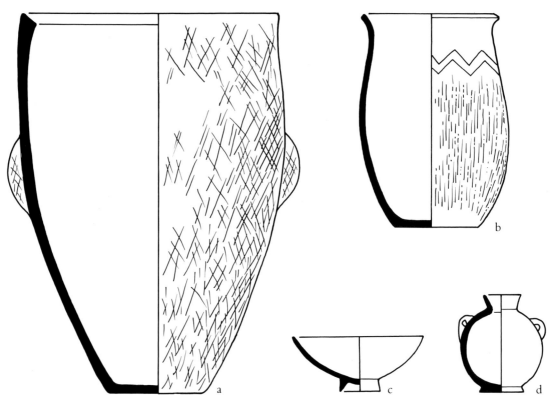

istics provide a context in which the role of pottery may be surmised. Homes, storage pits and burials are similar throughout the Peiligang culture. It is in the burials, alongside stone axes, spades, mortars and pestles, and occasional turquoise ornaments, that the pottery occurs.

The quality of the pottery is not greatly advanced from the south China examples – it is coarse and sandy in texture, red or brown in colour, and mostly plain except for some corded, impressed and stamped designs. Where it differs is in the variety of shapes. Numerous Peiligang vessels seem to be based on natural forms such as gourds. There are round jars with narrow necks and two shoulder lugs, bowls with or without ring feet, straight-walled cups and deep urns. These illustrate the use of different forms for different functions, even if they are simply divided between vessels for food and vessels for water. The new shapes convey new invention, while their varying proportions distinguish the regional groups within the Peiligang culture.

The use of clay is not confined to pottery vessels in this culture, for excavations at the eponymous site of Peiligang have yielded small figurines in the form of pigs with triangular heads and large snouts. Though sculpture may have been one of the earliest experiments with clay, it remained marginal to the mainstream ceramic tradition, which concentrated on the production of vessels.

The south-western and Peiligang sites are recent discoveries, so their pottery is not well known in the West. The next phase of the Chinese Neolithic is much more familiar, through the large red earthenware urns

3 Three earthenware urns with painted decoration. The urns are made by coiling, and the decoration is applied with a soft brush. Large urns with sweeping designs in black and purple are typical of the Banshan phase of the Gansu Yangshao culture. All c. 2500 BC. From left: HT 34.3cm; 37.5cm; 30.4cm. OA 1929.6–13.1, given by Ostasiatiska Samlingarnat; OA 1966.2–23.1; OA 1929.6–13.2, given by Ostasiatiska Samlingarnat.

painted in black and purple which were brought out of China earlier 3
last century and may now be seen in many European and American
collections. The Yangshao culture, named after Yangshao village in
Mianchi, north-western Henan province, includes sites from a large area
of northern and central China dating from between seven and five
thousand years ago. The earliest phase is typified by Banpo village at
Xi'an in Shaanxi province, the excavations of which are on public display
and may be visited easily. In its eastern section, Banpo village had six
kilns producing an impressive range of wares. Simple lidded jars with
grain impressions inside must have been used for storage; narrow,
thick-walled jars with pointed bases for fetching water; bowls and cups 1
for eating and drinking; and tripod vessels for cooking.

The usefulness of clay is again demonstrated at Banpo, where it is
made into such items as spindle whorls for hemp and silk, rectangular
knives, and grooved net-sinkers. Yet it is for the painted designs on red
pottery that Banpo is most renowned, in particular for the various
designs of fish sometimes joined to a round human face. Though most
Neolithic communities were situated near large rivers or their tributaries,
only the Banpo potters decorated their pottery with images of fish,
which must have been vital to all these communities.

The fish are invariably shown in profile with eye, body, tail and fins 4
usually discernible, and sometimes teeth as well. On some pots, the
designs are joined so that two or three fish appear on top of one another.
This form, composed as it is of elements of roughly triangular shape,
lends itself to simplification; in the process, the degree of representation
is sometimes so reduced that the decoration might not be recognisable
as fish but for the presence of the more naturalistically decorated vessels.
It is hard to decide which is the more sophisticated design. The temp-
tation is to consider the abstract image more skilled, since it depends
on the pre-existence of a realistic image. On the other hand, it is also
true that any artisan who does not recognise an image will tend to
simplify it. Thus abstraction may be the result of ignorance rather than
awareness.

Central China is without doubt the area where the most representa-
tional painted Neolithic ceramic designs appear. The Banpo phase was
succeeded in the area by the Miaodigou phase, named after the site at
Henan Shanxian Miaodigou. The Miaodigou pictorial designs do not
appear on shallow bowls, as at Banpo, but on tall narrow urns, sometimes
of bottle shape. One example is decorated with a lizard or newt climbing
round the body of the vase, so suitably following the form that a Ming
dragon comes to mind sooner than a Neolithic sketch. The necks of
some of these tall vases are modelled in the form of human heads. It is
interesting that the bottle-shaped urns with human heads appear not far
from the pre-Neolithic Peiligang site which yielded the small pig heads.

Another painted vase, from Henan Linru Yancun, bears an impressive
picture of a white cormorant with a fish hanging from its beak, and a 5
stone axe tied to a large handle painted with an x sign. The designs are
thought by Chinese archaeologists to have ritual significance, and it is

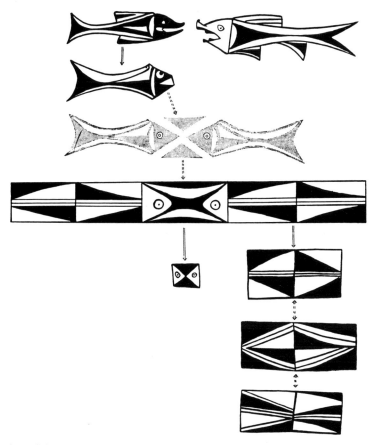

4 Reconstruction of the stages in the transformation of a naturalistic fish design into an abstract triangular design, based on material excavated at Banpo village. The stage shaded in light grey is hypothetical.

true that elaborately painted burial urns are a distinctive feature of central Henan province at this period.

In this phase of the Henan Neolithic, the dilute clay mixture known as slip was already widely used. A layer of slip applied to the unfired clay body was an ideal means of covering body flaws and providing a smooth ground for painting or, later on, for glazing. The use of slip within Asia is largely confined to China, and it was a major element in earthenware and stoneware ceramics until at least the twelfth century AD.

The Yangshao culture continued westwards into present-day Gansu and Qinghai provinces. Its earliest phase is known as Majiayao, after the type site at Gansu Lintao Majiayao. Although the Majiayao pottery includes some bowls and beakers with small animals painted on the interior, their most recognisable characteristic is the black curvilinear
6 designs which sweep round them, often punctuated with circles at the centres of spirals. The effect is particularly dizzy on the rounded bowls and wide-shouldered urns, but less heady on the taller-necked vases which have straighter, more restrained lines around two-thirds of their body. At the Majiayao site of Hetaozhuang, wooden caskets containing more than thirty pottery vessels have been found. Two tombs at Qinghai Datong illustrate the importance – or perhaps affection – with which

5 Painted design on an earthenware urn from Henan Linru Yancun.

pots were regarded: one contained a man and the top half of a vessel, while the other contained a woman and the lower half of the same vessel.

Vessels have frequently been found with burials from the next stage of the Yangshao culture, the Banshan phase. This occurred further north and west than Majiayao, though it overlaps with the north-westerly tip of the earlier phase. The vessels are sufficiently numerous to make possible an assessment of the social status of the entombed individuals from the number and quality of the pots buried with them. The decoration relates to the Majiayao spirals to some extent, often consisting of boldly painted spirals sweeping around large circles, covering two-thirds of the body of a large urn. The Banshan urns display the first use of 3 purple derived from manganese as well as black painted decoration. The human-headed urns known from the Miaodigou phase also appear at Banshan, along with a few rough drawings rather like stick figures. 7 There are occasional frogs and some plants, but the rest of the Banshan decoration consists of spirals and nets and, later, of waves.

The Banshan pots are known to have been made by coiling. In this method, a vessel is built up by placing coils of clay in sausage-like strips one on top of another, then smoothing them so that the joins between the coils are no longer visible. Analysis by xeroradiograph, a process similar to x-raying but providing much more detail, has shown that the coils were of uniform thickness and that the top of the pot was built up as a separate section. Xeroradiograph also revealed a diamond-shaped

6 BELOW LEFT Urn excavated at Gansu Yongjing Sanping. Majiayao phase, Yangshao culture. *c.* 3000 BC.

7 BELOW RIGHT Bowl painted with skeletal figure. Banshan phase, Yangshao culture. *c.* 2500 BC.

pattern on the surface, produced by the paddle and anvil used to smooth the coiled walls of the pot after construction.

3 The Banshan urns appear to be made of the ochre-coloured loess earth which covers north China. The clay content is very low, and it does not absorb water easily. Since coiling requires less plasticity and less added water than modelling or throwing, the technique is clearly appropriate to the raw material. The close relationship of technique and material lies behind the success of many Chinese ceramic types.

 The final phase of the north-western Yangshao culture, Machang, occurs in eastern Qinghai province and parts of Gansu. The urn shapes

8 are similar to those of Banshan, as is the decoration, but it is much less elaborate. Sometimes human figures are interspersed with the spirals and triangles of Banshan-type designs on the Machang pots. Many other painted signs also appear: at Qinghai Ledu Liuwan, 139 different signs have been identified. Some of these may carry symbolic meaning, but their simple format is quite distinct from the complex structure of marks which are found on Neolithic pottery from sites in east China, and which probably provide the basis from which modern Chinese characters evolved. The Liuwan signs might be significant, but they are simple marks rather than early characters.

 These three north-western phases have been known collectively as Gansu Yangshao. The presence of pots in burials shows that pottery was highly regarded. In addition, each phase of the pottery includes elements which may relate to religion. In the earliest Majiayao phase, for example, a pot appears with a row of dancing figures painted on the interior; in the Banshan phase, there is the skeletal figure mentioned above; and in the final Machang phase, an urn has been found moulded with a bisexual

8 ABOVE LEFT Urn with painted decoration, from Qinghai Ledu Liuwan. Machang phase, Yangshao culture. *c.* 2000 BC.

9 ABOVE RIGHT Vase with painted decoration excavated at Gansu Wu'an Huangniangniangtai. Qijia culture. *c.* 2000 BC. Approx. HT 14cm.

10 Clay figurine from Liaoning Kazuo Dongshanzui. The Hongshan site at Liaoning Niuhelang has yielded a large clay head and hands. Hongshan culture. *c.* 3500 BC. Approx. HT 6cm.

figure. The figures may be connected with priests communicating with spirits, but Neolithic religious practice in China is as yet little understood.

The central Yangshao culture extended north-west into Gansu and north-east as far as northern Hebei province, where it touched the major Neolithic culture known as Hongshan. The Hongshan culture covered the period from approximately 3500–2500 BC and the area which is now south-east Inner Mongolia and western Liaoning province. It is renowned mainly for fine jade carvings, but certain ceramic artefacts are also of considerable interest. The pottery vessels are mostly plain, although about a third are decorated with comb impressions, appliqués, or painting in black on red or red on black. The painted designs share certain similarities with those of central Yangshao, but on the whole are distinctive and local.

Far more astonishing than the vessels are the clay human figurines, some of half life size, discovered at the ritual site of Kazuo Dongshanzui. They occur near a rectangular structure of rock and slab, alongside fragments of painted cylinders. Some of the headless broken figures are 10 only 6 cm tall and represent pregnant women. The fragments of large figurines represent seated people and must have been nearly a metre high when complete. The ritual role these unique models may have played is a matter of speculation.

Hongshan was bordered on the east by the Xinle culture. It may be surmised that pottery played a subordinate role here, because the vessels are almost all made of the same sandy paste and in the same flat-bottomed urn form. On the other hand, wood, jade and hard stone artefacts are elaborately carved.

A little further south on the east coast, in the area of present-day Shandong province, is an interesting sequence of Neolithic finds. The site at Tengxian Beixin, with both coarse brown and fine grey pottery, appears to be intermediate between the Peiligang culture of the seventh millennium and the important Dawenkou culture that occupied Shandong province from *c.* 4300–2400 BC. The early Dawenkou pots are made of a fine red ware tempered with sand, shell or mica. Most of the vessels are red or brown, though some are grey and a very few are black. Painted designs are of flower petals, whorls and stars in complex colour schemes of black, red, grey, white and orange.

In the middle period, *c.* 3500–2900 BC, red ware still dominates but the proportion of grey ware increases. The potter's wheel having been invented during this period, some vessels show signs of retouching at the rim on a slow wheel, while a few small pieces appear to have been made on a fast wheel. By the late period of Dawenkou, *c.* 2900–2400 BC, a new ware appears, characterised by a fine, hard white or yellow body. Grey and black wares dominate and some of the black pots are polished to a lustrous finish. This highly worked finish replaces the earlier designs.

In addition to dazzling designs and fine finish, Dawenkou pottery also 11 assumes striking shapes. Typical of these are the *ding* tripod with bowl-shaped body, *gu* beaker, and *dou* cup or bowl on a high open-work pedestal; all are evident in the early period. With the advent of the potter's

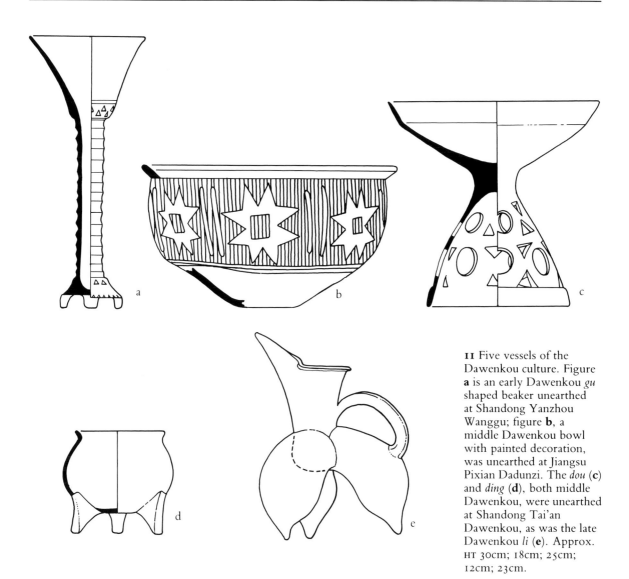

11 Five vessels of the Dawenkou culture. Figure **a** is an early Dawenkou *gu* shaped beaker unearthed at Shandong Yanzhou Wanggu; figure **b**, a middle Dawenkou bowl with painted decoration, was unearthed at Jiangsu Pixian Dadunzi. The *dou* (**c**) and *ding* (**d**), both middle Dawenkou, were unearthed at Shandong Tai'an Dawenkou, as was the late Dawenkou *li* (**e**). Approx. HT 30cm; 18cm; 25cm; 12cm; 23cm.

wheel in the middle period, these forms were refined to produce angled body profiles. The tall proportions of many of the Dawenkou forms imply a ritual function. A tripod vessel known as *gui*, with big bag-like legs, appears in the middle period, and a spouted tripod known as *he* in the late period. One vessel from Sanlihe, related in shape to the spouted *he*, is in the form of a bloated animal on four short legs, attesting once more to the existence of sculptural forms in Neolithic China.

The Dawenkou influence extended south into parts of northern Jiangsu province, an area bordered by the culture known as Majiabang, after the site of Jiaxing Majiabang. The ceramic vessels of Majiabang are simple: red or reddish-grey flat-based vessels fired at 800° or 850°C. The lack of kiln remains indicates that they were probably fired in fuel piles on the ground. The vessels repeat the Dawenkou shapes of *ding* tripod, *dou* bowl

on a pedestal, and spouted *he*. There are also examples of small clay animal and human figurines. For the first time, clay is also used as a building material at Majiabang. House walls were made of clay and reeds, while the floors were paved with clay, sand and mollusc shells.

The Songze phase in the same region developed from the Majiabang culture, but there is a great difference in the pottery. The Songze pottery is brown and greyish-black, and includes new vessel types such as bowls on pedestals shaped like flower petals. The incised decoration includes complex overlapping and interlacing designs, and some vessels have in- 12 cised symbols as well. This pottery was the most sophisticated in the Jiangsu region, but it was matched further south by the thick, porous black wares of the Hemudu culture of Zhejiang, located on the opposite side of Hangzhou Bay. The Hemudu pottery is of two types: a soft ware fired at up to 850°C, and a harder ware fired at up to 1000°C. The decoration is paddled or corded and in some cases incised with drawings of animals and plants and patterns derived from these motifs. This type of naturalistic 13 decoration is quite distinct from the painted motifs of the central Yangshao tradition.

The final area offering early Neolithic remains is the middle Yangzi basin. This region in eastern Sichuan and western Hubei includes the famous river gorges of the Yangzi; the culture here is called Daxi, after Sichuan Wushan Daxi. The pottery vessels, mostly red, are handmade, 14 though some curved-walled cups may have been made on the fast wheel. The surfaces are mostly plain and sometimes highly polished; a few pieces

12 BELOW LEFT Lidded jar with incised interlaced design from Shanghai Songze. Songze phase, Majiabang culture. *c.* 3500 BC. Approx. HT 30cm.

13 BELOW RIGHT Rectangular earthenware bowl with incised design of wild boar, unearthed at Zhejiang Yuyao Hemudu. Hemudu culture. *c.* 4500 BC. Approx. HT 10cm.

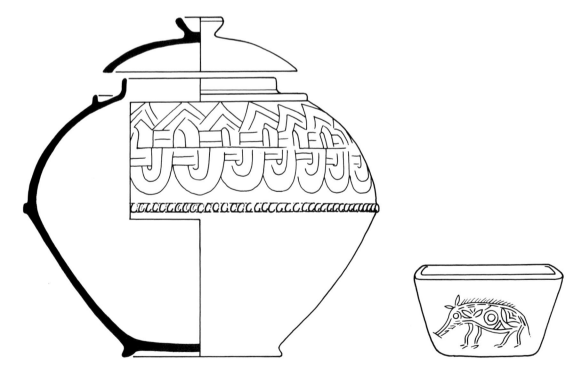

are coated with a red slip. It seems that in this area clay was as important as a building material as it was for ceramic vessels. The houses at Daxi had walls of grey clay mixed with burnt-clay fragments and potsherds, and the exterior surfaces were plastered with clay mixed with rice husks. The interior surfaces were washed with yellow clay, and the floors were plastered with clay tempered with fine sands.

Further down the Yangzi, in the region of northern Hubei and southern Henan provinces, is a continuation of the Daxi culture known as Qujialing, after the site at Hubei Jingshan Qujialing. No houses have been found, but burnt-clay fragments are plentiful. The most significant finds are animal figurines, possibly of chicken and sheep, and a large number of clay spindle whorls, many of them decorated with painted or fine-point impressed designs. This implies that textiles rather than pottery were the most prized handicrafts in the region. Objects fashioned in clay in this region are important for the light they throw on other artefactual media that have not survived in the archaeological record.

14 Bowl on a high stem. Unearthed at Sichuan Wushan Daxi. Daxi culture. *c.* 4000 BC. Approx. HT 19cm.

At the beginning of the third millennium BC, then, it is clear that pottery and the use of clay varied from region to region within China. In the far north-west, large rounded forms of red earthenware were painted with bold curvilinear designs. In central China, more restrained shapes of similar body were painted with representational designs and geometric motifs. In the north-east, grey and black wares were made in intricate forms with carefully finished surfaces. Further south, the black wares were incised with interlacing and pictorial motifs. Along the Yangzi River, the use of clay for building rivalled its importance for ceramic vessels.

Late Neolithic

Regional distinctions which are sharp in the first part of the Neolithic age become blurred during the third millennium as the different cultures began to interact with one another. Shapes and decoration are no longer particular to an area or culture. Transmitted and modified, they display a complex exchange of influences which becomes difficult to disentangle as the Neolithic age draws to a close and the foundation of civilisation begins. During this period, the most technologically advanced pottery was concentrated in an area of central China encompassing the northern, eastern and western parts of Henan province and the southern parts of Hebei and Shanxi provinces, as well as Shaanxi province to the west and Shandong province to the east.

The culture which pervaded these areas is known as Longshan, after the site of Longshan Chengziya in Shandong; pottery was first discovered here in 1930. Within the Longshan sphere, at Huaiyang Pingliangtai in eastern Henan, is the first evidence of a Chinese walled town, and it includes at least three kilns. The walls themselves were constructed of brown clay mixed with burnt-clay fragments, stamped down to form layers about 15 to 20 cm thick. Buried beneath the south gate of the town was a 5-metre section of underground water drainage made of interconnected pottery pipes 35 to 45 cm long. In northern Henan, houses were built of dark brown clay slabs laid sideways, one on top of the next, while half dry.

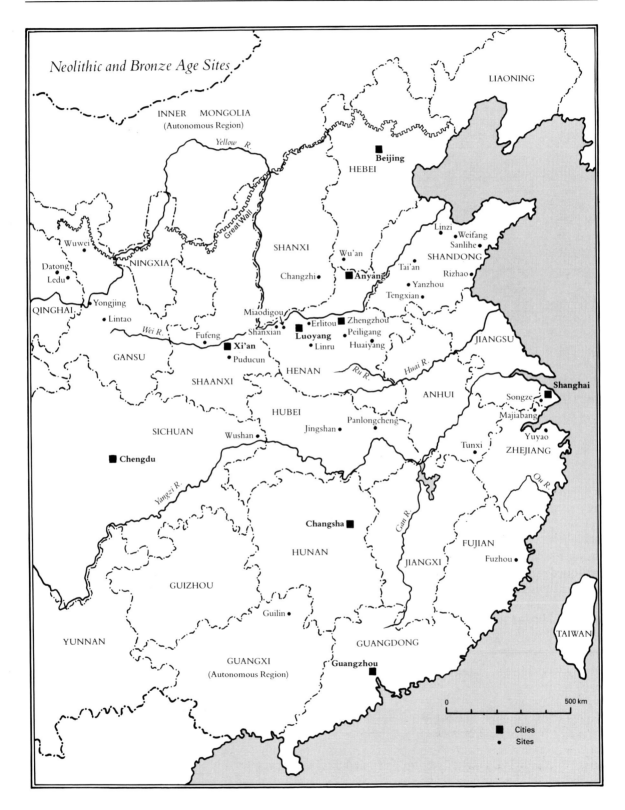

Neolithic and Bronze Age Sites

INNER MONGOLIA
(Autonomous Region)

LIAONING

Yellow R.

■ **Beijing**

HEBEI

Wuwei

• Linzi
• Weifang
Sanlihe •

Datong •
Ledu •

NINGXIA

Great Wall

SHANXI

Wu'an •

SHANDONG

Tai'an •

Rizhao •

Changzhi • ■ **Anyang**
• Yanzhou
Tengxian •

QINGHAI

Yongjing •
• Lintao

Wei R.

Miaodigou
• Erlitou • Zhengzhou
Shanxian • **Luoyang** Peiligang •
• Linru Huaiyang •

JIANGSU

Fufeng •

GANSU

■ **Xi'an**
• Puducun

HENAN

Ru R.

Huai R.

ANHUI

■ **Shanghai**

Songze •

SHAANXI

HUBEI

Majiabang •

Jingshan • Panlongcheng •

Tunxi •

• Yuyao

ZHEJIANG

SICHUAN

Wushan •

■ **Chengdu**

Yangzi R.

Ou R.

Gan R.

■ **Changsha**

FUJIAN

HUNAN

JIANGXI

Fuzhou •

GUIZHOU

Guilin •

TAIWAN

YUNNAN

GUANGDONG

GUANGXI
(Autonomous Region)

■ **Guangzhou**

0 500 km

■ Cities
• Sites

15 Two vessels of the Longshan culture, late period, unearthed at Shandong Jiaoxian Sanlihe: *dou* stem-bowl (left) and lidded vase. Approx. HT 14cm; 22cm.

Though these applications of pottery and clay show that a particular degree of urbanisation had been reached more than four thousand years ago, they are not the manifestation for which the earthenware of Longshan is renowned. The eponymous Longshan pottery is famous for being wheel-made, hard-fired, black, lustrous and very thin. The precise profiles resemble metal shapes. Some of the finest pieces, such as cups, boxes and jars, are quite small. They are considered to be ritual objects associated with oracle bones and carved jades from the same site.

The jades are sometimes carved with two circles and occasionally a straight line, implying eyes and a mouth. Decoration consisting of two carved circles is widespread on Neolithic jades, particularly positioned on either side of the right-angled corner of cylindrical objects known as *cong*, which have a square outer section and circular inner section. The motif is now believed to be the antecedent of the *taotie* monster mask which dominates Shang dynasty bronze decoration. Clay vessels bearing a similarly organised design have been found in northern Henan and southern Hebei provinces, showing that this idea, of two circles bisected by an edge or a line to imply a nose between two eyes, was not confined to jades during the late Neolithic. *Ding* tripod vessels from these areas have an appliquéd ridge down the outer surface of the leg with a disc of clay applied to either side of it. The wealth of decorative techniques and motifs available to the potters of the late Neolithic period in central China weighs against the possibility of such a contrived ornament having been invented in clay. The use of the motif on jade is so much more widespread and developed that, on present evidence, jade must be considered the original medium for it. The point is that the Chinese penchant for adapting motifs from one material, which may have dictated their design, to another had already begun before 2000 BC.

This use of borrowed decorative ideas on clay in the Neolithic period is limited, but the comparable use of adopted forms is a major issue in considering the shapes of late Neolithic ceramics and their metal counterparts. The earliest known bronze vessels in China are a group of *jue* wine vessels on three legs, which were excavated at Yanshi Erlitou in Henan.

16 *Ding* tripod showing applied clay discs to either side of a flange. Unearthed at Shandong Rizhao Liangchengzhen. Longshan culture. *c.* 2500–2000 BC. Approx. HT 10cm.

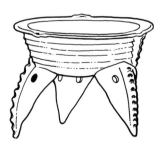

Erlitou is a controversial site; some archaeologists regard it as the first capital of the Shang dynasty (*c.* 1700–1100 BC), but others consider it to belong to the earlier Xia dynasty, which exists in literature and legendary history but has yet to be confirmed by archaeological discovery. The shapes of *jue*, *jia* and *he* are all found in pottery at Erlitou. *Jia* are also 20 amongst the earliest bronze vessels, further testimony that the major bronze vessel shapes of the Shang dynasty were derived from ceramic antecedents.

These early bronzes were cast in ceramic piece moulds. This is a unique beginning for metallurgy, as the earliest metal objects in every other part of the world are beaten or wrought. It is an interesting corollary that many late Neolithic and early dynastic Chinese ceramics display characteristics which serve no technical purpose in pottery but are essential to sheet metalwork. For example, some *jue* shapes have small round discs of clay applied above the handle, exactly where a rivet would be expected to appear on a beaten metal vessel. Strap handles and rolled rims are similarly redundant on pottery. Although no beaten or wrought metal objects have been found in China, the existence of such features on ceramics before the Bronze Age points to some contact between China and another early metal-using culture. Such a theory has yet to be borne out by archaeological discovery.

The invention of bronze casting diminished the role of ceramics to some degree. Prior to the use of bronze, only jade and lacquer rivalled pottery as a medium for ritual objects. Lacquer is a perishable material about which little is known at this period, while jade was carved into knives, axes and small sculptures. As far as we know, pottery was unchallenged as a material for ritual vessels. Only the finest pottery was destined for this role: pieces such as the thin, burnished black Longshan objects or the earlier finely 15 painted red earthenwares. Vessels supported on a high pedestal foot, a shape prevalent in the eastern seaboard cultures, are another example of 11 ritual ceramics. Yet even wares of this quality could not compete with a vessel of cast bronze in terms of complexity and expense. As the costliest material, bronze was to be favoured for the most important and precious objects for the next 1500 years or so. While thus supplanting pottery for this purpose, the same high cost of bronze precluded it from ordinary use, ensuring the continued production of ceramic vessels for all but the most refined needs.

As previously mentioned, Chinese metallurgy is unique for beginning with casting. It is further unique amongst casting techniques for using ceramic moulds rather than wax models. Clay was thus crucial to the casting of bronze. The bronze vessels were cast from three- or four-part piece moulds; some appendages, such as handles, were cast separately and then cast on to the bronze object. The procedure required great precision in order to work successfully, and it was vital that the clay moulds should not shrink when fired.

Recent analysis of Shang moulds at the British Museum has shown that 17 they are made of loess, the ochre-coloured dust blown on to the north Chinese plains from the heights of the Tibetan plateau, and better known as China's 'yellow earth'. Loess is dry and sandy with only a very low clay

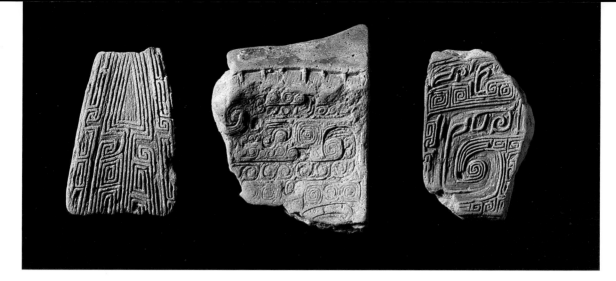

content. This means both that shrinkage is minimal and that extremely fine decoration is possible. The exquisite detailed ornament of Shang bronzes is therefore due to the properties of a particular type of north Chinese earth. It must also be true that much of the skill required for casting bronze had been acquired through centuries of previous experience in firing and designing kilns. The technique of moulding was used to produce ceramic *li* vessels in the late Neolithic period, so it is not only the properties of clay but also ceramic technology which were responsible for the bronze casting achievement.

17 Three ceramic piece moulds for casting bronze vessels. The moulds are made of loess, an ideal material due to its fine particle size and low shrinkage on firing. Shang dynasty, 13th–11th century BC. From left: max. L 5.8cm; 6.7cm; 5.3cm. OA 1939.6–16.2,3,1, given by A. D. Brankston.

18, 19 There are two types of Shang ceramic vessel which do seem to have fulfilled a ceremonial purpose: white wares and glazed wares. They have been found mostly in royal tombs dating from the later part of the dynasty when the capital was at Anyang, just north of the Yellow River. The white ware sometimes imitates bronze in shape, and often also in its decoration, which is deeply incised so that the surface relates to the texture of bronzes. The greater emphasis on diagonal axes in the decoration may, however, reflect the influence of textiles. The colour and body thickness, though, are features common to another class of late Shang ritual object: vessels cut from marble.

18 The most remarkable feature of the white ceramics is their composition. They are made of kaolin, the white clay which more than two thousand years later was to be used in enormous quantities for producing porcelain. The kaolin of the Shang vessels is pure, and some have argued that it would have given a true translucent porcelain if fired at a higher temperature. It was fired almost 400°C too low for porcelain – at about 1000°C – and the vessel walls are very thick. The selection of clay must have been highly skilled. Washing and mixing clays had been practised even in the Neolithic period, but the white kaolin pots and other high-fired Shang ceramics show that new heights had been reached in clay preparation.

The disappearance of the high-kaolin white wares is as intriguing as their appearance. The essential material, kaolin, on which the great tradition of Chinese porcelain manufacture was to be founded, was evidently in use more than two millennia before white porcelains were developed. So far no ceramics high in kaolin have been found at sites dating from between the Shang dynasty (*c.* 1700–1027 BC) and the sixth

18 Four white ware
fragments, made of kaolin.
The fragments come from
ceremonial objects and
represent the earliest use of
kaolin for ceramic vessels.
The decoration derives
from contemporary
bronzes and textiles. Shang
dynasty, 13–11th century
BC. From left (top row):
HT 7.9cm; 6.6cm; (bottom
row) 3.2cm; 4cm. OA 1940.
4–13.39,70,64,34, given
by Mrs G. Eumorfopoulos.

century AD, though some examples may yet be discovered. At least two possible reasons can be suggested to explain why the white wares may not have been developed during the Shang dynasty. A practical explanation is that the low-clay material was difficult to handle. It would have had low plasticity and would therefore break easily during modelling, firing or use. The fact that it survives mostly in fragments, and only rarely in complete vessel form, testifies to the brittle nature of the material. Another possible reason for the disappearance of white wares is their relation to bronze and marble. Ritual vessels were carved in marble during the late Shang dynasty but, like other forms of non-jade stone carving, they did not continue into the succeeding Western Zhou period (c. 1027–722 BC). If the white wares were indeed made to imitate marble, then there would have been no grounds for pursuing the use of such a difficult material; nor would kaolin be suitable for creating the large and often extravagant forms assumed by ritual bronze vessels at that time.

The most technically sophisticated Shang dynasty ceramics are the

19 high-fired wares exhibiting the earliest use of glaze. The bodies, though not of white kaolin, are nonetheless of carefully selected and prepared clays, and the pieces were fired at around 1200°C. Like the white vessels, they were perhaps used ceremonially. It is interesting that the ceramics made for ritual use are not always the most technically superior, but are frequently of a fine appearance. This aspect of ceramics is echoed at intervals throughout the history of Chinese pottery and porcelain: the most difficult to produce is not always the most highly prized, and appearance sometimes ranks above technique.

The importance of the Shang glazed wares should not be underestimated. A layer of glaze can make even low-fired earthenware pottery non-porous. Like high firing, this increases its ability to contain liquids efficiently, a major requirement of pottery vessels since earliest times. High firing techniques developed gradually, so the use of glazes is a considerable advance. Glazes also greatly improve appearance. In most cultures, the first glazes are fortuitous: in a wood-fired kiln, for example, ash can fall on to the pot and the silica in it will fuse with the ceramic body to form an accidental glaze. Some cultures found this effect pleasing and encouraged it. The Koreans, for instance, stirred up the fire to make the ash come down on to the pottery and produce more glaze. The Chinese, on the other hand, seem to have grasped the principle of applying glaze deliberately from a very early stage.

19 The earliest glazed wares have been found at the middle Shang capital of Zhengzhou in Henan, which was occupied in the fifteenth and fourteenth centuries BC. The best example is a jar with a wide flaring mouth, sloping shoulder, and a high foot. It is the antecedent of the

19 Glazed stoneware sherd, decorated with a stamped S-shaped design. Excavated at Erligang at Zhengzhou, the middle Shang capital, in Henan province. Similar sherds have been found in the south-eastern province of Jiangxi. Shang dynasty, 15th–14th century BC. L 10cm. OA 1959.2–16.24, acquired by exchange with the Institute of Archaeology, Academy of Sciences, Beijing.

bronze *zun* which became a standard shape for ritual vessels later in the Shang dynasty. The glaze is greenish-yellow, thin and uneven. Shang glazed wares are coated both inside and out. The shapes are similar to those of bronze vessels, and the decoration consists mostly of impressions on the pot, beneath the glaze.

The quantity of glazed wares increased as the dynasty progressed, particularly towards the south-east. In fact, there are so many more glazed wares south of the Yangzi River that the examples in the Shang capitals, even at Anyang where there are several, have been regarded as imports from the south-eastern coastal area to the Shang metropolitan centres. The areas of present-day Jiangsu and Zhejiang, where the glazed wares were made, correspond to the old states of Wu and Yue, which have been famous for green wares since the third century AD, yet it now seems that the area was the home of green-glazed ceramics for considerably longer. Excavations at the Shang city of Panlongcheng in Hubei province, north of the Yangzi, show that important urban areas existed far from the centre of Shang power, but were much influenced by it. If glazed wares were imported into the Shang capital from outside, then they must be viewed as important indeed, for the Shang metropolitan area exerted many more stylistic influences than it absorbed.

The great majority of Shang ceramics are humble in comparison with these high-fired glazed wares and white kaolin vessels. Although many imitate bronze vessel shapes and are made of fairly high-quality clays – for example, *jue* wine vessels in white clay similar to the type used in 20 the late phase of the Dawenkou culture – the grey, red and buff wares continue to form the staple pottery types for domestic use. At Anyang, in the later part of the Shang dynasty, local painted pottery shows that some practices persisted which had begun in the Neolithic period. Other types of decoration, such as incised and impressed patterns, bowstring lines and appliqués, continue to appear on everyday pottery throughout the Shang dynasty and for several centuries afterwards.

Urbanisation and the foundation of civilisation meant that artefacts were produced with a far greater degree of organisation than previously. There is evidence at all three Shang capitals – Erlitou, Zhengzhou and Anyang – that workshops were specialised. At Erlitou, the earliest of these, there is a clear distinction between workshops for bronze, pottery, bone and so forth. At Zhengzhou Erligang, the middle Shang capital, different work areas have been identified for clay preparation, modelling, decorating and so on. It seems that kilns were also specialised, with one for firing grey wares, another for sand-tempered wares, and yet another for hard white wares. Excavations at Anyang tell a similar story.

Signs and symbols occur on pottery vessels at Erlitou and later sites. Given the humble status of artisans and the still very rudimentary stage of writing at this period, it is almost impossible that such signs could be the names of the potters themselves. Insignia on Shang bronzes refer to the name of the clan commissioning them, or of their ancestor. It is possible that the pottery symbols serve a similar function, but the lower status of ceramics make this highly unlikely. The symbols incised on

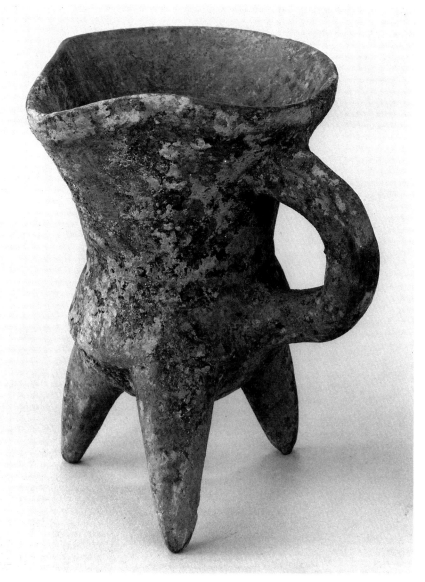

20 Earthenware vessel in the form of a ritual bronze *jue* wine vessel. Although the vessel imitates a cast bronze type, it displays certain features belonging to wrought metal objects, such as the flattened mouth-rim and strap handle. Said to have come from Anyang. Shang dynasty, 13th–11th century BC. HT 11.7cm. OA 1937.5-15.2, given by A. D. Brankston.

early ceramics would therefore seem most likely to be the names of the workshops in which they were produced. This practice is still followed today in some areas of China.

The Shang were overthrown, probably in the middle of the eleventh century BC, by the Zhou, a people from the west of their domain. The Zhou established a dynasty which lasted for more than eight centuries. During that time, Chinese civilisation was shaped in the traditional form that endured for more than two millennia, aspects of which survive even today. The dynasty is divided by historians into the Western Zhou, from the overthrow of Shang until 771 BC, when the capital moved eastwards from Xi'an to Luoyang, and the Eastern Zhou, from 770–221 BC. The

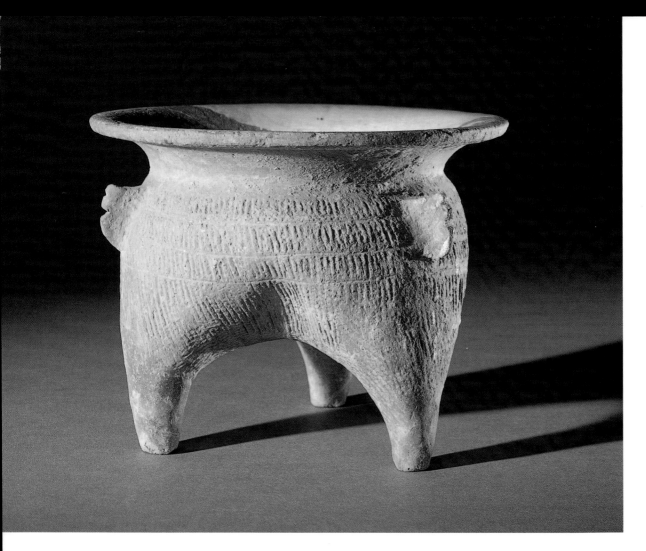

21 Earthenware *li* tripod vessel with striated impressed decoration, and three flanges which refer to bronze vessel shapes. Excavated from a tomb at Puducun, datable to the reign of King Mu, which also contained grooved pottery vessels. Western Zhou dynasty, 10th century BC. HT 14.6cm. OA 1959.2–16.1, acquired by exchange with the Institute of Archaeology, Academy of Sciences, Beijing.

Eastern Zhou is further divided into the Spring and Autumn period (770–481 BC), named after a famous text covering the history of the era, and the Warring States period, whose title is sadly self-explanatory.

Until at least the fourth century BC, bronze remained the material in which ritual vessels, bells, and the most valuable knives and ornaments were made. Late in the Warring States period the supremacy of bronze was challenged, chiefly by lacquer but also by the arts of inlaying or coating bronze in gold and silver and of encrusting it with precious and semi-precious stones. Pottery assumed a new role slightly sooner, although no significant technical or functional innovations seem to have taken place during the Western Zhou period. It is possible, however, that potters might have enjoyed some improvement in status if an anecdote in the *Zuo zhuan* (*c.* fifth to third century BC) is to be believed. This commentary tells of a wondrously skilled potter named You Efu, who lived during the early Western Zhou period. King Wu, who overthrew the Shang, took him as a son-in-law. Potters marrying princesses would have been impossible in the Shang dynasty, but the idea could at least be entertained during the Zhou.

Glazing undoubtedly improved between the eleventh and eighth cen-

21

turies BC. Examples dating from the tenth or ninth century BC have been found at Luoyang in the centre of the Western Zhou domain. Fired at around 1200°C, they are of a fine-grained kaolinic grey-white clay and quite thin. The glaze is greyish-green, thicker, and covers the pot more evenly than the Shang glaze. Glazed sherds excavated from workshop sites near the palace of the Western Zhou capital at Fufeng, near Xi'an in Shaanxi province, indicate that glazed wares were made in the north as well as in the south at this period. It is clear that glazing techniques were progressing in the Yangzi River area. At Tunxi in Anhui province, some 1000 km south-east of the Zhou capital, more than seventy glazed items dating from the ninth to the eighth century BC were found at one site. They are decorated by incising and impressing and also with wheel-made grooves. In some cases the bases are scratched with potter's marks.

The glazes fall into two types. One is a poorly fitting, uneven brown glaze containing 2 per cent iron oxide. It covers the outside of the vessel and the inner lip. The other is a consistent pale grey-green, containing only one per cent iron oxide and covering the entire vessel, inside and out. It is possible that the difference can be partly attributed to the

22 Jar with olive-brown glaze. The unglazed base bears an incised mark. A similar jar was unearthed in 1982 at Dashita, near Quzhou in Zhejiang province, along with seventy-two other high-fired glazed wares in the vicinity. Late Western and early Eastern Zhou glazed wares have also been found at Anhui Tunxi, Fujian Fuzhou and in southern Guangdong province. Late Western or early Eastern Zhou dynasty, 8th–7th century BC. HT 5cm, D 10.1cm. B60 P223. Asian Art Museum of San Francisco, The Avery Brundage Collection.

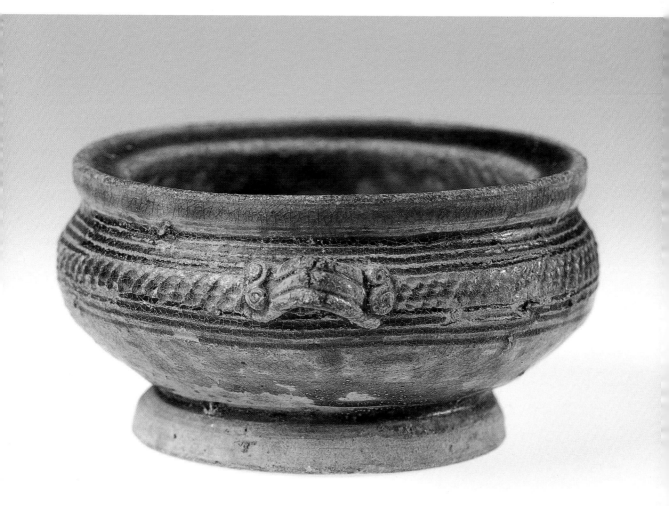

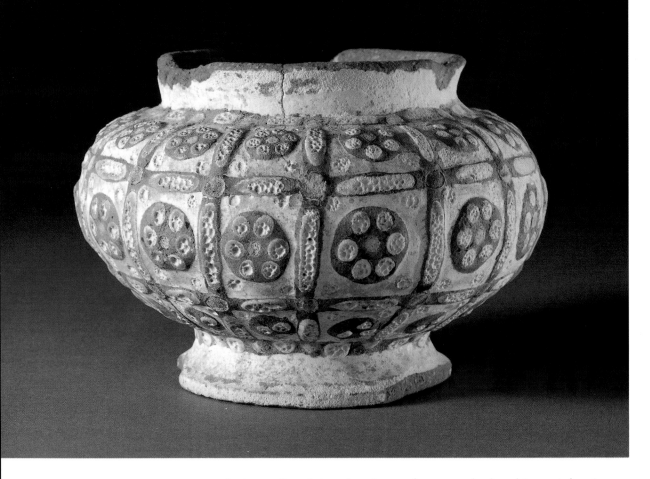

23 Earthenware bowl decorated with slip and glass paste. Said to have come from Xunxian, Henan province. The glass has mostly degraded. The body is coarse and gritty. Glass beads were widespread in China during the Eastern Zhou period, but it is rare to see the material combined with clay. Another example is in the Nelson-Atkins Museum of Art, Kansas City, Missouri. Zhou dynasty, 4th–3rd century BC. HT 9.5cm. OA 1968.4–22.18, Sedgwick Bequest.

technique of applying the glaze – for example, brushing might give an uneven effect while dipping the whole vessel into the glaze would result in a much smoother appearance. The distribution of high-fired glazed wares during the Western Zhou period is wide. Examples have been found in the provinces of Hebei, Shandong, Henan, Shanxi, Shaanxi, Anhui, Hubei, Jiangsu, Zhejiang and Jiangxi, an area covering northern, central and south-eastern China.

This is not the case during the succeeding Eastern Zhou period, when the glazed wares were again concentrated in the south-east along the lower reaches of the Yangzi River as they had been in the Shang dynasty. The glazes are predominantly grey-green with a few examples of yellow. Further north, in the area around the Yellow River, very few glazed pots dating from the seventh century BC and later have been found, and these are restricted to one type: a flat-bottomed urn. In the late part of the Spring and Autumn period, around the fifth century BC, potters began to make glazed wares on the wheel. The shapes became more regular and the body thickness more even. By the middle of the Warring States period, glazed vessels accounted for approximately half of all pottery production. They generally imitate bronze vessel forms, and the favoured decoration is an impressed pattern of large rectangles rather than the smaller squares and other designs on the earlier glazed wares.

Throughout the Zhou period unglazed, high-fired, impressed wares

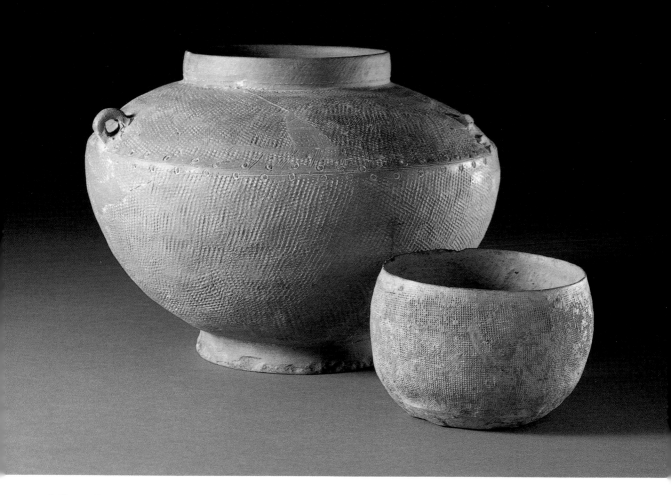

followed a course complementary to that of the glazed wares, flourishing in the Western Zhou, especially in the middle and lower reaches of the Yangzi, and appearing only occasionally in the area around the Yellow River. The absence of unglazed wares in the north is unexplained but may be due in part to that area being a centre of bronze production and glazed-ware use. Some pots from the south-eastern provinces of Jiangsu, Zhejiang and Jiangxi are impressed with two or three different designs on a single vessel. Wares impressed with geometric designs influenced bronze designs in the south-east. The pottery did not change much in the Spring and Autumn period but began to appear in new regions – along the east coast and in the southern provinces of Fujian and Guangdong. A large rectangle pattern and a fabric pattern were added to the Western Zhou repertoire of small squares, spirals, wavy lines and mat impressions, and the wares continued to flourish in the south-eastern area then ruled as the states of Wu and Yue. For some time the unglazed and the glazed high-fired wares remained similar in technique, decoration, and in being used mainly as vessels. Towards the end of the Eastern Zhou period, however, the glazed wares become more numerous.

Thus the development of ceramics proceeded throughout the Zhou dynasty. The high-fired vessels are the finest, and represent the important technological innovations that were to become the foundation of China's great ceramic tradition. Yet, during the Eastern Zhou, a new class of

24 Jar and bowl of impressed earthenware. The jar is decorated on the shoulder with a design of chevrons and circles in addition to the textile impressions which cover the rest of the vessel, including the base. Possibly from Jiangxi province. The thick-walled bowl also bears textile-impressed decoration. Similar bowls of the Eastern Zhou period have been unearthed near Shanghai. Both Eastern Zhou, 8th–3rd century BC. Jar: HT 14.1cm. Bowl: HT 6.1cm. OA 1940.4–13.31, given by Mrs G. Eumorfopoulos; OA 1940.12–14.306, given by Mrs B. Z. Seligman.

pottery arose: burial pottery. Inferior in quality to the high-fired wares and in status to the bronzes and lacquers it sought to imitate, this new type formed its own sub-tradition which was also to continue for many centuries.

Burial pottery was introduced as a result of the diversification in grave goods and the elimination of aristocratic lineages, both of which were aspects of the breakdown of the Western Zhou feudal system in 771 BC. China became fragmented into many separate states in place of the numerous feudal domains which had given allegiance to a central seat of power. Bronzes had been the major burial artefact in the Shang dynasty because they symbolised ancestral influence and were connected through ritual with the authority to rule. They had also become symbols of status as well as of power in the Western Zhou. For this reason, bronze vessels were often commissioned by minor feudal lords seeking to improve their status when their power was in fact small. Notions of divine authority, and with them the dignity of bronze vessels, became impossible to sustain when no central power remained and many states and kingdoms existed side by side. Bronze vessels continued to be cast, but bronze was also used widely for sets of bells in a ritual context and for architectural and other temporal functions.

The removal of previous connotations of ancestors and authority from bronze cleared the way for other materials, particularly lavish ones, to become fitting burial goods. In the Warring States period especially, when a degree of interstate rivalry in craftsmanship probably existed, gold, silver and, above all, lacquer were favoured. In the Western Zhou, people of power sought to impress by means of bronzes, which related to ancient authority and influence. In the Eastern Zhou, it seems that displays of wealth alone were sufficient. Hence clay, which is cheap, was used to imitate vessels in bronze and lacquer, which are expensive.

The imitations were accurate and widespread. Complex bronze vessel shapes were reproduced in minute detail. Given the technique of casting bronze from ceramic piece moulds, this is not surprising. Ceramics imitating lacquer were elaborately painted to give an exuberant surface decoration. Here again there is a link in technique, for lacquer designs are painted in black lacquer on red, or vice versa. The ceramic designs were painted in coloured pigments on to a body which had already been 25 fired. The effort invested in the decoration of lacquer and in its pottery imitations must have been comparable. The advantage of the lacquer in final effect is that it gleams, while the painted ceramic surface remains dull. The importance of any ceramic imitation lies in the overall effect. In the case of bronzes, this would be principally the form, and in lacquer, the decoration. In either case, the quality of the ceramic body material is insignificant, so that imitative pottery vessels produced for burial are always of low-fired earthenware.

A related burial practice with a slightly different history is that of interring ceramic figures made in human form. The tradition which culminated in the spectacular camels and tomb guardians of the Tang dynasty at first replaced the Shang and Western Zhou tradition of

immolating live slaves in grand burials. In tombs at the late Shang capital Anyang, three ceramic figures wearing shackles have been excavated. Live burials at the same site vary from several dozen to three or four hundred per tomb. Sacrificial burials continued throughout the Western Zhou and into the Spring and Autumn period. A tomb at Shandong Linzi Langjiazhuang dating from the early fifth century BC included some live burial victims, but there were many more pottery figures. This is the earliest known tomb in which ceramic burial figures play an important role. The fifth century BC must have witnessed a change in attitudes: the live burial of sacrificial victims was no longer regarded as ritually correct. Between 1949 and 1979 more than three thousand Warring States period tombs were excavated in China, of which only thirty included live burials. Many medium and large tombs contained none at all, amongst them a burial at Shanxi Changzhi Fengshuiling which yielded more than a thousand grave goods.

The changing attitude is also evident in texts of the Eastern Zhou period. The *Zuo zhuan*, a commentary dating from the fifth to third century BC on the history of the Spring and Autumn period, records instances of sacrificial burials accompanying particular personages. The philosopher Mozi, in the fifth to fourth century BC, records the entitlements or regulations applied to specific ranks: for royalty, a grand burial would include several hundred live sacrifices, and a modest one several dozen; for generals and noblemen, a grand burial would include several dozen victims, a modest one only a few. Mencius (372–289 BC), the disciple of Confucius who transmitted the philosopher's words, rails against the barbaric practice of burying human images in wood or pottery. How quickly the original gruesome ritual must have been forgotten.

Eastern Zhou mortuary figures are predominantly human in form and often appear in sets or groups of small sculptures. Larger single figures reveal details of dress, an example of the useful documentary aspect of burial pottery. When they do occur, animals are exotic, such as birds composed of six interlocking parts. Dogs and chickens were buried live in the Shang and Western Zhou periods, and this may be why the esteemed and important animals, such as Shang pigs and fancy birds, are represented in pottery rather than the humbler species actually slaughtered as sacrifices.

The evolution of simple bowls made of barely more than baked clay into well-proportioned, high-fired glazed vessels took several millennia. It was completed before the unification of China and the beginning of imperial history in the third century BC. With the major processes of clay preparation, wheel-turning, glazing and firing well explored, the importance of ceramics became established during the following two millennia, when their shifting role as industry, commodity, art object and burial accoutrement constantly produced technological advances and aesthetic experiments.

2

FUNERARY ART AND FUNCTIONAL VESSELS

The Han and Six Dynasties

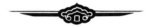

25 OPPOSITE Painted
earthenware wine jar and
cover. This burial vase is
an imitation of inlaid bronze
and painted lacquer vases
of the same decoration
and shape, known as *hu*,
and includes a *taotie*
monster mask above each
handle. Such imitations
were first made during the
Warring States period
(481–221 BC). The blue
pigment on this vase has
been shown by analysis to
derive from lapis lazuli.
1st century BC–1st century
AD. HT 48cm. OA
1936.10–12.233.

The importance earthenware acquired in imperial China could not
be more loudly proclaimed than by the 7000-strong army of
life-size terracotta warriors and horses which accompanied the
burial of Qin Shihuang. Known as the 'First Emperor', he unified the
country in 221 BC by joining up existing sections of the Great Wall and
standardising the script, currency, weights and measures. He ruled with
such terrible authority, however, that a furious populace overthrew the
dynasty after only a few decades. Their peasant leader, Liu Bang, was
to become the first Han emperor.

Qin Shihuang was not a man to do anything on a small scale, and
indeed the terracotta army, as it has become known, is impressive chiefly
for the size and quantity of the figures. More than seven thousand models
of men and horses were excavated in the suburbs of Xi'an in Shaanxi
province, beginning in 1974. The figures were mostly broken and many
appeared charred, leading some historians to propose that the buildings
beneath which they were positioned had collapsed in a fire. Whatever
the cause of the damage may have been, it is compensated by the army's
precise formation. The design and the positioning of the figures were so
accurate that it has not been difficult for Chinese archaeologists to
reassemble them. Several complete pieces have been widely exhibited in
Europe and America.

The figures are made of a low-fired earthenware which under analysis
appears to consist of the loess earth of the north China plain, the same 168
material which was widely used for bronze moulds during the Shang
dynasty (*c.* 1700–1027 BC). Apart from their size, the most arresting
quality of the figures is the detail of their hairstyles and facial expressions, 26
which vary greatly. Their armour is standardised, however, and the

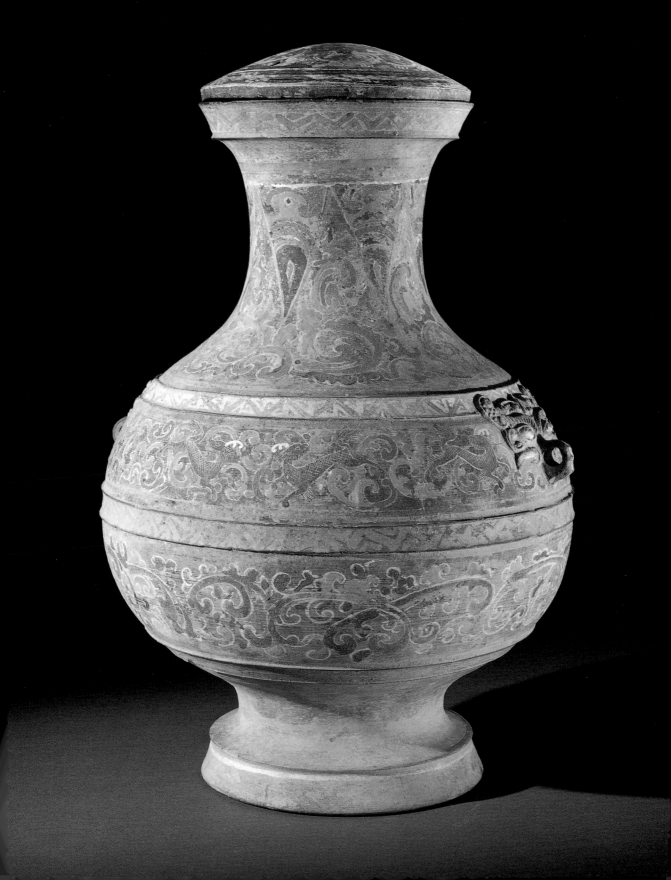

26 Terracotta soldiers from the tomb of Qin Shihuang, known as the 'First Emperor' of China (259–210 BC).

arms and trunk display no naturalism. The solid legs are straight and hefty to support the weight of the figures.

The greatest skill embodied in the terracotta army is the successful firing of such large objects composed of elements modelled separately and joined together. The quantity in which they were produced could only be achieved by a production system akin to a modern assembly line, with numerous craftsmen specialising in a single component. Technical specialisation was evident even in the bronze foundries of the Shang dynasty; it is an essential feature of Chinese industry and accounts for the country's success in producing artefacts of high quality in quantities eventually sufficient to export and thereby influence the outside world. Qin Shihuang's army is the earliest spectacular result of this degree of organisation.

Historical accounts record Qin Shihuang's authority and severity, so it is not entirely surprising that he should have organised such a display of power and personal protection for himself in death. This was not a new element in burial practice, for human images had featured amongst grave goods since much earlier times. In the centuries before the Han dynasty, painted and lacquered wooden images, and sometimes stone and pottery images were buried with the dead. Such figures are usually simple, and of modest proportions. Although figures the size of the terracotta army pieces are unknown elsewhere before the Han dynasty, in the latter period small earthenware figures are dominant amongst burial goods even in quite modest tombs.

In the early part of the Western Han dynasty (206–*c.* 100 BC), the type of tomb sculpture did not depart greatly from that of Qin Shihuang. Near the site of the capital, present-day Xi'an, a group of two thousand smaller figures and horses with similar details of dress and accoutrements has been unearthed. In the early years of the new dynasty, many battles were fought against the fierce nomadic Xiongnu people to the north, so the prevalence of cavalry and infantry amongst tomb models in north China is not surprising. Pots, too, changed little in the first sixty or seventy years of the dynasty, when strongly regional types survived.

Slightly later tomb goods of the Western Han show more of life at the court and amongst the nobility. Smaller in scale and less military in theme than the early Han models are groups of figures clearly taking part in banquets and festivities. Gaily painted with coloured pigments, they include dancers, acrobats and musicians as well as the court nobility they are entertaining. Accounts of such banquets occur in the dynastic histories and are corroborated by the archaeological finds.

Such figures reflecting daily life, albeit in rarified circles, are central to the development of pottery tomb sculpture from an exclusively imperial to a commonly used burial accoutrement. In the early Han dynasty, tomb figures represented martial power; in the middle Han, 27, 28 figures of servants and entertainers represent the daily life of the period's powerful nobility. By the latter part of the dynasty, relatively humble tombs contained models of mundane objects from the daily lives of ordinary people.

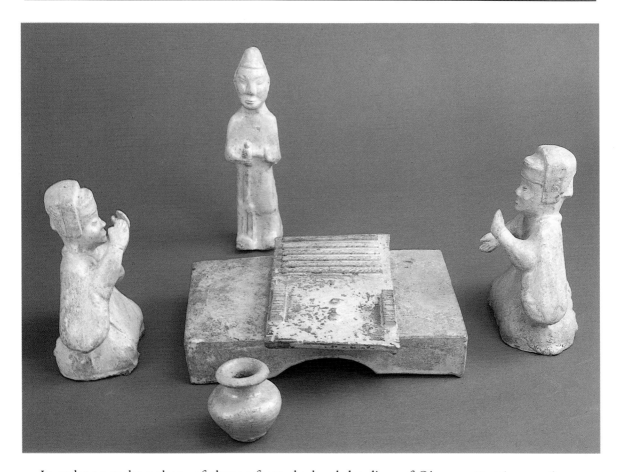

In order to make a show of change from the harsh legalism of Qin, whose institutions they in fact preserved, the Han rulers professed a return to Confucianism. In the reign of Emperor Wu (140–87 BC), a more uniform style of pottery emerged and techniques developed in central China spread rapidly to other parts of the country. Sets of earthenware vessels imitating ritual bronze groups were still produced, but models of domestic items which furnished Eastern Han tombs were now added to the potter's repertoire. During the Eastern Han period (AD 25–220), earthenware ritual vessels disappear completely and all burial pottery relates to daily life.

There are no Han documents describing formal beliefs concerning death, but evidence from literary texts and many excavated tombs makes it possible to deduce a generally held view of mortality at that time. It was believed that humans are made up of three constituent parts: the *xing* (body), the *hun* and the *po* (soul). Not until death itself did the soul divide into *hun* and *po*, and the first obligation of relatives was to attempt to dissuade the soul from leaving the body. Once this ritual attempt was performed, the body was considered dead and the *po* stayed with it. The *hun* departed for paradise, where it took up a hierarchical position equivalent to that which the deceased had held in life. The journey to

27 Burial group of earthenware figures at a gaming board. Most of the dark green glaze has become iridescent through prolonged exposure to dampness. The figures are thought to be playing *liu bo*, an ancient board game for two players with six pieces each. The boards were marked with divination symbols and the pieces with the animals of the four quarters. 1st–2nd century AD. Tallest figure: HT 25.6cm. Board: L 29cm. OA 1933.11–14.1, given by friends of the British Museum.

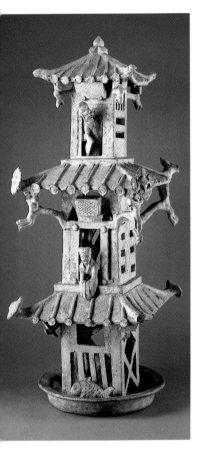

28 Earthenware burial model of a watchtower with degraded green lead glaze. The model represents a structure of wooden supports and tiled roofs complete with eaves tiles and provides interesting information on architectural forms no longer extant. Watchtowers like this would have been built within the walls of large compounds. 1st–2nd century AD. HT 85.5cm. OA 1929.7–16.1, given by Mrs Chester Beatty.

paradise was not necessarily straightforward or safe, hence the frequent occurrence in tombs of stellar maps and funerary banners setting out the route the *hun* must follow. It was for the benefit of the *po* that the tomb was furnished with essentials for future existence.

These furnishings included items in bronze, jade and lacquer, but the precious materials do not compare with the earthenwares in diversity of form. Burial ceramics were of two types: everyday pots which had been used by the deceased, and models of anything relevant to daily life. Stoves, well heads, granaries, duck ponds, pigsties, dogs, horses, houses, 28 watchtowers and a host of other domestic and agricultural models have been excavated in large numbers. The widespread use of common objects in place of ritual ones in the Han dynasty not only marks a break with religious tradition, but also reflects the rise of a material which, until two centuries previously, had been regarded as inferior. Models were far more easily produced in clay than any other material because of its plasticity, so it is possible that the increase in pottery was due to a higher demand for tomb furnishings.

The principal technical achievement in Han pottery was the development of lead glazing. One example of a lead-glazed earthenware vessel replicating bronze is known from the end of the Warring States period, but it was during the Western Han dynasty that the technique was first used on a large scale. Glaze fluxed with lead has a high refractive index, a smooth even melt, and a reasonable firing range.

The appearance of lead glazes in China is roughly contemporary with their emergence in Rome but a link, if it exists, has not yet been established. It is possible that lead glazes were discovered independently in each area. In China, the earliest examples come from the *guanzhong* area of Shaanxi province. There are very few from the early part of the dynasty, even including the reign of Han Wu. In the reign of Xuandi (73–48 BC) the practice spread quickly but occurs particularly in Henan province. Lead-glazed earthenware from the Eastern Han dynasty has been excavated at Gansu in the north-west, Shandong in the east, and as far south as Hunan and Jiangxi provinces.

The use of lead had several precedents in ancient China, the most important of which was in Shang and Zhou ritual bronzes. The quantity of lead used was peculiarly large for a bronze alloy, and it served the same purpose as in the glazes – that of lowering the melting point of the base material. In the Warring States period, lead carbonate was used as white powder make-up for women. Glass in the Warring States and 23 Han periods was of a lead-barium-silica composition. Lead glazes were coloured with copper to give green, or iron to give yellow-brown; the 29 overwhelming majority of Han glazed earthenwares are green. In either case the pieces were fired in an oxygen-rich atmosphere. Lead is poisonous to work with and can sometimes produce poisonous glazes after firing. It may be for this reason that all known glazed pieces are mortuary pottery, and items for daily use have not been identified.

A great number of surviving Han lead-glazed earthenwares are no longer a lustrous deep green but have a greyish-silver iridescent surface 27

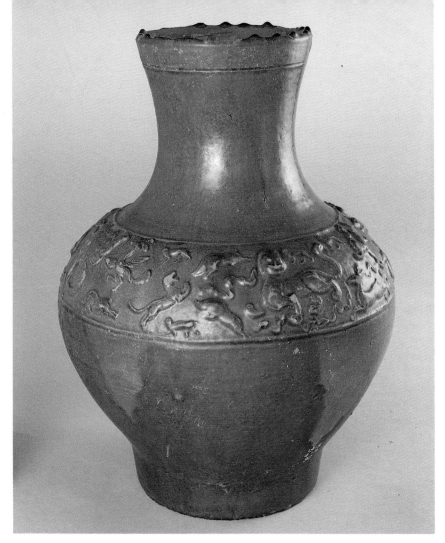

29 Earthenware *hu* wine vessel with lid and amber-yellow lead glaze. A moulded frieze of leaping animals decorates the shoulder of this burial vessel. The lead glaze includes a small amount of iron oxide which lends it the yellow colour. *c.* 1st century AD. HT 31.2cm. OA 1915.4–9.90.

30 Black earthenware jar with waisted profile and two bow handles, with decoration of striations around the neck and on the shallow raised footring. The type is known as Lifan after the area of Sichuan province in which such jars have been found. Jars of similar shape occur in the Neolithic cultures of Machang (*c.* 3000–2500 BC) and Xindian (*c.* 1500 BC). Said to have come from a tomb in Lifan. Han dynasty. HT 27.9cm. OA 1932.2–16.1.

which flakes off easily. This iridescence is the result of exposure to air and water, and occurs principally in areas where wet conditions prevail. Corrosion of the glaze is a continuous process, for once one iridescent layer has formed, water can penetrate between it and the glaze to produce another layer. Pots analysed so far have revealed from three to twenty layers of corrosion. This phenomenon also occurs occasionally on the lead glaze of the eighth-century AD Tang three-colour wares. It is confined to the green areas, indicating that the corrosion is linked to the copper colourant.

Architecture

A great deal of our information about Han dynasty architecture and construction comes from the tomb models of watchtowers, gates and agricultural buildings. More detail on certain aspects is provided by the ceramic building materials which have survived. Ceramics are found extensively amongst the architectural remains of the Qin capital Xianyang. The largest are the underground pipes forming a water system. These include not only straight pipes, but right-angle bends and funnels, indicating that the water supply and drainage system was reasonably sophisticated. The ground was paved with square bricks, either plain or with geometric decoration. More ornate, rectangular bricks were used on steps and walls. Some were moulded or incised with dragons and phoenixes. This is one of the earliest instances of the pairing of these two creatures, which was to become one of the most widely used artistic motifs right down to the present day. The majority of rectangular bricks, however, are decorated simply with a rope pattern. A few are impressed with characters that are names of officials, workshop supervisors, or places conquered in battle.

During the Western Han dynasty, hollow bricks became a vehicle for pictorial art in addition to their function as building materials. Elaborately decorated bricks were used on the walls and lintels of tombs, so that funerary architecture as well as funerary goods are a major source of information about life in the Han. The architectural decoration is just as varied, if not more so, than the burial goods: the moulded and incised bricks show agricultural practices, architecture, social customs, horse-drawn chariot processions, and mythological tales. In addition to the pictorial decoration are geometric border motifs and designs created by impressing the then common unit of currency, the circular *wu zhu*

31 Three painted earthenware bricks forming the roof support of a tomb. The edges of the hollow bricks are stamped with lozenge designs, as is the front of the central rectangular brick, which possibly bears the remains of a painted White Tiger of the West. 2nd century BC–2nd century AD. HT 60cm, L 81cm, 59cm, 81cm, combined L 121cm. OA+933.

32 Detail of a hollow grey earthenware brick, fired in a reducing atmosphere to increase its toughness. The civilian figure shown here forms part of the decoration on the side of a hollow earthenware pillar which, together with a companion pillar and a lintel also in the British Museum, probably formed the frame for a tomb door. The entire structure is decorated with figures, dragons and geometric border motifs. The characters to the left of the figure's head read *men gao chang*, a rank title which may be approximately translated as 'lieutenant of the gate'. 2nd century BC–2nd century AD. Detail: HT 20cm. Pillar: HT 114cm. Pillar and lintel: HT 142cm. OA 1937.7–16.5.

coin, into the damp clay before firing. Elaborately decorated earthenware tomb architecture is found throughout the Han empire but is concentrated in the central plains area.

In the Eastern Han, the practice of building tombs with decorated bricks was particularly developed in Sichuan province. Just as the tomb figures from Sichuan are distinct from the central Chinese tradition, so too is the tomb architecture, which portrays a liveliness not seen on the metropolitan examples. There is also a singularity of technique in the Sichuan tombs, for many of the bricks are painted rather than simply moulded or incised. Like their counterparts in central China, however, they are confined in area, in this case being concentrated in and around the Sichuan plain.

The most detailed information about Qin and Han buildings proper is provided by the many eaves tiles which have survived. Traditional

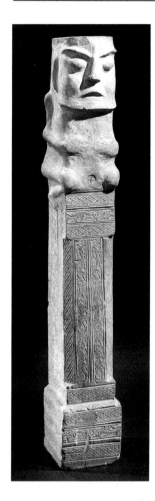

Chinese roofs comprise two rows of interlocking tiles of semicircular section. Small round eaves tiles are placed at the ends of the long roof-tiles to form a tidy edge. Occasionally, eaves tiles are semicircular, but in the Qin and the Han they are almost always round. The design tends to be quartered and, in the Qin, usually filled in with a spiral pattern. In the Han, particularly the Western Han, they are decorated with characters designating the palace, official or tomb for which they were intended. Some bear auspicious sayings, and these were intended as dedications to the building on which they were placed. Others are signed with the name of a workshop or, in some fewer cases, an individual artisan. In the Eastern Han, most eaves tiles were decorated with the appropriate animal of the four directions. This marked the religious or philosophical shift which took place in the middle of the Han. The shift is also evident in the changed nature of tomb goods, which occurred at the same time.

The mortuary pottery and the architectural ceramics, like the terracotta army and the Great Wall, were all made of loess. Loess is a good material for both large slab-built constructions such as the Great Wall and fine items such as the Shang dynasty bronze moulds, because its low clay content prevents distortion during drying and firing. Bricks and pipes made of loess clay were fired in reduction – that is, a smoky kiln atmosphere starved of oxygen – to increase their toughness. Unglazed funerary objects were similarly fired, lending them a grey tone. The greyness was due to the discolouring effect of reduced iron in the loess, which gave an unsuitable body colour for glazing. It was for this reason that the glazed earthenwares were fired in an oxidising atmosphere, resulting in a reddish body tone more suitable for setting off lead glaze colours.

High-fired wares

While lead-glazed wares were concentrated in the central area comprising Henan, Shaanxi and southern Shanxi provinces other inventions were taking place in the south-east. The coastal provinces of Jiangsu and Zhejiang produced high-fired stoneware with high-lime glazes by adding substantial amounts of calcium oxide, usually in the form of wood ash, to silica and alumina in the form of clay. This type of glaze first appeared in the Shang dynasty (*c.* 1700–1027 BC), when probably it was also manufactured in Zhejiang province and transported to the capital in Henan. This mixture of clay and wood ash was the basis of high-fired glazes in China for more than a thousand years, and was most highly developed in Jiangsu and Zhejiang.

In the far south, in the provinces of Guangdong, Guangxi and Hunan, another major type of glazed stoneware appeared during the Han dynasty. The southern and south-western areas, which had been on the periphery of the metropolitan sphere or even outside it throughout the earliest periods of Chinese history, eventually came under the control of the Han empire. Han influence was manifested in the hitherto independent cultural traditions of Guangdong and Guangxi by the production of bronze vessels in central Chinese forms, with decoration which often

33 Grey earthenware pilaster from a tomb. The apotropaeic figure surmounting it, though of odd proportions, is complete, with its feet appearing on either side of the pilaster. The pilaster would have been positioned centrally at the entrance to a brick tomb, supporting a triangular slab, with doors on either side, creating the impression of a house. 1st century BC–1st century AD. HT 113.9cm. OA 1942.10–10.1, given by the National Art Collections Fund.

combined the two traditions. The high-fired ceramics of the Han dynasty closely imitate the bronzes, with the result that many southern ceramics look like bronzes from central China. The ceramics are funerary rather than functional pieces. All this is reminiscent of the relationship between bronzes and ceramics in east China during the earlier Eastern Zhou period.

In the Han dynasty east China retained its position as the leading centre of high-fired ceramics by producing a superior green glaze and new vessel shapes. During the Western Han dynasty, high-fired wares from east China resembled the numerous sets of lacquer and bronze vessels .which have been found in tombs of the period, but Eastern Han ceramics seldom have a clear bronze prototype. Two forms in particular, the *hu* vase and *pou* jar, were modified to a fuller, more typically ceramic shape, and seem to have been used as food containers. Examples found in Han tombs in Xi'an and Luoyang were probably transported to north China with foodstuffs inside, and later buried with their owners. Sherds of such wares have been found amongst the greenware kiln sites of east China, which include Ningbo, Wenzhou, and Shangyu in Zhejiang

34

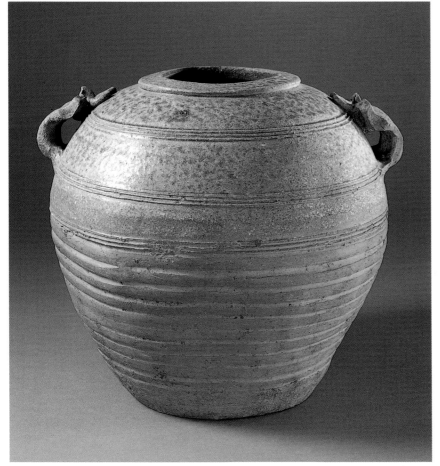

34 *Pou* jar with green glaze. The interior of the jar is partially glazed. The unevenness of the glaze on the shoulder suggests that ash may have been sprinkled directly on to the unfired jar. The handles are surmounted by an applied double spiral of clay. Many *pou* like this have been excavated from Han dynasty tombs in eastern China, particularly in Jiangsu province. Han dynasty, *c.* 1st century AD. HT 23.2cm. OA 1924.12–15.35, given by O. C. Raphael.

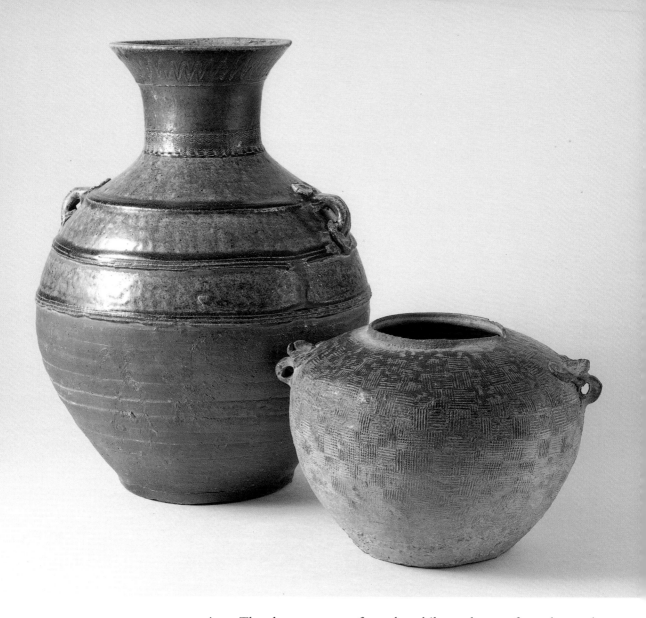

province. The glazes on wares from these kilns and wares from the south seldom cover more than half of the vessel, and always the upper half. The interior of the mouth is glazed but the lower part of the body is generally fired to a reddish colour. This is because the clay body re-oxidises on cooling after a reduction firing, but glazes cannot re-oxidise so easily.

In east China, the glaze was retained neatly around the middle of the pot by a raised cordon of clay which effectively caught any glaze before 35 it could run down towards the base. Some eastern glazes possess a thicker, more even consistency and a deeper colour than had previously been known, and with which the southern Han glazes could not compare. Such glazes anticipate the fine green glazes for which the area became renowned in the centuries following the collapse of the Han empire.

Six Dynasties: the south

In the last years of the Han dynasty, many northern Chinese fled south to escape the increasing chaos and warfare which accompanied the decline of the empire. Once the dynasty had ended in AD 206, China was not to be reunited for almost four centuries, save during the fifty-two-year period of the Western Jin dynasty (AD 266–317). Small kingdoms and short-lived dynasties were founded all over China throughout the period, which has become known by various names including Six Dynasties (used hereafter), Northern and Southern Dynasties, Wei and Jin.

The natural barrier of the Yangzi River separated the disunity of the north from the disunity of the south so that two broad cultural traditions, which exerted only limited influence on one another, may be discerned. The flight of educated northerners to the opposite side of the river meant that, for at least two centuries, the south fared better in terms of literature and crafts than the north, which was mostly occupied by nomadic peoples from beyond China's northern and western frontiers.

A major influence affecting north and south alike was the development of Buddhism. The first Buddhist settlements in China belong to the first century AD and were situated in eastern China in the areas of present-day Shandong and Jiangsu provinces. Han dynasty Buddhist carvings have also been found in Sichuan province in west China. The religion spread gradually, taking the form of prosperous monastic estates in the south and large cave complexes in the north, such as those at Yungang near Datong and Longmen near Luoyang.

These four centuries of disunity and confusion had a liberating effect on ceramics. For as long as important ritual objects were made of intrinsically precious materials, ceramics were limited to a minor role. In the Han dynasty, for example, painted lacquer and gilt bronze were the most precious materials, and earthenware vessels simply imitated their forms. Bronze production declined steeply in the course of the Han dynasty while lacquer maintained its prominent position. Then, with the breakdown of the Han social order that coincided with technological advances in ceramics, the high-fired glazed wares of east China were well poised to fulfil new roles. Throughout the third and fourth centuries AD, the eastern greenwares gradually replaced lacquer, bamboo, wood, metal and low-fired earthenware as vessels for eating, drinking, and washing in the domestic realm, and for lamps, inkstones, and palettes in the scholarly sphere. The sculptural qualities of clay were extended from earthenware burial figures to adventurously shaped vessels, and ceramics emerged as a medium with which to experiment and make fine objects. This had last happened during the Neolithic period.

The hard bodies and glossy surfaces of the new ceramics made them both attractive and useful, since they were strong and impervious to water. These advantages no doubt contributed to their success in replacing so many materials for so many objects. Greenwares undoubtedly dominated ceramic production during the Six Dynasties period, but other important developments took place in the high-fired tradition,

36

35 OPPOSITE Two glazed jars. The taller jar has incised decoration around the neck and raised cordons around the body to prevent the glaze from running. The lower part is red because of the re-oxidation of the body after the reduction firing necessary to produce a green glaze; glazes, however, do not re-oxidise so easily. Similar jars incised with bird and animal motifs are amongst the grandest high-fired wares of this period. The smaller jar is an example of provincial high-fired glazed wares. Sherds of similar ware have been excavated at Han dynasty sites in Zhejiang province. *c.* 1st century BC–1st century AD. From left: HT 33.8cm; 15.3cm. OA 1973.7–26.173,167, Seligman Bequest.

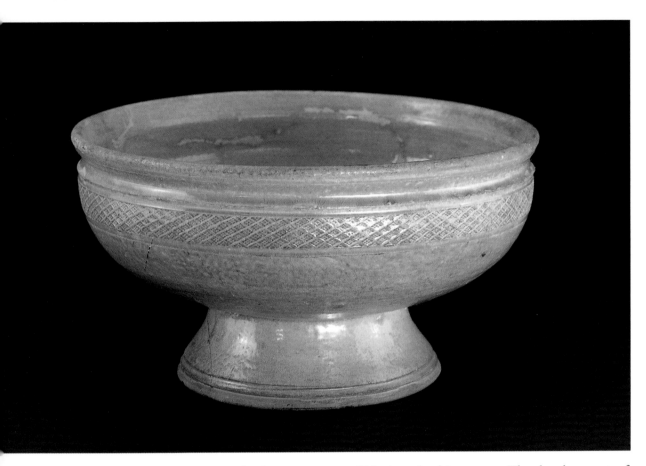

36 Bowl on high foot, Yue ware. There are three small spur marks on the interior of the bowl, indicating that another piece was stacked on top of it in the kiln. The interior of the high foot is unglazed. Impressed rhomboid designs occur widely on early Yue wares. Eastern Jin dynasty, AD 317–420. HT 13.3cm. OA 1971.9–22.1.

namely the appearance of black and white wares. The development of high-fired ceramics between the third and sixth centuries AD can be traced not only through finds from dated tombs, of which there are many, but also from the inscriptions which were occasionally incised on the ceramic body before glazing.

During the Three Kingdoms period which followed the Han, the areas of present-day Zhejiang and Jiangsu provinces fell within the Kingdom of Wu. Before the Han dynasty, the same area had been known as Yue, a name revived in the Tang dynasty (AD 618–906). In the intervening period the region was called Ji, but its greenwares have nonetheless traditionally been referred to as Yue wares. The term 'old Yue' is often used to denote the greenwares of the area before the Tang dynasty. Although the Kingdom of Wu lasted only sixty years (AD 220–80), a number of developments related to the growing independence of ceramics from bronze occurred during that time. The major kiln sites were in Shangyu county in Zhejiang province, and it was here that the naturalistic forms of rams, lions and frogs as well as ornate burial urns 37 were introduced. Certain types, such as a wide-shouldered, narrow-based *guan* jar, three-quarters glazed, were evidently developed and then discontinued within the period.

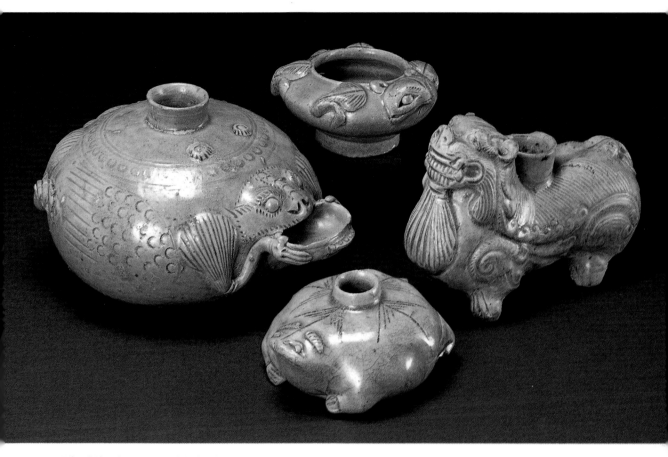

The kiln design established in Shangyu became the standard shape for southern Chinese kilns up until the Ming dynasty. It consisted of a long narrow firing chamber whose shape earned it the name of dragon kiln. Dragon kilns exploited the natural slopes of the many hills in the area. Such kilns proliferated throughout the Wu period and by the beginning of the third century AD numbered more than sixty at the Shangyu site alone. Other important kilns were sited at Jiuyan near Shaoxing in Zhejiang province and at Junshan near Yixing in Jiangsu. All of these kilns produced pottery in the new shapes, of which examples have been found as far away as Guizhou, Guangzhou and Hunan provinces. When in AD 317 Nanjing became the capital of the Eastern Jin dynasty, demand for ceramics was increasing. Many new kilns were established in Zhejiang province in the counties of Xiaoshan, Yuyao and Deqing and near Wenzhou city, as well as in the provinces of Jiangxi and Hunan. Paradoxically, and presumably as a result of the new competition, the kilns in operation at Shangyu halved in number during the same period.

The earliest Yue-type burial urn with models of people, animals and architecture on it comes from a tomb in Zhejiang at Xiaoshan, dated AD 258; the latest dated example, of AD 302, was found near Nanjing. The earlier urns have relief moulded figures around the shoulder of the

37 Group of desk objects, Yue ware. Frog-shaped droppers were first made in the Eastern Han dynasty, and the legs on early examples are less pronounced than on these pieces. Clockwise from left: 3rd–4th century AD; Western Jin dynasty (AD 265–317); Eastern Jin dynasty (AD 317–420); 3rd–4th century AD. HT 8.4cm; 3.7cm; 8.5cm; 4cm. OA 1968.4–22.20, Sedgwick Bequest; OA 1973.1–23.1, given by Rt Hon. Malcolm MacDonald. OA 1973.7–26.174, Seligman Bequest; OA 1943.2–15.7, M. K. Coldwell Bequest.

vessel while the later ones have increasing quantities of superstructure 38
rising from the shoulder and mouth of the jar. In general, the applied
models represent wealth and abundance, but some vessels boast small
Buddhist figures as well. Such urns are ornate burial objects. Small jars
in the form of toads were designed as water droppers for calligraphers
to add water to inkstones and palettes, thus introducing ceramics to the
scholar's study. Large straight-sided basins, with paired fish incised on
the interior base, are examples of functional domestic green wares.
Another well-known form introduced in the third century AD is the
crouching lion, probably used as a stand or holder rather than as a vessel.
The shapes and details of such lions are closely related to the massive
stone lions which still guard tombs of the Six Dynasties period on the
outskirts of present-day Nanjing.

Chicken-head ewers made their first appearance in the second half of
the fourth century, concentrated in the vicinity of Nanjing. Squat ewers
with a wide body, short slim neck and a small spout in the form of a
chicken head have also been found in Zhejiang, Jiangxi, Anhui, Hunan,
Fujian, Guangdong and Guizhou provinces. Antecedents dating from
the preceding Three Kingdoms period were jars with purely decorative
chicken heads applied to the shoulder, but it was in the mid fourth
century that the typical version with a handle and true spout appeared.

38 Burial urn, Yue ware.
This type of burial jar was
produced in eastern China
during the 3rd and 4th
centuries AD. The animals
are symbols of prosperity.
Approx. HT 27cm.

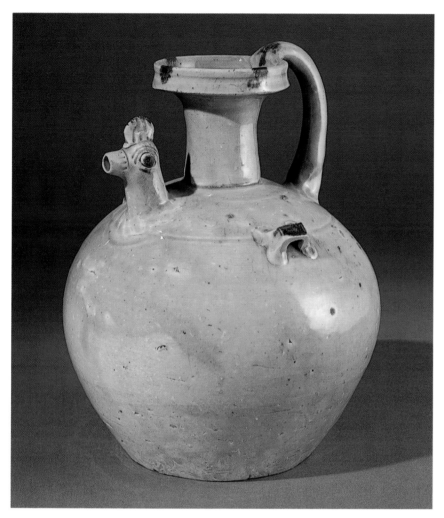

39 Chicken-head ewer, Yue ware. The smooth grey-green glaze is marked with iron-brown spots highlighting the chicken's eyes and comb, the two lugs and four points around the mouth-rim. The base is unglazed. Ewers of this type have frequently been found around Nanjing, the Eastern Jin capital, and also in the southern provinces of Zhejiang, Jiangxi, Anhui, Hunan, Fujian, Guangdong and Guizhou. Eastern Jin dynasty (AD 317–420), second half of the fourth century. HT 23.2cm. OA 1972.1–26.1, Brooke Sewell Fund.

By the middle of the fifth century, taller, narrower proportions lent the form a more elegant profile. The body of the less numerous fifth-century examples is often decorated with incised lotus petals, usually pendant from the shoulder but occasionally rising from the vessel base. Incised lotus petals are the most prevalent decorative motif on greenwares of the Six Dynasties period and are probably associated with Buddhism. Some fourth-century chicken-head ewers have details such as the chicken's eyes, the mouth rim and lug handles highlighted in dark brown. This results from applying a different glaze rich in iron (or perhaps pure iron oxide itself), and coincides with the appearance in east China of black-glazed wares, which also frequently take the form of chicken-head ewers.

Although a black-glazed jar was recovered from an Eastern Han dynasty tomb at Zhenjiang in Jiangsu province, the ewers are the first major black wares in Chinese ceramic history. Their glaze composition actually differs little from the green glazes which had been in use since

40 Jar, Yue ware. The green glaze which covers most of the jar has a yellowish tinge. This piece is said to have come from Yangzhou. The taller, narrower shape of this jar in comparison to the rather squat forms of the early Six Dynasties period is paralleled in the proportions of chicken-head ewers. 5th–6th century AD. HT 32cm. OA 1924.12–15.42, given by O. C. Raphael.

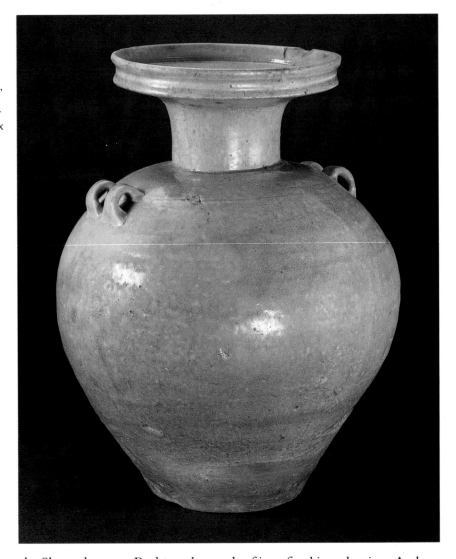

the Shang dynasty. Both are the result of iron fired in reduction. A glaze containing one per cent iron oxide would produce a blue glaze when fired in a reducing atmosphere. The reason the early green wares are yellowish-green rather than blue is that both the ash and the clay which were mixed to create the glaze contain titanium dioxide. The glazes became progressively greener as the raw materials were refined and the reduction firings were managed more successfully; hence most Six Dynasties high-fired wares have a green rather than yellowish-green hue. Finer raw materials for these glazes also contribute to the fluidity and translucency for which they are renowned.

A good green glaze is achieved with an iron oxide content of between 0.75 and 2.5 per cent. At 2.5 per cent the glaze is an olive colour and will darken as the iron content increases. This reaction cannot be exploited far, however, for at around 6 per cent iron, the glaze will be black, just like

that of the fifth-century chicken-head ewers from Deqing and other eastern kilns. Unfortunately, the rather fluid nature of lime glazes and the fluxing effect of iron oxide itself prevented the establishment of a tradition of high-iron glazes in the region; iron black wares did not reappear until the Tang dynasty, and then in north China. Fluidity also explains why only small spots of black ornament appear on fifth-century greenwares: lack of viscosity combined with the tendency of iron to diffuse in high-lime glazes meant that larger designs would become illegible. This type of iron decoration was as short-lived as the black wares, and only reappeared on greenwares in the twelfth to thirteenth centuries when ferruginous brown spots were applied to Longquan celadons.

The north

In the north, greenwares appeared once again during the Northern Wei dynasty (AD 441–534) after an absence of perhaps a thousand years, and were much influenced by the greenwares of the south. The final version of the chicken-head ewer was in fact a northern product. It had a tall elegant body, a large chicken for a spout, and a graceful handle ending in a dragon's head holding the rim of the ewer between its jaws. In the second half of the sixth century, similar vessels occur in Shaanxi province but their spouts are not functional. They should be considered vases, like the early versions dating from the third century, rather than ewers. The early sixth-century northern green glazes are more yellowish in tone than the southern glazes, which by this period were an attractive greyish-green colour. Where the northern glazes collected in a pool on a detail, they assume a bluish tint. This attribute is later exploited in the seventh-century wares to provide contrasting colours on a single object.

40

Most northern high-fired ceramics of the Six Dynasties period have been found in tombs, particularly in Hebei province. The only identified kiln sites were at Zibo in Shandong province and in the northern suburbs of Anyang in Henan province. However, the existence of numerous styles of greenwares strongly suggests that several other contemporary kilns remain to be identified. The well-known 'jewelled' type of vessel, so called because of the abundance of applied, moulded and high-relief ornament on the pots, was apparently confined to the Northern Qi period (AD 550–577) which preceded the reunification of China under the Sui (AD 581–618). The carved and applied motifs on such wares, which are mostly vases, include half-palmette scrolls, beaded roundels, lotus petals, *apsarasas* (flying angels) and grotesque faces.

42

Most of these are alien to the Chinese decorative repertoire as developed over the preceding centuries, and reflect the influence of designs from far to the west of China. Indian and ultimately hellenistic designs entered China with Buddhism, which by the sixth century AD was well established in north China. Even though the foreign motifs occur widely on small, easily transportable objects such as ceramics and silver, the designs seem to have appeared first on larger, less movable architectural forms. The palmette and lotus scrolls which protrude from Northern

41

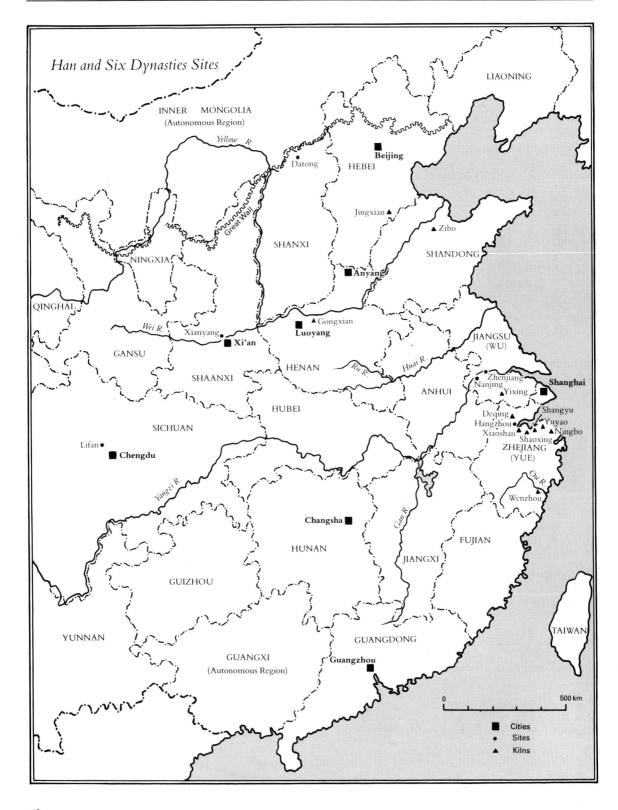

Han and Six Dynasties Sites

INNER MONGOLIA
(Autonomous Region)

Yellow R.

LIAONING

• Datong

Beijing

HEBEI

Jingxian ▲

▲ Zibo

SHANXI

Anyang

SHANDONG

Great Wall

NINGXIA

QINGHAI

Wei R.

▲ Gongxian

GANSU

Xianyang •
Xi'an

Luoyang

JIANGSU
(WU)

SHAANXI

HENAN

Ru R.

Huai R.

ANHUI

Zhenjiang •
Nanjing •

Shanghai
▲ Yixing

HUBEI

Deqing ▲
Hangzhou •
Xiaoshan

Shangyu
▲
Yuyao
▲ Ningbo
Shaoxing

SICHUAN

Lifan •
Chengdu

ZHEJIANG
(YUE)

Yangzi R.

Ou R.

Wenzhou

Changsha

Gan R.

HUNAN

JIANGXI

FUJIAN

GUIZHOU

YUNNAN

TAIWAN

GUANGXI
(Autonomous Region)

GUANGDONG

Guangzhou

0 500 km

■ Cities
• Sites
▲ Kilns

41 Earthenware reliquary urn with degraded green lead glaze. The urn is in three parts: stand, bowl and lid. The collar on which the bowl rests was a separate unit but the glaze has caused it to adhere to the bowl. Buddhist ceramics such as this appear in the Sui dynasty and occur more widely during the first two centuries of the Tang dynasty (AD 618–906). 7th century AD. HT 56.7cm. OA 1930.7–19.58, given by Harvey Hadden.

Qi greenwares are found more than a century earlier on the Northern Wei cave temples at Yungang near Datong in Shanxi province, and subsequently at the Longmen caves near Luoyang in Henan. This same ornate beaded and jewelled decoration also dominates the style of sixth-century Buddhist sculptures in stone and gilt bronze. In the fifth century, the linear style of Longmen Buddhist sculpture is reflected in that of earthenware burial figures.

The ornate forms of fifth and sixth century greenwares also occur in high-fired white wares. White wares were produced on a large scale in north China from the early seventh century until the Song dynasty (AD 960–1279), but examples from earlier centuries are rare. The first known group comes from the Northern Qi dynasty (AD 549–577) tomb of Fan Cui at Anyang in Henan province, which is dated to AD 575 and included ten white ware pieces. The only known white wares before that date are the heavy, thick-bodied Shang dynasty (c. 1700–c. 1027 BC) vessels which were also recovered at Anyang in Henan. Not far from Anyang are the Gongxian kilns, which were one of the major producers of Tang dynasty white porcelain. The body composition of white wares of the Shang, Northern Qi and Tang dynasties is similar, though the later pieces are of a more finely prepared material. The white ware glazes are extraordinarily low in iron.

The Han lead glazes were used in north China until the early fourth century AD, a hundred years after the collapse of the dynasty, but no examples are known from then until AD 484. Unglazed pottery tomb figurines seem never to have fallen out of production and it would not be surprising if the same is eventually shown to be true of the lead glazes. At Datong in Shanxi province the tomb of Sima Jinlong, dated AD 484, contained dozens of pottery figurines, some painted in unfired pigments and others covered in green lead glazes. The tomb also contained a single high-fired greenware, so it is an important find relating to the history of northern ceramics in this otherwise slightly obscure period.

Whereas the figurines are part of an unbroken tradition of mortuary pottery, the fifth-century lead-glazed vessels mark the introduction of new shapes and ornament. The most widespread form in fifth- and sixth-century lead-glazed vessels is the *bianhu* (literally, 'flattened vase') or pilgrim flask, whose origins lie in the leather bottles of the north-western nomads. The decoration is usually moulded in high relief, and its designs are rooted in the mounted archers and paired motifs of Sasanian metalwork. No analyses of the sixth-century lead glazes have been carried out but in appearance they are more fluid than the Han examples. Most of the pilgrim flasks are glazed in a dark brown colour, presumably from using iron as a colourant. The lead glazes that were rediscovered shortly before the Tang dynasty were to become widely used in the funerary art of that glorious period.

42 OPPOSITE Greenware vase with heavy moulded appliqué decoration. The foot is restored. The jewelled style of ornament with half-palmettes and beading was the result of Chinese contact with West Asia, and was probably introduced initially via architecture and silver rather than ceramics. Four similar vases have been excavated from the Feng family tombs at Jingxian, Hebei province. Two are from a tomb dated AD 565. Probably from Jingxian, Hebei. 6th century. HT 38.3cm. 1956.964, Ashmolean Museum, Oxford.

3

FOREIGN INFLUENCES AND CHINESE TRADITIONS

The Tang Dynasty

43 OPPOSITE *Sancai* bottle vase. The coloured lead glazes have run down the vessel, thereby obscuring some of the details of the decoration. The rilled neck and incised horizontal lines suggest a metalwork prototype, in this case probably Buddhist bronze vessels. The applied medallions and tassels derive from Central Asian ornament. First half of the 8th century AD. HT 27.7cm. OA 1968.4–22.22, Sedgwick Bequest.

Sui ceramics, like the dynasty itself, are a succinct prelude to the glory and gaiety which characterise the succeeding Tang dynasty. In a rule of less than forty years (AD 589–618), the Sui achieved the reunification of China after almost four centuries of disarray, and laid foundations for the long reign of the Tang in much the same way as the Qin had prepared the ground for the Han six centuries earlier. The tombs of Sui officials and nobles include many fine ceramics, particularly white wares, which anticipate major developments in high-fired wares between the seventh and tenth centuries.

Yang Jian, who became Emperor Wen of the Sui (Sui Wendi), was head of the last of a succession of dynastic houses which had held sway in north China despite their nomadic origins. His success in reunifying the country was achieved in part by turning back to thoroughly Chinese traditions. He revived Confucian values and elements of Han bureaucracy in order to gain the confidence of the southern Chinese elite, families who had fled from northern invaders over the previous centuries to settle in the south-eastern provinces of Jiangsu and Zhejiang. The Emperor himself was half Chinese and half Tartar. His mixed ancestry, his northern base and his choice of ancient Xi'an for the capital combined to shift the focus of the empire once more to the area of Shaanxi and Henan.

The most sophisticated Sui ceramics come from northern China, yet those from the south are not without interest. Heavy yellow-glazed wares from tombs in Changsha in Hunan province include lamps and inkstones. The latter, rarely found in the tombs of the martial northerners, reflect the literary interests of southern Chinese gentlemen scholars. In the north, ceramics of the Sui period display surprisingly

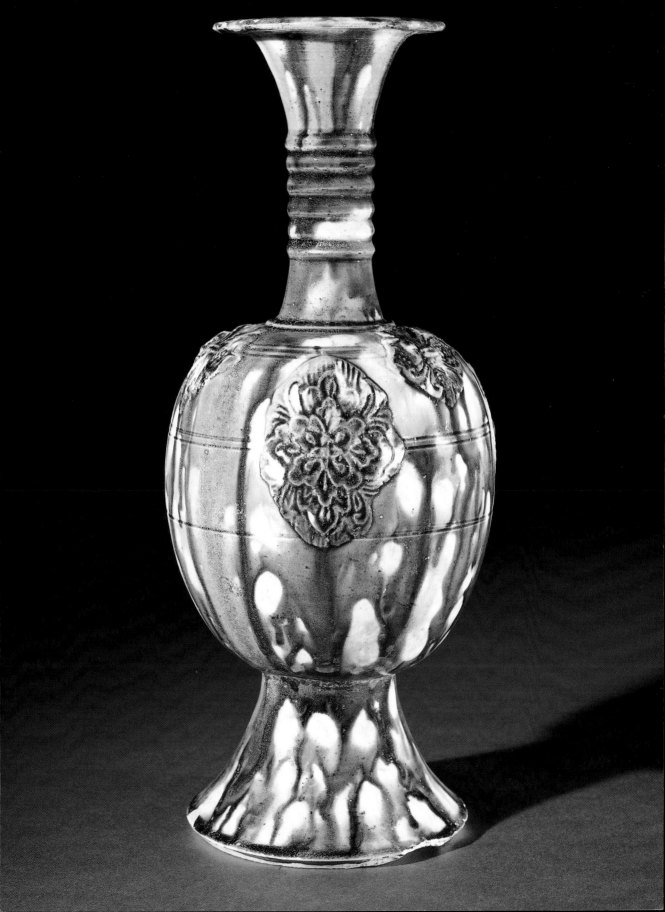

44 Straight-sided cup made of white porcellanous stoneware, with an even, grey-green glaze. Three spur-marks inside reveal that wares of this type were stacked for firing. The flat base signifies a date early in the seventh century. Cups of this shape in bronze have been excavated from a Sui dynasty tomb in Changsha and in jade bound with gold from a Sui dynasty tomb in Anyang. In ceramic, they are usually of white porcelain, first made in Henan and later in Hebei province. Sui dynasty, 7th century. HT 8.2cm. OA 1909.6–5.4, given by J. Spier.

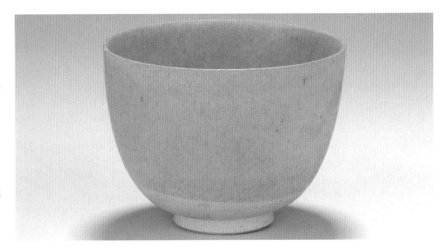

limited western Asian influence, given the examples of the fifth century and the fact that the dynasty itself was not wholly Chinese. It is unlikely 44 that the restrained forms could be the result of direct instructions from the court to adapt to Chinese styles, yet it is possible that Sui Wendi's far-sighted support of China's nobility and institutions filtered down to merchants and artisans who perceived that artefacts in that tradition would better suit the new times. Such western Asian influences as exist on Sui pottery derive more from the motifs of Buddhism than from the precious artefacts which had had such an impact in preceding centuries. By the time the Sui held power, Buddhism had taken such a deep hold on the country that it had to be tolerated, even as Confucian values and education were being promoted to ensure Sui credibility. Indeed, temples and monasteries were greatly encouraged by Sui Wendi, and the lotus flower of Buddhism in its architectural rather than its natural form is one of the prevalent motifs on all Sui artefacts.

In AD 618 the Sui collapsed because of the profligacy of Sui Yangdi, the founder's son. Nonetheless, its legacy of reforms and institutions was a strong foundation on which the succeeding Tang dynasty was able to build and prosper. Once again the imperial family was Chinese and confident of being able to maintain control throughout the country. During the seventh century, the dynasty steadily increased its power. The eighth-century reign of the Emperor Minghuang (AD 712–56) was the zenith of Tang rule and constitutes one of the best-known periods in Chinese history. Emperor Minghuang's capital of Chang'an ('eternal peace', present-day Xi'an) was the most cosmopolitan city of the eighth-century world.

The dynasty's strong centralised rule afforded great prosperity. Within China, the revival of the Han bureaucratic examination system attracted the brightest scholars in the empire to the capital, while from beyond its frontiers merchants from all over Asia came to trade at the Chinese city which marked the easternmost point of the great Silk Route. Sogdians, Armenians, Zoroastrians and Nestorian Christians all contributed to the capital's rich diversity of nationalities and religions. In ceramics, such

variety was chiefly manifest in brightly glazed wares produced for burial. The large camels and figures which loudly proclaim contact with regions west of China are simply the best-known expressions of influences which penetrated all aspects of crafts in the Tang dynasty, and Chinese artisans assimilated and used these to their own satisfaction. Many of the motifs which prevail amongst Tang textiles, stone carving, glass, silver and ceramics had in fact entered China during the fifth century. Their wide use in the eighth, in greater number and broader application, marks the reopening of the Silk Route and the consequent Tang fascination with the exotic.

Sasanian and other western Asian designs on ceramics appear on both the colourful lead-glazed wares and the high-fired white and green monochromes. The white wares of the Tang dynasty discarded the more flamboyant applied ornament of the earlier high-fired wares, and indeed are noted for their simplicity.

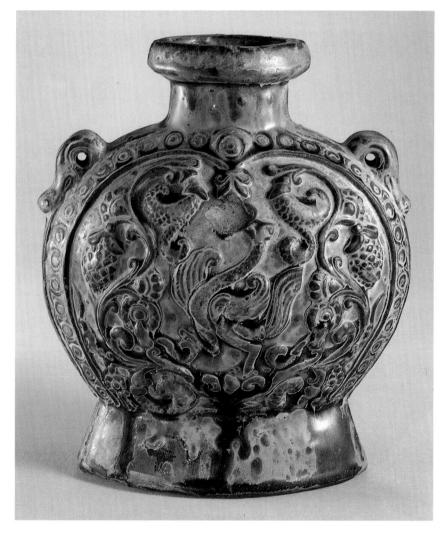

45 Stoneware pilgrim flask. The flask has a dull brown glaze tending to dark green where it is thick, and was probably made in Henan province. The flat base is unglazed. High relief decoration with Hellenistic motifs, such as the vine leaf and half palmette, seems to be confined to pilgrim flasks. The border of small circles is a further example of a non-Chinese motif. The design is repeated on the reverse of the flask. 7th or possibly 8th century. HT 23cm. OA 1936.10-12.253.

63

White wares

High-fired wares are usually at the forefront of the ceramic technology of their period. Energetically modelled and often brightly coloured burial figures are better known today than the high-fired monochrome wares, but the latter were without doubt the more highly regarded by contemporary connoisseurs. Amongst China's array of sumptuous products – silk, jade, lacquer and metalwork – it was the 'porcelains' which counted rather than the burial pieces, however gay or skilled those might be. In the Tang dynasty the esteemed position of high-quality ceramics was affirmed, and they joined the objects made from other prized materials as items of imperial tribute. China's finest artefacts had traditionally been sent to the court from the provinces ever since the empire was established in the Han dynasty (206 BC–AD 221). The provincial gazetteer *Yuanhe junxian zhi* states that in the Kaiyuan period (AD 713–42), Henan offered as tribute white porcelain. Excavations of the Daming Palace at Beimenwai, Xi'an, have yielded white sherds of the type produced at

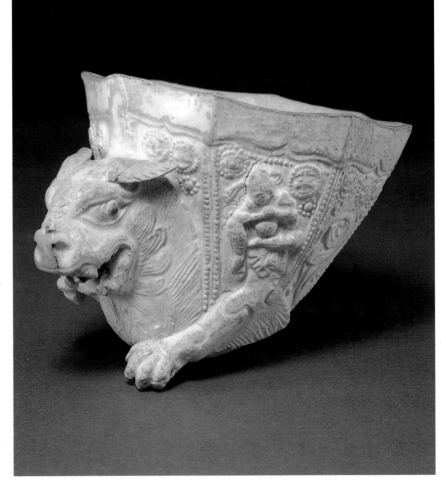

46 White porcelain rhyton with iron-brown highlights. The rhyton is a Classical form unknown in China before the Sui dynasty, when this piece was made. West Asian ornament evident on this rhyton includes beaded borders and roundels, more usually found on stucco and silver; the style of the seated figure, in particular his drapery; and the half-palmette behind the lion's paw. The thinness of the body and the whiteness of the material place this piece amongst the world's earliest porcelains. Sui dynasty, 7th century. HT 8.6cm, D (of mouth) 9.3cm. OA 1968.4-22.21, Sedgwick Bequest.

the Gongxian kilns in Henan, corroborating the textual evidence of the gazetteer. The kilns of Gongxian are situated only about two miles from the Luo river, which means that transport to the capital at Chang'an (present-day Xi'an) would have been simple. In the middle of the seventh century the Empress Wu persuaded the emperor that the court should move to Luoyang, and from then until the eighth century that is where the imperial household indeed spent much of their time. No kiln remains have been found at Luoyang, and the proximity of that city to the Gongxian kilns makes it probable that the latter also supplied porcelain to the court during that period.

Early in the eighth century, economic reasons caused ceramics to be used increasingly in place of bronze. The unification of China had resulted in a greatly increased population and an expansion of the economy. Available copper cash became insufficient for the empire's needs, and in AD 713 an imperial edict was issued prohibiting the export of currency, followed in 723 by a decree forbidding the manufacture of

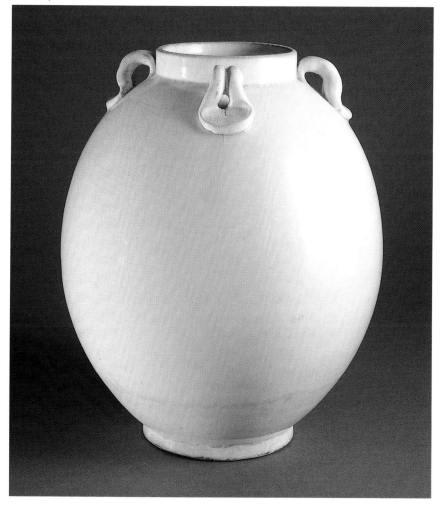

47 Round-bodied jar. The glaze, which has crazed, has a greenish-yellow tone where it has pooled. A swag mark above the foot suggests that it was applied by dipping. The interior is glazed, but the flat base is not. This type of white, porcellanous stoneware was produced at kilns in the northern provinces of Hebei and Henan, using the local secondary kaolin clay. 7th century. HT 30.1cm. OA 1968.4-22.23.

bronze vessels. Such edicts were not necessarily obeyed, yet in northern China the proximity of the court and the existence of established kilns may well have limited the production of bronzes in favour of ceramics.

Literary and historical references to ceramics increase with their rising status. Numerous Tang poems mention fine ceramics and in the eighth-century *Cha jing* ('Tea classic'), a whole section on vessels is devoted to the merits of various ceramic wares. In the Sui dynasty, white wares had been the most technologically advanced ceramics. On the evidence of the tribute wares, they were also the most admired before the middle of the Tang dynasty.

Fine white wares of the Sui and early Tang periods are arguably the world's earliest porcelains. In the West the definition of porcelain has always been debated in terms of colour, translucency and vitrification. In the East it has always been so broad that the Western arguments barely apply. The Chinese porcelain which potters sought to reproduce in Europe from the sixteenth century onwards, and in the Middle East from the twelfth, was the pure porcelain stone, later mixed with kaolin, manufactured in South China, principally at Jingdezhen, from the tenth century. Its pertinent qualities are hardness, whiteness and translucence, and all three are also found in the northern Chinese white wares of the seventh century. [44, 46, 47]

The seventh-century white wares are of two physical types and come from two sites: the Xing kilns at Neiqiu and Lincheng counties in Hebei province, and the aforementioned Gongxian kilns of Henan province. Some Xing wares are comparable to Gongxian wares in composition, but the Xing kilns also produced another class of fine porcelain which falls outside the rest of northern white ware production. It is characterised by a compact and translucent body. This was achieved by using potash feldspar in the unusually high quantity of around 40–60 per cent, as opposed to only a few per cent in later Xing wares. Feldspar is difficult to grind. It was not used at Jingdezhen until the twentieth century, and its occurrence in the early Xing porcelain is currently isolated in China's ceramic past. These feldspathic porcelains appeared only briefly during the Sui dynasty and did not, on present evidence, continue into the Tang.

A measure of their quality is the absence of slip between the body and the glaze. Slip was widely used on monochrome wares to mask imperfections in the body and provide a smooth surface for glazing. It was particularly used on white wares, when imperfections in the body's colour as well as its surface texture could mar the final appearance of an object intended to be pure white and gleaming. The Sui Xing wares consist of clear glaze applied to a translucent white body. Superficially they resemble the much later porcelain stone blanc-de-chine products of Fujian province, and may be regarded as an incident of extraordinary virtuosity in China's early ceramic history. At present, numerous sherds of this material have been discovered, but entire pieces are still lacking.

The Tang wares of the Xing kilns do not possess the remarkable potash feldspar composition, but are nonetheless the finest of the remainder of

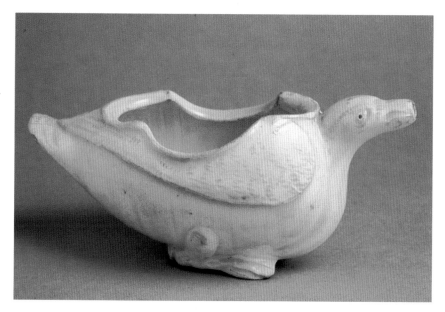

48 Porcelain water dropper in the form of a duck. Inside, just behind the neck, is a small turtle. The glaze has a greenish tinge where it pools. Water droppers were used for adding water to inkstones in order to mix ink, which was in solid cake form. Probably from North China. 10th century. HT 6.4cm, L 14cm. OA 1947.7-12.50, Oppenheim Bequest.

Sui and Tang white porcelain. In broad terms, the clays of Gongxian and Xing white wares are the same in that they are part of a swathe of secondary kaolin and fireclays laid down across North China some three hundred million years ago, and now lying beneath strata of coal and loess. The Gongxian and Xing kilns are situated in areas where the loess layers are comparatively shallow, making the clays more accessible. The original rocks from which these clays were produced were exceptionally pure. As a result the most widespread clay contaminants of iron and titanium occur in unusually small quantities. This accounts for the whiteness of the northern porcelains.

White porcelains gained imperial recognition in the early Tang, as shown by the aforementioned finds at the Daming Palace, but it is clear that they were also preferred by a much wider clientele. The output of the kilns in Henan and Hebei appears to have been large. A handful of glazed sherds at the Gongxian site imply that white wares eclipsed the much longer tradition of greenwares for a time, though the latter were in turn to oust the white wares a century later. Fine white wares have been found in tombs of the Sui dynasty. These include simple straight-sided cups which imitate the shape of jade cups, and a double-bodied amphora from present-day Tianjin, with an inscription beginning 'this precious vase . . .'. Domestic shapes, such as bowls and dishes, appear to have been produced in greater numbers, and the censers and water sprinklers made for Buddhist ritual are also numerous. Large quantities of Gongxian and Xing wares have been found outside China, particularly at the Middle Eastern sites of Siraf in the Persian Gulf and Samarra in Iraq.

It has often been said that white wares seek to reproduce the brightness and thinness of beaten and wrought silver. Indeed many white Chinese porcelains display not only the impressive thinness associated with

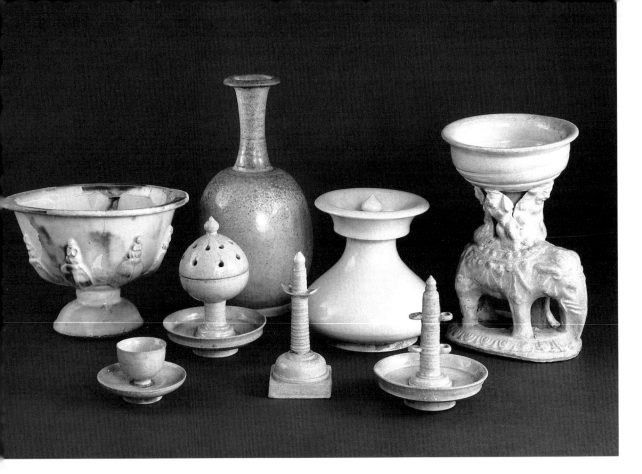

49 Group of flasks, censers and stands associated with Buddhist ritual. The bowl supported by the elephant and figures probably served as an offering bowl. With the exception of the tall cup on the left, which is earthenware splashed with green glaze, all the items are of white porcellanous stoneware and date from the 7th to 9th centuries. From left: HT 12.8cm; 4.5cm; 12cm; 23cm; 11.4cm; 13.3cm; 10.4cm; 19.8cm. OA 1937.7-16.41; OA 1938.5-24.104; OA 1936.10-12.145; OA 1909.4-1.76; OA 1936.10-12.147,120, 146; OA 1931.12-15.1, given by H. J. Oppenheim.

precious metal, but also the decorative techniques of silver such as beading and ring punching. In many cases, however, the forms of the 46 early white porcelains are simplifications of the elaborate moulded relief decoration and complex shapes, inspired by glass and metal objects, of the early greenwares from which they derive. Simple forms may have been adopted as a means of displaying the new whiteness of body and glaze to best advantage.

Greenwares

During the eighth century, the supremacy of white wares was finally challenged by greenwares, which enjoyed a revival at their south-eastern heartland, the Yue kilns of Zhejiang. Greenwares had barely been 1, 50, produced in the north during the early part of the Tang dynasty and 51, 52 production in the south-east had also declined drastically. The resurgence of the Yue kilns may have been related to two factors already mentioned: the prohibition of bronze for making vessels, and the spread of tea drinking.

In AD 760 the aforementioned *Cha jing* of Lu Yu was published. This short but much quoted work covers the cultivation and drinking of tea and discusses the various utensils relevant to its preparation and consumption. The tea bowl section runs: 'For bowls, Yuezhou is best, followed by Dingzhou, then Wuzhou, Yozhou, Shouzhou and Hongzhou. Alternatively, Xingzhou is (sometimes) put in the position of Yuezhou but there are several reasons why this is not the case. Xing

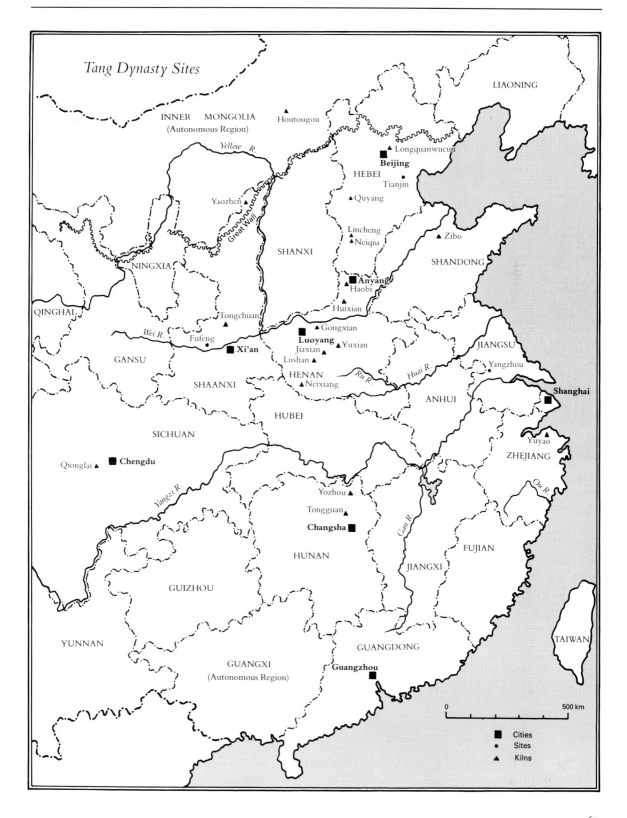

Tang Dynasty Sites

LIAONING

INNER MONGOLIA
(Autonomous Region)

▲ Houtougou

Yellow R.

▲ Longquanwucun
■ **Beijing**

HEBEI
• Tianjin

▲ Yaozhen

Great Wall

▲ Quyang

NINGXIA

SHANXI

Lincheng
▲ Neiqiu

▲ Zibo

SHANDONG

QINGHAI

▲ **Anyang**
Haobi

Huixian ▲

Tongchuan ▲

▲ Gongxian
■ **Luoyang**

JIANGSU

Wei R.
Fufeng •

Jiaxian ▲ Yuxian

GANSU

■ **Xi'an**

Lushan ▲

Yangzhou •

SHAANXI

HENAN

Ru R.

Huai R.

▲ Neixiang

ANHUI

■ **Shanghai**

HUBEI

SICHUAN

ZHEJIANG
▲ Yuyao

Qionglai ▲ ■ **Chengdu**

Yangzi R.

Yozhou ▲

Ou R.

Tongguan ▲

Gan R.

Changsha ■

FUJIAN

HUNAN

JIANGXI

GUIZHOU

YUNNAN

TAIWAN

GUANGDONG

GUANGXI
(Autonomous Region)

Guangzhou ■

0 500 km

■ Cities
• Sites
▲ Kilns

porcelain is like silver, Yue is like jade; this is the first reason Xing is not as good as Yue. Xing porcelain is like snow, Yue is like ice; this is the second reason Xing is not as good as Yue. Xing porcelain is white, so the tea appears red, Yue porcelain is green and makes greener the tea; this is the third reason Xing is not as good as Yue'.

This passage not only reveals the names and reputations of various eighth-century kilns, all of which have been identified through excavation except Dingzhou, but it also distinguishes the merits of porcelain relative to other materials. The most interesting revelation, perhaps, is that white porcelain resembling silver was held to be inferior to green porcelain resembling jade. Jade traditionally had been prized in China, whereas silver could have been associated with the contemporary international glory of Tang. Whether Lu Yu's view is accurate or simply reflects his own taste is hard to judge, just as it is hard to discover whether his opinions followed or influenced the contemporary view of porcelain.

What is beyond dispute is that there existed a class of Yue ware which attained a new importance for ceramics. *Mi se* ('secret colour') Yue ware has been lauded for its jade-like appearance by Ming historians, Song connoisseurs and Tang poets alike, but the question of its identity has long been a matter of conjecture. Only the finds uncovered in 1987 at the Famen Temple at Fufeng in Shaanxi province have made it possible, finally, to distinguish this prize amongst porcelains. The crypt of the

50 Globular jar, Yue ware. The green glaze has a grey tone, and the base is glazed. The carved lotus petals and the appearance of this shape, in bronze, amongst altar vessels, both suggest a Buddhist connection. This type of jar was made at the Shanglinhu kilns in Zhejiang province in the late Tang dynasty; in the north similar jars were made at the Ding kilns (compare fig. 69). 9th or possibly early 10th century. HT 11.4cm. OA 1936.10-12.70.

temple, closed in AD 874, includes a tablet stating that it accompanied fourteen secret-colour wares used by the Emperor Yizong to hold Sakyamuni's cremated finger bones. The octagonal bottle, five bowls and six dishes of greenware, found together with two silver bowls, were of a beautiful jade-green colour not seen amongst the sherds of the Shanglinhu kiln site, and only rarely amongst the tomb goods of the Yue royal families.

That court wares were produced at Gongyao at Shanglinhu is evidenced by an inscribed jar discovered at that site, so for once it is possible to be sure that the kiln site, the emperor, the poems and the ware itself are all closely related. It seems fitting that the context should be one of such ritual importance as the consecration of the relics of the Buddha himself. It is unlikely that ceramics ever before had approached so closely the sphere of imperial religious practice, and it is not surprising, given the revival of bronze in the succeeding Song dynasty, that they so rarely attained such status again.

1, 51, 52 In the second part of the Tang dynasty and throughout the period of the Five Dynasties (AD 906–60), Yue wares were well known and widely used both within China and without. After this period they declined. They have been found in Indonesia, Sri Lanka, near Karachi and at Brahminabad in Pakistan, at Siraf and Samarra, and as far west as Fustāt near Cairo. Usually simple in shape, the wares include vases, bowls, dishes, boxes and so forth. The decoration, incised by hand under the

51 Box and cover, Yue ware. This finely modelled and incised lotus petal box represents the last phase of Yue ware production. The body is pale grey, and the green glaze covers the interior of both base and cover. The Yue kilns declined in the face of competition from the Jingdezhen kilns in Jiangxi province, which were established in the 10th century. Early 10th century. HT 6.4cm. OA 1947.7-12.47, Oppenheim Bequest.

glaze, derives mostly from the natural forms of plants, clouds and, on later wares, birds. The chemical composition of Yue wares, or at least of Yue wares which remained in China, appears to have changed little over the whole course of the kilns' activity from the third to the tenth centuries. The almost ubiquitous clay and glaze contaminants of iron and titanium retain a more or less constant percentage in the body material, which is greyish white. In the glaze their total remains on the whole below three per cent. The firing temperature was also constant and was probably at least 1190° or 1200°C.

The variation in Yue ware colour, from yellow-green to grey-green to the rare jade green, must therefore be due to changes in firing conditions. The design of large dragon kilns such as those at Shanglinhu all but excludes the possibility of an even kiln atmosphere throughout. The eminent Chinese ceramic scientist Li Jiazhi has postulated that this lack of predictability is the reason behind the otherwise unexplained success of a few pieces in each firing, which were then termed *mi se* wares. A strong reduction atmosphere is required for the jade-green tone. That is hard to control, particularly in a large kiln, so some wares quite by chance were transformed to a better colour than others.

52 Vase, Longquan ware. Greenwares of this type, from southern Zhejiang province, closely resemble certain Yue wares from the northern part of the same province. The body of the vase has six shallow lobes, all incised with the same cloud design. The glaze, which has a soft green tone, is thinly applied and covers the base of the vessel (illustrated in colour on the frontispiece). The type is utilitarian. A similar, lidded example in the Ashmolean Museum is incised with a tall floral design crossing two lobes of the vase. Early 10th century. HT 33cm. OA 1924.6–16.1.

Black wares

Northern greenwares enjoyed no such eminence. A green-glazed and a black-glazed bowl, both from the Yaozhou kilns in Shaanxi province, were found amongst the treasures of the Famen Temple, so clearly some wares of high quality were known in the north. They are not celebrated in literature, however, nor are they generally found in either Chinese or Western collections. This implies that the wares were neither significant nor numerous, in contrast to Yue wares. The northern high-fired pieces were probably inspired by the green and the earlier black ceramics from the south. The Yaozhou greens ranged from dark to almost yellow and were produced by applying transparent glaze directly to the body or on to a slip layer coating the body. The olive or yellow tone provides a means of distinguishing these wares from the south-eastern green-glazed pieces. Their decoration is carved, stamped or incised. Flowers, especially chrysanthemums, are the main design.

The black glaze appears to have been applied to simple domestic wares and small toys and boxes. Recent excavations in Huangbaozhen at Tongchuan, Shaanxi province, have shown that the most interesting Yaozhou wares are those decorated with slip. Some pieces were painted in slip on the unfired body and then covered with a thin transparent glaze. After firing, the painted areas were pale yellow and the unpainted pale green. Other black pieces were decorated with slip applied to designs formed by removing areas of the glaze. This filled-in decoration seems to be restricted to the Yaozhou kilns. The slip-painted wares are amongst the earliest such ceramics in China, and may be compared to the products of the Tongguan kilns near Changsha in Hunan province.

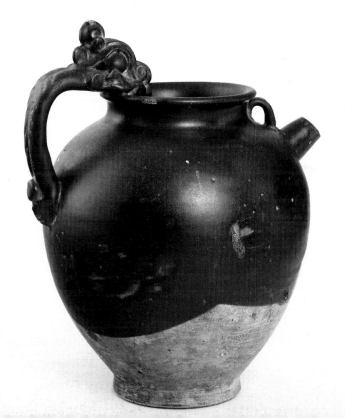

53 Dragon-handled ewer with black iron glaze. Where the glaze is thinner, towards the foot, it has a lighter brown colour. The base is flat and unglazed, while the interior is entirely glazed. The back of the handle bears an incised chevron design. Tall, slender dragon-handled vases were made in white ware at northern kilns in the 7th and 8th centuries, but this stouter black ware form, with its more bulbous dragon head, is of later date. The ewer was probably produced in Henan province. 8th–9th century. HT 27.4cm. OA 1936.10-12.215.

54 Dish, Huangdao ware. The black glaze is mottled and tends towards brown on the underside of the dish. The foot and base are unglazed. Kilns devoted to splashed ware were widely distributed, at Lushan, Jiaxian, Neixiang and Yuxian in Henan province, Jiaochang in Shanxi, and Tongchuan in Shaanxi. Of these, Lushan is the best known.
D 25cm, HT 4.4cm.
OA 1967.12-12.2, given by Sir Alan and Lady Barlow.

Greenwares have also been found in late Tang levels at the Jiancicun kiln site at Quyang in Hebei province, but the most prominent high-fired northern ceramics of the period must be the black wares produced in 53 Henan. Black wares are more numerous than green throughout the Tang dynasty in North China. As in the south, it is probable that their production was uninterrupted from its beginnings in the fourth century AD. The Henan wares of the eighth and ninth centuries are distinguished in many cases by blue or grey and white splashes. These pieces appear 54 never to have merited the attention of poets or connoisseurs, nor have they been found outside China, but they are integral to the long northern tradition of strong black domestic wares. Splashed wares were made at Huangdao and Haobi in Henan province. Plain black-glazed pieces were made at Huixian and Xiguan in the same province and at Zibo in Shandong province, as well as in Shaanxi at the Yaozhou kilns mentioned above. The coveted white, green and black wares were all the result of exploring raw clay materials, glaze composition and firing techniques. The beautiful monochrome products continue traditions founded in the third century AD. Yet, at the same time as these plain ceramic forms were being developed, the parallel tradition of making ceramic burial goods was producing wares in bright colours and borrowed shapes.

Three-colour wares

The restrained and the riotous were produced side by side at three north Chinese kilns. Between them these kilns seem to have been responsible for the majority of lead-glazed *sancai* or 'three-colour' wares which furnished the tombs of the noble and rich for more than a hundred and fifty years of the Tang dynasty. Huge quantities were produced at Yaozhou near Tongchuan in Shaanxi, at Neiqiu in Hebei and at Gongxian in Henan. Recent analyses at the British Museum have shown that the monochrome and the lead-glazed wares are made of the same body material and fired at the same temperature, though the lead-glazed wares must have had a second firing at a lower temperature.

The exact date of the introduction of Tang *sancai* is unclear. The earliest excavated pieces are from the tomb of Li Feng, Prince of Guozhong, the fifteenth son of the Emperor Gaozu. The tomb is dated AD 675 and the technique does not appear well developed, so the coloured glazes may have been introduced around the third quarter of the seventh century. Green lead glazes from the fifth-century tomb of Sima Jinlong in Shaanxi and brown lead-glazed pilgrim flasks of the sixth century, discussed in the previous chapter, provided the technological background for *sancai* wares.

55 Lidded jar with *sancai* glazes. This shape of jar is known as a *wannian* ('myriad year') jar because it was favoured as a burial type. The decoration has been achieved by use of a resist, either of powdered kaolin or of wax. The stripes and florets are typical of the ornament on polychrome woven silks of the period. *Wannian* jars occur with monochrome lead glazes from the *sancai* palette and also, less frequently, in white ware and greenware. First half of the 8th century. HT 25.4cm. OA 1946.7-15.1, Colhurst Bequest.

56 OPPOSITE ABOVE Wide earthenware dish, covered in slip and decorated with *sancai* glazes. The high pedestal foot is hollow and unglazed. Wide, open forms such as this could retain detailed decoration more easily than vertical forms, on which the glaze ran down. On this example, the design has been achieved by use of a resist. First half of the 8th century. HT 11.2cm, D 35.5cm. OA 1936.10-12.211.

57 OPPOSITE BELOW Three earthenware boxes. The two flat-lidded boxes are decorated with *sancai* glazes and resist decoration, while the taller box with knopped lid is splashed with cobalt blue glaze. The interiors of the smaller boxes have a thin white glaze, and the bases are all unglazed. Flat-lidded boxes were made until the first quarter of the 9th century; the higher, knopped-lid type continued throughout the 9th century. 8th–9th century. From left: HT 3.8cm; 7.1cm; 3.9cm. OA 1936.10–12.116; OA 1947.7–12.30,32, Oppenheim Bequest.

The new colours were achieved quite simply by adding metal oxides to a lead glaze. The oxides were copper for green and iron for amber or brown. Together with the cream glaze, they provided the three colours by which the wares are known. However, many pieces also have blue and black glazes, albeit in small quantities. The blue is the result of cobalt, no source of which has been identified within China for that time, and which must have been imported from the West. It would therefore have been expensive. A sign of its expense is that it was used only in small quantities, whether combined with other colours or used for monochrome pieces; the single-colour blue-glazed pots are notably smaller than the green or yellow examples.

Sancai glazes were applied to every shape and size of ceramic artefact either singly or in combinations. The tendency of the lead glaze to run slightly accounts for the mingling of the colours which gives *sancai* pieces their exuberant appearance. Despite this low viscosity and its attendant problems, the lead glazes are quite stable in terms of holding colour.

The properties of a glaze affect the nature of a ceramic's decoration, and the tendency of the three-colour lead glazes to run dictated several stylistic features. Careful modelling and impressed decoration were used to help contain one glaze colour in a particular area. This worked well with flat open forms such as trays or shallow dishes, but these methods naturally met with only limited success on vertical pieces. On figurines the heads are usually not glazed at all, but are finely modelled with the hair and features painted on in pigments after the firing. The pieces are not fired subsequently, so the pigments are not fixed and flake off easily. It is rare to find them in much quantity or detail.

The coloured glazes were sometimes liberally applied to vessels to give a confused, streaked appearance. At other times they were used in pairs to give a simpler mottled effect. Another way of using the new palette was to splash one glaze with a second one of another colour, usually green on white, though blue on white is also known. Resists, which keep the glaze from adhering where they are applied, are a way of controlling the glazes and were used particularly to make geometric patterns. Many patterns produced in this way relate to the stripes and florettes common on textiles of the period, as does the resist technique itself. Wax has generally been thought to be the resist used for both ceramics and textiles, but recent research shows that, on some ceramics, a powdered kaolin resist was used instead. The potter's new palette led, then, to an abundance of decorative effects. Most of these were achieved through exploring the possibilities of coloured glazes, but this in turn released a capacity for reproducing designs originally used on other materials.

In assessing the source of a design or shape, it can sometimes be useful to consider what material is most sympathetic to that pattern or form. In the Tang dynasty, most vessels were thrown in wet clay on a wheel, and curved forms were easily made. Metal was mostly wrought or beaten, so intricate profiles and sharply defined detail were not difficult to achieve. Potters, however, do not seem to have been deterred from

59 OPPOSITE Group of *sancai* tomb figures comprising two earth spirits, two *lokapāla* and two civil officials. The horses, two camels and several grooms also in the British Museum belong to the same group, said to have come from the tomb of Liu Tingxun, who died in AD 728. Chancellor Liu was a general of the Zhongwu army, a Lieutenant of Henan and Huainan districts, and a Privy Councillor. The memorial tablet found with these figures records his skill in military matters and the arts of statesmanship, and that he died at the age of seventy-two. These figures are amongst the tallest of extant Tang burial figures, and form part of the largest group from a single site belonging to a public collection. First half of 8th century. From left: HT 96cm; 109cm; 104cm; 103cm; 109cm; 96cm. OA 1936.10–12.225,222, 220–21,223–4.

attempting to use clay to produce the shapes and ornament more usually found in objects of metal or other materials, and Tang ceramics display influences from these objects in various ways. Many such ceramics did not borrow directly from their original source, but used shapes and ornament which may have been transmitted via several forms and countries, undergoing numerous modifications *en route*. Some examples are ewers in the shape of Sasanian metal or glass vessels; ornament of applied medallions, as seen in western Asian metalwork and stucco; and 43 the sharp profiles and ring handles on small cups of Sogdian inspiration. 58

Burial wares

The use of *sancai* wares in the north was subject to social restrictions, so the discovery of glazed figures in tombs is a clear indication of the status of both the ceramics and the deceased. The alignment of graves, the statues in front of the tomb entrances and the contents of tombs all had to be arranged in proper observance of historical traditions for burial. This was particularly true in the case of imperial tombs, and the Tang histories record admonitions for restraint in the building of imperial tombs, just as attempts were made to curtail the extravagance of Han emperors. The richness of the Tang imperial tombs, even minor ones, suggests that such pleas were not much heeded.

Earthenware figures formed part of the funerary procession and were displayed on carts. The number and size of the figures were determined by the rank of the deceased. Once the procession had arrived at the tomb, all the models were lined up outside, forming something akin to the spirit roads of stone sculptures at the imperial tombs. When the coffin had been placed inside the burial chamber, the figures were moved into the tomb and placed in their proper positions. Certain types of

58 Earthenware cup with ring handle. The cup has an amber-coloured lead glaze. Cups of this shape occur in silver and *sancai* ware, indicating perhaps that the ceramic type is an imitation for burial purposes. The ring handle is not of Chinese origin but probably derives from a Sogdian design. *c.* 8th century. HT 6.3cm. OA 1947.7–12.24, Oppenheim Bequest.

figure related directly to their funerary role: for example, the seated beast
with a half-human face whose function it was to frighten away spirits,
and the guardian figures known as *tian wang* (heavenly kings) in Chinese.
The guardians are also known by their Sanskrit name of *lokapāla*.

In addition to these large and more formal figures, there occurs an
array of animal models. These range from the splendid polychrome
camels of the Silk Route to small white-glazed domestic animals such as
dogs or pigs.

Human figures range from the exotic grooms and merchants associated
with the silk trade across Central Asia to the more humble figures of
Chinese servants. Courtly Chinese figures and those portraying
foreigners tend to be glazed or painted with unfired pigments, whereas
servant figures are generally glazed white. The development of figures
can be traced from the seventh-century examples, which are straight and
slender, through to a more plastic style around the turn of the eighth
century, and culminating in a positive plumpness in mid-eighth-century
models of court ladies. The seventh-century pieces are glazed in white,
tending to a yellowish or straw colour due to small amounts of iron in
the body clay. It is interesting that this fault in the tomb models is not
to be found in the white-ware vessels of the same period, and even in
burial figures the iron was refined away in the eighth century.

59

Tomb models reveal interesting details of the daily life and concerns of metropolitan Tang China. The connections with exotic foreign musicians and merchants are complemented in the Chinese types by details of occupation and dress. Such details often correspond to descriptions in contemporary short stories, which are the earliest works of Chinese fiction. Accounts of banquets where musicians and dancing girls entertained correspond to groups of tomb figurines holding musical instruments or swaying in dresses with unusually long sleeves. Whatever their size or decoration, tomb figures were made in several moulded parts. These were then assembled by luting, a method of joining pieces of unfired clay together by applying a dilute clay mixture to serve as a glue. It is true that moulded reliefs are used for camel trappings and caparisoned horses, and incising is found to some degree on the larger figures such as *lokapāla*. However, the resist motifs and detailed decoration of the vessels is not generally to be found on tomb models, on which bright colour takes precedence.

In the middle of the eighth century the Sogdian general An Lushan succeeded in toppling the Emperor Minghuang, ending China's great prosperity for centuries to come. The Emperor and his concubine Yang Guifei were forced to flee the capital in AD 756, taking the perilous mountain road to Sichuan in one of the most famous events in Chinese history. Ten years of famine and strife ensued, and though the Tang dynasty lasted a further hundred and fifty years, it never regained the glory of the first half of the eighth century.

60 Tomb figure of a horse. The horse is hollow and, like all complicated burial figures of the Tang, was moulded in separate parts and luted together. The horse is glazed in cobalt blue; such quantity of blue is unusual on figures and particularly on animal figures. First half of the 8th century. HT 29.3cm. OA 1940.7–15.1, given by Mrs G. Eumorfopoulos in memory of her husband.

Before the fall of the emperor, *sancai* burial figures and ornate vessels had been produced on a large scale, but declined thereafter. It is not surprising that the production and role of *sancai* should have changed along with the burial practices they had once complemented. Written records of the late eighth and ninth centuries include descriptions of increasingly lavish funerals, together with the traditional admonitions for their restraint. The preferred burial accoutrements included elaborate wooden sculptures embellished with pearls and jewels, and items of precious metal. The disappearance of *sancai* from assemblages of precious objects was probably due to the disruption of the Hebei and Henan kilns during the An Lushan rebellion. The wares were still produced in the later part of the Tang dynasty, but in smaller quantity and for export.

Export

Sancai sherds from Mantai in Sri Lanka, from Samarra and from Fustāt have been shown to come from Gongxian and probably one other unidentified Chinese kiln. The designs, however, are simpler than those of the early eighth century, and do not include appliqué or resist decoration. The shapes also indicate a ninth-century date, for many of the exported *sancai* wares have everted lips and raised lines, both features of ninth-century Chinese silver vessels. Dishes with wide flat rims are not at all Chinese in form, and may well have been made specifically for a Middle Eastern market in which that shape was both indigenous and popular. *Sancai* and other later Tang wares bound for Japan, South-east Asia, the Middle East and Africa have been found in large numbers at the port of Yangzhou in Jiangsu province.

61 Three marbled wares: a neck-less jar, a tripod dish and a cup. The marbled effect was produced by mixing two earthenware clays of different colours before the pieces were modelled. The clays were usually red and buff, and the wares were covered with transparent lead glazes of either yellow or green. Marbled wares are mostly burial pieces. All 8th–9th century. From left: HT 7.5cm; D 14.5cm; HT 7.5cm. OA 1925.10–12.2; OA 1937.7–16.44; OA 1936.4–13.1, Reginald R. Cory Bequest.

In 1975 and 1981 some sherds were discovered at Yangzhou of the Gongxian-type body with geometric decoration in underglaze blue, imitating Persian style. The technique of painting on the ceramic body in blue pigment derived from cobalt is associated with the Yuan and Ming dynasties some five hundred years later, when it appears on wares of complicated shape and refined body material. At that period too there was a high level of contact with the Middle East. As in the fourteenth-century pieces, the blue pigment is low in manganese. This implies that it was imported, since the cobalt ores extracted in China itself have a high manganese content.

Most of the finds from Yangzhou are more familiar than these sherds. The majority are greenwares either from the Yue kilns or from a local kiln area. Some are fine, including a sherd with bird and flower decoration in high relief, though most of the pieces are vessels for everyday use. There are a large number of white wares and examples of wares with yellow, brown and black glazes. Apart from the local greenwares, the finds represent all the major wares being produced in north and south China in the late eighth and ninth centuries. A few of the greenwares and other pieces with coloured glazes are incised or painted with single-character surnames such as Wang and Li.

Tongguan and Qionglai

Wares from the Tongguan kilns near Changsha in Hunan province figure largely amongst the finds from Yangzhou; indeed, they are almost as numerous at Yangzhou as around the Tongguan kiln site itself. That they were exported in quantity is also evident from their discovery right across Asia and even as far away as Africa. Examples have been found at Laem Pho and Ko Kho Khao on the Kra Isthmus in Thailand, at Prambanan in central Java, at Mantai in Sri Lanka, and at Brahminabad and Bambhore in Pakistan. Further west they appear at Samarra and at Manda and Shanga in Kenya; eastward they have been found in both Japan and Korea. The wares themselves are not at first glance refined or intricate and are predominantly domestic wares for daily use. Ewers with a short spout on the shoulder are the most common, though vases 63 and pillows are also prominent. The glaze is a lead-free lime glaze of amber or brown colour.

The decoration of the Tongguan wares lends them an important position in the development of Chinese ceramics: for the first time it is executed in underglaze colours painted on to the body. Some iron-brown painting is known on wares of the Six Dynasties, but at Tongguan copper colours were used. The decoration usually appears green but is very occasionally red. This use of underglaze painting and of copper, together with the appearance on some wares of the first opaque, phase-separated glaze, make Tongguan wares innovative on three different counts. The painted designs fall broadly into three types: abstract patterns, pictorial decoration and calligraphy. The abstract patterns are the 62 most common and generally consist of circular motifs made up of rows of dots.

62 Three Tongguan ware jars. Tongguan wares from Changsha are the earliest instance of the consistent use of underglaze painted decoration. The calligraphy, the bird and the geometric design all influenced slip-painted decoration at the Cizhou kiln complex in the north. All were unearthed in Hunan province. From left: HT 22cm; 19.2cm; 13.7cm.

63 Ewer, Tongguan ware from Changsha, Hunan province. Although the shape, the glaze colour and the splashed decoration all bear a superficial resemblance to northern *sancai* wares, the stoneware body and high-fired glazes of Tongguan wares distinguish them as a separate group. Most Tongguan wares are in utilitarian shapes and were used domestically, or exported. 8th–9th century. HT 29.5cm. OA 1961.5–15.3.

The pictorial designs, usually located on the front of a ewer beneath its spout, depict young boys, flowers, or birds and flowers combined. Pieces with pictorial decoration appear in the ninth century and seem to have been exported only rarely. Calligraphy appears predominantly on ewers and may refer to their intended contents, for many bear four-character phrases associated with wine. Other characters are simply family names. Verses of poetry decorate a large number of pieces found at the Tongguan kiln site. The lines of five or seven characters follow the established forms and content of Tang poetry, though these laments about parting and descriptions of scenery are far removed from the skilled, evocative verse of the famous Tang poets such as Bai Juyi or Li Shangyin.

Poetry and the bird and flower painting on Tongguan ceramics are reminiscent of court activities earlier in the Tang dynasty, and they are not the only elements which may derive from that more glorious era. Applied reliefs similar to those on eighth-century *sancai* wares appear in the ninth century on the shoulders of Tongguan vases and ewers. They take such forms as figures, birds, animals and flowers. The relief, together with the surrounding vessel area, is splashed with a contrasting glaze colour – for example, dark brown on an amber pot. Technically, however, the ceramics from Changsha differ markedly from the *sancai* of Henan and Shaanxi. It has already been mentioned that Tongguan wares have a lime glaze as opposed to the lead glazes of the north, and they are coloured only with copper and iron. The clay is inferior. Although the basic composition is similar to that of high-quality southern wares from Zhejiang and Jiangxi, it is of a lower grade, and large grains of quartz and iron minerals show that it was poorly prepared. The Tongguan kilns are of the southern 'dragon kiln' design and the wares were fired between 1170° and 1220°C, making them one of the earliest examples of high-fired copper glaze. In these ways the Tongguan wares of Changsha show the application of a significant degree of technical innovation to ceramics of low quality and humble purpose.

Another aspect of the finds at the Tongguan kilns suggests the popular nature of their output. This is the large number of small animals and figures. Nearly two hundred such pieces were excavated, many of them simple toys in the form of people, riders, dogs, pigs, elephants, horses, frogs, sheep and so forth. The rest of the finds are similar in form, representing birds, lions and sheep, for example, but are functional implements such as waterdroppers and paperweights. Thus we are reminded again of the scholarly pursuits of the southerners, which are further reflected in the brush washers and inkstones found with these small ceramic sculptures.

The Tongguan kilns near Changsha were not alone in producing interesting ceramics outside the mainstream of northern *sancai* and stone-ware types. The Qionglai kilns in Sichuan are similarly known for painted wares and small glazed toys, though these seem to have been confined to the locality and not transported worldwide like the Tongguan pieces. Production began at Qionglai before the Tang dynasty and

continued until the Yuan (AD 1279–1368), though the coins and dated sherds all belong to the eighth and ninth centuries. Most of the wares

64 are covered with a white slip and glazed light green, yellow or brown. Their schematic floral painting is executed on and under the glaze, usually in brown. Many of them are simply monochrome.

The clay available to the Qionglai potters was high in iron and titanium, and therefore of a lower quality even than the Tongguan kind. Three methods of covering the body were adopted to improve its dark colour: white slip, opaque glazes and dark-coloured transparent glazes. A few white-bodied pieces are known to be from Qionglai, though none of them is fine enough to fit the description by the famous Tang poet Du Fu, who lived in Sichuan and wrote in c. AD 760 of a light, jade-like white porcelain renowned in the provincial capital, Chengdu.

The presence of slip-decorated, monochrome-glazed and underglaze-painted wares in such a variety of colours, shapes and ornamental motifs sets the Qionglai pieces apart as products of a kiln which tried to produce everything. Technically they relate closely to the Tongguan wares of Hunan, and it seems there must have been contact between the two kilns along the Yangzi River. In other respects, however, the Qionglai kilns are as isolated in their activities as they are geographically.

64 Bowl from the Qionglai kilns, Sichuan. The poor dark brown body material is typical of Qionglai ware, as is the decoration. A dark green glaze shows on the upper exterior of the bowl, while the interior has a thick white slip painted with green glaze decoration beneath a transparent glaze. The Qionglai kilns began making greenwares in the Six Dynasties period, and appear to have continued production into the 11th century. Pieces such as this are amongst the earliest glazed and painted ceramics. 8th–9th century. HT 6.4cm, D 18.6cm. OA 1909.12–14.25, given by Thomas Torrance.

Liao

The Tang dynasty was succeeded on the north-east periphery of its empire by the Liao (AD 916–1125), which controlled territory in Liaoning province and parts of present-day Hebei and Inner Mongolia. The Qidan people ruled at the same time as the Northern Song dynasty, yet Liao ceramics owe more to established Tang types than to contemporary Song wares. The debt is evident chiefly in the use of lead glazes in *sancai* colours, and in shapes adopted from the carinated forms of ninth-century silver ware.

The six major Liao kilns identified so far are distributed throughout the area and are situated at Longquanwucun near Beijing in Hebei province, near Liaoyang in Liaoning province, and at Shangjing and Gongwayao village in Inner Mongolia. Gongwayao was the largest kiln and, together with the Liaoyang kiln, produced the finest Liao wares.

65 Tall vase, Liao dynasty. The white glaze has a slight yellow tinge where it has pooled. The foot, which is raised a little, is unglazed. Most Liao dynasty kilns produced white wares, the foremost being Longquanwucun in Hebei province and Shangjing in Inner Mongolia. Greenware vases with dish mouth and tapered base were made in Zhejiang province in the late Tang dynasty (see fig. 52), and this white example is a taller version of that shape. 10th to early 11th century. HT 46.6cm. OA 1936.10–12.186.

During the tenth century, lead glazes were applied only in single colours, most usually to a flattened bottle shape probably derived from the leather bottles traditionally used by nomadic peoples. It was not until the eleventh century that green, yellow and cream lead glazes were used together in a revival of the Tang *sancai* palette; they were applied to trays and dishes of late Tang silverware shapes, and to larger forms as well, such as vases and round jars. The decoration of these wares was incised quite heavily into the body before glazing, a technique which, though prevalent on eighth-century *sancai*, is not so well known on the ninth-century wares. The roughly drawn floral sprays of the large Liao pieces are perhaps closer to Henan painted black wares of the Northern Song than to the more careful designs of the Tang. Indeed, the Baofeng kilns in Henan are known also to have produced *sancai* wares in the Northern Song period, though the precise relationship between these and the Liao *sancai* has yet to be established.

Black wares produced at Liao kilns were on the whole quite coarse, yet these wares too revived an early, even pre-Tang form: that of the round-bodied, short-spouted ewer. Greenwares found in Liao tombs come mostly from Zhejiang, Jiangxi and Shaanxi provinces, and are only rarely of local manufacture. The imported ceramic which exerted most influence on Liao wares was, without doubt, Ding ware. Liao white wares resemble Ding wares so closely in certain aspects that it has been widely suggested that the Inner Mongolian kilns witnessed an influx not only of the wares but also the potters of Hebei. The Longquanwucun kilns were situated so close to the Ding kilns in the same province that the two wares are often indistinguishable from one another. The Northern Song Ding kilns developed traditions of shapes and glazing established at the Xing kilns during the late Tang period. Liao bowls show little alteration from the typical Xing form, yet the contrast between the shapes and ornament of high-quality Ding ware and those of Liao wares of the same rank serves to illustrate the independence of Liao potting. Liao ceramics are distinctly regional and often fine, though firmly based in Tang types and displaying awareness of the great Song developments taking place in the rest of China.

4

THE CLASSICAL PERIOD

The Song Dynasty

onnoisseurship and commerce were the two apparently opposed currents at the heart of Song ceramic consumption. Song wares have been so renowned for their elegance, restraint, equilibrium and beauty that the dynasty has long been regarded as the classic period of Chinese ceramics. Yet the gentry who demanded such fine qualities were themselves supported by an economy which required the widespread export of lesser stonewares and porcelains. In some cases, as we shall see, the connoisseurs were even the clandestine supervisors of the commercial activity. Like Tang ware, Song pottery and porcelain were not only required in quantity within China, but were exported all over Asia and even to some parts of Africa.

During the Tang dynasty, China had been enriched by trade along the Silk Route and the exotic goods, people and cultural influences that it brought. For the Song dynasty, the far-reaching consequence of the eighth-century An Lushan rebellion within China and the Central Asian Tasal rebellion without, was the need to establish a dynasty that could resist and effectively close China off from any ideas, goods or armies which might come from the north-west. Pressure from nomads along the length of the empire's northern borders was a constant strain on the Song, both militarily and economically; eventually it resulted in the flight south of the court in the early twelfth century. Ideologically, the need to resist foreign influence contributed to an examination of the Chinese past which resulted in the revival of Confucianism. Economically, it led to an expansion of domestic industries and a focus on the south-eastern coastal regions for trade.

The enormous social changes the Song dynasty witnessed were likewise rooted in eighth-century events. Until then, land had been divided

66 OPPOSITE Porcelain vase, Ding ware. The vase is glazed entirely except for the thin foot ring. Vases of this form were also produced at the Ru and Guan kilns which, like the Ding kilns, provided ceramic wares for the imperial palace. Song dynasty, 11th–12th century AD. HT 21.9cm. OA 1936.10–12.26.

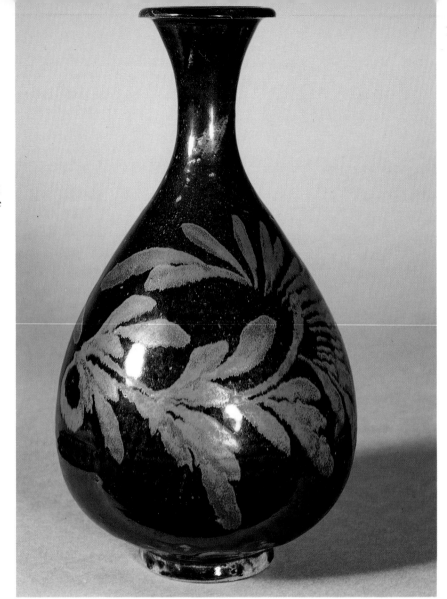

67 Vase, black ware. The black glaze has a yellowish tinge near the foot, where it has run thin. The decoration is achieved by painting with an iron-saturated glaze which fires reddish brown instead of black. Wares of this type were made in north China at the Henan kilns producing Cizhou-type wares, and also in south China at kilns in Fujian province. 12th–13th century. HT 27.1cm. OA 1947.7–12.148, Oppenheim Bequest.

between peasants who paid almost all their earnings in taxes, and large landowners who wielded political influence and paid almost no tax. Simplification of taxation in the eighth century made it possible for individuals to accumulate land, and harder for aristocrats to maintain their privileges. The introduction of bureaucratic examinations for entry into government service further reduced the influence of the great land-owners, so that by the middle of the Song dynasty, the old aristocracy had become part of a new gentry largely made up of those successful in trade or government. Commerce still fell short of social acceptability, however, so the gentry sought to imply that their wealth derived from agriculture. Socially ambitious merchants tried to acquire respectability in two ways: by operating official monopolies for the government and by controlling commercial taxation. Ceramics played a part in both.

Such activity is little documented, for contemporary records stress agriculture as the basis of the economy, but a gazetteer of Fuzhou in the

south-eastern province of Jiangxi mentions in one of its biographies that the gentleman Zeng Shuqing of Nanfeng planned to transport Jiangxi porcelain to north China for sale. Regarding taxation, the writings of Lu Jiuyuan include a letter of protest against the decision of the administrators of Jinqi county, also in Jiangxi, to begin taxing income from porcelain.

Land reforms also affected the humblest peasants. During the Northern Song period (AD 960–1127), approximately half of China's population was made up of people whose position was roughly equivalent to that of tenant farmers paying a proportion of their yield in rent. This was an improvement on the position of their forebears, who had been hereditary retainers on big estates. This degree of liberation must have made large numbers of people available to work in towns and industries if they so chose, rather than being compelled to labour in the fields. Lu Jiuyuan, cited above, also records that in Jinqi county most 'pottery households' were farming families whose members worked as potters in the agricultural off-season. If this were true of other regions, it would explain the enormous growth in the number of kilns, which were then able to meet the demands of the new middle class for high-quality ceramics.

The Song gentry – or gentlemen scholars or scholar officials as they have variously been known – took a great interest in antiquity. The revival of Confucian philosophy brought with it an interest in the material remains of the past, and people began collecting bronzes and other ancient objects. Large collections were formed, some of which were published in illustrated printed books. These collections had a wide influence. Bronze vessels for contemporary altars were soon cast in ancient forms, and jades were likewise carved in archaic shapes. It is not 81 surprising, then, that ceramics too were made in shapes and colours that reflected those which had been revered in antiquity. Particular social classes began to demand particular wares, and this was true not only of the scholar-official connoisseurs, but also of certain emperors, Buddhists, and even of the common people. During the Song dynasty particular kilns began to specialise in one type of ware to a far greater degree than before, and throughout the dynasty a succession of kilns enjoyed the position of imperial favourite, though recent excavations make it seem increasingly likely that most kilns sent examples of their best wares to the court as tribute.

The demand for fine ceramics must have stimulated the perfection of the three main categories – white, green and black wares – developed during the Tang dynasty. The Song potters produced bodies and glazes, shapes and ornaments which were mutually enhancing to a degree that has never been surpassed. Nowhere amongst Song ceramics – not even in the low-fired wares – is seen the Tang practice of taking shapes and decorations from glass, metalwork and textiles and applying them all to a single object. It is the exploration of clay, glaze and firing that gave the Song potter a thorough understanding of the craft, so that the forms and colours produced were deceptively simple. The discreet ornament

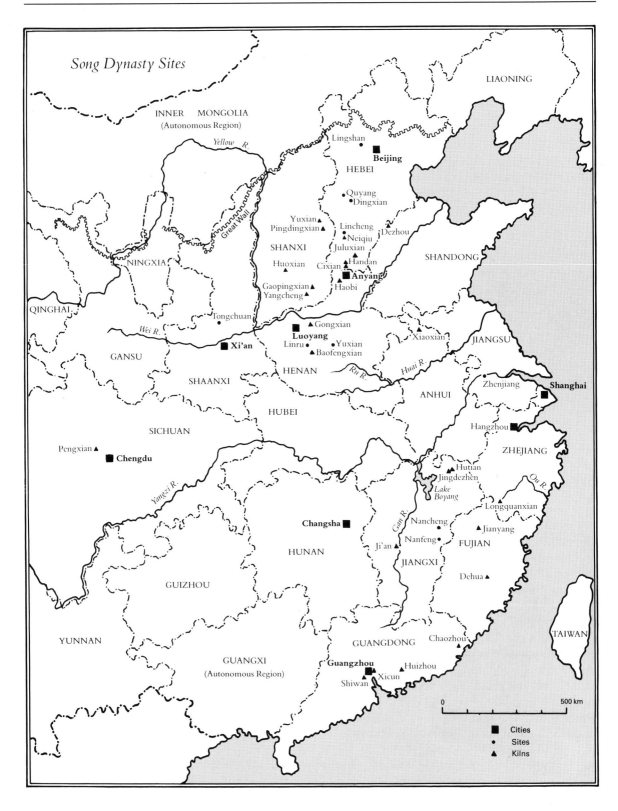

Song Dynasty Sites

LIAONING

INNER MONGOLIA
(Autonomous Region)

Yellow R.

Lingshan

Beijing

HEBEI

Quyang
Dingxian

Yuxian
Pingdingxian

Lincheng
Neiqiu
Dezhou

SHANXI

Juluxian

SHANDONG

Huoxian

Cixian
Handan

Anyang

NINGXIA

Gaopingxian
Yangcheng

Haobi

QINGHAI

Tongchuan

Gongxian

Wei R.

Luoyang

Xiaoxian

JIANGSU

Xi'an

Linru
Yuxian
Baofengxian

GANSU

HENAN

Ru R.
Huai R.

ANHUI

Zhenjiang

Shanghai

SHAANXI

HUBEI

Hangzhou

SICHUAN

ZHEJIANG

Pengxian

Chengdu

Hutian
Jingdezhen

Yangzi R.

*Lake
Boyang*

Longquanxian

Ou R.

Changsha

Nancheng

Jianyang

Can R.

Ji'an
Nanfeng

FUJIAN

HUNAN

JIANGXI

GUIZHOU

Dehua

YUNNAN

TAIWAN

Chaozhou

GUANGDONG

Guangzhou

Huizhou

GUANGXI
(Autonomous Region)

Shiwan
Xicun

0 500 km

■ Cities
● Sites
▲ Kilns

chosen to complement those forms and colours resulted in ceramics with an aesthetic attraction that concealed the technical accomplishment which produced them. This combination of unobtrusive technical discipline and obvious loveliness is what lies behind the reputation of Song wares as classics and masterpieces.

The shapes, decoration and even the colour of many Song ceramics were copied at other kilns, even in the same period at which the specialist kiln produced them. The difference in raw materials locally available to the various kiln complexes, however, ensured that derivative wares were not close copies. Kiln specialisation did not prevent major ceramic types being imitated, often at kilns hundreds of miles away from the original production centre.

'The five great wares'

Connoisseurs in the Southern Song, Ming and Qing dynasties have accorded five Song wares the status of 'the five great wares of China'. They are the products of the Ding, Ru, Jun, Guan and Ge kilns. The first known to have been seen by a Song emperor was Ding ware, which is recorded as having been accepted at the imperial palace during the Northern Song dynasty. Ru and Guan wares are similarly mentioned in contemporary texts, though Jun and Ge are not. However, all five wares have often been considered 'imperial', and while there is little doubt that they were sent to the court, evidence that they were commissioned by the emperor is scant. It is possible that the wares were sent as annual imperial tribute, together with other local products from the provinces, and that certain of them chanced to find favour with the emperor of the day.

The Ding kilns are situated in present-day Jiancicun in Quyang county, Hebei province. In the Song dynasty this area was in Ding prefecture (as distinct from Ding county, also in Hebei). The kilns began production during the eighth century, in the mid to late Tang dynasty, and remained productive until the thirteenth or fourteenth century. The Song wares are undoubtedly the high point in this six-hundred-year period, but the late Tang and Five Dynasties wares are themselves of considerable interest. The premier white wares of the mid Tang came from the Xing kilns in Neiqiu county, Hebei province, not far from the Ding kilns. The most common Xing form is a bowl, typically rather heavy, with a rolled lip and a glossy glaze. Xing wares were at their height in the eighth to ninth centuries and are described in Lu Yu's eighth-century *Tea Classic* as being 'like silver' and 'like snow'. Ding ware receives no mention in literature before the tenth century, but the early examples are notoriously difficult to distinguish from Xing, and the Ding porcelains have been regarded as the successor to Xing in the northern white ware tradition.

It has been suggested in China, after much comparison between the two wares, that some distinguishing features of the early Ding ware might be: unevenly everted lip; wheelmarks on the outer surface even though the interior may be smooth; an unglazed base; unevenly applied

66, 73, 75, 77, 150

68

93

68 Porcellanous white bowl with rolled lip. Large teardrops of glaze appear on the exterior of the bowl, and wheel marks are evident on the interior. The wide flat foot ring of this and similar bowls is known as a *bi* disc foot, after the flat circular ancient ritual jade type called *bi*. Bowls of this type represent the later stages of Ding ware, and similar examples have also been excavated at Gongxian in Henan province. They were widely exported and have been found at Samarra in Iraq, which previously earned them the name 'Samarra' type. This piece was probably made at the Xing kilns. From Hebei province. 9th century. HT. 4.5cm. OA 1956.12–10.22, given by D.R. Hay Neave.

glaze, particularly on the exterior where 'teardrops' form; and a generally thin glaze layer. Another characteristic of pre-Song Ding wares, which are primarily bowls, basins and small cups, is their pure white or slightly bluish-white colour, due to the wood-fired reducing atmosphere in which they were fired. It was probably in the tenth century that coal replaced wood as the kiln fuel. This provided an oxidising atmosphere which gave the Ding glaze its famous ivory shade. The tenth-century wares, when decorated at all, are most commonly carved with a lotus design. The lotus is associated with Buddhism, and two of the most extensive groups of fine Ding ware were in fact recovered from Buddhist monuments.

Two pagodas in Ding county, Hebei, called the Jingzhi and the Jinzhong pagodas, contained almost one hundred and fifty high-quality Ding wares between them. Many of the pieces are embellished with gold or silver rims. The bowls, plates, cups, vases and other items were combined with Buddhist implements such as water sprinklers, incense burners and a conch shell. The pieces are datable from two plates from the Jingzhi pagoda bearing inscriptions which name the years AD 955 and AD 977. Bowls, water sprinklers and incense burners from these and other tenth-century tombs and pagodas are incised on the base with the character *guan* meaning 'official'.

It is tempting to deduce from these marks that Ding was an 'official' kiln producing official wares, but in fact the inscribed wares all pre-date the use of Ding as an imperial ware. Examples found as far away as Egypt make it seem more likely that *guan* implied that a piece had been made to fill an order from a merchant, a monastery or a private individual. Later wares with moulded decoration are incised with various titles such as 'office of imperial banqueting' and 'office of imperial medicine' as well as the names of palaces and pavilions. Two small cups of eleventh- to twelfth-century date in Shanghai Museum are the only examples known so far of inscriptions painted in red: both are painted on the interior with the characters *chang shou jiu* ('longevity wine').

69

69 White porcelain neck-less jar. The body of the jar is thin and the glaze has formed teardrops on the exterior. The petal design is continuous. The glazed base is incised with the character *guan* (official), which was used at both the Xing and the Ding kilns in Hebei province. Lidded examples of this type are also known. This piece is probably from the Ding kilns (compare fig. 50). 10th century. HT 5.9cm. OA 1947.7–12.56, Oppenheim Bequest.

It was during the eleventh century that the quality of Ding wares reached a peak. The forms were larger and the decorative repertoire expanded to include all sorts of flowers, plants, and animals. The decoration was incised freehand on to the pots when they had dried to leather-hardness. The shapes of bowls and dishes in particular sought to imitate the lobed forms of late Tang and Song silverware. The extreme thinness of the body possibly derives from the same impulse, and Ding porcelains of the eleventh century are amongst the lightest of all Chinese ceramics.

There was a gratifying demand for such fine wares which, combined with the difficulties presented by their thinness, prompted the introduction of a new firing technique. Rather than fire each item in its own saggar, the box protecting the pot from direct flames, the Ding potters invented a saggar with stepped sides. By placing bowls or dishes rim down on the steps, each object was not only better supported and less likely to warp, but also a stack of several pots could be fired in one saggar. This saved both space and saggar material, and the still huge saggar heaps at Quyang bear witness to the scale of this practice. The disadvantage of the new system was that the rim had to be wiped clean of glaze to prevent its adherence to the saggar, and this created the *mang kou* or 'rough mouth' of Ding ware. The solution to this problem was to bind the rim in silver or, more usually, copper. Gold rims had been added to precious jade and occasionally ceramic cups since the early Tang dynasty. A few Ding pieces have gilded decoration, so the metal rims on many more Ding porcelains may be a mark of the esteem in which they were held as much as they are a solution to a practical problem.

The beautiful ivory coloured wares were considered fit for the emperor until a flaw began to rankle. The Ding glaze, applied by dipping, had a tendency to run and form small 'teardrops' or '*mang*'. This character is the same one used to describe the *mang kou* or rough mouth of the Ding wares. *Mang* also means wheatsheaf, coarse, or boundless, which could imply that the wares were simply too numerous to merit imperial

70

71

70 Stoneware mould and saggar. The mould appears to be for Ding ware dishes. It is of a thick, chalky white stoneware. A fifteen-character inscription incised on the reverse gives the date (equivalent to AD 1189) and the name of the maker, Dongzhang. The saggar, which is of a stepped design for firing bowls on their rims, is of the type invented at the Ding kilns of Hebei province. It is known, however, that rim-down firing was soon introduced at the southern kilns of Jingdezhen in Jiangxi province, and this saggar is reported to come from Hutian, one of the major Jingdezhen kilns in the Song dynasty. 12th century. Mould: D 29cm. Saggar: D 15.3cm. OA 1926.4–21.1; OA 1938.5–16.3, given by A.D. Brankston.

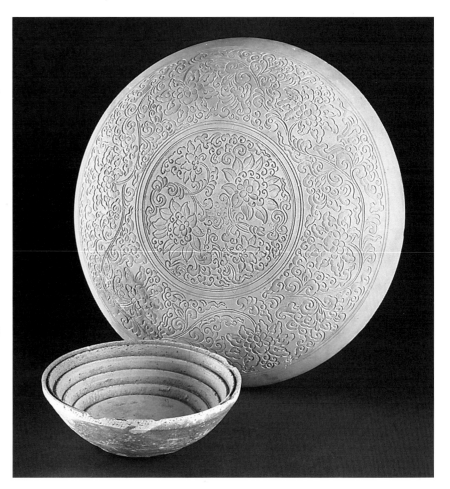

patronage. In any case, it is clear that they fell from favour at court.

Another new technique was introduced at the turn of the eleventh century. Instead of being decorated by hand, the leather-hard clay was pressed over a dish-shaped mould already carved with ornament. It was 70 then removed and fired, and the mould was used again. The intricacies of the decorating process having been eliminated in this way, production could be increased enormously. Moulding the ornament had the effect of increasing its density, thereby reducing its impact. Though many new motifs were introduced with moulding – children and phoenixes, 71 for example – the ornament became much more crowded, so that such figures appeared amidst banks of foliage. This type of decoration is similar to that of the textiles of the period, particularly *kesi* tapestry-weave panels. Moulded decoration could only be applied to the interiors of open forms, however, so that exteriors of bowls and dishes, and of more complicated shapes, continued to be incised for some time. Examples of late-twelfth-century incised Ding wares have been found in tombs in Anhui and Jiangsu provinces in east China, and in many places across north China.

71 Porcelain bowl, Ding ware. The decoration shows children amidst lotus scrolls and is moulded. The sides of the bowl flare widely from a narrow foot, the diameter of which is approximately one-fifth that of the mouth. Although the moulded decoration appears less delicate than the decoration on incised wares, the body of the vessel is as thin and the bowl as light as the earlier Ding porcelains. 12th–13th century. HT 6cm, D (at mouth) 21.3cm, (at foot) 4.2cm. OA 1947.7–12.62, Oppenheim Bequest.

Late Ding wares were not made or fired with as much care as the mid-Song pieces. A circle in the interior of each bowl was wiped free of glaze so that another could be placed inside without the two bowls adhering together. Thus stacked, the bowls were fired in a tall pile. This practice contrasts sharply with the earlier method of firing in individual saggars.

Analyses of Ding ceramic bodies have shown that, although the overall quality of the wares was highest in the Northern Song period, the body composition changed little between the Tang and the Jin dynasties. A local clay was used, possibly from Lingshan. It had a high alumina content of about 31 to 35 per cent. The porosity is low at less than two per cent, and the glaze is high in magnesia and low in lime compared with the contemporary southern white glazes from Jingdezhen and Dehua. Such porosity and glazes persisted until the Jin dynasty.

The kilns at Jingdezhen in Jiangxi province have been in production continually since the tenth century. Their imitation of Ding ware, called Southern Ding, must have been amongst their earliest products. The shapes and decoration of the Jiangxi bowls are close to the Ding originals,

72 Porcelain dish, Ding ware. The thickened, bracketed rim of this dish could only be produced by moulding, yet the decoration is incised. This is a rare combination of the two techniques. The base is glazed, and the cavetto is incised with a floral design. The incised scene of a cow seated on grass by water, gazing at the moon and a constellation, is in the style of Southern Song album leaf paintings. Compositions rarely appear on porcelain at this date, and it is notable that the style belongs to the decorative rather than the literati school of painting. 12th century. D 25.8cm. OA 1947.7–12.61, Oppenheim Bequest.

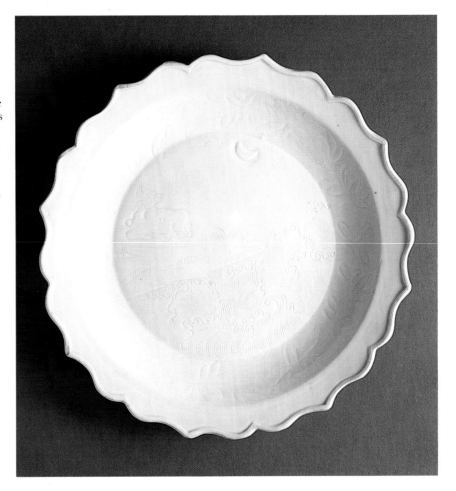

but the difference in the colour is striking. The reducing atmosphere of the southern kilns, combined with the very low titanium and iron impurities in the raw materials, gave a light blue glaze colour which was to become well known under the names *yingqing* ('shadow blue') and *qingbai* ('blue-white'). The mouths of the bowls are wiped clean and a glazed foot ring shows that they were also fired upside-down. These pieces display a link between the finest northern white ware tradition and the early stage of what was to become the greatest kiln complex of all.

In the eastern province of Anhui, which borders the northern part of Jiangxi, the kilns in the county of Xiao produced mainly white wares with incised and impressed decoration, as well as yellow-glazed and black-glazed wares in smaller quantities. The Southern Song writer Zhou Hui wrote: 'When I was on an excursion to the borders, I saw that the Ding wares used in Yan [northern Hebei] had a clear and pleasing colour. In recent years those used are produced in Su, Si and neighbouring areas, and are not genuine'. The counties of Su and Si are in the precise area of Xiao county where so many white wares have been found, and

it is clear from this account that they were deliberately made to imitate Ding wares from the north. To the far west in Sichuan province, white wares in the Ding style were made at Peng county. Some of the wares were coarse but others were fine and white with combed, incised and impressed decoration in Ding style.

Closer to the Ding site in north China, the kilns of Pingding, Yuxian and Yangcheng in Shanxi province all produced white wares over a long period contemporary with the Ding kilns, by which they were clearly influenced. It is from Huoxian, another Shanxi kiln, that the best-known continuation of Ding traditions emerged. The Huoxian wares have simple relief decoration often interspersed with characters, and the glaze-free ring in the interior shows that they were stacked for firing, like the Jin dynasty Ding wares. Huoxian wares, which were widely exported and thus appear in Western collections, mark the latter end of the great Ding tradition. Some secondary products of the Ding kilns are better known through literature than through surviving examples. These include the red, green, gold and black wares, of which only the red and black are represented by entire pieces.

The mystery which surrounds these wares extolled in literature for a long time also shrouded one of the most famous of northern wares. Ru wares have long been regarded as the acme of Song ceramics, and are praised for their beauty and rarity by almost every connoisseur writing from the Southern Song onwards. Until recently there were thought to be fewer than forty extant examples, more than half of them in Britain. **73, 74** The simple undecorated forms, never more than 30 cm high, are most prized for the even grey-blue glaze which covers the entire object save five small spurs on the base, on which the wares were fired. They represent the epitome of court taste. The classic examples were produced for a period of only about forty years, apparently to satisfy Emperor Huizong (AD 1100–1125) in particular.

His taste was upheld by his successor Gaozong, who established his court at Hangzhou after being forced to flee south by the Jin invaders from the north. Gaozong reigned from 1127 to 1163. In AD 1151 Zhou Mi records in the *Wulin Jiu Shu* a list of Ru wares presented to the Emperor: one pair of wine bottles, one basin, one incense burner, one box, one incense sphere, four cups, two jars, one pair of incense holders, and one large and one small cylindrical censer – sixteen items altogether. This is the largest number of Ru wares recorded together, and is a clear indication of the range of shapes produced. Lu You, also writing in the Southern Song period, offers an explanation for the adoption of Ru ware for court use: 'In the old capital [during the late Northern Song period] Ding wares did not find their way to the palace; only Ru wares were used because Ding wares usually had rough [unglazed] rims'.

Another attribute of Ru wares seems to have been the thick unctuous glaze texture, described elsewhere as 'like lard dissolving but not flowing'. This comparison would arise because the most prized type of jade in China is the one known as mutton fat, and it seems that glazes resembling jade were the most admired. Another much quoted Southern

73 Vase, Ru ware. The thick, smooth glaze covers the entire vessel except for the foot ring. Late 11th to early 12th century. HT 19.8cm. OA 1978.5–22.1, given by Alfred and Ivy Clark.

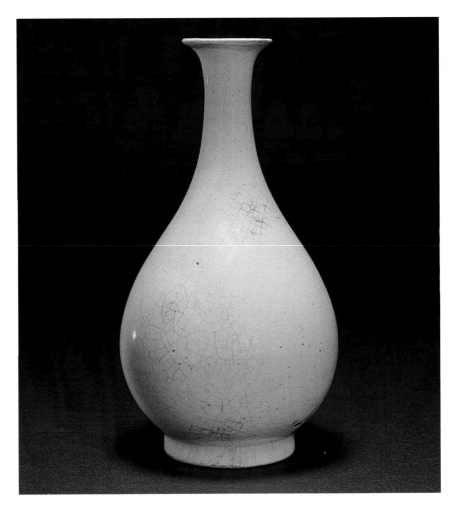

Song remark about Ru ware is that of Zhou Hui who wrote: 'Ru ware was fired for the palace; the glaze contains agate. Only those items rejected by the court could be taken away and sold; recently they are exceptionally difficult to obtain'.

The wares remained extremely hard to find until 1986. The exciting discovery of the Ru kiln site has produced nothing to challenge the esteemed position of Ru wares in China's ceramic history and has provided much additional information about the context of their production. The site at Henan Baofeng Qingliangsi covers 250 thousand square metres with kilns densely distributed throughout. Close by is an abundant agate mining site where veins of red, yellow, blue, green and white agate are faintly visible on the earth's surface. This is just as described in the Ru prefecture section of Du Wan's Song dynasty *Guide to forests and stones*. Agate is composed of almost pure silica, so silica revealed in a Ru glaze analysis cannot be attributed to any particular mineral. The discovery of the mines at Qingliangsi, however, makes plausible Zhou Hui's description of Ru glaze as containing agate.

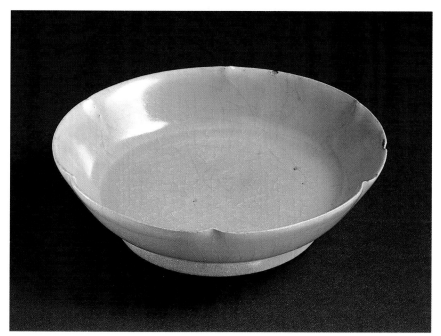

74 Dish, Ru ware. The dish is slightly foliated at the rim. There are three small spur marks on the glazed base. Shallow dishes of this shape are usually considered to be brush washers and were found in some quantity at the Qingliangsi excavations. Some examples bear impressed designs in the centre. Late 11th to early 12th century. D 13.8cm. OA 1936. 10–19.1, given by Alfred and Ivy Clark.

The excavations have shown that the famous court pieces were only a small part of the kiln production, which included black wares, three-colour wares, black-on-white and green-on-white decorated pieces, as well as pieces with incised decoration and a significant number of carved and incised Ru wares of inferior quality. For Song kilns to produce a wide variety of wares in addition to their speciality was usual, so the most interesting finds from Baofeng are the blue- and the green-glazed pieces which clearly belong to the Ru type. The earliest ones, from the first fifty years or so of the Northern Song dynasty (AD 960–c. 1010), are simple objects with warm-looking glazes and little decoration. The mid-eleventh-century pieces show a wider variety of shapes with much more decoration, and the designs are carved or executed in raised lines.

The glazes of these pieces are glossy and densely crackled. The crackle resulted from applying several layers of glaze and is a renowned feature of the wares from the finest period, the reigns of Zhezong and Huizong (AD 1086–1125). The grey-blue glaze colour is the result of iron fired in reduction, linking Ru to the greenware tradition which began in Henan in the fifth century. The discovery of Qingliangsi has shed much light on Ru, the most exclusive Chinese ceramic. The great remaining mystery is that of the tenth-century Chai ware. Not only the kiln site but also the ceramics themselves remain to be identified despite frequent mentions in essays by connoisseurs.

Henan province was also the location of the third of the five great kilns of China: the Jun kilns. The long search for the Ru kilns had concentrated on the county of Linru near the Ru river in central Henan, but in fact that large site was one of two which between them produced the majority of Jun, not Ru, wares. The other is Yu county.

Linru was the main production centre for Jun wares as well as for greenwares of the Song dynasty. Four Jun kilns have been identified to the north-east of Linru city and four more to the south, intermingled with greenware kilns. Both groups are situated on tributaries of the Ru river. The finest kiln in the southern group is Wugongshan, which produced high-quality wares during the Song. In the northern group, some of the finest Jun glazes came from the Donggou and Chenjiazhuang kilns.

Jun wares fall into four groups according to their appearance: green, lavender-blue, lavender-blue with purple splashes and purple-and-blue 75 streaked. This is more or less the chronological order in which they have traditionally been arranged in Europe and America. The colour and shine of the green and the lavender-blue glazes have led to the mistaken view that these wares are related to Ru wares. The Ru kiln sites at Baofeng did include Jun-type glazes amongst the three-colour, the black-glazed and other minor produce found there. Nonetheless, the Jun and Ru technologies were not quite the same and the two wares should not be considered as variants of the same ceramic type.

The most widespread Jun shape is a bowl of slightly conical profile. It occurs with green, plain lavender-blue or purple-splashed lavender-blue glazes. Another typical shape is a small ovoid jar, often with lugs at the shoulder. Some shapes, such as pear-shaped bottle vases and *meiping* high-shouldered vases, are the same as fine Ru and Ding pieces. Others, such as deep basins, flat dishes and the common shapes just mentioned, suggest a more practical ware. All Jun wares are thickly glazed, though sometimes the rim of an object is left with a thin layer of olive glaze and thick globules form at the base. The bodies are also thick. Mary Tregear has pointed out that in their weight, quality and shape, Jun wares are similar to the strong serviceable Cizhou wares used in ordinary households across north China during the Song and Jin dynasties.

The humbler purpose of Jun wares suggested by their wide distribution and strong, if not heavy, potting is further implied by the absence of any reference to them in the writings of the Song connoisseurs who extolled the virtues of Ru ware and at least mentioned Ding. Ming and Qing collectors rectified the omission, and Jun wares have long since been regarded as imperial wares produced for court enjoyment. Some evidence for this view has recently been provided by the excavation at Yuxian of the purple-and-blue streaked wares, the fourth group mentioned above. The streaked wares are bigger and stouter than the other types, and are all of shapes designed for the growing or display of flowers. The bulb bowls and jardinières typically have complicated 76 foliated cross-sections and applied bosses around the edge, both of which features are better known in metalwork. Another shape peculiar to Jun ware is a flat, circular dish with flattened rim, which may also have been influenced by metalwork.

Some of these large pieces are incised on the base with the characters *feng hua*. The same characters appear on Ding and Ru wares, though in at least one case they are a Qing addition known to be the name of a

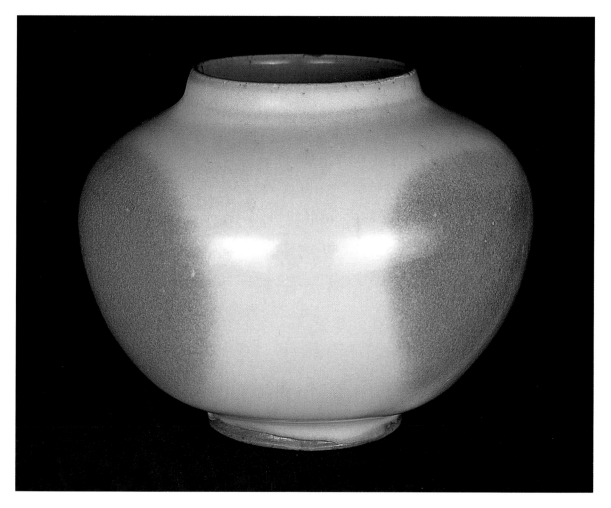

pavilion in the imperial palace at the Northern Song capital, present-day Kaifeng. Some pieces of Jun ware have longer, more finely incised inscriptions carved in the Qing dynasty and describing their precise location in the imperial palace in Beijing. Other characters on the Jun wares, and only on them, are single-character numbers from one to ten, impressed on the base of such shapes as the *zun* vases and bulb bowls. These have been explained in various ways. The Qing document *Nan yao biji* says that the numbers were used to denote pairs of objects, while the *Taoya* and *Yinliu Zhai shuoci* both say that odd numbers were carved on pieces with purple splashes or streaks and even numbers on lavender-blue monochrome ones. A survey of forty-two numbered examples in three shapes, excavated at Juntai kiln in Yuxian, shows a relationship between the dimensions and the numbers. The largest examples were numbered one, and the smallest ten. Those in between followed sequence. Numbers incised inside the foot ring on bulb bowls and *zun* vases appear to support the marking of pairs as described in the *Nan yao biji*. Distinguishing sizes by number implies substantial

75 Globular jar, Jun ware. The thick glaze covers the base and the vessel's interior. The copper splash continues around the unillustrated side of the vase. The jar was probably made at the Linru kilns. 12th century. HT 9.1cm. OA 1936.10–12.151.

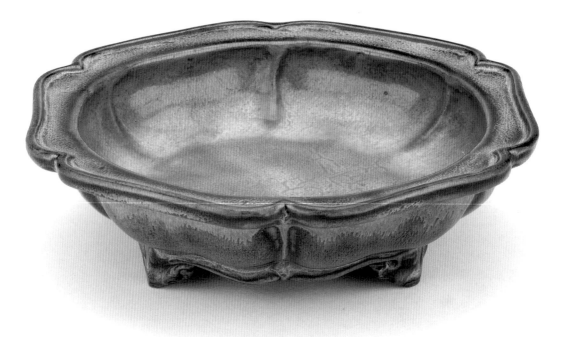

76 Dish, Jun ware. The flat rim is glazed purple and the interior blue. The base is coated with a brown dressing, has seventeen spur marks and is incised with the character *jiu* (nine). Such numbers indicate the vessel's dimensions. The dish was probably used to support a small jardinière. *c.* 12th century. HT 6.1cm, D 19.2cm. OA 1925.7–17.1, given by the Keechong Hong.

production for a large market. No kiln supplying only the court would need to specify orders in terms such as 'ten size-five vases and a hundred number-eight bulb bowls'.

The dating of these large, numbered flower vases, bowls and pot stands with applied bosses has not been established. They have been excavated alongside pieces incised with the Northern Song palace name (see above) and coins of the Xuanzong (AD 1068–85) period. On the basis of the Yu county excavations, the eminent Chinese scholars Feng Xianming and Wang Qingzheng believe that this type of Jun ware is Northern Song. Western experts still believe that the large, heavy purple pots represent the last phase of Jun production in the Yuan or early Ming dynasties.

More fascinating than the sequence and intent of the ceramics are their appearance and technology. Green, black and their intermediate yellowish glazes were produced over a long period and in several areas, but light blue pots and purple-red splashes were not known before Jun ware. The blue was produced by spontaneous unmixing of the glaze into silica-rich and lime-rich glasses at high temperatures. The purple-red areas were the result of copper ore in suspension painted on to the glazed but unfired vessel. A few Song dynasty copper-red sherds have been reported from Guangxi province in south-west China, but as yet they have not been fully researched. The only other use of copper-red prior to the Jun splashed wares occurs on a few pieces from the Tongguan kilns of the late Tang dynasty, near Changsha in Hunan province, and at some northern kilns making green splashed wares. The Changsha

kilns produced pre-Jun opalescent glazes as well, which were splashed on the shoulders of some otherwise quite ordinary jars. Other non-cobalt blue glazes before Jun are those splashed on the shoulders of jars from Lushan county, just north of Linru and also in Henan province.

The particular opalescence of Jun and Tongguan glazes is caused by a process known as phase separation. When a glaze of Jun-type composition is fired it forms an emulsion of two liquids called liquid phases. The optimum temperature for the emulsion formation is at or a little below 1200°C in the cooling. Above that temperature, less emulsion occurs. The glaze must be cooled slowly.

Jun kilns were densely packed with individual saggars for each piece, and the kiln itself was surrounded with earth. They took a long time to heat up and even longer to cool, and the combined processes would probably have taken a matter of days rather than hours. A large part of the skill in producing successful Jun glazes, which were generally applied to the simplest of pots, thus lay in accurate judgement of the firing cycle. Careful preparation of the raw materials was also important. Jun body material contains approximately two per cent iron and is a stout stoneware. Its grey body offsets well the lavender-blue glazes which were successfully achieved by a combination of appropriate materials, careful preparation and considerable skill in firing.

In AD 1127 the non-Chinese tribes who had been pressing at China's northern borders since the foundation of the Song dynasty finally seized control of the capital. The Jin dynasty (AD 1115–1234) was established and soon ruled China as far south as the Huai river. The Song emperor fled south with his court to Hangzhou in Zhejiang province, which at that time was a modest fishing town called Linan. He regarded this capital as temporary, and speaking of the construction of his new palace, the emperor said it must be 'simple and economic, not luxurious and adorned'. One requirement, however frugal the palace might be, was a supply of ceramic vessels.

The ware produced in Hangzhou to fulfil this need is Guan or 'official' ware. Allusions to northern Guan ware of the Song dynasty are generally taken to refer to Ru ware, since that is the northern type most similar to Guan ware in appearance, and was clearly enjoyed in the imperial palace. Production by the Ru kilns ended with the Northern Song dynasty, and it is widely believed that the Ru potters accompanied the court to Hangzhou in order to continue supplying the emperor with fine ceramics.

Guan ware is mentioned in at least two Southern Song texts. Tao Zongyi of the Yuan dynasty wrote: 'During the Zhenhe (or Xuanzhen) reign period a porcelain kiln was set up by officials in the capital. It was named Guan kiln. After the new government was established in the south, Shao Chengzhang (also called Shao Ru) managed the imperial rear gardens. He carried on the system of the old government and set up a kiln in Xiuneisi, which was called Nei kiln, and specially produced greenwares. The product was exquisite, with well-refined clay and a lustrous, clear glaze. It became a new treasure of the world. Later another

new kiln, also named Guan kiln, was set up in Jiaotanxia. Its product was quite pale compared to the Nei porcelains.'

The site at Jiaotanxia has been excavated twice. The green-glazed sherds discovered there were almost indistinguishable from those of the nearby Longquan kilns (see below), and it has been suggested that Longquan supplemented orders that the Guan kilns could not meet on their own. The Xiuneisi kiln has never been positively identified despite frequent searches. Recent excavations reveal that the Wuguishan kiln fulfils all the Xiuneisi criteria except the name. It has now been suggested that the Xiuneisi might in fact have been an institution or office, rather than a practising kiln.

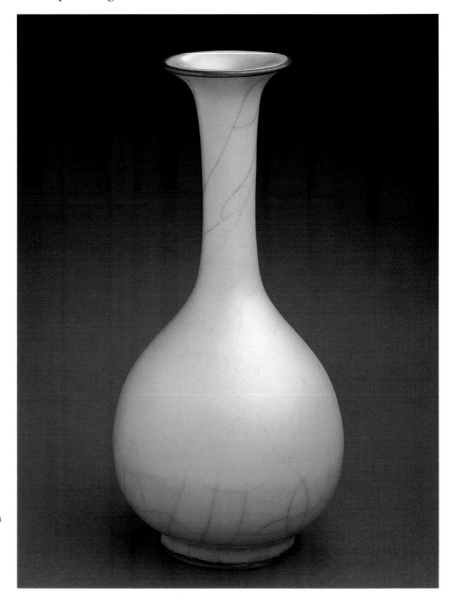

77 Vase, Guan ware. The thick glaze appears to have been applied in several layers. The crackle follows the stress lines of the thrown shape and is coloured by iron present in the body material. 12th–13th century. HT 18cm. PDF 4, Percival David Foundation of Chinese Art.

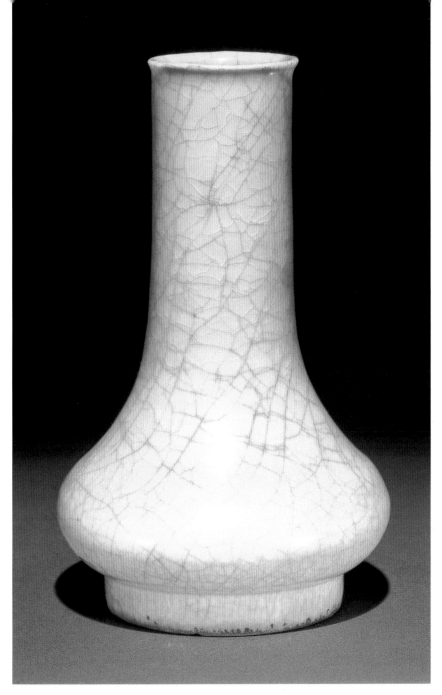

78 Vase, Longquan ware. The multiple crazing implies that there are several layers of glaze. The uppermost crackle is highlighted with iron. The base and interior are both glazed. The vase appears to have been made in imitation of Guan ware. 12th–13th century. HT 23.4cm. OA 1936. 10–12.66.

Wuguishan produced everyday wares in the Tang dynasty and the early Song dynasty. The body and the thin glaze of the earliest wares are comparable to Guan wares, though the modelling and production techniques differ. The sherds of the next stratum include both thinly and thickly glazed pieces. The thickly glazed examples have between two and four coats of glaze, making it thicker than the body itself. Ru wares also had several layers of glaze, so perhaps this thickness indicates a link between the two types. Multiple layers of glaze and refirings reduced the likelihood of a crackle in the glaze. Crackles were not regarded as a serious defect, particularly when they formed a spiral rising around the

vessel, but the uncracked examples were probably the most highly prized. The glazes appear to have been applied by pouring, dipping and brushing. Guan wares were fired in reduction, and the high iron content of the east Chinese body clay resulted in the characteristic dark brown or black colour on the unglazed rim and foot. Guan ware varies from the everyday to the specialised, and even includes imitations of ancient bronze vessels.

The imperial court was not quick to establish itself at Hangzhou, as the unhurried pace of the building of palaces and government buildings illustrates, and it appears that the thickly glazed Guan wares began to be produced in quantity only towards the end of the twelfth century. Writing on greenwares in the *Yun Lu Man Zhao* of AD 1206, Zhao Yanwei comments 'Recently, Linan [Hangzhou] itself has a greenware kiln whose products are superior both to Yue and to Longquan wares'.

Ge, the fifth great kiln of China, has not yet been found. Excavated examples of Ge wares have come from several Yuan tombs, but none yet from Song tombs. The provenance has been suggested as either southern Zhejiang province or further south in Jiangxi province. Ge wares are similar to Guan wares in their shapes and techniques, their most distinct feature being an increased crackle. Many Ge wares are an ivory rather than a jade colour, and a virtue is made of the glaze crackles by rubbing iron into them so that they become a deep grey. Their dating and place of production remain obscure. Ge means 'elder brother' and tradition has it that there was an accompanying *di* or 'younger brother' kiln. They were said to have been supervised by Zhang Son Number One and Zhang Son Number Two respectively, but as little is known about the brothers' identity as about their kilns. Both kilns are recorded in numerous tracts from the Yuan dynasty onwards, but not at all in texts from the Song.

It is not surprising that a Yuan date has been suggested for Ge wares. Whatever their true date and location, Ge wares have been recognised as one of the five great Song wares by frequent mentions in the writings of connoisseurs, and by their reproduction at the kilns of Jingdezhen in the fifteenth and eighteenth centuries.

Another Song dynasty Zhejiang ware is comparable to Guan and Ge products but is rarely mentioned by the connoisseurs who wrote about Song ceramics. The kilns at Longquan county in the southern part of Zhejiang began operating in the tenth century, though the characteristic blue-green, thickly glazed, simply shaped wares did not appear until the Southern Song period, when production more than doubled. The loveliness of Longquan wares is due not only to the thick translucent glaze with its jade-like colour and texture, but also to the fine body of the pots. The Longquan body is light grey, so pale that it is almost white. The glaze is thus shown to its best advantage, not having first to conceal the dark colours of a rough clay body. Indeed, the quality of the wares was so high, they have long been regarded as porcelains. 80

More than fifty kilns have been identified in the vicinity of Longquan city, the most important of them being the two southern ones on the

79 Stoneware ewer, Zhejiang greenware. The carved lines are asymmetric, so that the glaze has pooled and the decoration is emphasised. The interior is glazed but the base is not. Despite the demise of the first-rank Yue kilns in the 10th century, many other production centres throughout Zhejiang continued to make greenwares. The relationship between these wares and contemporary northern greenwares was close. 11th–12th century. HT 13.1cm. OA 1973.7–26.293.

Ou river at Dayao and Jincun. Finds at Jincun include pieces with crackled glaze and a black body. Since the local clay does not result in a black body, such pieces appear to have been made in deliberate imitation of Guan wares at periods when the Wuguishan and Jiaotanxia kilns could not adequately supply the court at Hangzhou.

Large numbers of bowls and dishes were produced, probably for everyday use. Much of their decoration imitated Northern Song wares, particularly the carved lotus petals on bowl exteriors, reminiscent of eleventh-century Ding wares, and the incised fish on their interiors, in the style of both Ding and Yaozhou bowls. Many such pieces, as well as large flat-rimmed dishes, were exported throughout China and abroad.

Included amongst export pieces, somewhat surprisingly, were the Longquan vessels which reproduce the shapes of Shang and Zhou dynasty ritual bronzes. The pursuit of antiquity that had engaged the Northern Song emperors persisted in their exiled successors during the Southern Song dynasty. The publication of illustrated catalogues of collections of ancient artefacts provided the patterns for contemporary bronze-casters to produce vessels in archaic form. These were imitated in ceramic wares, particularly at the Longquan kilns. There were many precedents for ceramics imitating more precious materials, such as bronze and marble of the Shang dynasty; lacquer of the Eastern Zhou and Han; and glass, silver and jade of the Tang dynasty. These were all faithfully copied by, or at least inspired, the potters of successive dynasties from the earliest periods of Chinese history.

80 Lidded vase, Longquan ware. The glaze is thick with a slight crackle. Its bluish tone shows that the vase is amongst the earlier products of the Longquan kilns. Later wares were darker green, probably to increase their resemblance to jade. 12th century. HT (with lid) 12.3cm. OA 1972.5–17.1, given by Mrs Alfred Clark to mark the centenary of the birth of R.L. Hobson.

The *gu* shaped vases and tripod incense burners made at Longquan relate to bronzes in their form and jade in their colour. The glaze texture, with so many bubbles suspended in successive layers, was also similar to jade. It would not be surprising, then, if these wares were regarded more highly than other ceramics. Yet Longquan alone amongst the great Song wares receives no mention in literature. They have been found at kiln sites, wharves and other ordinary places, and are occasionally reported from burials. The archaistic shapes in Longquan ware seem rather to have served the special function of altar wares, the vases probably being filled with flowers and the incense burners with sand to support incense sticks.

In an age of connoisseurship, use as a burial object need no longer be a mark of prestige. Preservation of ceramics made for altars would be assured by their being handed down from generation to generation, and ceramics produced for collectors were preserved by similar means. However lofty the aspiration of Longquan wares, with their classic forms and time-honoured hues, they were not the type selected by the

court, which favoured Guan ware or its imitations from Longquan. This would suggest that the Southern Song emperors, who were great patrons of scholarship, painting, and the learned and applied arts, preferred ceramics for their own sake.

81 The Longquan incense burners, tripods and flower vases must have been produced for those who were sufficiently educated to appreciate their archaistic allusions but not of sufficiently high rank to enjoy court wares: the scholars. The gentlemen scholars and officials of the Song dynasty comprised China's new gentry, and it was they who dictated the most refined styles of Longquan pottery. There has always been a division between Chinese ceramics produced for export and those produced for more local consumption. It might be a surprise, therefore, to see items quintessentially Chinese in taste being exported. However, the archaistic forms which were exported from Longquan were destined for Japan and Korea, and the scholarship of both these countries was based on the Chinese classics. In philosophy and learning, the Chinese tradition dominated East Asia. The artefacts associated with that tradition

81 Vase and incense burner, Longquan ware. Ring handles on the vase and the three raised flanges on the tripod burner refer to ancient bronze vessel forms. Three holes on the interior of the burner may have held incense sticks, and there are gold lacquer repairs on the rim. Southern Song dynasty (1127–1279). Vase: HT 21cm. Burner: HT 10.4cm. OA 1929.7–22.6, Henry B. Harris Bequest; OA 1938. 5–24.9.

likewise prevailed amongst those who interested themselves in it, be they Chinese, Korean or Japanese.

Longquan wares were exported in large quantities throughout the succeeding Yuan dynasty and right up until the end of the Ming (see below). Sadly, the quality was not maintained. The blue-green shade of 80 early Longquan wares was the result of a low amount of titanium contaminant. Analyses have shown that in many cases the glaze contains unmelted material, so in fact the quality of much Longquan ware lies in the thick glazes being slightly underfired. The more ordinary appearance of the more thinly glazed, glossy olive green Longquan wares of the fourteenth century onwards, after the fall of the Southern Song, is due 100 to a greater level of contamination in the raw materials.

Greenwares and white wares vied for supremacy almost continually, it seems, from the fifth century to the twelfth. In the late eleventh century, when the Song capital was still in the north, the county of Yaozhou in Shaanxi province presented greenwares to the court, according to the official Song history and Wang Cun's *Yuan feng jiu cheng zhi*. The particular reigns mentioned cover the period from 1078 to 1106, precisely when the Ding kilns began to decline and the Ru kilns were still producing folk wares.

The region of Shaanxi, which in the Song dynasty was called Yaozhou, is today Tongchuan county. It is clear that the Huangbaozhen kilns in that area were responsible for the greater part of the northern greenware produced at that time. Kilns in Henan province, most notably those of Linru and Baofeng, also made green ceramics but their produce cannot compete with the Huangbaozhen wares in quality or appearance. The sturdy wares of Henan were either undecorated or bore impressed or moulded designs comparable to the later, inferior Huangbaozhen pieces.

The Yaozhou wares, as they are still called, are notable for their deeply carved ornament. The carved designs and green glazes were first made in the tenth century. Before then, the kilns produced white and black-and-white wares (see Cizhou ware below). Their appearance almost certainly owes much to the Yue wares, whose attractive grey-green 82 colours and incised ornament had by then long inspired imitations in the north. The pure composition of the northern clay was a disadvantage in this instance, for the green glaze covered a pure light-coloured body; this made it appear green or greenish yellow, not the grey tone of the Yue wares produced by the higher iron content of the local clay. Northern greenware can be distinguished from the Zhejiang grey-green of Yue and the blue-green of Longquan by its typically olive colour.

In the thirteenth century Lu You recorded in his *Lao xue an biji*: 'The greenwares of Yaozhou are called Yue wares, for they resemble the secret colour of Yuyao [kilns]. Yet they are extremely coarse and are used only by restaurants because they are durable'. Bowls in Yue shape and with similar lotus ornament are amongst the early produce of Huangbaozhen, but the sturdy practical bowls Lu You mentions are probably those used in his own time of the Southern Song dynasty, when the kilns of Shaanxi were within the Jin domain.

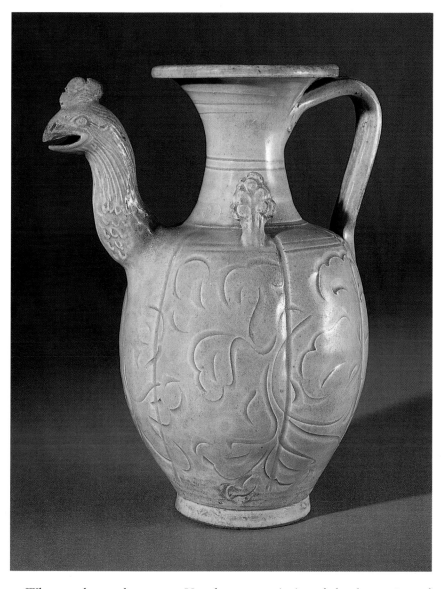

82 Ewer with chicken-head spout, Yaozhou ware. The body is six-lobed, with a schematic carved floral design. The base is glazed. The tool used for carving on northern greenwares, which were quite hard in their dried but unfired state, was probably sharpened bamboo. 11th–12th century. HT 22.3cm. OA 1936.10–12.69.

Whereas the tenth-century Yaozhou wares imitated the decoration of Yue wares, the eleventh-century motifs related closely to those of the contemporary Ding wares. Paired ducks and fish amongst waves, carved lotus petals and incised flowers are all common to the ceramics of the two kilns. The carving on the Yaozhou wares is incised more deeply than on most Ding pieces so that the glaze pools. The design, therefore, is as clear from the contrasting depths of colour as it is from the incising itself.

The development of Yaozhou decoration followed the same course as the Ding ornament. In the twelfth century moulds were introduced at the Yaozhou kilns as they had been at the Ding, and with the same result: crowded and static decoration. The dominance of moulded wares

83 Foliated bowl, Yaozhou ware. The design of a duck amidst waves is incised on the interior beneath the dark green glaze. The base is glazed. Similar incised decoration occurs on Ding wares from Hebei province and *qingbai* wares from Jiangxi. D 17cm. OA 1973.7–26.285, Seligman Bequest.

84 Stoneware moulds and kiln furniture. The conical mould was used for northern greenware bowls and has a relatively deeply cut design. The underside of the thick rim is incised with the character *ma* (horse), which in this case is probably the family name of the mould maker. The triangular stamp was used for impressing designs on leatherhard ceramics, probably also at kilns in the north. The two firing rings were used for setting wares in the kilns, and were collected in Hangzhou at the Phoenix Hill site, where Guan wares were produced. Mould: D 14.2cm. Stamp: D 5cm. Firing rings: D 9.8cm; 7.7cm. OA 1937. 7–16.138; OA 1933.7–11.17; OA 1933.5–18.1 (a,b), given by P. Brooke.

at both kilns coincides with the establishment of the Jurchen rulers in north China and the removal of the Song court to the southern city of Hangzhou. The Yaozhou kilns continued throughout the twelfth century, but although greenwares were to retain their supremacy over white for some time, the emperor's move south meant that those types were supplied by the Guan and Longquan kilns of Zhejiang. Northern greenwares suffered a slow steady demise, during which the black wares of higher iron content rose to prominence.

Popular wares

Cizhou wares have already been mentioned for the relationship of their shapes to those of Jun wares. Cizhou is situated in Ci county, Hebei province, but the name is used loosely to refer to a type of sturdy stoneware produced at many kilns throughout the northern provinces of Hebei, Henan and Shaanxi during the Song, Jin and Yuan dynasties and even, in some areas, into the Ming. The wares are distinguished by their solid forms and bold black-and-white decoration. Their status was inferior to that of the other major wares already discussed, and Cizhou

85

85 Pillow, Cizhou-type ware. The pillow, set on a square base, seems to have been coated first with white slip, then with black slip which was incised and then cut away before a transparent glaze was applied. Scrape marks are visible on the white background. A closely related pillow was found at the site of Juluxian, a county town in Hebei province, flooded in 1108. Late 11th to early 12th century. HT 23.6cm, W 33.6cm. OA 1936. 10–12.169.

86 Stoneware pillow, Cizhou ware. The scene probably depicts Wang Zhaojun, the Han dynasty princess who was married to a nomad from the north-west for political reasons. The front of the pillow is decorated with bamboo designs while the back and ends are painted with panels of flowers. The decoration is painted in brown slip on white slip. The unglazed base is stamped with the Zhang family mark, including the characters *gu xiang*. 13th century. HT 14.2cm. L 41.6cm. OA 1936. 10–12.165.

pieces have long been known as popular ceramics. There are several reasons for this reputation.

Cizhou wares appear not to be mentioned at all in writings of the Song dynasty, and there is no evidence that they were offered as tribute to the court. They are not the specialised product of a single kiln or kiln complex, but were made at many sites across a large area of north China. The ceramics themselves are strong and fairly large, with a utilitarian feel far removed from the finely modelled forms and delicate coloured glazes of other Song wares. The decoration of Cizhou wares is executed chiefly in black or white slip beneath a transparent glaze. It thus combines two simple media for its effects rather than concentrating them into a single, cleverly calculated glaze of one colour.

The ornament itself is not ordered or formal and varies from the freely painted to the heavily carved. Some wares are decorated by the sgraffito technique in which one layer of slip is applied on top of another and cut away to make a design in contrasting colours of slip. Additional detail may be incised, and the piece then coated with a transparent glaze. Some painted wares are covered in a thin green lead glaze, and towards the end of Cizhou production, in the thirteenth or fourteenth century, a turquoise glaze was occasionally used in the same way. At the same time a technique called 'cut-glaze' was introduced. Cut-glaze wares have a

88

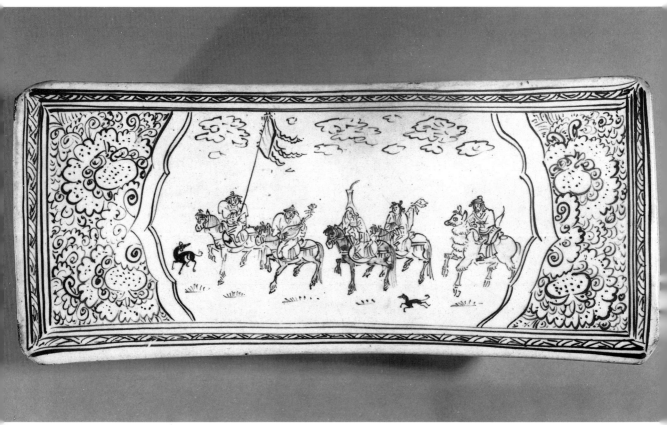

very thick layer of slip, usually black, from which the ornament is cut away to reveal the body rather than an underlying slip layer. The Song techniques of slipping, painting, incising and glazing were used together or in almost any combination, just as the use of black or white slip was interchangeable. Variety of this order, over such a long period and wide area, is hard to categorise systematically; but it is possible to attribute certain types of decoration to certain kilns, albeit tentatively, such as ring-punched backgrounds at Dengfeng and white-rimmed black bowls at Haobiji, both in Henan province, and cut-glaze decoration from kilns in Shanxi.

86 Many Cizhou wares, and particularly pillows, are stamped on the base with the name of the family who produced them and the district in which they operated. Such marks can indicate the date of a piece, as in the Zhang family wares marked 'ancient Xiang'. Xiang was the name of the area around Anyang until the Jin dynasty, when it was changed to Zhangdefu; thus pieces marked 'ancient Xiang' must have been made after the name was changed, i.e. during the Jin rather than the Northern Song dynasty.

The painted decoration on Cizhou wares is largely based on contemporary styles of bird and flower painting. In this respect it is similar to the Tongguan wares produced in Hunan province during the Tang dynasty. The frequent occurrence of calligraphy is another feature common to both. Some Chinese archaeologists say that the shapes and decoration of Cizhou pieces, which were first produced during the late Tang, spring from the styles made at the Tongguan kilns. Whether or not precise links between the southern and northern types can be established, a comparison of the wares suggests several points common to popular, as opposed to imperial, ceramics.

The most obvious is the use of painted decoration. Until the Ming dynasty, polychrome ceramics with intricate designs were burial or domestic wares, while those for the court were relentlessly monochrome, unless ornamented with discreet incised designs, or embellished with gilding. The endless possibilities of painted decoration were used to enliven the dishes and vessels used by ordinary people. The calligraphy on Cizhou wares, occurring principally on jars and bottles, generally denotes their function as wine containers, while some larger pieces bear poems of a popular nature. The style of calligraphy is called *mishu* or 'rice script'. Its bold sweeping strokes have a strength and attraction similar to that of the freely painted pieces, and both are well suited to the strong forms of the Cizhou wares.

Painted decoration has its own technical requirements and, just as the Tongguan kilns introduced underglaze painting, copper-red colouring and phase-separated glazes, so the Cizhou kilns introduced overglaze enamel painting several centuries before it became widely used on 87 porcelain. The iron-red, iron-yellow and copper-green coloured enamels were used to decorate the interior of small bowls and to paint the figure models peculiar to this type of ware in the north.

Variety in the amount of iron oxide created the distinctive appearance

of another class of northern pottery in the Song dynasty: Henan black ware. The vases, bowls and jars were made at the same kilns that produced the Cizhou wares. Their forms and weight are comparable to those of the slip-decorated wares, and in some cases the ornament is related. The Henan wares are black and shiny in appearance, with reddish-brown matt painted decoration. The contrasting effects were simply achieved. The black glaze contains enough iron to give a fine black, while still being able to dissolve in the glaze: that is, around five or six per cent. When additional iron is painted on the glaze, the excess

87 OPPOSITE Bowl with white slip, transparent glaze and overglaze enamel decoration. The white slip covers only half of the bowl's exterior. Cizhou bowls of this type represent the earliest use of overglaze enamel decoration, and date almost exclusively to the 13th century. They are known to have been made at five kiln sites at least: Haobiji, Bacun and Quheyao in Henan province, Bayizhen in Gaoping, Shanxi province, and Dezhou in De county, Shandong province. 13th century. HT 5.5cm, D 13.8cm. OA 1973.7–26.255, Seligman Bequest.

88 LEFT *Meiping* vase, Cizhou ware. The peony scroll decoration is carved in white slip under a colourless glaze, over which a green lead glaze has been applied. Green lead glazes were applied over many types of Cizhou decoration, including painting, from the late 11th until the 13th century. Extant examples are relatively few. The shape, decoration and colour of this *meiping* all occur at the Guantai kiln site in Handan county, Hebei province, which is the likely provenance for this piece. Late 11th–12th century. HT 39.5cm. OA 1936. 10–12.175.

iron crystallises to give a reddish-brown colour. The Henan decoration thus consists of iron solution and iron suspension effects used together.

The reddish-brown (iron suspension) glaze was used for painting 67 schematic, lively motifs such as plant sprays on to the black pots. It was also used in an apparently more haphazard fashion to give variegated or splash-decorated pieces. Streaked glazes were particularly applied to deep or wide bowls.

Bowls of similar appearance but smaller proportions were the main product of kilns far away from Henan in the south-eastern coastal province of Fujian. The Jian kilns are famous for their tea bowls, most of which had the finely streaked iron glazes known as 'hare's fur'. The 89 effect is produced by the natural unmixing of the glaze into different glasses as it melts. The other ware for which the Jian kilns are well known, although it was also produced in Henan, is the 'oil spot', so-called after spots resembling oil droplets on the plain black-glazed wares. Oil spot is less common than hare's fur, probably because such pieces were produced in smaller quantity, but also possibly because of the difficulty in achieving the effect. The oil-spots themselves are rich in magnetite. They change to the more common hare's fur type with slightly more heat.

Jian wares are peculiar in Chinese ceramic history for being used by the emperor as well as by officials, monks and ordinary people. In each case they were used for drinking tea. Tea drinking, as we have seen, became widespread during the Tang dynasty, and it remained popular throughout the Song. According to the *Cha Lu* ('Notes on tea') written by Cai Xiang in the eleventh century, black bowls, and particularly those with hare's fur streaks, were preferable to either green or white because they better showed the white colour of the whisked tea. Emperor Huizong, last emperor of the Northern Song dynasty, made the same comment as Cai Xiang when writing about tea, adding that the bowls should be deep and sufficiently wide to allow the tea to be whisked effectively with the bamboo implement designed for that purpose.

Excavations at the Jian kiln site have yielded sherds incised with the names of earlier Northern Song emperors' reigns, such as Yongxi (984–987), Zhidao (995–997) and Mingdao (1032–33). Many more bear the characters *jin zhan* ('tribute bowl') or *yong yu* ('imperial offering'). There can be no doubt that Jian ware tea bowls were used in the imperial households of the Northern Song dynasty. Yet the Song writer Cheng Dacheng wrote in his *Yu Yan Fan Lu* that Jian bowls were no longer used by the emperor in tea presentations, having been replaced by large white bowls usually with a yellowish tone. It is not clear what this latter ware might be, but it seems that the preference continued for a rougher type of ceramic for tea bowls than for other imperial ceramics.

The Jian wares were not only thickly glazed but also quite thickly potted. Though there is no evidence that they were used by the court during the Southern Song dynasty, they remained popular elsewhere. Jian bowls were used particularly in the monastic communities in the neighbouring province of Zhejiang, where the Tianmu mountain monas-

teries welcomed many Japanese monks. These monks took the bowls back to Japan where they were known as Tianmu or, in Japanese pronunciation, *temmoku* wares. This is why black wares have for so long been inappropriately referred to as *temmoku*.

Many of the tea bowls in Japan and Korea were bound around the rim in silver or copper. This was a way of covering the rough rim that was often exposed when the glaze melted and ran. It also increased the value of the bowls. Chen Xianqiu has surmised that different qualities of bowls were made for imperial, monastic or popular consumption. Sherds engraved on the base with a hexagonal mark resembling a tortoise shell suggest a Buddhist emblem which may be associated with monastic tea bowls.

These Jian wares were the produce of the kilns at Jianyang county, Fujian, and relate in some measure to the black wares of Henan province. The kilns at Jizhou in neighbouring Jiangxi province likewise relate to Henan wares, but more broadly, since they include painted wares and display something of the variety of the Cizhou types. They are well known for wares with resist designs on brown and yellow mottled

89 Stoneware bowl, Jian ware. The glaze is finely marked with rust colour on black, in the style known as 'hare's fur'. Bowls of this type were produced at the Jian kilns in Fujian province and at kilns in Henan province. They were offered as imperial tribute but were particularly favoured by monastic communities both in China and in Japan, where they were later imitated. 12th–13th century. D 13cm. OA 1947.7–12.142, Oppenheim Bequest.

91

90 Tea or wine bowl, Jian ware. The small bowl has a neat design produced by contrasting iron glazes. A yellow halo around each of the dark spots must be the result of a lower concentration of iron oxide. 12th–13th century. HT 4.5cm. OA 1936. 10–12.156.

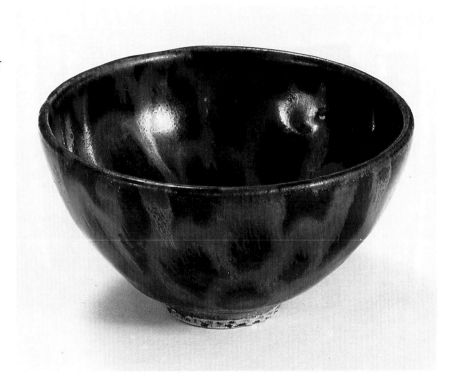

91 Tripod censer, Jizhou ware. The underside is glazed dark brown. Stoneware censers were produced at Jizhou during the Southern Song dynasty. This style of decoration is known as 'leopard-spot' and was produced by means of a resist. Examples are comparatively rare, and a similarly decorated vase in the Jiangxi Provincial Museum has phosphatic blue areas between the spots. 13th century. HT 12.5cm. OA 1926.4– 14.1, given by Lt-Colonel K. Dingwall.

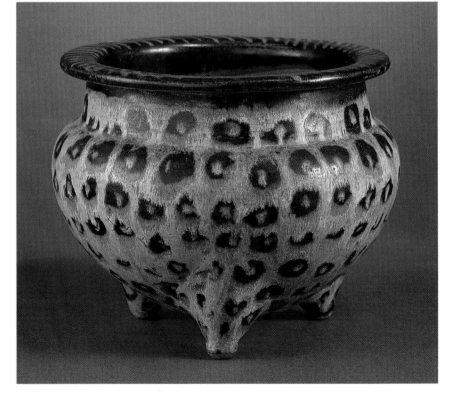

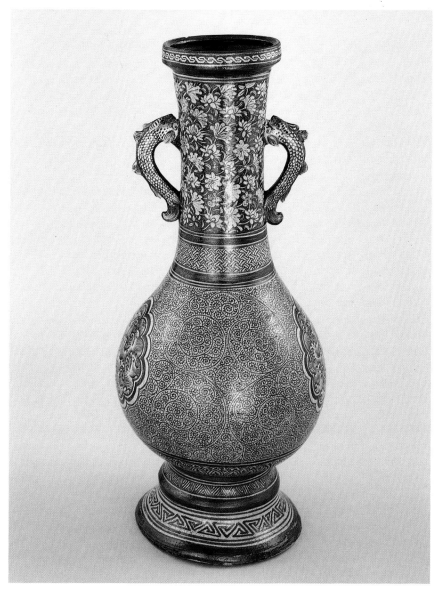

92 Painted vase, Jizhou ware. On each side of the vase is a fourteen-lobed medallion filled with a design of breaking waves. The decoration is painted in brown and white beneath a transparent glaze. The flowers and a basket-weave pattern on the neck of the vase both occur widely on Jizhou wares of the Southern Song dynasty. The breaking waves and the fronded spirals of the body decoration are each used to cover entire pieces, but are seldom executed as finely as on this example. Breaking-wave panels also occur on 14th-century blue-and-white porcelains. The vessel shape and the densely decorated borders are both found on Yuan dynasty bronzes. Yuan dynasty, 13th–14th century. HT 44.2cm. OA 1936.10–12.85.

grounds. The most widespread is the paper-cut decoration usually found in four panels inside small bowls. The paper-cut was placed on the glazed but unfired ware, and burnt away in the kiln to leave the design. The usual motifs were floral patterns or auspicious characters. A more enigmatic design was that produced by a single leaf placed inside a black-glazed bowl, leaving its skeleton pattern. The simplicity of the design is similar to the sketchy plant sprays on Henan black wares, and both possess a directness which is distinct from the glaze patterns or bold painting of other black wares. In the later stages of Jizhou production, fine

92 slip painting decorated larger ceramics of more complex form. Such pieces date from the Yuan dynasty and are comparable to the more

detailed decoration of the late Cizhou painted wares which depict literary themes.

Excavations at Jizhou have revealed, in layers beneath those bearing the brown-and-white painted wares, considerable quantities of another kind of ware, for which Jiangxi is more greatly renowned. *Qingbai* ('blue-white') or *yingqing* ('shadow blue') wares were produced at Jizhou, Nanfeng and other parts of Jiangxi province but most were made at Jingdezhen. They foreshadowed the white porcelain which became so well-known throughout the world as china. The *qingbai* wares are recognisable from their thinness and their pale blue glazes over incised or impressed decoration.

The close relationship between *qingbai* shapes and decoration and those of the famous northern kilns has been mentioned already in connection with Ding ware. Not only were such motifs as fish, water waves and flowers to be found in Hebei, Shanxi and Jiangxi alike, but the techniques of their execution were also similar. The asymmetric profile of the incised lines of the decoration on Yaozhou green wares in the north was used to equal effect on the wares from Jingdezhen. The blue-tinted glaze, which could at times appear almost white, pooled in the lines of the decoration to give a clear blue which contrasted well with the plain areas. The everyday forms of the great Song kilns were all produced in *qingbai*, as well as a few metal-derived ewer shapes and funerary urns which are more or less peculiar to Jiangxi province.

The technology of *qingbai*, as with all Song wares, depended on the resources of the area. South-east China, and particularly Jiangxi province, is rich in deposits of white, pure, porcelain stone. Porcelain stone itself is low in clay and therefore also low in plasticity. The lack of clay ought, in principle, to make the material difficult to work, but in this case the shortfall in plasticity was made good by the peculiar composition of porcelain stone. It contains a good deal of secondary mica, a mineral with a structure of tiny flat plate-shaped crystals. Their shape allows the crystals to slide smoothly over one another, imparting to the material a plasticity which its low clay and moisture content would normally preclude.

The very purity of the material had its own advantages in the form of smoothness and good white colour. In the tenth and eleventh centuries, *qingbai* wares were made from the local porcelain stone, unmixed. The cool bluish tint of the pieces is accounted for partly by the reducing atmosphere given by the fuel, which was the locally abundant pine tree. It will be remembered that at the Ding kilns, before the switch from wood to coal and thus from reducing to oxidising atmosphere, the wares had a blue-white rather than an ivory tone. During the twelfth to fourteenth centuries another clay material, kaolin, was added to the porcelain stone to increase its smoothness and plasticity. The porcelain stone was processed into small white bricks, the *bai tunzi* which have been known in the West as petuntse. Both porcelain stone itself and porcelain stone mixed with kaolin give hard white translucent ceramics. These have traditionally been regarded as the world's earliest porcelains,

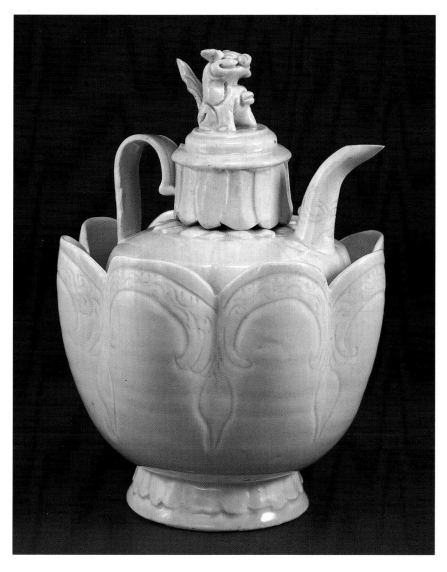

93 Porcelain wine ewer and warming basin. The blue tint of the glaze, particularly evident where it has pooled, shows that this piece is from a southern kiln. Two similar ewers and basins appear in the late Song painting in the Beijing Palace Museum, *Han Xizai's Night Revels*, which is a copy of the lost 10th-century original by Gu Hongzhong. A comparable piece was unearthed in 1963 at Nancheng county, Jiangxi province, from a tomb dated 1057, and a further example has been found in a tomb dated 1087 in Susong, Anhui province. That area is one of two mentioned by the 11th-century writer Zhou Hui as producing imitation Ding ware. 11th century. HT (combined) 25.5cm. OA 1936.10–12.153.

though in fact the Xing wares of the Sui dynasty precede them by some four centuries.

It is remarkable that the exceptionally high quality of Jiangxi porcelain took such a long time to be appreciated within China. The porcelains of Jingdezhen did not receive any major imperial or official recognition until some four centuries after their invention. Until then, they were burial and export wares.

The large number of dated tombs containing *qingbai* wares makes it possible broadly to deduce the course of its production. Most pieces have been excavated from tombs in Jiangsu and Jiangxi in south-east China and Liaoning province in the north-east, but the wares were actually widespread. They occurred also in Zhejiang, Hunan, Hubei, Anhui, Shaanxi, Sichuan, Jilin and Inner Mongolia. The porcelains

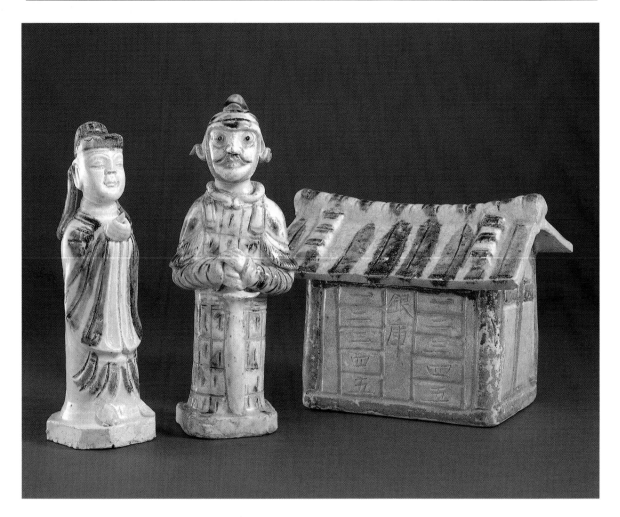

comprise all types of items for daily use, such as bowls, dishes, wine 93
pots, pillows, incense burners and small boxes. Some shapes, such as 95
bowls, ewers and small dishes or cups, occur regularly in the eleventh
century but hardly at all in the twelfth. Others, such as tall burial urns,
do not appear until late in the twelfth century and increasingly in the
thirteenth. In the case of small covered boxes, a Tang dynasty form can
be seen to continue into the Northern Song and become widespread in
the Southern Song period.

It has been suggested that ceramic boxes were made primarily to
contain cosmetics, but also varieties of perfumes and spices. These
were imported in such large quantities during the Southern Song that
traditional containers of precious gold, silver, jade, carved lacquer and
so forth could no longer meet demand. The ceramic boxes were ex-
ported, and many examples found both within China and abroad bear
incised inscriptions on the base. The five-character inscriptions all follow 95
the same formula, naming a family and describing the shape of the
object. More than a dozen families are mentioned. The marks imply that

numerous small family workshops, specialising in one type of ware, existed at Jingdezhen. The only comparable arrangement occurred at the Henan and Hebei kilns producing Cizhou wares, of which the Zhang family were the most renowned manufacturers. A comparison between the organisation of the two kiln complexes would support the view that in its early stages, Jingdezhen was a kiln area producing serviceable ceramics for a very wide market.

The tall lidded urns which seem to be peculiar to thirteenth-century Jiangxi province are a good example of ceramics produced specifically for burial, as distinct from the household items interred with their erstwhile owners. Apart from by their tall narrow shape, the urns are most easily recognised by the small moulded figures applied around the neck or the whole upper half of the body. Moulded appliqué ornament is not common on Song ceramics, and in *qingbai* ware it seems only to appear on burial vessels. Freestanding moulded *qingbai* figures continued the tradition of burial models which had begun in the Zhou dynasty, and almost never ceased. The Song figures are quite small, usually around 20 cm high, and include models of buildings as well as soldiers, officials and guardians. The models are highlighted in places by the addition of iron-brown glaze over the shiny pale blue glaze. In this strategic use of dark brown highlights, Jiangxi burial wares recall third-century east Chinese green-glazed urns adorned with applied figures, as well as the slightly later green animal models. Even more, they recall some of the white and brown glazed figurines of the Sui dynasty.

Apart from the details on *qingbai* wares, the only other use of dark brown iron glaze in combination with paler glazes is the quite distinct addition of ferruginous spots to selected Longquan green wares. The Longquan brown spots are carefully applied to adorn otherwise plain pieces, and are thus far removed from the detailing function of iron glaze on *qingbai* wares. Iron-brown decoration is also found on a small number of *qingbai* Buddhist figures excavated at the Hu'an kiln in Jiangxi.

Burial ceramics in the form of life-like models and daily wares seem to be almost as widespread during the Song dynasty as they had been during the preceding dynasties. However, a clear distinction may be drawn between the roles of the Song burial wares and their predecessors. During the Han, Six Dynasties and Tang periods, the finest ceramics of the day had been interred alongside other treasures of high intrinsic or contemporary value. This was not so in the Song dynasty. The best stonewares and porcelains were presented to the Song emperors or collected by their officials and literati. All these were connoisseurs and collectors whose interest in antiquity often centred on material remains and who were inclined to hand on their possessions to their heirs. The prevailing philosophies of the time did not stipulate that paraphernalia be provided for an afterlife, so there was little advantage in burying high-quality accoutrements. Hence the most widely found ceramics from tombs are large scale and utilitarian, from such kilns as the Cizhou complex in the north and Jiangxi province in the south.

94

94 OPPOSITE Group of tomb models, *qingbai* ware. The rough body material has fired a creamy yellow colour, and the *qingbai* glaze is combined with iron-brown details. The decoration is deeply cut. The horizontal panels on the architectural model are incised with the characters for the numbers one to five, and the two central characters are *yin* (silver) and *ku* (store house). The models were probably made in Jiangxi province at Jingdezhen. 11th century. From left: HT 18.9cm; 20.1cm; 13.9cm, L 17.3cm. OA 1983. 7–29.2,3,4.

95 Porcelain box, *qingbai* ware. The lid of the hexagonal box is moulded with a floral motif. The unglazed base is stamped with the five-character mark of the Ye family. Both box and lid are glazed on the interior. 13th century. HT 4.4cm, D 5.9cm. OA 1933.10–18.1, given by Sir Percival David.

Export

Most ceramics exported during the Song dynasty were of roughly the same quality as those found in burials, so *qingbai* is also dominant in this context. As the Jurchen people pressed on the northern borders, Song territory was reduced, and so was the empire's revenue. Rice and other commodities became dearer, and great efforts were made to increase trade in order to boost the economy. In AD 971 a port was established at Guangzhou (Canton) and was soon followed by others at Quanzhou, Hangzhou and Ningbo along the east coast of China. In 1137, ten years after the fall of the Northern Song dynasty, the Southern Song Emperor Gaozong commented on the advantages and the importance of overseas trade.

Commercial activity is documented in greater detail than ceramic production, but records indicate a thriving ceramic industry. A complete text, written by Zhao Ru Shi in 1225, is devoted to China's external relations and cultural exchange. Over a quarter of the foreign places it mentions counted Chinese ceramics amongst their imports. They include Vietnam, Malaysia, Indonesia, the Philippines, India and Africa; yet excavations in many more countries, not least Japan, have proved Zhao Ru Shi's list incomplete. In general, the wares exported from China are greenwares, white wares and *qingbai*.

Japan imported Song *sancai* and the black wares favoured by monks in addition to the usual Chinese types. The total of more than three hundred white ware sutra boxes excavated in Japan suggests that it was the monastic community who particularly favoured Chinese ceramics. There are many Japanese documents recording the imports but most reveal only the names of otherwise unknown merchants. Occasionally the accompanying cargo is described, and it was usually silk.

Korea imported a still greater variety of Song ceramics. *Qingbai* wares were again the most numerous, but many other northern wares not

usually found abroad made the more straightforward journey to Korea. Greenwares found in Korea have been from the more northerly Yaozhou and Linru kilns as well as from Longquan. The black and white slip-decorated Cizhou wares also found in Korea seem not to have been exported elsewhere. The greater interest of the Koreans in Song ceramics is upheld by the wares Korean potters produced in imitation of them. The court ceramics of the Koryo dynasty all betray the influence of Yue, Ru and Ding ware, and also perhaps Cizhou ware. The Koryo potters produced fine green wares of more or less Chinese form, with incised decoration derived from the Yue and Ding ceramics. They also introduced a new technique called *songgam* ('inlay'), which consisted of combining black and white slip decoration, usually of birds and flowers, with green glazes. It may have been inspired by the painted and slipped decoration of Cizhou wares.

Japan and Korea are distinct amongst importers of Song ceramics for their acquisition of wares made primarily for use within China. While countries to China's west imported Yue ware early in the dynasty, and *qingbai* wares were traded to south-east Asia, Pakistan, India and Africa later, *qingbai* wares do not seem to have been highly regarded within China. The south and south-east Asian countries which acquired them also purchased an equal number of wares that appear to have been made specifically for export. Not surprisingly, these wares came from the coastal provinces of Fujian and particularly Guangdong.

The main Guangdong kilns producing export wares during the Song dynasty were Xicun, Chaozhou and Huizhou. Of these, Xicun was the largest and produced the finest ceramics. Both the quality and appearance of the Guangdong Song wares vary enormously. Coarse and fine, dark and light bodies all occur, and the glaze colours include white, *qingbai*, grey, cream, green, yellowish-brown and dark brown. They variously resemble the wares of Yaozhou, Cizhou, Ding, Yue, Jingdezhen, Jianyang, and Jizhou. In the range of their wares, these kilns may be likened to the versatile Tang site of Qionglai in Sichuan, though the overall quality of the Guangdong wares is higher.

The decoration is carved, incised or painted, the painting executed in iron brown. It has not been established whether it is under or over the glaze since the glaze and painting have mixed, either because the second was applied before the first had dried or because they diffused during firing. The greenwares imitating Yaozhou pieces are exceptional amongst the Guangdong wares for being moulded. It is thought that a Yaozhou mould might have been used at the Xicun kilns initially, before the potters there made their own.

The finest Guangdong ware comes from Xicun and equals any of the famous imperial Song wares in quality. It is a type which has appeared more frequently in China than abroad, though examples are known from Jakarta in Indonesia and Fustāt in Egypt. The hard creamy-white glazed ware is recognised by its ornament of an exotic bird, either incised or modelled. The incised birds decorate the centre of bowls or dishes, usually with floral scrolls incised in the cavetto; on many pieces, the

96

96 Base of a porcelain dish. The colour of the glaze, the design of the bird's head and the overall high quality of this piece relate it to finds from the Xicun kilns in Guangdong province. The fragment was acquired by A. D. Brankston in Jizhou, Jiangxi province, but no comparable wares have been excavated in that area. The similarity of the material and the bird decoration link the fragment to the phoenix-head ewer (see fig. 97). 10th century. D 20.5cm. OA 1938.4–12.41, given by A.D. Brankston.

bird's eye and the flowers are punctuated with spots of iron brown. The modelled heads of birds form the tops of ewers or bottles, which may also have incised flowers elsewhere. The finest example is the phoenix-head ewer in the British Museum.

The phoenix-head ewer has been described by scholars as monumental, magnificent, and as one of the most remarkable pieces in the whole gamut of Chinese ceramics. Some have said it comes from the Liao domain in north-east China, but whether it is from the far north or the south, the fact that such an object should have been made at a kiln on the very periphery of the Song empire is a testament to the period's glorious ceramic achievement. Hand in hand with the perfection of long-esteemed traditions, for which the Song potters are justly renowned, went the invention of new techniques and styles of ornament at kilns producing popular wares which received little acclaim in their own time.

Ding wares of the eleventh century mark the height of the tradition of white wares which began in North China in the late sixth century. No later ceramics from that area were to match their warm white colour, light body or finely executed decoration. The still older greenware tradition of east China culminated in the secret colour Yue wares of the ninth century, shortly before the beginning of the Song dynasty. Nonetheless, the Ru wares of Henan and the Guan wares of Hangzhou refined yet further the green-glazed type, with their deep even colours

97

1

73, 77

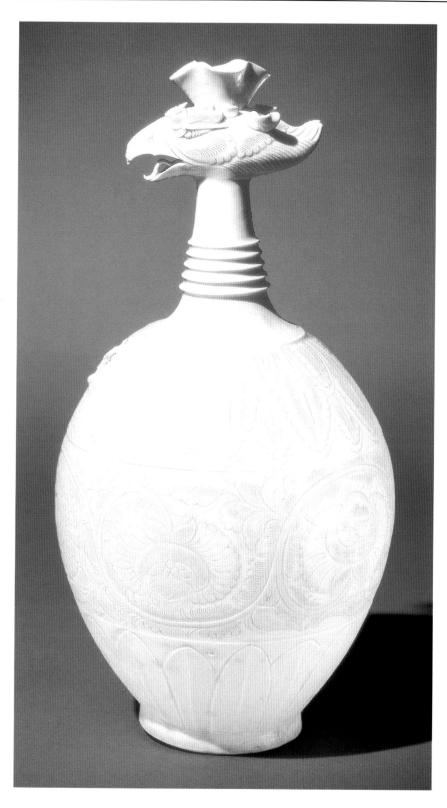

97 White porcelain phoenix-head ewer with green-tinged glaze. This piece is widely regarded as the finest example of the phoenix-headed vessel type, but its provenance is debated. Tall vases with rilled necks and simple phoenix heads are known from Liao territory, while a more squat ewer form is known from Guangdong province and has been found in south-east Asia. Sherds of a ware similar to that of the British Museum ewer have been found at the Xicun kiln site outside Guangzhou. This phoenix-head ewer at one time had a spout, but there is no suggestion that it ever had a handle as well; this relation to a more vase-like form may point to a northern origin. No closely comparable examples have been excavated. 10th–11th century. HT 39.5cm. OA 1936.10–12.206.

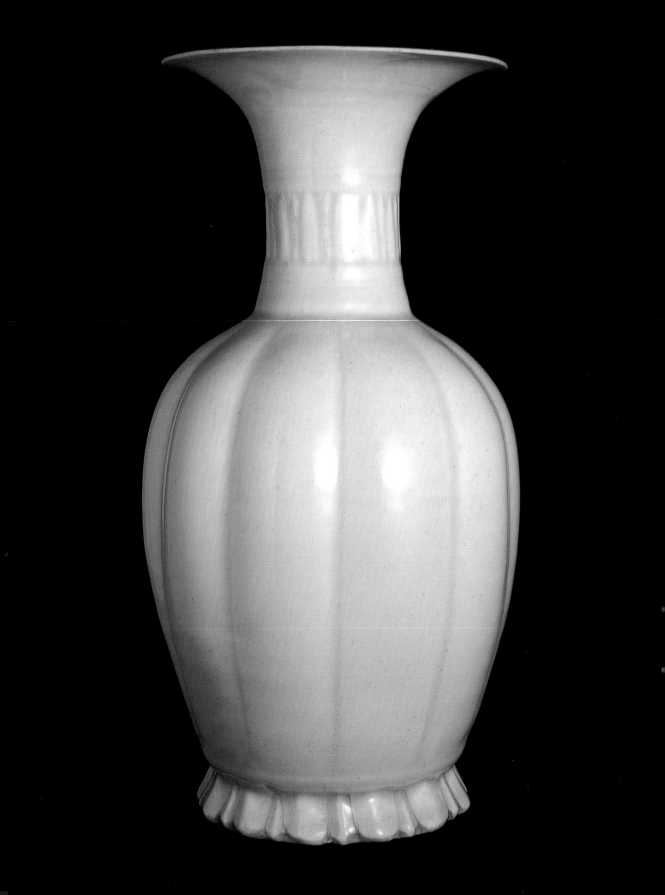

enhancing the simplicity of the forms they so thickly covered. The final development in greenwares, however, was the later Song type from the Longquan kilns, whose potters produced perhaps the smoothest and most tactile glaze found on Chinese porcelain.

All these wares display mastery of materials and firing. The high quality of Ding, Ru and Longquan wares assured their favour with emperors, officials and scholars, whose taste in turn dictated their appearance to some extent. Technical excellence and noble patronage meant that these wares more than any others embody the achievement and aesthetic of their times. However, it was in popular ceramics that inventions occurred. Two such inventions took place in the north within the kilns producing Cizhou wares, and relate to painted decoration. The first, underglaze painting, had appeared on Changsha wares in the late Tang. That kiln's relation with Cizhou resulted in an array of painting styles executed in slip under clear glaze. Underglaze painted decoration in south China dominated production at Jingdezhen from the fourteenth century onwards, beginning at a time when painted decoration was becoming increasingly detailed on the last of Cizhou production. The second invention was overglaze painting in enamel colours. In the fifteenth century, overglaze painting was combined with underglaze blue at Jingdezhen. From that point on, most Chinese porcelain was decorated in one or another of these two media, or a combination of both. Yet the first use of overglaze enamel was, it will be remembered, on Cizhou wares painted in iron-red, iron-yellow and copper-green. In this way, the essence of Ming and Qing dynasty porcelain ornament was anticipated in country stonewares of the Song dynasty.

The southern contribution to the history of porcelain was the first use of porcelain stone. This was used directly from the ground at Jingdezhen in the tenth century, and was increasingly mixed with kaolin in succeeding dynasties to give a whiter, more plastic clay with a wider firing range. Pure porcelain stone was not so easily worked, a disadvantage which may partly explain the inferior role of *qingbai* ceramics during the Song dynasty. Porcelain stone fired at high temperature has been the basis of Jingdezhen manufacture since the tenth century, though it was scarcely appreciated before the end of the fourteenth. The body as well as the ornament of Ming and later porcelain was anticipated in the humbler ceramics of the Song dynasty.

It was an age which concluded a thousand years of one ceramic tradition and ushered in another which is still alive today. All the wares were produced on a prodigious scale for a wide range of markets. The finest of the mature stonewares were enjoyed by emperors, while the ordinary stonewares and primitive porcelains were known to half the world.

98 OPPOSITE Porcelain vase with *qingbai* glaze. The unglazed base reveals the bright white porcelain body. The interior is glazed and the flattened mouth is decorated with three bow-string lines. Vases of this shape were widely imitated in greenware by Korean potters. 11th–12th century. HT 25.6cm. OA 1947.7–12.73, Oppenheim Bequest.

133

5

THE WORLDWIDE EXPORT OF PORCELAIN

The Yuan, Ming and Qing Dynasties

The ceramic trade which was established in the Song dynasty was maintained throughout the succeeding Yuan dynasty (AD 1279–1368) and, with a few interruptions, the Ming and Qing dynasties as well. The markets were concentrated in different regions at different times, but the influence of China's porcelains has been sustained and worldwide, affecting the ceramic industry of almost every importing country. Within Asia, up until the fourteenth century, the potters of Korea imitated Chinese porcelain with considerable success, and Japan's potters did so for a much longer period. In the Middle East, the twelfth-century attempts to reproduce Chinese wares went on throughout the Ming. The local raw materials and relatively low firing temperature permitted only limited improvement on the early fritware body, yet in appearance the green and the blue-and-white wares made in that region between the fourteenth and sixteenth centuries bore a decent resemblance to their Chinese prototypes.

In Europe, porcelain was barely known before the seventeenth century. The porcelain produced by Duke Francesco I de' Medici in the sixteenth century, though a chemical tour de force, was not a viable material for ceramic vessels. Dutch blue-and-white earthenware reproduced only the designs and not the durability of Chinese porcelain. When the English and the Germans succeeded in making a comparable, hard-bodied ware in the eighteenth century, they were soon able to produce it on a scale close to that known hitherto only at Jingdezhen, China's porcelain city. This had profound consequences for the Chinese ceramic industry, for until the Industrial Revolution China was the only nation able to mass produce ceramics and other artefacts. It would never have been possible for China to produce and export the quantity of

ceramics it did without the assembly line practices and specialisation in narrow skills peculiar to that nation as early as the third century BC (see chapter 2). Quality made Chinese porcelain desirable worldwide, but quantity made it available, and quantity is at the heart of the export trade in ceramics.

Chinese porcelain influenced the ceramics of the importing countries and was in turn influenced by them. For example, importers commissioned certain shapes and designs, and many more were developed specifically for foreign markets; these often found their way into the repertory for Chinese domestic items. In this way ceramics were a vehicle for a worldwide exchange of ornamental styles.

Many Chinese ceramics are described in official histories or discussed in the writings of connoisseurs, and some may be dated from comparable tomb finds. None of these sources sheds light on export ceramics, but information is provided by the orders and bills of lading of foreign companies and by the inventories of collections. Even more directly informative are intact collections, such as that of Augustus the Strong at Dresden, and sunken ships.

The wreck of a ship laden with porcelain was discovered in 1976 off the coast of Korea at Sinan. It is dated to AD 1323, or possibly a few years earlier, on the basis of inscribed wooden tags attached to packets of coins. Many of the tags also bore Japanese names, so it is supposed that the ship was travelling to Japan via Korea, having probably set out from Ningbo in Zhejiang province. Modest amounts of ceramics from the major north Chinese Jin and Yuan dynasty kilns were recovered from the wreck, along with some eight thousand greenwares from southern kilns. It has been assumed that the latter were Longquan wares from Zhejiang province, but the discovery of Longquan-type greenwares in recent excavations at Jingdezhen throws some doubt on this attribution. Longquan wares were exported to Japan and Korea during the Song dynasty, and evidently demand for them continued into the Yuan period. The forms were much the same as those produced for use within China (see chapter 4).

The Middle East

A concession was made in design for greenwares exported in the opposite direction, to the Middle East, in that the pieces were larger. This is particularly true of dishes used at the imperial banquets of the sultans, who favoured greenwares because they were reputed to sweat or even break in the presence of poison. Longquan-type wares were exported to the Middle East until the early fifteenth century, when they could no longer compete with the more colourful blue-and-white wares of Jingdezhen which by then were admired within China as well. Towards the end of the Longquan kilns' period of production, the green glazed wares were incised with decoration copied from the underglaze blue or 100 red painted wares. 101

The Topkapi Saray Museum in Istanbul, Turkey, houses what remains of the collections of the Ottoman sultans within their former palace.

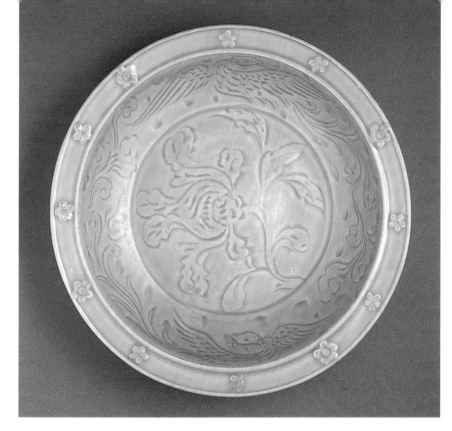

100 Dish, Zhejiang greenware. The base is glazed except for a large ring, where it was supported in the kiln. The phoenix and peony decoration relates to moulded and incised designs on Jiangxi wares, the main export rivals of the Zhejiang kilns at the beginning of the Ming dynasty. 14th–15th century. D 35.5cm. OA 1936.12–19.9, given by Mrs Kay.

Chinese porcelains of the Yuan to the Qing dynasties number 10,358 items. Of the pieces dating before the middle of the fifteenth century, greenwares outnumber blue-and-white by approximately ten to one, yet there are several reasons why this ratio does not necessarily reflect the preferences of the sultans up to that time. The earliest wares entered the palace as booty, an unreliable means of assembling a comprehensive collection; the arrival of these and subsequent acquisitions was not recorded; and the Topkapi itself was only built in the second half of the fifteenth century and was frequently ravaged by fire, most notably in 1574 when the kitchens were destroyed.

At Ardebil, near the Caspian Sea in Iran, the shrine of the fourteenth-century Sheikh Safi houses another important collection of Chinese porcelain. The ceramics were dedicated to the shrine in 1611 by Shah Abbas and are itemised in an inventory totalling 1162 pieces. The terms used in the inventory are unfortunately rather vague, and the document gives no indication of the Persian estimation of the objects. The very fact of the collection's dedication and inventory at a place of such religious and political importance, however, does imply that the Chinese porcelains occupied a significant role in Iran in the early seventeenth century. The wares themselves date from the fourteenth to the end of the sixteenth century and include some magnificent examples, particularly pieces dating from before the middle of the fifteenth century. Several are in typical Xuande style but of large proportions, sometimes even exceeding 60 cm in diameter. It is interesting that amongst the Ardebil porcelains there are only some fifty greenwares; the remainder are almost exclusively blue-and-white.

Fourteenth-century Chinese porcelain production is closely associated

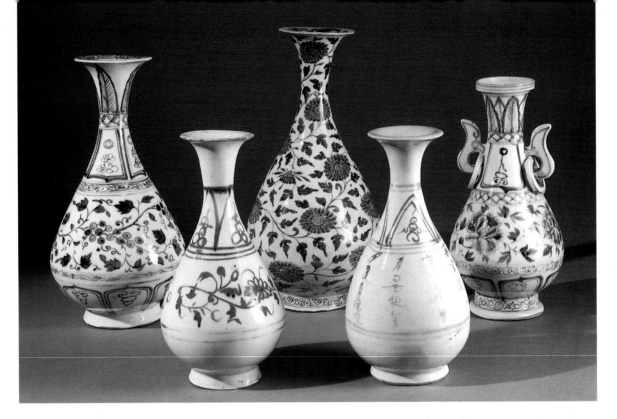

101 Five porcelain bottle vases. These early underglaze painted wares were all exported and would have been made in considerable quantity. The vase second from left is an example of underglaze copper-red glaze painting. The calligraphy on the vase second from right is a poem about the seasons. Yuan dynasty, 14th century. From left: HT 28.5cm; 23.3cm; 30.6cm; 23.2cm; 24.8cm. OA 1975.10–28.3, given by Sir John Addis; OA 1961.2–16.3, given by R. F. A. Riesco; OA 1924.1–14.1, given by C. T. Loo; OA 1975.10–28.2, given by Sir John Addis; OA 1947.7–12.162, Oppenheim Bequest.

with the export of blue-and-white wares throughout Asia and particularly beyond, to the Islamic lands. Blue-and-white decoration is thought to have made its first appearance during the second quarter of the fourteenth century. It is noticeably absent from the Sinan shipwreck of 1323, yet the pair of temple vases dated 1351 in the Percival David Foundation display a competence which implies the technique was well understood by that date. Cobalt blue was imported from Iran, probably in cake form, and was ground into a pigment which was painted directly on to the leather-hard porcelain body, before glazing and firing. The technical relationship between the blue-and-white wares and the *qingbai* wares of Jingdezhen, which were the most widely exported during the Song dynasty, remains to be established. The closeness of early painted decoration to incised decoration on the *qingbai* wares is, however, quite apparent. Blue-and-white porcelain produced at Jingdezhen was used in temples and occasionally in burials within China, but most of the Yuan dynasty products appear to have been exported.

The Mongol rulers of Yuan China had their capital in the north at Beijing. They did not interfere with the literary and artistic life of Chinese scholars and expressed no interest in porcelain, but were keen to encourage trade. Under these conditions production at Jingdezhen flourished. The marketing of porcelain was controlled by Muslims, who occupied a large quarter in the port town of Quanzhou in Fujian province on the east coast. During the Yuan, this port was one of the most important trading stations in the world. The other principal ports of the Yuan and early Ming periods were Ningbo in Zhejiang province, further north on China's east coast, and Guangzhou (Canton) in Guangdong province on the south coast. Quanzhou and Guangzhou had already been major ports during the Song dynasty. Quanzhou was well situated

to handle porcelain from Jingdezhen, although the wares were also transported south for export from Guangzhou.

Blue-and-white porcelain was much appreciated in the Middle East where, since the eleventh century, attempts to use the native cobalt ore to produce it had been foiled by inappropriate body materials. Islamic tradition quickly revealed itself in the Jingdezhen wares. By the middle of the fourteenth century, large dishes were densely decorated in geometric patterns better known in Islamic metalwork or architectural decoration than in Chinese ornament. The fact that only one large fourteenth-century blue-and-white dish has been found in China is an indication of how insignificant these wares were to Chinese collectors of porcelain.

102

102 Blue-and-white dish made for the Persian market. The base is unglazed, and the exterior is decorated with a peony scroll. The lotus scroll in the cavetto is reserved in white, as seen on Islamic ceramics, rather than painted in blue. Yuan dynasty, 14th century. D 45.7cm. OA F1670.

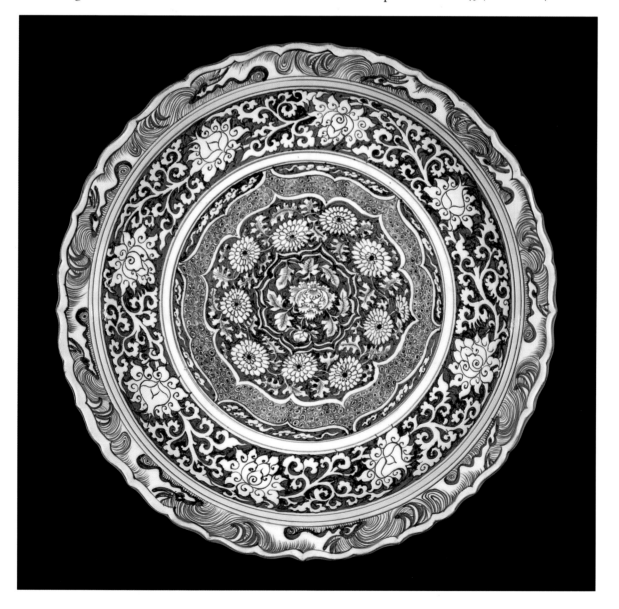

The crowded ornament does not occur on red and white painted wares, which are not large and were made for the Chinese market. Small wares with simpler decoration in either underglaze cobalt blue or copper-red painting, often beaded, were exported throughout south-east Asia during the fourteenth century.

With the establishment of the Ming dynasty in AD 1368 came almost immediately the decree of Emperor Hongwu that overseas trade must stop. This policy ended four centuries of free trade which had been consistently beneficial to China, but it did not halt the manufacture of porcelain itself. In addition to domestic requirements, porcelain was still one of the favourite items, along with silk, to present to foreign ambassadors in return for their gifts, or for sending as tribute to foreign countries. These two practices continued throughout the Ming dynasty as important means by which porcelain found its way abroad. Hongwu's edict was reissued several times during his reign, which implies that it was not strictly obeyed. That trade was heavily curtailed, however, is borne out by complaints in the official Ming history about the lack of aromatics, which formed the principal commodity imported by the merchants who exported porcelain. This history also records that 19,000 items of porcelain were sent abroad as official gifts in 1383.

In the last quarter of the fourteenth century, more underglaze red than underglaze blue ware was produced, and floral decoration replaced the orderly designs of the earlier pieces. Emblematic designs appear on the fourteenth-century painted wares, such as the flowers of the four seasons: peony for spring, pomegranate for summer, chrysanthemum for autumn and camellia for winter. It is also in this period that the eight precious items of Buddhism appear on altar wares. Clearly at this stage they had a religious significance which was lost by the Qing dynasty, when their images are frequently scattered on underglaze blue and enamelled wares.

The Emperor Yongle, son of Hongwu, ascended the throne in 1403 after some intrigue. Contrary to his father's policies of closing China to the outside world, he sent huge missions overseas for both official and trading purposes. The maritime expeditions of Zheng He, a Muslim from Yunnan province in southern China, are famous in Chinese history. Between 1405 and 1433 Zheng He led seven trips with a retinue of 27,000 men to more than thirty countries in south-east Asia, western Asia and east Africa. Several members of these diplomatic missions wrote accounts of the voyages, including Gong Zhen's *Foreign countries in the West*, Feixian's *Travel notes on wondrous lands* and, the best known, Ma Huan's *Overall survey of the ocean shores*. The last two works include comments on the high esteem in which Jingdezhen blue-and-white ware was held in foreign countries.

A mark of that esteem is the vast number of imitations of Chinese blue-and-white and greenwares produced in Syria, Egypt, Turkey and Persia in the period corresponding to the Ming dynasty in China. During the twelfth and thirteenth centuries, a ceramic body imitating the appearance, though not the hardness, of porcelain had been produced by potters both in Iran and in northern Syria along the Euphrates,

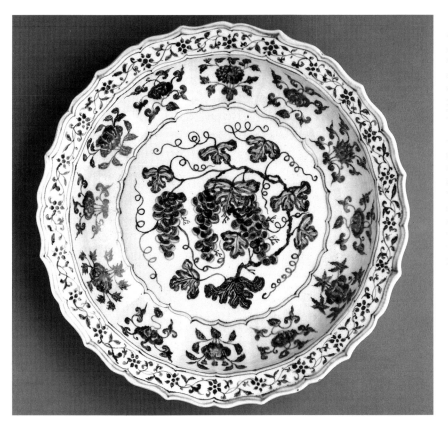

103 Blue-and-white lobed dish painted with vine clusters. The base is unglazed and coated with a brown dressing, and the exterior is decorated with flowers. Vine decoration is limited to export wares (see fig. 101). Archaising Ottoman dishes of this size and with similar decoration were produced at Iznik in Turkey in the third quarter of the sixteenth century, a century and a half after the Chinese dishes were made. Early 15th century. D 41cm. OA 1968.4–22.27, Sedgwick Bequest.

particularly at Raqqa. The material was composed of a clay and crushed quartz mix, known as frit, and was used as the body for fine underglaze-painted and lustre wares. In Timurid Persia (AD 1378–1506), contacts in the early fifteenth century gave rise to imitation Longquan wares, and to blue-and-white wares. The latter were decorated with Chinese motifs and incorporated Chinese shapes such as dragon handles. In contemporary Mamluk Egypt and Syria, popular motifs on blue-and-white ceramics included lotus and peony flowers, and dragon and phoenix designs. During the late sixteenth and early seventeenth centuries, kraak porcelain and Swatow wares were two major export types imported in quantity. As a result of this trade, in the middle of the seventeenth century when China was in turmoil and trade with the Middle East declined, Iran mass-produced imitation Chinese blue-and-white export wares both at Meshed in Khurasan and in the south-eastern part of the country, probably near Kirman.

In Turkey, fine blue-and-white wares were produced at Iznik, evidently to make good any shortfalls in Chinese porcelain, and also at Kütahya. These were in Chinese shapes but with lavish decoration based on the chinoiserie of earlier fifteenth-century Timurid and Ottoman artefacts. From the 1520s onwards, closer imitations of Chinese blue-and-white porcelain took as models not contemporary imports, but the late Yuan and early Ming wares of the fourteenth and fifteenth centuries.

104 Porcelain lidded jug. The globular body, tall cylindrical neck and dragon handle all imitate Timurid Persian metalwork of the 15th century. The breaking waves and floral scroll motifs are Chinese but appear to have been copied from a Timurid chinoiserie design. This example is unusual for retaining its lid, which is decorated with tessellated hexagons related more closely to Islamic ornament than to Chinese. Early 15th century. HT 18.7cm. Burrell Collection, Glasgow.

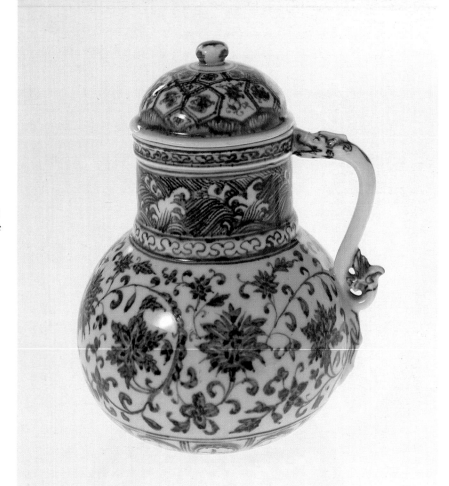

Such antiques probably reached the Ottoman court collections as booty seized at Tabriz in 1514 and at Damascus a few years later.

Chinese porcelain was undoubtedly costly in the Middle East, and its position was that of a luxury article; however, it was not revered item by item as it was when the Europeans began to acquire it. At the Topkapi Saray in Istanbul, for example, it was used for the most lavish feasts and otherwise stored in vaults. 'Ali ibn al-Hasan al-Khazraji's early fifteenth-century history of the Rasulid dynasty of Yemen records that, as part of the festivities accompanying the circumcision of the son of Rasulid Sultan al-Malik al-Ashraf Ismā'īl in 1392, five hundred new Chinese porcelain dishes were given out for the serving of sweetmeats. The role of Chinese porcelain was the same throughout the Middle East as in Turkey and Yemen, so it is no surprise that many local imitations were produced, some of which were even acquired in Europe later as Chinese objects.

While the Middle East was imitating Chinese porcelain during the sixteenth century, China in turn was producing large quantities of blue-and-white porcelain in Islamic shapes and decorated with Arabic calligraphy. Most date from the Zhengde period (1506–21), when the quality of blue was watery and tended to grey. The Arabic calligraphy of such wares is mannered if not indecipherable, and consists of Persian proverbs or verses from the Koran. The poor quality of the calligraphy is an example of the difficulties of writing foreign scripts, and also of

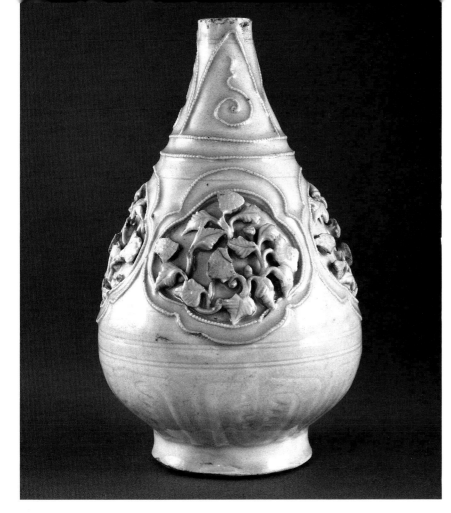

105 Vase, *qingbai* ware. The vase has been cut down at the neck. The base is glazed. Four quatrefoil cartouches contain applied moulded floral decoration in a style seen occasionally on combined underglaze blue and red painted porcelains of the same period. There is some incised decoration but other outlines are executed in beading. Beaded decoration is confined to *qingbai* export wares and Buddhist figures. The vase is similar in shape and type to the Fonthill vase in Dublin, the earliest recorded Chinese porcelain exported to Europe. *c.* 1300. HT 24.4cm. OA 1961.10–21.1, Brooke Sewell Bequest.

148 the Chinese potters' willingness to tackle any design placed before them, regardless of the accuracy of their results. The pen boxes, brush rests, incense globes and other items which fall into this category were not exported to Islamic lands, but were made principally for China's own increasing Muslim population. It has been suggested that such artefacts were also used by the Zhengde emperor himself, who had embraced Islam and was known to wear Arab dress occasionally.

The West

cf. 105 Chinese porcelains first reached Europe in the fourteenth century, and must have been purchased from intermediate trading stations or merchants. The early pieces were exchanged as gifts amongst Europe's nobility. The most famous example of this is the *qingbai* vase formerly mounted as a ewer in silver-gilt enamel at the order of Louis the Great of Hungary (1348–82) and presented to Charles III of Durazzo. It was acquired by the National Museum of Ireland in the 1860s and is now best known as the Fonthill vase. The first Europeans to trade directly with China were the Portuguese, who arrived at Guangzhou in 1517. In 1517, having been denied access to the ports of Guangzhou and Quanzhou, they were allowed to settle at Macau. They were permitted to sail to Guangzhou twice yearly to purchase goods which they resold throughout Asia. Smaller quantities were imported to Portugal, and half

106 Pilgrim flask decorated with the arms of Philip II of Spain (1556–98). This elongated form of the pilgrim flask is not a Chinese shape. The arms of Spain, *Castille and Leon quarterly*, were copied from the reverse of a Spanish dollar. The reverse of the flask is decorated with a Chinese scene of scholars in a landscape. This is one of the earliest examples of commissioned armorial porcelain. Philip II is said to have possessed several thousand pieces; comparable examples are in Dublin, The Hague, New York and the Victoria and Albert Museum in London. Late 16th century. HT 30.5cm. OA F778+.

a dozen shops in Lisbon supplied wares to other Europeans. The Emperor Charles V owned plates bearing his monogram, which must have been some of the earliest porcelains made to European order at Jingdezhen. His son Philip II of Spain is said to have owned three thousand pieces.

An apparently unique adaptation of the wares for the purpose of interior architectural ornament was made by the Portuguese and deserves mention. King Manuel of Portugal (1469–1521) owned Chinese porcelain in considerable quantity, and at least some of it is thought to have been housed at his residence, the Santos palace, in Lisbon. In the seventeenth century, probably between 1680 and 1685, a Casa des Porçolans ('porcelain room') was constructed at Santos by its then owners: a chamber with a pyramidal ceiling was set with two hundred and sixty Chinese bowls and dishes dating from around AD 1500 to the early years of the Qing dynasty, when the porcelain was installed. Clearly in this case the porcelains were regarded as wares to be used in quantity.

106

Early European attitudes to porcelain were more reverent. Marco Polo wrote of it in 1292 using the term *porcellana*, after the thin white shell of the cowry. He thus gave it the name which has been used throughout the West ever since. Chinese porcelain and its Middle Eastern imitations arrived at Florence via Damascus and Alexandria and were resold in the ports of the northern Mediterranean to European merchants. True to the spirit of the Renaissance, the Italians attempted to reproduce the hard, translucent material so different from their own earthenware maiolica, which was fired at temperatures of only 850 or 900°C. The Duke of Ferrara is reputed to have enjoyed some success with his attempts during the 1560s, but there exist no pieces attributable to this exercise. In 1575 Francesco de' Medici produced a form of European porcelain which, according to contemporary documents and modern analysis, owed much to the body preparation techniques of Ottoman Iznik potters. Medici porcelain, as it is known, is classed as 'soft-paste' and has a white body. After an initial firing, it was painted with blue decoration remotely derived from Chinese floral motifs, combined with solidly European designs. The body could not be thrown on a wheel and so was rolled into slabs which were then joined together in moulds. This sequence invariably introduced structural weaknesses that were exaggerated on firing. It was a highly expensive and experimental enterprise, and indeed, production was impossible to maintain without the patronage of Francesco de' Medici after his death in 1587. Only some twenty-six examples of Medici porcelain survive.

Export ceramics

At Jingdezhen, by contrast, the loss of imperial patronage in the late Ming dynasty had positive results. Since the reign of Chenghua (1465–87), the Ming emperors had interested themselves less and less in porcelain production, with the result that standards of both material and decoration had declined steadily. When the Wanli emperor died in 1620, the country was economically and militarily weak, and funds for the porcelain industry were diverted to pay for armies to ward off the increasingly threatening Manchus on China's northern border. The kilns needed to find new customers, and quickly did so overseas. The Japanese and European purchasers demanded shapes and ornament not known to the Jingdezhen potters, and it is probable that these foreign requirements provided the impetus for the vigorous new painting style of blue-and-white wares for the Chinese market in the second quarter of the seventeenth century. This innovative period lasted from 1620 until 1683 and is known as the Transitional period. Before examining its export wares in detail, attention should be paid to the ceramics produced specifically for overseas trade in the last 150 years of the Ming dynasty.

Kilns in the southern coastal region produced quantities of ceramics for export during the late Ming, just as they had done between the tenth and fourteenth centuries. A broad group of wares from this area has been loosely termed 'Swatow', after the port now called Zhantou in northern Guangdong province near the border with Fujian. Typical

107 Enamelled porcelain dish, Swatow ware. The red, turquoise and black enamel designs are painted over the glaze, the turquoise being washed sketchily over motifs drawn in black. The base is glazed, with quantities of kiln grit adhering to it. The central motif is known as a 'split pagoda' and is peculiar to dishes of this type. The four square cartouches around the rim contain identical, undecipherable inscriptions. Persian polychrome wares produced in Kirman in the 17th century probably derive from enamelled Swatow wares. Late Ming dynasty, *c.* 1600. D 38.5cm. OA F486+.

Swatow wares are large open forms such as dishes, painted with sketchy designs over the glaze in red, green, turquoise and black enamels. The colours and general appearance of these wares, though not their size, are reminiscent of the early overglaze enamel painted wares of the Song dynasty Cizhou kilns. The body is of porcelain stone but poorly prepared, so the wares feel coarse in comparison with those from Jingdezhen. Swatow wares have been found far more frequently outside China than within, and appear to have been a product mainly for the south-east Asian market.

Slip-painted wares have also been grouped imprecisely under the heading of Swatow but are quite different in appearance and technique from the large polychrome wares. Painted in white slip on a monochrome glaze of either mid-blue or toffee-brown, their shapes and decoration recall traditional late Song and early Ming wares produced for Chinese scholars and officials. The bulb bowls, pear-shaped vases and wide-bodied jars are painted in a free style with dragons chasing the flaming pearl, with lotus ponds or with prunus blossom, all of which motifs appear on fourteenth-century porcelain. The blue and brown glazes are peculiar to these wares, which seem to have been made in Fujian during the sixteenth and seventeenth centuries. Examples have been excavated throughout south-east Asia.

Another recognised type whose origins remain obscure is the class of large brown-glazed storage jars usually known as martaban. The wares are coarse, iron-glazed and often large, and were in all probability containers for exported foodstuffs as well as being export articles themselves. The jars often have lug handles and sometimes bear incised and moulded decoration. Production of these pieces, which continues today, has been estimated as beginning as early as the Song or even the Tang dynasty. Large jars of this type were manufactured in Thailand but small ones have been found amongst shipwreck cargoes dated to the Ming dynasty. Utilitarian wares of this nature would presumably not be manufactured too far from their ports of departure, and at least one kiln

108 Martaban jar. The shoulder of the stoneware jar has six lug handles, each terminating in a dragon head. The body is sharply incised with a bold dragon design, of which the style implies a mid to late Ming date. Martaban jars are known to have been made with little alteration over a long period, and excavations in the vicinity of Guangzhou have yielded sherds impressed with Northern Song dynasty reign marks. Martaban jars were originally produced for the export of wines and pickles. 15th–17th century. HT 63cm. OA 1973.4–16.1, given by Miss Fannie Goldstein in memory of her father Joseph Goldstein.

known to have produced them is the Shiwan kiln near the city of Guangzhou.

Late Ming export wares of Jiangxi province, from the kilns of Jingdezhen, have also suffered from imprecise terminology. *Kraakporselein* is the term coined by the Dutch for an easily recognised type of blue-and-white ware produced during the reign of Wanli (1573–1619) and imported into Europe in large quantities. It is also used sometimes to refer to later wares of similar appearance. Kraak ware, as the English call it, is distinguished by the arrangement of its ornament into panels; these usually radiate to a bracketed rim notorious for its liability to chip, though this feature is typical of mid-seventeenth-century wares. Its motifs are taken from nature with deer, horses, plants and birds as the typical designs; the dominant shapes are deep bowls and wide dishes. Many of the motifs relate to those found on late Ming polychrome wares, but in general both the ornament and the quality of kraak ware are distinct from those of Chinese domestic wares. Kraak ware is an example of a product not made to order, but certainly made specifically for export.

Japan

Orders for porcelain exported to Japan in the same period were much more exacting. In the last years of the Wanli era and throughout the Transitional period, the Japanese ordered pieces to their singular taste in

109 Porcelain dish, Kraak ware. The individual motifs all appear on Wanli porcelain for domestic use, but their arrangement in panels belongs to a specific export type. Kraak wares were exported to northern Europe and also to Persia, where they were imitated at Meshed in the 17th century. Late 16th century. D 27.5cm. OA 1984.2-2.33.

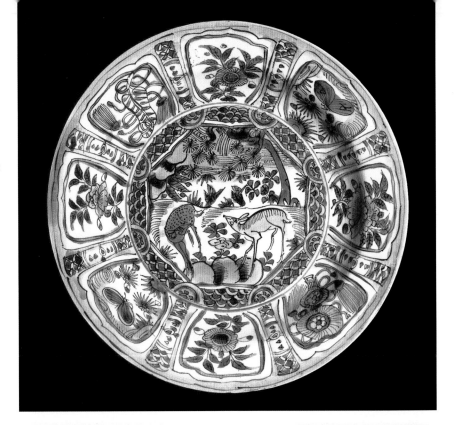

110 Porcelain vessel in the form of a frog. The transparent glaze over the blue decoration has a bluish tinge. The base is unglazed and the spout is bound in metal. Vessels of this shape are known as *kendi* and were made primarily for export to south-east Asia. This example was acquired in India. Ming porcelain was exported to India but in smaller quantity than to other parts of Asia and the Middle East. 16th century. HT 17cm. OA 1948.4-15.1, given by Lady Bradford.

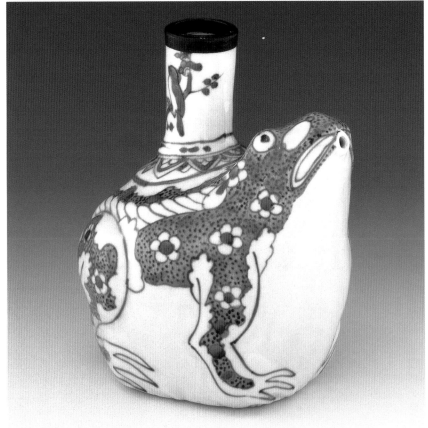

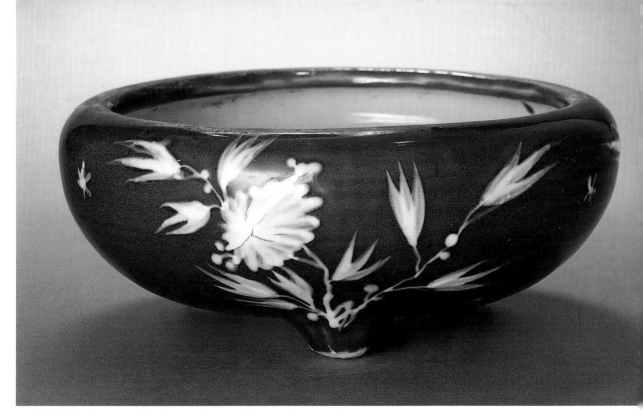

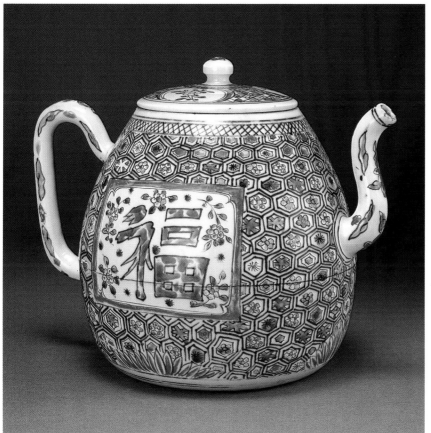

111 ABOVE Censer bowl, Swatow ware. The bowl stands on three feet and the interior is glazed white. This type of slip-painted ware was made in blue and white or brown and white, and was mostly exported to south-east Asia. 17th century. HT 8.5cm. OA 1984.2-2.50, Addis Bequest.

112 LEFT Porcelain lidded ewer with underglaze blue and overglaze enamel decoration. The large character in the reserved panel is *fu* (happiness). The base is unglazed. The ewer was probably intended for wine. Its shape and the diaper background distinguish it as a ware for export to Japan. Late 17th to early 18th century. HT (with cover) 19cm. OA F493+.

quite small quantity. Some of the orders were handled by the Dutch, who were denied access to the interior of China but operated in the Far East from a base at Port Zeelandia in Taiwan. The Portuguese also carried porcelain between China and Japan, along with silk and gold. The Japanese required specific pieces for use in their tea ceremony, which was increasingly widely practised. The tea masters requested particular designs for themselves and perhaps a small group of followers, so the orders were small and the prices correspondingly high. They supplied the Chinese merchants with paper patterns and wooden models for the potters to work from, and the merchants could then discuss the details with the potters themselves. Individual wares were often much admired; preserved in family collections, they exist today in proportionally greater quantity than other export ceramics.

Tea ceremony ceramics included cups and dishes. The dishes were used for serving sweetmeats in the initial stages of the ceremony and were made in a variety of geometric and naturalistic shapes. The blue-and-white tea wares were produced in the last few years of the Wanli period and up until the end of the Ming dynasty. Unusual new shapes were made, particularly in the Tianqi period (1621–7), and many of them are marked. The blue-and-white pieces made for the Japanese are known as *ko-sometsuke* wares, which means 'old blue-and-white'. Enamels were sometimes combined with underglaze blue decoration and depict certain Chinese motifs within designs arranged in panels or roundels according to Japanese taste.

Certain body and glaze characteristics of the tea wares exported to Japan make it difficult to be certain of the location of the kilns which produced them. There are invariably flaws and the body is not always of a finely prepared material. Technical perfection was not a requirement, but it is almost impossible to estimate whether the blemishes on the Chinese-made pieces were due to carelessness or not. Certainly they display great diversity of body, glaze and decoration.

Another type of seventeenth-century export ware for Japan is, in contrast, characterised by technical superiority and uniformity of body, glaze and cobalt tone, which link it with the best pieces produced at Jingdezhen for European export and Chinese domestic use. This group began to be produced in the Chongzhen era (1628–44) and is known as Shonzui after a much debated inscription which appears on several of the pieces. The Shonzui wares, like the *ko-sometsuke* and the enamelled pieces, were produced for the tea ceremony and conform to appropriate shapes and ornament. In contrast to the fine tea wares produced in limited quantity to special order, huge amounts of ordinary porcelain and stoneware were shipped from China to Japan in Dutch vessels. In 1635, for example, it is recorded that a total of 135,905 pieces of coarse porcelain from Fujian was shipped via Taiwan to Japan. There is no doubt that the Chinese elements in the designs of pieces imported to Japan were retained in the *kakiemon* and *imari* enamelled wares produced in Japan at Arita for at least two hundred years after the Chinese wares first arrived.

Europe

European requirements for porcelain differed from the Japanese demands, and so did the attitude to the material. From the arrival of the first examples in the fourteenth century until the end of the sixteenth century, porcelain was an object of wonder to the Europeans. Most examples in royal collections were mounted in silver and, in the case of Italy as previously mentioned, an elaborate attempt to reproduce the strange material was undertaken. During the sixteenth century, both Portugal and Spain imported Chinese porcelains and sold small quantities to other Europeans, yet neither country exploited the keen interest of their neighbours in porcelain and other exotic oriental articles such as silk and lacquer. Throughout the seventeenth century, the Portuguese and Spanish concentrated on trade within Asia, and each shipped westwards only enough porcelain to satisfy demand in their own country.

It was the Dutch who eventually acted upon this gap in the market. Having initially been reluctant to confront the Portuguese in Asian waters, Dutch merchants quickly set up companies to trade over the route round the Cape of Good Hope once Cornelis Houtman had successfully sailed it between 1595 and 1597. In 1602 these various companies joined forces and established the Verenigde Oost Indische Compagnie, better known as the VOC or Dutch East India Company. The VOC was organised in six chambers (Amsterdam, Middelburg, Rotterdam, Delft, Hoorn and Enkhuizen), which were represented by sixty governors and a board of seventeen directors. Later in 1602, at Middelburg, the Dutch sold the oriental cargo of the captured Portuguese carrack *San Jago* for great prices. This stimulated the interest of both public and traders in Chinese products. Similar sales took place two years later of cargoes of porcelain, silk, gold, lacquer and drugs.

Relatively strong and bulky for a luxury item, porcelain was stowed first in the hold with the larger cargoes. Though company records reveal that new ships were used for each Far Eastern sailing, inevitably some were wrecked. The earliest shipwreck discovered so far is the *Witte Leeuw*, which sank in 1613 near St Helena in the South Atlantic. The cargo included several thousand pieces of blue-and-white porcelain, almost exclusively *kraakporselein*, along with quantities of martaban jars.

Kraakporselein of almost identical design appeared in another (unidentified) shipwreck found in 1983 and dated by its discoverers to between 1643 and 1646. The wreck included 25,000 unbroken pieces of mainly 114 blue-and-white porcelain, comprising cups, dishes, bowls, ewers, jars, covered boxes and other shapes. Of these, 2,600 pieces were kraak ware, which accounted for approximately 10 per cent of the recovered items.

There is no doubt, then, that once begun, the importing of Chinese porcelain into Europe quickly became a large-scale commercial operation. Demand for the wares must have been high, yet they cannot have occupied the same treasure-like role as the porcelains of the previous centuries. The cargoes of the *Witte Leeuw* and the later wreck consisted of many small items, such as drinking cups and tiny boxes, intended for use rather than display.

113 *Famille rose* plate decorated with a schooner. The Dutch inscription on the rim reads: 'Christopher Schooneman, Chief Mate of the ship Vryburg, in the roads off Wanpho [Whampoa], in China, in the year 1756.' Employees of the Dutch and English East India companies were allowed a personal porcelain cargo, the size of which accorded with their rank. This is clearly an example from such a cargo. *c.* AD 1756. D 22.7cm. OA F598, Franks Collection.

114 OPPOSITE Porcelain wares from a shipwreck. These four pieces come from the wreck of an unidentified ship which probably set sail in the 1640s, and are representative of the range of sizes and styles exported from China at that time. The glaze on the white box has degraded as a result of immersion. Mid-17th century. Kraak dish: D 29.5cm. OA 1985.11–19.38. Jar: HT 14.5cm, OA 1985.11–19.22. White box and cover: D 13.5cm, OA 1985.11–19.2. Blue-and-white box and cover: HT 2.9cm, OA 1985.11–19.36.

Trading in the South China seas was not easy, for with the exception of the Portuguese vessels which had an arrangement to put in at Guangzhou, foreign ships were not permitted to land in China, nor were Chinese ships allowed to land in foreign ports. Dutch traders bought mostly at Bantam and Patani until the second quarter of the seventeenth century. At that time they established themselves on the island of present-day Taiwan, and the Chinese junks obtained permission to sail there. Not long after, the output of the Jingdezhen kilns was severely curtailed by the wars which followed the founding of the Manchu Qing dynasty in 1644, and in 1662 Taiwan was lost to the Ming remnant known as Coxinga. The VOC thus turned to Japan, though its porcelain was expensive and production irregular, and to Persia, whose potters were producing alternative porcelain after Chinese models. It was only after the reorganisation of Jingdezhen under the Kangxi emperor in 1683 that Chinese porcelain was available once more, and by then the Dutch had competition from the English who were already trading at Amoy and Macau.

From 1700 onwards, the English East India Company traded at Guangzhou. They shipped to London and from there to the American colonies, the Caribbean, Ireland, Germany, Italy and, above all, Holland. The English perhaps more than any other nation were responsible for the worldwide renown of Chinese porcelain in the eighteenth century.

Chinese merchants had never concerned themselves with the ultimate destinations of their wares, simply carrying them as far as other Asian ports to be disposed of as the merchants of those ports wished. In fact, most European carriers of Chinese cargoes established their own offices in Guangzhou in the eighteenth century. The English were the first to do so in 1715, followed by the French and the Dutch in the late 1720s, the Danes and the Swedes in the early 1730s and, much later, the Americans in 1784.

113 Between about 1700 and 1730 the Dutch East India Company traded little in porcelain, but once their office in Guangzhou was opened in 1729, they imported ceramics into Holland in large quantities. Within a few years the company had the idea of sending samples of wares for the Chinese potters to reproduce, and these samples were duly ordered from the Delft potteries. Surprisingly, the Delft potters were unable to fire polychrome enamel decoration, so the company resorted to sending coloured designs on paper instead. Cornelis Pronk made numerous

drawings for this purpose, but in the event the Jingdezhen potters also had difficulties making the wares. Their problem was not the coloured decoration, but the complicated shapes required. These were difficult to make because southern Chinese porcelain clay is of a soft, sticky consistency not easily modelled. It can be thrown, but the elaborate shapes familiar in porcelain were the result of thrown and partly dried pieces being carved and pared down. Only small quantities of porcelain made after Pronk's designs were successfully produced. They took months to execute and were highly expensive, with the result that after a few years the VOC ceased ordering such unprofitable wares.

Pronk's two-dimensional designs were more quickly adopted by the Chinese potters. Colour and the execution of painted designs were old skills and could be applied to the quantities of undecorated stock sent regularly to Canton from Jingdezhen. These took only a few weeks to deliver, as opposed to the months required for the new shapes which had to be made at the Jiangxi kilns, and could be shipped back to Europe in the same season in which they were ordered.

Armorial porcelain

A better-known way in which paper designs were used as patterns for porcelain decoration is the dispatch of coats of arms to Canton. Armorial dinner services were first ordered by European clients in the second decade of the eighteenth century, though individual items are known from the end of the seventeenth century. By the end of the eighteenth century, there was barely a single well-to-do English family without a Chinese dinner service decorated with their own coat of arms. Of course, 115 the Portuguese and Spanish royal families had acquired such services in blue-and-white porcelain over a hundred years before the first northern Europeans did, but the trade between those countries and China differed, as has been shown, from that of Holland, England or France. The most widely used patterns for the decoration were book plates.

The earliest English armorial services, up to about 1720, were decorated in either underglaze blue, Chinese *imari*, or *famille verte*, and the arms were repeated several times on each piece. More numerous are the services decorated in *famille rose* enamels or in iron red, in both cases with a good deal of gilding added. Second services were sometimes ordered and were usually produced in underglaze blue. There were occasional problems with the depiction of arms since the Chinese porcelain painters had no understanding of the intricacies of heraldic devices: tinctures were sometimes copied instead of interpreted, or the names of the colours were written clearly beneath the enamel colours themselves.

Dinner services, armorial or pictorial, account for the staggering quantities of porcelain exported to Europe. Most vessels carried tens of thousands of pieces, and the annual porcelain cargoes of the London and the Dutch East India companies amounted to hundreds of thousands of items. Even in 1780, when English porcelain was the vogue in Holland and Chinese imports were accordingly reduced, the VOC ordered a total of eight hundred thousand pieces from Jingdezhen. Dutch East India

115 Gilded *famille rose* dish, decorated with the arms of Talbot impaling Clopton. This dish is part of a service made for Henry Talbot of Dorking, who married Catherine, daughter of Sir Hugh Clopton of Stratford-upon-Avon, in 1735. Chinese dinner services often commemorated the linking of two families through marriage. *c.* 1735. D 39.2cm. OA F733+, Walker Bequest.

Company records quote high numbers for both porcelain items and guilders. Such quantities are astonishing considering that fine porcelains have come to be regarded almost as individual works of art. The scale of the China trade was decisively illustrated in 1986 when the cargo of a Dutch East India shipwreck was recovered from the South China seabed and sold. The ship had been packed with tea, which supports the view that porcelain may have been carried as ballast for tea cargoes, and the number of ceramics recovered exceeded a hundred thousand. Many of the pieces were sold individually as curios and minor works of art. The discoverers of the wreck identified it as the *Geldermalsen*, dated 1752. Its cargo provides a clear impression of the scale and variety of imported wares, for it included cups and saucers, plates, bowls, butter dishes, and entire dinner services. The overwhelming majority are decorated in underglaze blue, not only because it was favoured but also because overglaze decoration erodes on prolonged immersion in salt water. Many of the apparently underglaze blue decorated pieces may therefore in fact be underglaze blue and overglaze enamel decorated wares, from which the coloured ornament has vanished. A few discoloured enamel wares were retrieved from within heaps of tea.

Chinoiserie

It is worth considering the reasons behind imports on such a scale. The chinoiserie craze which gripped northern Europe for much of

116 Punch bowl, perhaps the only example of export porcelain depicting a cricket match. The scene, which appears three times on the bowl's exterior, is taken from the headpiece to the first broadsheet edition of the laws of cricket, engraved after Francis Hayman's 'Cricket in Mary-le-bone Fields', and published by John Wallis and L. Binns in September 1785. The original painting hangs in the Long Room at Lord's. On the interior of the bowl is a ship with the name 'Thirxs' on the stern, probably a misspelling of Thirsk, the Yorkshire birthplace of Thomas Lord, who may have commissioned the bowl. 1786–90. HT 15.2cm, D 35.5cm. MCC Museum, Lord's Cricket Ground.

the eighteenth century developed in an age of economic strength and intellectual inquiry, particularly in Britain. The Industrial Revolution provided the wealth to sustain a taste for the exotic, yet it was only the ancient industrial habits of the Chinese which made it possible to satisfy the demand. It is remarkable that in 1613 a single cargo bound for Europe included several thousand porcelains. It is surely more remarkable that a single kiln complex, which moreover happened to be in decline at that period, could supply all of them. The technologies of porcelain, silk and lacquer production were all centuries old by the time these luxury items were exported to the West. Indeed, the kind of factory organisation which was about to be established in Europe was already centuries old in China.

Items mass-produced in one country were thus admired as individual works of art in others. There were instances of porcelain being used in quantity, as in the Santos palace porcelain room in Lisbon and the dinner services in Britain, but on the whole it was displayed in groups of not more than a dozen items. Highly decorated enamelled wares were particularly admired and often acquired as a garniture of five pieces for display on a mantelpiece or staircase. In seventeenth-century Holland, blue-and-white wares were displayed in cabinets or on chimneypieces, as can be seen faithfully depicted in many paintings of the period. Where porcelain was displayed in quantity or used architecturally, as at Sans Souci in Potsdam or the Trianon at Versailles, it was more often of European manufacture though it may have imitated oriental styles.

The first European ceramics inspired by Chinese porcelain and pro-

duced in quantity were the tin-glazed earthenwares of the Delft potteries in Holland. The decoration was executed mostly in blue and white, though the use of coloured glazes was eventually achieved. In England similar wares were produced at the Lambeth, Bristol and Liverpool factories and are known as 'English Delft'. Potters at these kilns appear to have had less difficulty with coloured decoration.

Another Dutch seventeenth-century earthenware type emulated the red stoneware of Yixing in Jiangsu province. From the 1670s onwards the potters at Delft produced low-fired red wares in imitation of the teapots imported from east China. These were light red, unmarked and usually decorated in relief with Chinese motifs. The arrival of eighty-two such teapots in London in 1699 is noted in the East India Company records, and in 1703 the Company sold more than a thousand chocolate cups of the same ware. From around 1700, the red stonewares were reproduced at the Staffordshire potteries, where they showed a greater variety of shapes and decoration than the Delft versions. The later eighteenth-century pieces were less Chinese in style, though some of them bore bogus Chinese potters' marks.

The most important Yixing imitations were produced at Meissen under the direction of Johann Friedrich Böttger, a chemist who had been engaged by Augustus the Strong of Saxony to create porcelain. At the Leipzig Fair of 1710 he exhibited 'red porcelain' for sale and 'white porcelain' for examination only.

In 1765 the Bristol factory, under the direction of a Mr Cookworthy, made the first English hard-paste porcelain out of China clay and stone.

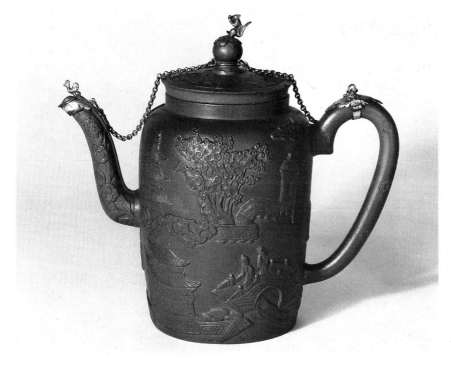

117 Teapot, Yixing stoneware with gold mounts. The teapot is decorated on both sides in relief with a scene of figures on a bridge, with a pagoda and blossoming plum tree nearby. Garden scenes in relief were the most widespread type of decoration on Yixing export wares and the type most reproduced on European imitations. A teapot of the same shape and similar decoration in the K. S. Lo collection bears the seal mark *Yunshi ju*. 18th century. HT 14cm. OA 1927.2–19.1.

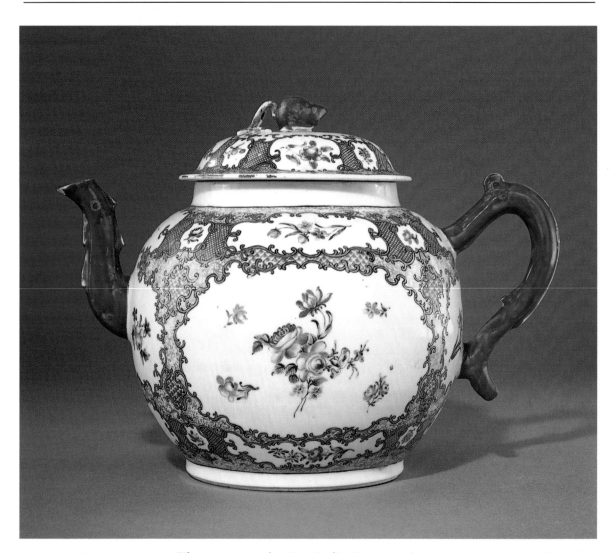

118 Porcelain teapot decorated with *famille rose* and iron-red enamels and gilding. The pot, which holds more than three quarts, belonged to Dr Samuel Johnson (1709–84) and later to Mrs Piozzi (formerly Mrs Thrale). It was acquired in 1892 by A. W. Franks. The teapot is mentioned in Marryat's *History of Pottery and Porcelain* and in Seeley's *Mrs Thrale: a Sketch of her Life. c.* 1760. HT (with lid) 21.2cm. OA F597+, Franks Collection.

The next year the East India Company's agent at Guangzhou brought back samples of raw materials used at Jingdezhen and presented them to the great man of English ceramics, Josiah Wedgwood. The most familiar chinoiserie design for English porcelain and earthenware, the willow pattern, was created in England; neither the motif nor even the legend is known in China, although it has represented the essence of Chinese art and literature to many Europeans. The willow pattern thus characterises one extreme of English chinoiserie, while the truly exotic heights to which it was taken are best displayed by George IV's Royal Pavilion at Brighton. There, Chinese wallpaper and Cantonese bamboo furniture sit amongst an English realisation of Kublai Khan's 'princely pleasure dome' at Xanadu, as described in Coleridge's poem.

The porcelain created at Worcester, Chelsea and Bow in the eighteenth century eventually replaced Jingdezhen ware in England. The Cornish stone of which it was made is structurally comparable to Chinese

porcelain stone, and once it had been discoverd and processed within a highly organised industry, the Chinese wares had little to offer and were expensive by comparison. The change was not complete until the nineteenth century; in the early decades of their operations, the English porcelain factories produced good but essentially functional wares for those who could not afford Chinese porcelain. As the English and other European factories flourished throughout the nineteenth century, Jingdezhen was in decline. Nonetheless, many styles were produced at Jingdezhen specifically for the Western market. The shapes, sizes and decoration of the Chinese imports are best shown in the nineteenth-century catalogues of Liberty's of Regent Street, which had played a significant role in the introduction of oriental goods to England from its founding in 1876 and still continues to import Chinese porcelain. The opening in the 1980s of many more specialist shops importing large and small porcelain wares, still in the main from Jingdezhen, is evidence that an export trade which began in Roman times, flourished from the tenth to fourteenth centuries, and took Europe by storm in the seventeenth and eighteenth centuries, is alive and well today.

6

LATER ARCHITECTURAL AND POPULAR CERAMICS

1500 Onwards

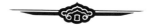

China's ceramic traditions are so rich and so varied that it is not possible to describe them in continuous chronological sequence. Regional differences in culture and geology produced numerous local ceramic types which were largely independent of the major northern stoneware or southern porcelain traditions, though they must inevitably have been influenced by them to some degree. The function of ceramics in China's history is also richly varied, and not limited to the development of a single class of wares such as vessels or funerary sculpture. This chapter examines two other important ways in which ceramics were used, by reviewing their role in architecture and in religion; also discussed here are three of the better-known local pottery traditions: those of Fujian, Guangdong and Jiangsu provinces.

In the pre-Han period, earthenware was used for drainage systems and fortifications, but little is known of its use as a building material. At Qin Shihuang's mausoleum, constructed in the third century BC, earthenware paving bricks cover the areas where his terracotta army stood, and in the Han dynasty which succeeded his short-lived Qin dynasty (221–206 BC), earthenware bricks were used systematically for building tombs. These were often decorated with pictorial scenes (see chapter 2) and, together with eaves tiles, appear to have been covered with the same green lead glazes used for enhancing tomb figures and models. Yellow-glazed tiles were introduced shortly afterwards for imperial buildings, and glazed roof tiles, still used today, have probably been made continually since that time. Chinese buildings, not generally erected to last as monuments, have traditionally been constructed of wood and have therefore perished, but the evidence of ceramic funerary models and printed illustrations suggests that their design changed little over successive centuries.

119 OPPOSITE Daoist shrine, Longquan ware with lacquer and gilding. In the lower grotto is the God of the North with attendants and guardians; in the middle grotto are Confucius, Buddha and Laozi; and at the top is an Arhat riding a mythical beast. On the reverse are nine round perforations and an incised inscription meaning: 'Made on an auspicious day in the 4th year of the Yongle period', AD 1406. HT 49.5cm. OA 1929.1–14.1, given by Sir Percival David.

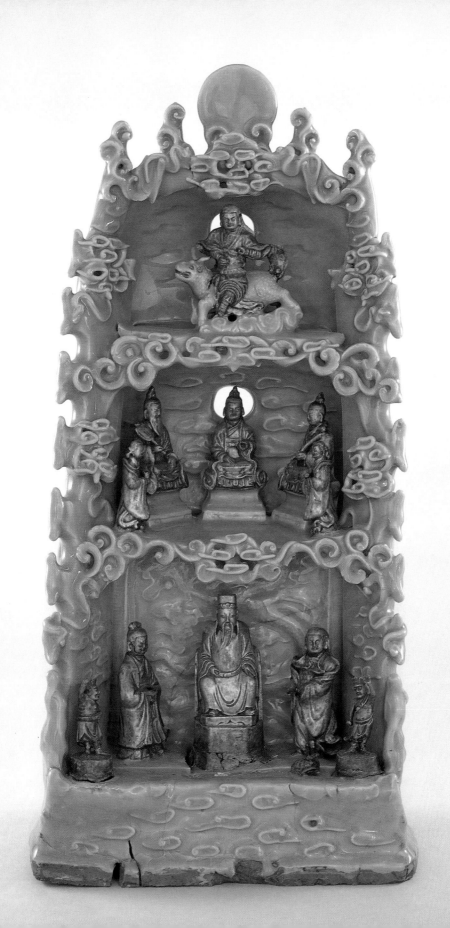

Brick pagodas are an exception. They do not survive well, but numerous crumbling and unadorned brick pagodas of the Tang and Song dynasties still exist and can be seen around the Chinese countryside. One of the best preserved and most interesting is at the Xiuding temple near Anyang in Henan, which dates from the seventh century and retains a large amount of earthenware relief-decorated brickwork. A rectangular tile from the Xiuding pagoda in the British Museum collections is of 120 grey earthenware with traces of unfired pigment, and comes from the topmost row of tiles, directly below the eaves.

It is probable that the practice of cladding pagodas with decorated ceramic tiles was widespread from at least the Tang dynasty onwards. A celebrated example is the 'porcelain pagoda' erected by the Ming emperor Yongle (1403–24), who had built at his capital Nanjing a nine-storey pagoda faced with porcelain bricks and dedicated to the memory of his parents. The pagoda was destroyed during the Taiping rebellion in the 1850s but is recorded by both Chinese historians and European travellers, whose accounts and drawings of it inspired a glazed porcelain roof at the Trianon in Versailles, though this too has disappeared. Examples of the bricks are found in many Western museum collections, and recent excavations at Jingdezhen revealed several examples of white-bodied, white-glazed L-shaped bricks which are technically similar to Yongle white porcelain vessels, but with slight flaws. They are considered by the archaeologists of the site to have been produced for the porcelain pagoda but rejected for their low quality.

In the reign of Yongle, there is evidence that porcelain bricks were used not only on walls, but also as paving. The Persian Hafiz Abru's *Zubdatu't Tawarikh* includes an account of the Persian embassy sent to China in 1419 by Shahrukh. The description of their audience with the Emperor in Beijing includes the following:

To the right and left there was an unbroken succession of buildings, pavilions and gardens. The whole of its floor was constructed of polished blocks made out of bricks of China clay, which in lustre are quite like white marble. It was an area two or three hundred cubits in length and breadth. All joints in the blocks of the floor did not show any deflection or curve even to the extent of a hair's breadth, so much so that one would think they had been ruled with a pen. The blocks of stones were inlaid with Chinese dragons and griffins and polished like pieces of jasper in a way as to excite the wonder of a man.

The use of highly coloured glazed ceramics in architecture was greatly developed during the Ming dynasty, though white porcelain was used only by Yongle, and other examples take the form of brightly coloured low-fired wares. At the tomb of Yongle himself, outside Beijing, is a complete structure made from yellow-glazed bricks. It takes the form of a small oven a metre or so high for burning offerings. The tiles are moulded with a lattice imitating woodwork. Panels with flowers or leaves and tiles depicting figures were used to decorate walls and buildings in the Ming dynasty. Important imperial buildings were roofed in

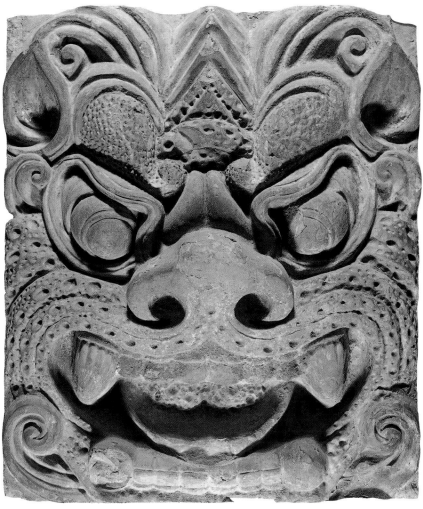

120 Earthenware tile moulded with a monster mask from the 'Red Pagoda' at Mount Qingliang, Henan province. The tile was fired in reduction, giving it a grey colour, and then covered with a red pigment. The 5th-century pagoda of the Xiuding temple was restored by the Emperor Taizong. This tile comes from the uppermost row, beneath the eaves of the pagoda. Tang dynasty, reign of Taizong (AD 627–50). HT 43cm. OA 1983.7–25.1.

two tiers, with a course of glazed, relief-decorated tiles between them.

A good example of monumental glazed brickwork is the nine-dragon screen at Datong in Shanxi, dated 1377, the ninth year of the Emperor Hongwu. It stands 45m long and 8m high, and is decorated in high relief and brightly coloured glazes with dragons chasing flaming pearls. Shanxi province appears to have been the main production centre for important architectural ceramics during the Ming dynasty.

The thirty-seven acres of buildings which comprise the official halls and private pavilions of the Forbidden City are roofed with yellow-glazed tiles. At the northern end of the imperial complex, in Beihai park, is a hill called Coal Hill which stands directly behind the northern entrance to the palace, and which affords a rare view of gleaming ceramic acres. The floors as well as the roofs of the Forbidden City were once covered with yellow tiles.

Architectural ceramics are not obvious collectors' items, nor are they so easily transported as small vessels, so there are relatively few examples in Western museum collections. However, the British Museum does

have a large yellow-glazed animal head retrieved from the ruins of the Ming palace at Nanjing. The Victoria and Albert Museum collections include a group of turquoise and purple glazed roof tiles and ornament, presented in 1912 and similarly retrieved from the ruins of the old summer palace in Beijing. This palace was an interesting combination of traditional Chinese and Louis XIV architecture, commissioned by the Qianlong emperor in 1747 and designed by the Jesuits.

Roof tiles must have been required throughout China, yet there are few indications as to their places of manufacture. It is likely that they were made locally all over the country in the same way as other functional ceramics, though there are records of imperial workshops at the Fragrant Hills to the west of Beijing, and also in mountains near present-day Shenyang in the north-eastern province of Liaoning. Tiles from the Shiwan kilns just outside Guangzhou, on the south coast of China, were exported to both Thailand and Korea in great quantity and should perhaps be regarded as strong functional pieces like the martaban jars produced for export at the same kilns.

The Ming dynasty was also the period in which ceramic figures of mythical animals first appeared on roofs to ward off evil spirits. The animals were set in a row along the curved edge which runs from the top ridge to the eaves of traditional Chinese roofs, giving them their distinctive profile. It was important that the animals made up an odd number, and they do not seem to have exceeded eleven altogether. They

121 Principal forms of glazed roof tiles, as illustrated in a work on the fundamentals of Qing dynasty construction. The largest, most elaborate tile ornament was placed at the end of the roof top, with the smaller figures descending in a row to the eaves.

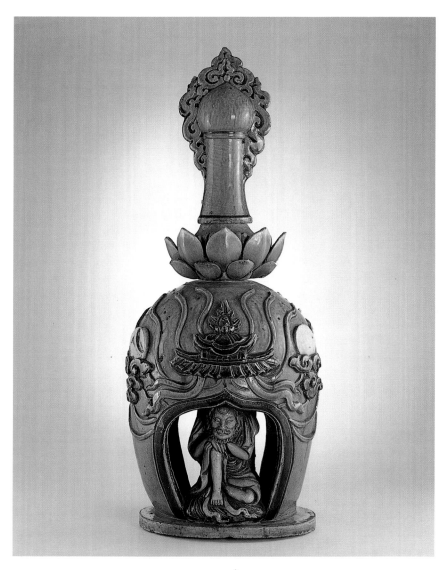

122 Glazed stoneware roof finial for a temple. The finial is in three parts with applied ornament of the sun, the moon and clouds. The figure represents the historical Buddha, Sakyamuni, in meditation prior to his enlightenment. The depiction of the Buddha as a hermit seated in this way was a common convention in Yuan and Ming dynasty Buddhist art. 16th century. HT 74cm. OA 1938.5–24.133.

are known as acroteria, and are usually glazed yellow or green. The glazes were applied to an earthenware or stoneware body which had already been fired. This technique is known as 'enamel on biscuit' and was also used for ordinary roof tiles, and particularly for figures and certain vessels.

The guardian role of acroteria, and their green and yellow glaze colours known as Ming *sancai* ('three-colour'), make it possible to regard them as the heirs of the Tang *sancai* burial figures. The mythical half-human beasts which defend grand Tang tombs are similar to those which sit on Ming and Qing roofs; the Tang *lokapāla* figures also appear on roof tiles, but are usually glazed in purple and blue. Ridge tiles and architectural finials glazed in more colours are associated with a particular
122 Ming ceramic type known as *fahua*.

The term *fahua* denotes wares with bold decoration in deep blue, turquoise, purple, yellow, green and white alkaline glazes, usually separ- 123 ated from one another by a raised trail of white slip outlining the motifs. Because of this technique they have been regarded as ceramic versions of cloisonné wares, on which coloured enamels are separated by copper wire. *Fahua* ('bounded pattern') refers literally to the slip-trailing, but is used to describe all pieces glazed in the above-mentioned palette, particularly those with a deep blue or turquoise ground, even though on many examples the boundary between different colours is incised rather than raised.

Fahua wares were produced in the fourteenth, fifteenth and sixteenth centuries both in north China, where they were made mainly in Shanxi, and in the south, probably at Jingdezhen. Southern wares were fired unglazed and the enamels subsequently applied to the biscuit porcelain, while on the low-fired northern wares a slip was applied between body and glaze. Incised rather than raised boundaries appear more frequently on porcelain *fahua* wares than on low-fired ones, on which the raised trail of slip predominates. Many *fahua* wares are large items such as roof tiles and garden seats, and even the vessels are in large forms such as *meiping* vases.

Ming *sancai* and *fahua* glazes were not therefore restricted to architectural ceramics, but were also used in a religious context for sculpture and altar vessels, as well as for burial figures. The green, amber and cream glazes of Tang *sancai* persisted in the Liao dynasty (AD 907–1125) but are otherwise little known before their revival in the enamel-on-biscuit technique of the middle Ming. A group of large Liao dynasty *sancai* sculptures from cliff temples at Yizhou in Hebei province is well known from the four examples in Western collections. Two are in New York, one in Philadelphia and a fourth in the British Museum. They belong to a set of *lohan*: disciples of the Buddha traditionally found in groups of sixteen in ancient temples, eight pairs on either side of the main Buddha figure. The Yizhou *lohan* are individually modelled, with 124 different facial expressions, and the British Museum *lohan* has a serious and serene air.

Large *lohan* glazed in the *sancai* palette were produced in the Chenghua period, as were other popular figures such as the large *Budai* ('laughing Buddha') placed near the front of temples and attended by the Good Boys and Bad Boys. The Good and Bad boys, in the guise of ministerial officials or judges of hell, hold notebooks for making their reckoning of a person's life before deciding whether they should be dispatched to heaven or to hell. Such figures are often glazed with a combination of the *sancai* green, yellow and cream colours and the *fahua* aubergine, thus combining the two palettes of architectural and religious ceramics.

Burial models also use both sets of colours, though as with the architectural ornaments they are not usually found together on one piece. While the temple ceramics recall Tang traditions in their colours, their large sculpted forms and their purpose in turning away evil, Ming burial ceramics are more akin to Han tomb models in their representations of 125

123 OPPOSITE Stoneware *meiping* vase decorated with lotus flowers and insects above waves, and gadroons around the shoulder. The base is unglazed. The decoration is outlined in raised trails of white slip. *Fahua* ware, probably from Shanxi province. 15th century. HT 41.5cm. OA F67.

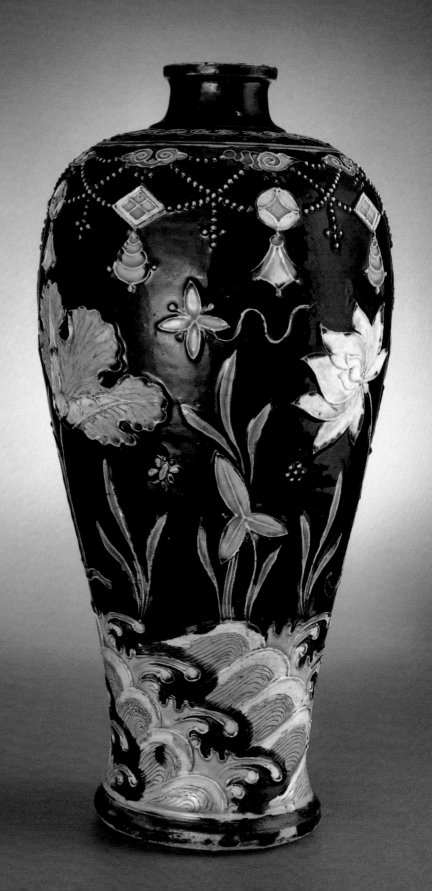

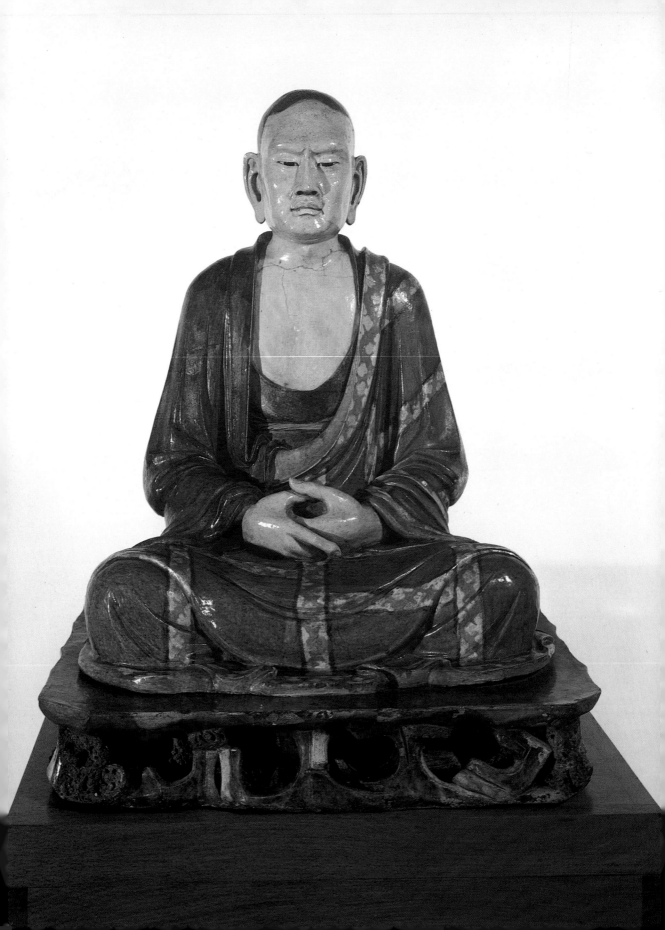

architecture and household effects. The well-heads and granaries of the Han are paralleled in the Ming by small chairs and dishes of food, but in each case the reference is to daily life.

The tomb of one Ming emperor contains stoneware altar vessels in its innermost chamber. From the Southern Song dynasty onwards, altar vessels were important artefacts. Made in bronze, cloisonné and ceramic, they were used in temples and private domestic altars as well as in tombs, where they were often carved of stone. The forms were based on archaic bronze vessel shapes; the principal ones were *jue* wine vessels, incense burners modelled after ancient *gui*, and flower vases of either beaker or round-bodied form. The much later pricket candlestick form was also included in the traditional altar sets of the Ming and Qing dynasties.

Ceramic altar sets were mostly heavy wares. *Fahua* glazes were often used, but generally the green and yellow enamel on biscuit glazes were not. A ware peculiar to altar vessels appeared in the mid and late Ming, characterised by a deep cobalt-blue ground with white relief-decorated dragons reserved against it. Most extant examples show traces of gilding on the white dragons, so the original blue-and-gold scheme must have appeared lavish. Altar wares were not only made as sets of small vessels, but also in large versions placed in front of temple altars rather than on top of them. Three parts of an altar set in the British Museum, with typical late Ming polychrome decoration, bear the Wanli (1573–1619) reign mark and are of that period.

Fine porcelain altar vessels were made at Jingdezhen in *qingbai* ware and blue-and-white in the Yuan and early Ming periods, and several new ceramic shapes connected with Buddhism were also introduced at that kiln. Such wares include lotus dishes and monk's cap ewers, and are discussed in the following chapter. The production of fine porcelain altar wares and sculpture at the Dehua kilns in Fujian was on a much

124 OPPOSITE Stoneware *lohan* with *sancai* type glazes, from Yixian, Hebei province. The pierced rock of the separate base may represent the famous stone of Lake Tai in Jiangsu province. The banding on the yellow robe represents patchwork traditionally worn by monks as a sign of humility. Liao dynasty (AD 907–1125). HT 103cm. OA 1913.11–21.1, given by the National Art Collections Fund.

125 BELOW Earthenware funerary model of a house complex. The ornamental screen inside the main door blocks the entrance of evil spirits (which travel in straight lines) as well as the view of the main reception hall. At the rear is a sealed storehouse; side buildings provide living accommodation and kitchens. Ming dynasty, 14th–15th century. Main hall: HT 42.8cm, L 36.9cm. OA 1937.7–16.6–12.

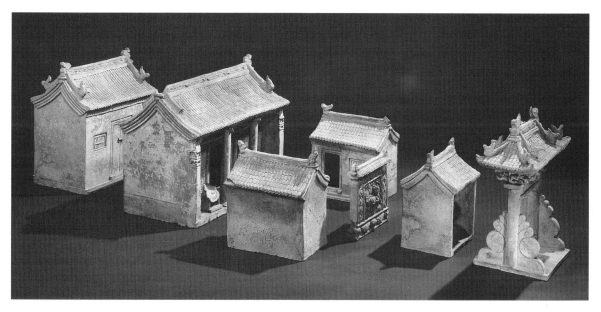

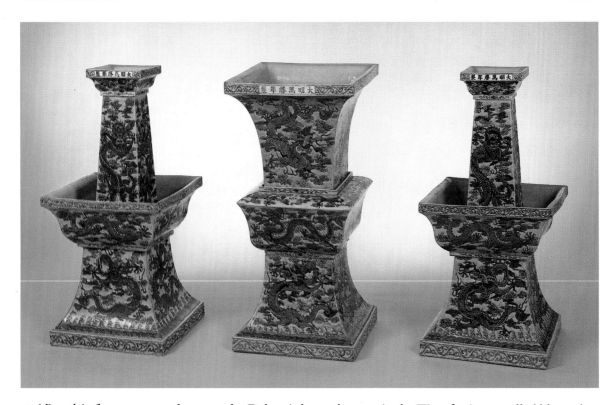

126 Porcelain flower vase and two candlesticks decorated in enamels on the biscuit. The candlesticks are composed of four parts and the vase of three. A second flower vase and a censer originally completed a five-piece altar set; the censer is now in the Israel Museum, Jerusalem. The quality and size suggest that the set was made for an important temple. Late Ming dynasty, Wanli mark and period (1573–1619). Candlesticks: HT 74.1cm. Vase: HT 73.3cm. OA 1930. 10–17.1, 2, 3, purchased with the aid of the National Art Collections Fund and Friends of the British Museum.

larger scale. Dehua is better known in the West for its so-called blanc-de-chine porcelain, which was exported to Europe in large quantities during the Qing dynasty, but in the earlier period of production almost all the wares were altar vessels and sculpture. The vessels do not usually exceed 15 or 20 cm in height, and are mostly in the shapes of archaic bronze vessels such as the *jue* tripod wine vessel, the *gu* wine beaker, and incense burners modelled on the ancient *gui* food container. In addition to these traditional shapes are simple round-walled bowls, probably for alms. One such bowl in the British Museum, one of only a handful of dated Dehua wares, bears an inscription painted in brown around its rim, dating the piece to AD 1511.

Dated Dehua wares are more valuable to the scholar than dated wares from other places because the kilns have operated for nearly a thousand years, and the material of twentieth-century Dehua ceramics is the same as that of the earliest of the Song dynasty wares. Altar vessels, sculpture and the later, everyday and export forms produced at the Fujian kilns are not easy to date closely from their shapes and, since the body material offers no clue, modern copies are notoriously difficult to distinguish from older pieces. The glaze can, however, provide an indication. The Ming glaze possesses a warm, slightly reddish tinge whereas the Qing glaze has a colder appearance. Tens of Ming dynasty kilns have been discovered at Dehua, but more than a hundred Qing dynasty sites are known, indicating that the wares were produced on a large scale in the later period.

128

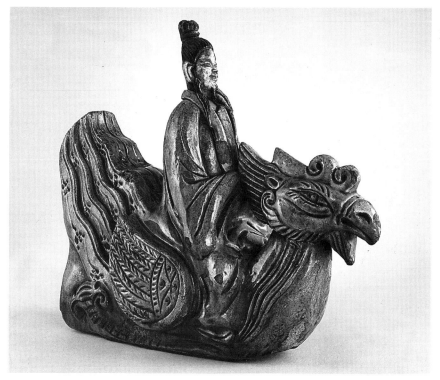

127 Stoneware roof tile said to come from the Great Llama temple, Huang Si. A figure seated on a hen is always positioned nearest the eaves of an important building and is said to represent the wicked Prince Min of the state of Qi, who died in 283 BC after being strung from a roof corner: too heavy to be carried to the ground by the hen, he was prevented from climbing up the roof by the presence of a *qiwen*. Between the hen and the *qiwen* were usually positioned a series of other mythical animals which, from the Ming onwards, were arranged in specific order (compare fig. 121). Ming dynasty, 15th–16th century. L 30cm. OA 1907.11–5.4, given by C. H. Read.

At the same time that the kilns began producing wares for export they introduced wares for everyday use such as vases, jars, bowls and basins. One of the shapes which had appeared in Dehua porcelain during the Ming dynasty but seems to have been more widespread in the Qing is that of the plum blossom cup. These small libation cups, shaped to a rounded point at the base, are decorated in relief with small plum blossoms. The shape is an imitation of rhinoceros horn cups. It is for their sculptures, however, standing up to 60 cm high, that the Dehua kilns are best known. The local porcelain stone material is particularly suitable for sculpture because of its plasticity, which also accounts for the material being used unaltered for so many centuries.

Early export pieces were modelled in religious forms mostly for Portuguese Christians, and include many images of the Virgin and Child. Sculptures for the domestic market were also religious, as mentioned above, and the Goddess of Mercy, Guanyin, is the most prevalent image. Many other religious figures were modelled in Dehua porcelain, however, and the kilns are famous for their representations of popular religious images in addition to more formal Buddhist ones. Such figures include the Guardian Kings of the four quarters, the God of Longevity, Shoulao, Liu Hai on his three-legged toad, and many more. Although brown-glazed and enamel-decorated wares are known from Dehua, most pieces, and particularly the sculptures, are plain white.

An unusual feature of Dehua porcelains is the fact that they are very often signed, usually in the form of a small seal impressed into the back

128 Dehua porcelain figure of Cai Shen, God of Wealth. The figure is modelled with armour and extensively incised with dragons and floral decoration. A fifteen–character inscription on the reverse of the base reads: 'Made at the *wei* hour on the *renyin* 26th day of spring in the 37th year of Wanli', AD 1610. HT 26.5cm. OA 1930.11–13.1.

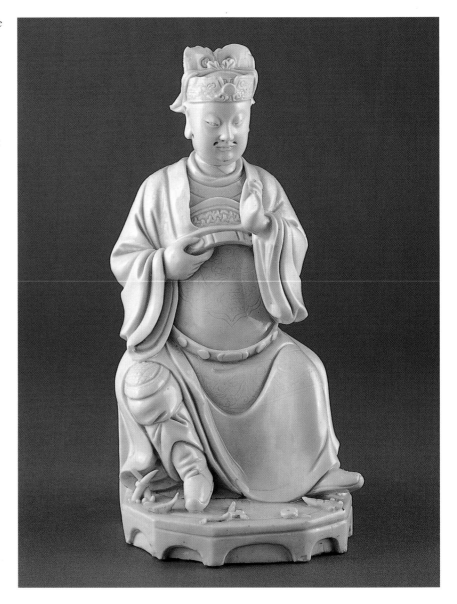

of a sculpture. Signed ceramics are not traditional in China because wares were produced in quantity, often passing through the hands of several individual artisans. Apart from the Cizhou popular stonewares of the Song dynasty, the kilns of Dehua in Fujian and Yixing in Jiangsu are the only ones where signing was the usual practice. Signatures are only useful, however, where there are literary records to provide more information, or where a chronology of potters has been established. In the case of Dehua this has not yet been done, and until the local genealogies have been studied in detail no precise dating can be carried out on the basis of the signatures. The most famous Ming signature is that belonging to He Chaozong.

Popular ceramics were also produced at the Shiwan kilns, situated to the south-west of Foshan near Guangzhou on China's south coast. Sherds dating to the Tang and the Song have been unearthed in the vicinity, but the heavy, thickly glazed wares associated with the kilns were first produced in the late Ming or possibly even early Qing dynasty. Earlier wares were produced for export and as containers for trading goods throughout south-east Asia. Shiwan is renowned for three ceramic types: roof tiles and ornaments, imitation Jun ware, and religious and popular sculpture.

The roof tiles are known to have been exported to Korea and south-east Asia as well as throughout China, but no features have been identified to distinguish them from other, local, architectural ceramics. The blue 129 and purple Jun-type glaze is one among many Shiwan imitations of Song glazes and other media, such as jade and bronze, with archaic and refined connotations. The Jun-type glaze was first made there in the late Ming or early Qing dynasty. Opaque coloured glazes are widely used not only on incense burners and altar vessel forms from Shiwan, but also on sculptures. Like the Dehua kilns, Shiwan produced popular religious figures such as *Budai* ('Laughing Buddha'), Shoulao and Guanyin, but Shiwan is alone in producing figures of folk heroes. This tradition began at least as early as the mid-nineteenth century, when models mocking British officials were made during the Opium Wars, and has continued and flourished throughout the twentieth century.

Shiwan models include animals and birds as well as figures, and they are more naturalistic than other clay sculpture. This is entirely due to the plasticity of the local clay, which is very different from the southern porcelain stone of Jiangxi, which could only be modelled into elaborate shapes with considerable difficulty. Shiwan wares include the roughest of later Chinese ceramic production. They are linked to the porcelains of Fujian and the stonewares of Jiangsu by the use of potters' marks. Twentieth-century family lineages have been established, but the most famous Shiwan name, and therefore the most widely used, is that of Zu Tangju of the Ming dynasty.

Kilns at Yixing in Jiangsu province are famous for the brown and red stonewares known in Chinese as *zisha* ('purple sand') wares. Jiangsu province is renowned as a stronghold of China's literati, so it is not surprising that the local ceramics are associated with the sedate activities of scholars and gentlemen, rather than the more robust traditions of popular religion.

An important feature shared by Dehua porcelains and Yixing stonewares is the use of potters' signatures, which are far more illuminating in the case of the latter. This is because Yixing wares were acquired by people who wrote, mentioning them in numerous treatises on ceramics and collecting. The most complete accounts of the wares are the early seventeenth-century *Yangxian minghu xi* by Zhou Gaoqi, and the *Yangxian ming tao lu* by Wu Xian of the Qing dynasty.

Song kilns have been found in the Yixing area and their products 152 mentioned by a Song poet, but the *zisha* wares were not heavily in

129 Vase with 'robin's egg' glaze, Shiwan ware. The finely speckled blue and lavender glaze is inspired by Song dynasty Jun ware (compare figs. 75 and 76), and the type is amongst the finest later products of the Guangdong kilns. 18th century. HT 23.5cm. 38/342, Burrell Collection, Glasgow.

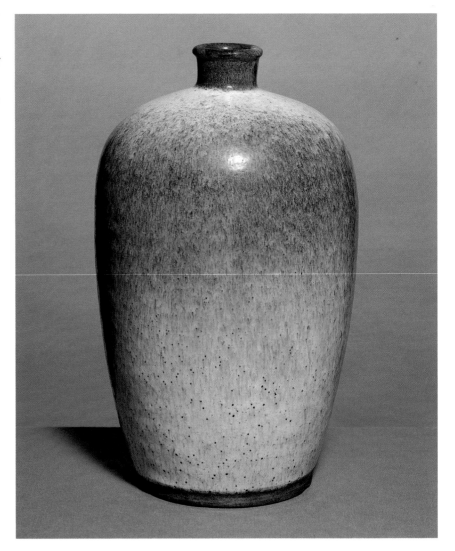

demand until quite late in the Ming dynasty. The earliest datable piece known is a teapot recovered from the tomb at Nanjing of the eunuch Wu Jing, who was interred in 1533. The first known Yixing potter, Gongchun, was active slightly earlier, in the Zhengde period, but few of his works are indisputably genuine. Gongchun is reputed to have been taught how to make teapots by a monk at a temple south-east of Yixing. The hills in that area are certainly the source of the purple clay after which the wares were named, and also of orange-red and buff-coloured clays. The different clays were used both singly and mixed together, and this accounts for the range of colours in 'purple sand' wares.

The material is ideal for enhancing the taste and aroma of tea, and the teapots, which were never washed and developed fine patination, are the foremost products of the Yixing kilns. The most famous Ming maker

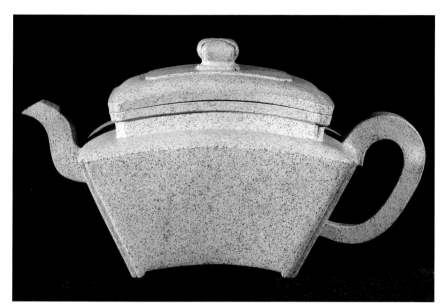

130 LEFT Stoneware teapot with lid. The grey flecked body of this teapot illustrates the variety of clays used at Yixing. The base bears the seal mark of Chen Mingyuan, one of the most celebrated Yixing potters of the Qing dynasty. Late 17th to early 18th century. HT 9.4cm. OA F2458.

131 ABOVE Detail of the base of fig. 130, showing the mark *Chen Mingyuan zhi* in seal script. OA F2458.

of teapots is Shi Dabin, whose works were faked even in his own lifetime. Three signed examples of his work have been recovered from tombs, however, and these provide scarce information on the master potter's work. One is from Yangzhou and datable to 1616; a second is from a tomb in Fujian province datable to 1612; the third, from Wuxi in Jiangsu, was found in a tomb of the Chongzhen period (1628–43). The excavated teapots share several characteristics, including a curved spout, absence of ornament and an even-textured sandy body material without the added bits of fired clay seen on later *zisha* wares.

The foremost Qing dynasty Yixing potter was Chen Mingyuan, who was active in the Kangxi period. He was highly educated and the first to apply seals as well as inscriptions to his teapots. Poems occur frequently on Yixing wares, and those on Chen Mingyuan pieces are noted for a higher standard of composition. He is also associated with the small naturalistic objects peculiar to the Yixing kilns, for in addition to teapots and desk objects such as brush-rests, the kilns also produced *zisha* melons, fruits, nuts and other shapes taken from nature. The taste for plain, undecorated wares persisted throughout the Qing but was accompanied by a vogue for thick, bright enamel decoration painted directly on to the brown body without a glaze layer in between.

The religious, folk, scholarly and export traditions of ceramics from the prominent provincial kilns of Jiangsu, Fujian and Guangdong have all survived to the present day.

7

IMPERIAL PORCELAINS FROM JINGDEZHEN

The Yuan, Ming and Qing Dynasties

Jingdezhen in Jiangxi has produced most of China's porcelain for more than a thousand years. Situated in Fouliang county, Raozhou prefecture, the ceramic city grew up on the strength of locally abundant porcelain stone deposits, large forests and a river which flowed into two major river systems. This coincidence of raw materials, fuel and cheap transport put Jingdezhen in a position to satisfy the demand for porcelain throughout Asia, Europe and America for centuries on end. The city also supplied most of China with both everyday and ceremonial wares over the same extended period, and continues to do so today.

The Chang river on which the town is situated flows into Boyang lake and from there the Gan river leads south towards Guangzhou (Canton). The Yangzi river can be entered near Jiujiang at the northern end of the lake. Once on the Yangzi, cargoes could travel to the east coast ports to be shipped abroad, or could go north again along the Grand Canal towards Beijing. From its apparently remote situation in the hilly province of Jiangxi, Jingdezhen was in fact well placed to supply porcelain both to the empire and the outside world with comparative ease.

Existing almost exclusively as a manufacturing and marketing town over so many years, Jingdezhen has long been synonymous with porcelain production. Numerous connoisseurs and ceramic historians have written accounts of the city and its bustling activity. The local gazetteers produced by every Chinese prefecture have also, in the case of Jingdezhen, naturally included descriptions of the porcelain industry. The best known accounts are Jiang Qi's *Taoji* ('Pottery notes') written in the Southern Song dynasty; the letters dated 1712 and 1721 of the French

132 OPPOSITE Lidded *meiping* vase, porcelain with underglaze blue decoration. The scroll decoration on the neck and shoulder of the vase is repeated on top of the lid. The base is unglazed. Yuan dynasty, 14th century AD. HT (to top of lid) 44.5cm. OA 1972.6–20.1, Brooke Sewell Bequest.

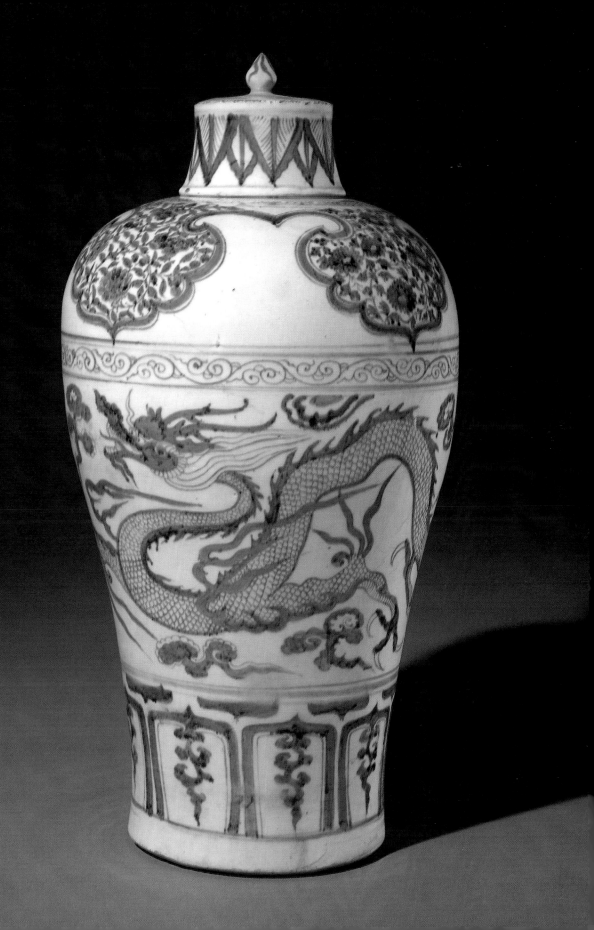

Jesuit missionary Père d'Entrecolles; the notes on porcelain manufacture written by the imperial supervisor Tang Ying in the 1740s; Zhu Yan's *Tao Shuo* ('Pottery explanations') of 1774; Lan Pu's *Jingdezhen Taolu* ('Jingdezhen pottery records'), compiled in the 1790s but published posthumously in 1815; and Chen Lu's *Tao Ya* ('Pottery refinements'), written in 1906.

Still more valuable information has appeared as the result of recent excavations of the Yuan and imperial Ming factories at Jingdezhen. In addition to a refined chronology of porcelain, the archaeologists Liu Xinyuan and Bai Kun have established that the earliest account of Jingdezhen, Jiang Qi's *Taoji*, was not written during the Yuan dynasty as previously thought, but in the Southern Song. Jiang Qi's account was included in the first Fouliang county gazetteer in 1270, and was reprinted in every subsequent edition. The essay gives many interesting details about the porcelain industry, such as the registers of kiln dimensions and of the number of employees, which were maintained in order to ensure correct taxation proportions; the payment of potters in land for them to cultivate rather than in wages; the different wares produced, in accordance with regional preferences throughout China; and the fact that the unfired porcelain paste would freeze in winter and could not be used.

The excavations themselves have yielded the tangible evidence of all these practices. Two tonnes of sherds were recovered in 1982 from the site of the imperial factory, and a further ten tonnes were found in 1983–4. In one area of the Dongsiling site, sherds of badly misfired porcelains were found together with saggars and other kiln material dating to the Xuande period (1426–35). Nearby was another sherd heap of the same date, composed of almost perfect, neatly broken pieces. The implication is that because these pieces were blemished, they were not fit for the emperors but, because they bore his mark, they could not be sold. They were therefore broken deliberately to prevent the possibility of anyone selling them. The resulting clean damage done to the pieces made it possible to reassemble these wares, a task undertaken by the archaeological team. This conservation has given clear information on the shapes and sizes of early Ming imperial porcelain.

The earliest excavated Jingdezhen wares are grey-bodied, green-glazed pieces reminiscent of Yue wares, and come from the lowest level at the Liujiawan kiln at Hutian. They date to the Five Dynasties period in the first half of the tenth century AD. These early pieces appear to be deliberate imitations of the eastern wares. Excavated with the green wares were white pieces of the same shape and decoration, known as Five Dynasties white wares. These are the first true porcelains of Jingdezhen. It was probably in the middle of the Northern Song period that the more bluish, transparent-glazed *qingbai* wares appeared, at first undecorated but soon sporting fine incised motifs. *Qingbai* wares continued to be produced throughout the Southern Song and Yuan dynasties.

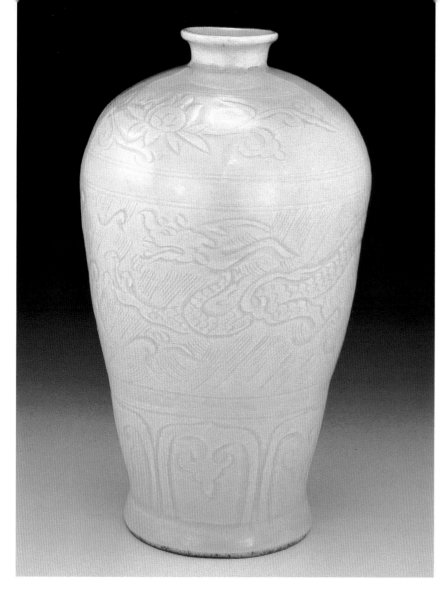

133 *Meiping* vase, porcelain with *qingbai* glaze. The vase is incised with lotus flowers and a dragon amidst waves. The vessel has been made in three parts and subsequently joined together. The base is glazed. An almost identical piece has been excavated from a tomb dated AD 1325 in Wannian county, Jiangxi province. Yuan dynasty, *c.* 1300–1325. HT 26.8cm. OA 1975.10–28.1, given by Sir John Addis.

Yuan

The Mongol rulers of the Yuan dynasty (AD 1279–1368) established the Fouliang Porcelain Bureau in 1278 before their control of China was even complete. In 1295 the bureau was increased fourfold and its director raised in rank, and the period from 1295 to 1324 is regarded as one of the most productive of the dynasty. The Mongols did not involve themselves in matters of Chinese taste and seem to have supported the porcelain industry for purely commercial reasons, yet a great stylistic shift occurred during the period of their rule.

The three major ceramic wares of Yuan dynasty Jingdezhen were *shufu*, *qingbai*, and underglaze blue or red painted porcelain. Other important ceramic types were produced at Longquan in Zhejiang province and at the Cizhou kilns in north China. Despite being found largely outside China, *shufu* wares are so called after the characters *shu* and *fu*, usually translated as 'privy council', which are found on their interiors and distinguish them as products for official use. They are otherwise

recognisable by the opaque white glaze which coats their thickly potted forms. The main shapes are dish, bowl and stem-cup, the last being new and used mostly ceremonially from its inception until the end of the Ming. These shapes all suit official wares, which has led to the suggestion that *shufu* porcelains were made in the first phase of the Fouliang Porcelain Bureau when production was smaller and possibly limited to court wares. The opaque whiteness of the *shufu* pieces was achieved by limiting the amount of ash in the glaze, so that it contained only five or six per cent calcium oxide as opposed to 10 to 15 per cent in *qingbai* wares of the same period. The higher firing temperature required by the lower calcium content meant that the body needed a greater amount of aluminium oxide. This was provided by kaolin, which was added to porcelain stone in small quantities.

Qingbai wares of the Yuan dynasty display several new types of decoration. The increasingly common form of *meiping* (plum blossom vase) is divided into three distinct areas of incised ornament, corresponding to the shoulder, body and foot of the vessel. This arrangement is adopted on many underglaze painted wares. Openwork decoration is another feature shared by the two types, but on *qingbai* it is generally combined with beading, a technique largely confined to that ware. Fine beading outlines *qingbai* decoration in a fashion more commonly seen on silver, lending a sumptuous impression evident also in its other main application of representing jewellery on ornate *qingbai* Buddhist figures. However, the most impressive feature of certain Yuan *qingbai* wares is much more straightforward: their great size. Large forms could only withstand firing if the body material were sufficiently plastic, an advantage gained by the use of kaolin. Tall standing vessels were made for altars and relate in their stature and function to the first proper blue-and-white wares. Additional kaolin in the porcelain body also provided a smoother ground for the blue painting. Some early blue-and-white decoration is painted over incised lines, displaying another link between the well-established *qingbai* tradition and the beginning of the painted one.

Blue-and-white porcelain was probably first manufactured at Jingdezhen in the second quarter of the fourteenth century. Its export to the Middle East on a considerable scale is well known, but there was little demand for it within China itself, where it was probably regarded as slightly gaudy. However, some examples of early blue-and-white have been found in tombs dated to the late Yuan period, while others seem to be associated with Buddhist ceremonies. The two tall vases in the Percival David Foundation in London are the most famous examples. Their inscriptions date them to 1351 and record the name of the Buddhist establishment for which they were produced. In the following year Jingdezhen fell from Mongol control, and 1352 is accordingly considered the end of Yuan porcelain manufacture at that site.

In the fourteenth century and well into the fifteenth, cobalt ore was imported from Iran where it had been used for at least a hundred years. The viscosity of the Yuan porcelain glaze prevented the cobalt diffusing

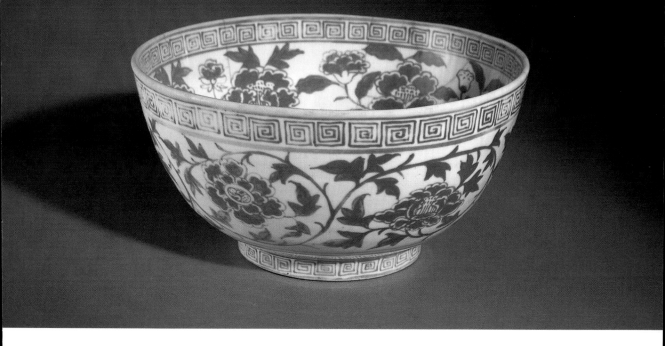

during firing, making possible the clear and intricate designs for which early blue-and-white is renowned. Underglaze copper-red is often used together with underglaze blue in the earliest Jingdezhen painted wares and, in the second half of the fourteenth century, the copper pigment was used alone to produce red and white porcelains. Restricted to about 134 half a century of production, these underglaze red pieces are not as well known as the blue-and-white wares. It is notoriously difficult to produce bright red colours on porcelain; the Jingdezhen potters of the late Yuan and early Ming succeeded by using copper oxide in two ways. It was either prepared and applied in the same way as the cobalt pigment, or it was used to colour a glaze which was likewise painted directly on to the unfired body. Underglaze red pigment can easily fire to dull grey or 101 dark red, whereas the underglaze glaze more consistently produced a red of greater brightness and warmth.

Underglaze and slip painted decoration were used at the Tongguan kilns near Changsha during the Tang dynasty and at the northern Cizhou kiln complex in the Jin dynasty (AD 1115–1234), where overglaze red, green and yellow colours also made their first appearance. The established use of coloured decoration at Jingdezhen, in either cobalt blue or copper-red pigments painted directly on to a porcelain body and then coated with glaze, nonetheless marked a new departure for Chinese ceramics. The technique of painting over the glaze, using enamel colours, followed within a century, and the preoccupation with ornament was established.

The possibilities presented by painted decoration were as numerous as the motifs which could be devised or borrowed. The decoration of Yuan and later porcelains was often highly skilled, and includes landscape narratives in addition to ornamental motifs. The variety and quality merit close attention. The painted wares from the fourteenth century to the present day should, however, be regarded as a single tradition, in

134 Porcelain bowl with underglaze copper-red decoration of peonies, and a key fret border. Underglaze copper-red painting appeared on Korean 12th-century greenwares before it was used at Jingdezhen. Early Chinese examples were exported, but in the late 14th century the wares appear to have found favour with the first Ming emperor, Hongwu (1368–98). On many pieces, the copper-red pigment fired a dull grey; this bowl is an example of a successful firing. Second half of the 14th century. HT 10.5cm. Lent by the Hon. Kate Trevelyan.

the way that the ash-glaze monochromes of the pre-Yuan period formed a tradition which developed over nearly a thousand years. The greater availability both of Ming and Qing wares and of the relevant historical data has in the past sometimes led to a concentration on the attractiveness of these porcelains at the expense of the innovative and striking stonewares of the previous millennium.

Hongwu

The first Ming emperor was the general Zhu Yuanzhang (1368–98), whose title was Hongwu. He rejected the painted wares as he rejected the practice of free trade which China's merchants had enjoyed from the eleventh century until his accession. The export of ceramics from China had operated during this period in two ways: private trade and official

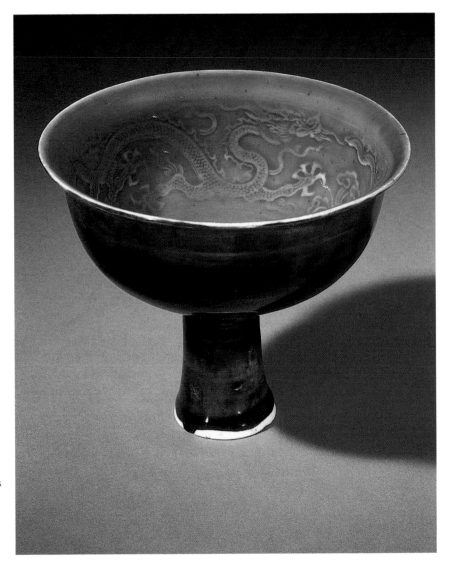

135 RIGHT Porcelain stem-cup. The interior is decorated with two moulded dragons and an incised cloud design beneath a cobalt blue glaze, and the exterior is covered with a dark reddish-brown iron glaze. This type of decoration appears on both white ware (see fig. 137) and copper-red wares (see fig. 136) of the Hongwu period. Only a handful of blue and brown wares are known. Ming dynasty, Hongwu period (1368–98). HT 11.2cm. OA 1968.4–23.1, Sedgwick Bequest.

136 OPPOSITE (LEFT) Bowl with copper-red glaze. The design of two moulded dragons around the interior of the bowl, combined with an incised cloud motif in the centre, is typical of vessels of this period. The exterior is decorated with a border of incised lotus petal panels around the foot. The base is unglazed. Ming dynasty, Hongwu period (1368–98). D 19.3cm. OA 1968.4–22.37, Sedgwick Bequest.

exchange. The Emperor Hongwu must have had only limited success in banning private trade, for his edict on the matter was repeated at intervals of two or three years throughout his reign. Tribute exchanges with foreign rulers were maintained but many early Ming documents bemoan the shortage of aromatics, the principal commodity imported by the ceramic merchants.

Having founded a new dynasty and established a new capital at Nanjing, the first Ming emperor was duty bound to prove the infamy of his precedessors, particularly as they had been foreigners and were considered barbarians. It is not in the least surprising, then, that the Ming court did not adopt the blue-and-white porcelain so closely associated with the period of Mongol rule. According to one account, Hongwu established a porcelain factory at Zhushan (Pearl Hill) in Jingdezhen in 1369, one year after the Ming conquest was complete. Blue-and-white porcelain was produced in designs tailored to Chinese rather than Islamic 134 taste, while similar designs were executed in red for the emperor himself. The plain copper-red wares had no precedent. No systematic attempt had previously been made to produce monochrome wares in this elusive colour, and only some of the Hongwu efforts were successful. The best 136 pieces have a pinkish-red tone, while the less successful ones tend to a brown colour. Few pieces survive; most are small bowls or dishes with moulded dragons on the interior sides. There are also a few examples of 137 Hongwu white wares.

137 BELOW White porcelain dish. The interior is moulded on the sides with dragons and incised in the centre with three cloud motifs. The base is unglazed. The decoration is comparable to other Hongwu pieces, but white examples are rare. Ming dynasty, Hongwu period (1368–98). D 19cm. OA 1930.2-15.1, given by Wu Lai-hsi.

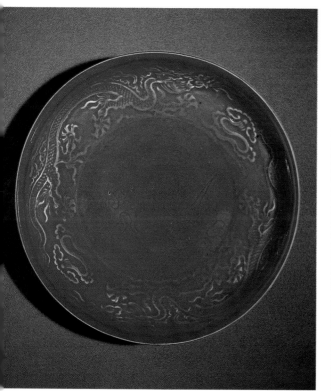

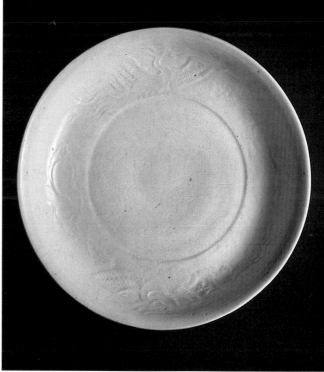

Yongle

The recent excavations at Jingdezhen reveal with unprecedented clarity the taste of an emperor. Yongle, the third Ming emperor, succeeded to the throne in AD 1403 and reigned until 1424. Ninety-eight per cent of the finds from the Jingdezhen stratum attributed to his reign are white wares. The Emperor may or may not have been aware that white porcelain had also been highly esteemed at the beginning both of the Tang and the Song dynasties. The association of plain white with mourning and filial piety may have been high in his consciousness, since it was by usurping his own nephew, the designated successor to Hongwu, that Yongle became emperor. Such an act left the new ruler with a serious need to prove his legitimacy. Emperor Yongle publicly honoured his deceased father, the Emperor Hongwu, four years after his accession with elaborate Buddhist ceremonies held in his father's memory, and again in 1412, when he started construction of a nine-storey pagoda dedicated to Hongwu and his empress. This was the 'porcelain pagoda', now demolished, at the Baoen Temple in Nanjing. It was faced with white porcelain bricks, of which some examples are amongst the most recent Jingdezhen finds.

In 1407 Yongle conferred titles upon the fifth Tibetan hierarch, Halima, for officiating at the services in honour of the emperor's parents. This Tibetan connection seems a likely explanation for the appearance during Yongle's reign of the 'monk's cap' jug, a shape original to Tibetan metalwork jugs whose mouth is in the form of a monk's cap. Yongle white monk's cap jugs are either plain or incised with floral scrolls or, 138 more rarely, Tibetan sutra scripts. This last type may even have been produced for the occasion of the Nanjing ceremonies of 1407, in which the emperor himself offered incense. Other new shapes of Yongle's reign include white vessels in Islamic metalwork forms and in the Chinese archaistic bronze forms of *yi* and *jue*, and ewers with angled shoulders. Vases, jars and other pieces of Yuan type assume a more slender form.

The Yongle white wares have fine bodies with a slightly matt glaze. Their near transparency is perhaps attributable to the very low calcium oxide content (approx 2.5 per cent) of the glaze, and in this respect may be regarded as a further stage in the development from *qingbai* (10 to 15 per cent) and *shufu* (4 to 6 per cent). The purity of the Yongle body and glaze materials resulted in wares superior to anything preceding them, and they have traditionally been referred to in both Chinese and foreign texts as 'sweet white wares'.

Jingdezhen porcelain of the Yongle era was not exclusively white as the use of copper red continued into his reign, and even the relatively small number of red-glazed wares excavated at Jingdezhen come from a stratum which the archaeologists have dated as 'late Yongle', though they are close to Xuande pieces in style. The quality of the copper-red monochromes which could be attributed to Yongle's reign is not high. The more interesting pieces are those on which a dragon is reserved in white against a red ground, creating a striking variation of two-colour decoration. Another Yongle variation is that of copper-red sea monsters 139

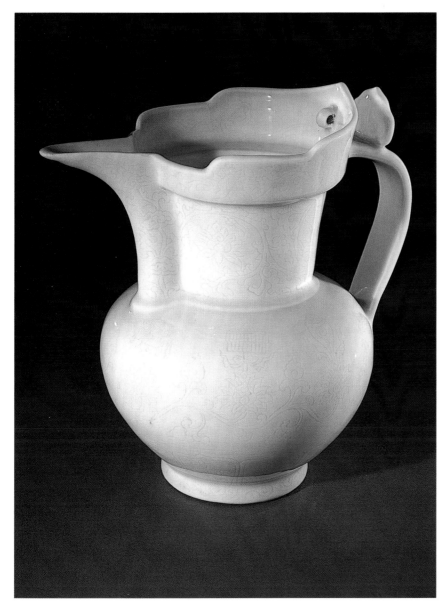

138 White porcelain 'monk's cap' ewer. Monk's cap jugs (*sengmao hu*) take their name from the caps worn by Tibetan monks, and their shape from Tibetan metalwork. This particularly fine white body and glaze are peculiar to the Yongle period; the type is sometimes known by the later name of 'sweet white ware', perhaps from its resemblance to sugar. Yongle white wares often bear traces of gilding but none is evident on this example, which is incised with floral scrolls. Ming dynasty, Yongle period (1403–25). HT 19.4cm. OA 1952.5–12.1.

against a ground of underglaze blue waves, a theme already known in the Song but possibly recurring at this period as a result of the numerous ocean voyages embarked upon under Yongle's auspices. No underglaze red painted style has been satisfactorily distinguished from that of the Hongwu wares, which have traditionally been regarded as the end of that particular, rather short-lived, tradition.

Cobalt blue, on the other hand, enjoyed some prominence in the Yongle period. The ore was still imported from Persia and applied to an increasingly white and smooth porcelain, producing an effect more brilliant than ever. Blue-and-white wares were widely exported once

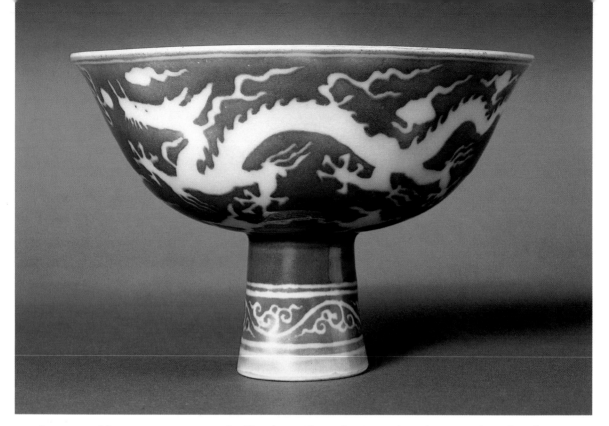

139 Stem-cup with copper-red glaze. The design of two dragons chasing the flaming pearl amidst clouds is reserved in white against red on the exterior, and appears on the white-glazed interior incised in the *anhua* technique. It has been suggested that this type of reserve decoration was originally gilded, but no traces of gilding remain on this piece. The interior of the hollow stem is glazed white. Ming dynasty, Yongle period (1403–25). HT 9.7cm, D 15cm. OA 1968.4–23.2, Brooke Sewell Bequest.

more, and offered as gifts to foreign rulers, but it is clear that they were also finally acceptable to the emperor of China. Those pieces found at the site of the imperial factory (so designated in 1402), or included amongst the first group of porcelains ever to bear the name of the emperor in whose reign they were produced, are decorated in one of two ways which distinguish their elevated intent. They bear either the five-clawed dragon symbolic of the emperor (or the phoenix ascribed to his empress), or they are painted with the type of carefully drawn floral scrolls and geometric borders incised on white wares but original to gold vessels.

The appearance of the reign mark must denote a new status for ceramics. The practice of marking an object with the name of the individual for whom it was intended is rooted in China's highest tradition: that of the archaic bronzes which in ancient times were associated with the authority to rule. Archaistic practices had begun in the Song dynasty, and it is in the related realm of connoisseurship that reign marks belong. They are quite distinct from the characters denoting drinking rhymes, serial numbers or vessel functions which had hitherto adorned some kinds of generally humbler ceramics.

The mark *Yongle nian zhi* ('made in the years of Yongle') is painted in underglaze blue on the interior of a few forms such as stem-cups or small bowls. The characters are executed in the open, squarish forms of *kaishu* ('regular') script. More refined still are the stem-cups, mostly white but including a few red, which bear the same characters impressed or incised in seal script. Seal script was derived from Qin and Han character forms and had been used for seals and other formal needs for centuries. A famous court calligrapher named Shen Du (1357–1434)

140 produced seal script closely resembling that on the Yongle stem-cups. It is recorded in the *Ming hui yao* that designs for porcelain were prepared at court and sent to Jingdezhen. Since Shen Du was one of the most admired calligraphers of his day, often required to inscribe precious objects and antiques in the imperial palace and temple, it is likely that the reign mark was drawn by him. The use of his calligraphy as a pattern for such marks, and their very appearance on porcelain, are a testament to the new heights reached by ceramics in the early Ming dynasty.

Xuande

The porcelain of the reign of Emperor Xuande, who succeeded to the throne in 1426 and ruled until 1435, is often regarded as China's finest. White wares were still produced but their importance waned. Copper-red monochromes reached heights which have never been surpassed; underglaze decoration combined careful composition and brilliant blue; and the overglaze enamel technique was established.

Copper-red monochrome porcelains were the ceremonial wares of the Xuande period. Only a few dozen examples survive, mainly shallow
141 dishes and a few deep bowls and stem-cups. The colour is a bright dark red. Recent analyses at the Shanghai Ceramic Institute have shown the glaze composition to be simple, but the firing highly complex. The red glaze comprises the same transparent glaze of blue-and-white painted wares with a half to one per cent of copper oxide added. The amount of copper is critical. It is thought that approximately half of it volatilises and disappears during firing. Too little copper provides no colour at all; too much makes the glaze a dark brownish colour. On close examination the red glaze of a Xuande piece has a mottled appearance in contrast to Qing copies, which are usually more homogeneous. The Ming copper reds are slightly underfired and may not have achieved their rich mottled

140 ABOVE Seal script mark reading *Yongle nian zhi*, from an early Yongle period stem-bowl, and apparently after calligraphy by Shen Du.

141 BELOW Porcelain bowl with copper-red glaze. The interior is also glazed red. The most successful red monochromes belong to the Xuande period. Ming dynasty, Xuande mark and period (1426–35). HT 7.6cm. OA 1947.7–12.321, Oppenheim Bequest.

142 OPPOSITE Porcelain
flask with underglaze blue
decoration of lotus and
lingzhi fungus scrolls. The
base is unglazed. Ming
dynasty, Xuande mark and
period (1426–35). HT
51.2cm. OA 1975.10–28.19,
given by Sir John Addis.

texture had they been fully fired in a long cycle. Many variables affected the copper-red colour, and the success rate of a copper-red kiln load must rarely have exceeded 30 per cent.

The appearance of such a select ware for such a limited period suggests two things about Ming imperial ceramics: first, that the emperor was closely associated with, if not also directly responsible for, inspiring at least one particular ceramic type; second, that the glaze recipe and firing methods were the jealously guarded secrets of a small group of potters. If the latter were not the case, the beautiful red porcelains would have been made in far greater quantity, and generations of potters would not have failed in their attempts to reproduce the red monochromes. Copper-red wares of the Chenghua period (1465–87) excavated at Jingdezhen have a distinctly blackish tone. It was not until the eighteenth century that wares approximating to the Xuande reds were produced, and then only by a method whose results generally lack the freshness of the Ming pieces. In the Xuande period copper red was also used to produce silhouette images on white porcelain, reversing the Yongle practice of white against red.

Blue-and-white porcelain reached the stage regarded as its classical period. Many pieces bear the Xuande reign mark, implying that the painted wares were used in the palace. Cobalt was still imported from Persia but the designs, which preserved some aspects of Yongle blue-and-white style and introduced many new ones, were far removed from the crowded patterns of fourteenth-century pieces destined for the Middle East. The blue pigment was used liberally and, where it precipitated out through the glaze, black patches appeared. This created the effect known as 'heaped and piled'.

In contrast to earlier painted decoration, the scrolls of foliage on Xuande porcelain cover the whole vessel rather than being confined 142 within rigid areas and borders. Many wares, particularly large dishes, were used as backgrounds for rock and bamboo compositions similar to album leaves and, in a few cases, even complete landscapes. The landscape style of painted porcelain is that of a Southern Song group known as the Ma Xia school after its leaders, Ma Yuan and Xia Gui. The typically spare, diagonal composition of Ma Xia landscapes, favoured by the Xuande emperor, was associated with the contemporary Zhe school of painting which has been consistently condemned by Chinese connoisseurs as escapist and by Western art historians as merely decorative. The association of painted ceramics with styles falling short of approved scholarly taste is worthy of note. In this matter the Emperor's preference may perhaps again be discerned. Yongle favoured white porcelain and the paintings of the fourteenth-century literati. Xuande preferred fine red ceremonial wares, which were produced in small quantity alongside painted ceramics inspired by a less august school.

Xuande introduced imperial taste, as exemplified at court and copied by the people. Highly decorated porcelain, on which dragons were the usual design and overglaze enamel colours were often added, became the standard luxury ware from his reign onwards. The combination of

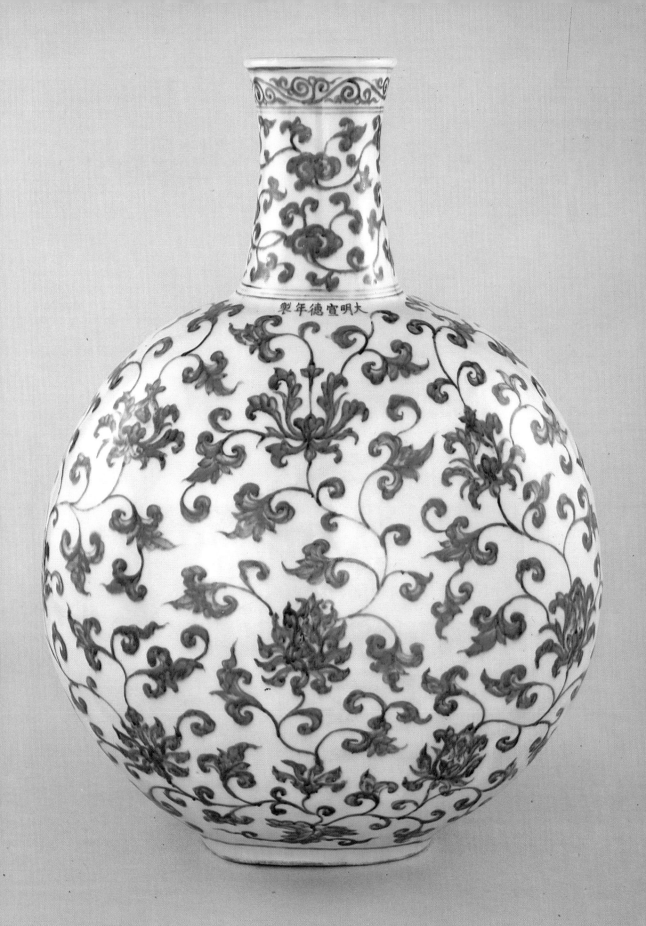

underglaze blue decoration with overglaze painted enamels in red and green appears on a Xuande dish from the Jingdezhen excavations. The addition to these colours of yellow and transparent purplish-brown enamels made up the *doucai* or 'fitted colours' palette which was perfected in, and always associated with, the late-fifteenth-century Chenghua period. *Doucai* was so called because the designs painted in blue outline under the glaze were completed and filled in with the overglaze colours. In addition to the *doucai* type, Xuande wares include low-fired coloured pieces with a yellow, turquoise or green ground.

The Xuande period was followed by three reigns that have long been regarded as ceramically insignificant. The Emperors Zhengtong (1436–49), Jingtai (1450–56) and Tianshun (1457–64) did not put their names on the porcelains of their reigns, so it is difficult to attribute any wares to the middle of the fifteenth century. Consequently, many have thought 143 that the imperial factories at Jingdezhen all but closed down between 1436 and 1465, when Chenghua ascended the throne. In fact, records exist of orders for porcelain for Zhengtong in 1442, for Jingtai in 1455 and for Tianshun in 1460, when Jingdezhen is recorded as having received

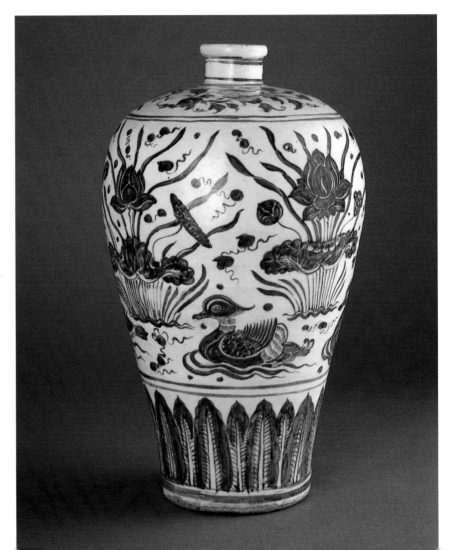

143 *Meiping* vase. A horizontal join just above the painted ducks shows that the thick porcelain vase was made in two parts and luted together. Wares of similar form and decoration have been discovered at Jingdezhen in strata dating between the reigns of Xuande (1426–35) and Chenghua (1465–87). The base is unglazed. Ming dynasty, mid 15th century. HT 37.7cm. OA 1973.7–26.359.

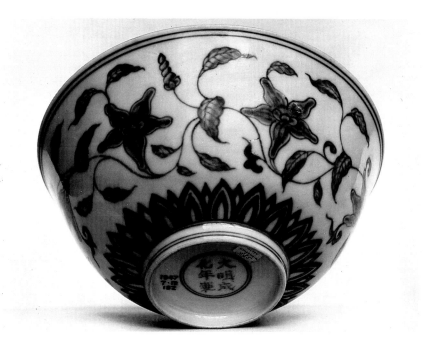

a commission for 33,000 pieces. An edict of 1438, declaring that any potter who copied imperial styles should be killed and his family exiled, adds to the impression that the imperial factory remained operative. Along the west wall of the imperial factory have been found a large group of sherds in a stratum that implies a Zhengtong date, despite their resemblance to Xuande pieces. Such a resemblance is entirely to be expected between two such short, consecutive reigns. The absence of a Jingtai mark on porcelain is more remarkable because it appears widely on cloisonné enamel; perhaps porcelain simply was not rated highly in the middle of the fifteenth century.

Chenghua

The mark of Chenghua (1465–87) was to become the most widely imitated of all marks. This seems appropriate, since the Jingdezhen excavations yielded a Chenghua piece with the mark of Xuande which is probably the first example of a porcelain bearing the name of an esteemed bygone period. The archaeologists of the site do not believe that the piece can have been produced as a fake. Not only is the calligraphy clumsy, but, because court wares were not sold, no market existed for bogus imperial pieces. Later Chinese potters used the mark of Chenghua frequently because the Chenghua wares were fine and rare. The most evident contrast between Chenghua and Xuande pieces is the tone of the underglaze blue decoration. Early Chenghua pieces have the dark colour, almost black in places, characteristic of imported cobalt ore, but the slightly later examples have a clear, much lighter blue imparted by the Chinese ore discovered locally in Raozhou prefecture.

144

The stratigraphy of the Jingdezhen excavations indicated that there were three phases of production in the Chenghua period. The first two phases cover the period 1465–71, and comprise pieces which are similar to Yongle and Xuande wares in both shape and decoration. The pieces

associated with Chenghua were produced between the seventh and twenty-third years of his reign (1472–87). Typically small and fine, they bear the reign mark within a square or rectangular rather than a circular 145 frame. The characters dating at least one example of calligraphy from Chenghua's reign, considered to have been executed by the emperor himself, are so similar to those of the porcelain reign marks that it seems likely Chenghua's own calligraphy provided the pattern for them. Both body and glaze of later Chenghua pieces are usually smooth and flawless. A distinguishing feature of Chenghua porcelain is the use of the same glaze for base and body. When the body is unglazed, it has a warm yellowish tone resulting from the slightly higher than usual iron content of the porcelain body.

Small pieces were produced in increasing quantity between 1481 and 1486, and several examples incorporated Buddhist inscriptions. According to the Korean official history of the period, the Chenghua emperor was devoutly Buddhist, even to the point of donning the appropriate monastic robes for Buddhist ceremonies. In their small size, the highest quality Chenghua porcelains may be likened to the white wares of the Tang dynasty and the Ru wares of the Song. They are mostly in the form of delicate stem-cups or wine cups, and take their

145 Bottle vase. The decoration was outlined in blue under the glaze and filled in with green enamel over the glaze. The mark is executed in underglaze blue within a vertical double rectangle on the base. It is a feature of Chenghua wares that the same glaze is used for both the base and body of a vessel. Other examples of this rare ware are in the collections of the Palace Museum, Beijing, and the Shanghai Museum. Ming dynasty, Chenghua mark and period (1465–87). HT 19cm. OA 1953.5-9.1.

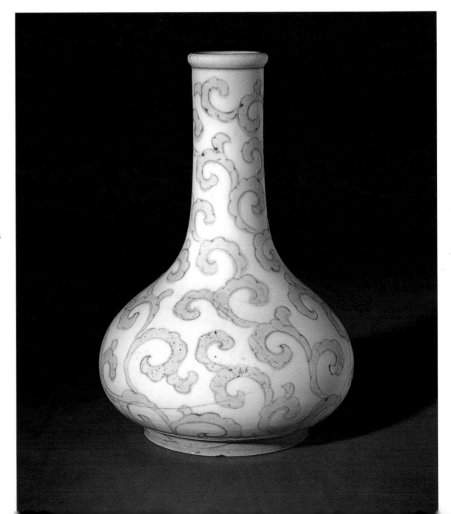

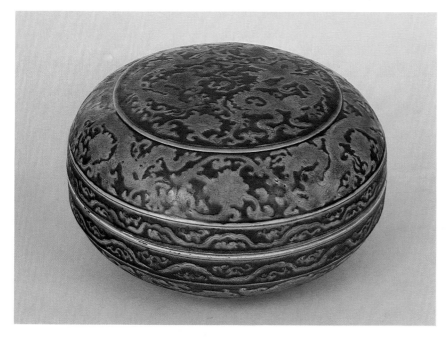

146 Porcelain box and cover decorated in overglaze blue and turquoise enamels. The decoration of dragons chasing the flaming pearl on the lid, and of dragons and lotus flowers on the box, is incised as well as coloured. The interior of both box and cover is glazed. Ming dynasty, Chenghua mark and period (1465–87). HT 13.4cm, D 25.6cm. OA 1979.7–22.10, Harris Bequest.

name from the *doucai* enamel decoration they bear. *Doucai* designs are painted under the glaze in blue outlines which were filled in over the glaze with clear red, green, yellow and purplish-brown enamels. The designs are pictorial and include figures, plants and animals, often amidst brief landscapes. *Doucai* wares were the precursors of the polychrome enamelled porcelains which were to dominate late Ming production, and in the Wanli period (1573–1619) a pair of *doucai* wine cups already fetched high prices.

The enamel glazes used in small quantity for *doucai* decoration were also used in combinations with each other to glaze entire pieces. Known but uncommon in ceramic collections are the green and yellow, purple and yellow, blue and yellow, red and green, turquoise and black wares of the Chenghua period, all of which were numerous in the Jingdezhen excavations.

Late Ming

The reigns of Hongzhi (1488–1505), Zhengde (1506–21), Jiajing (1522–66), Longqing (1567–72) and Wanli (1573–1619) constitute a period of gradual decline in the porcelain industry. The imperial style of decoration established in the fifteenth century lasted until the end of the dynasty, and late Ming ornament essentially consists of variations on the dragon theme. The dominant motifs on porcelain right up until the seventeenth century are dragon and phoenix, and pairs of dragons chasing the flaming pearl, and these appear combined with lotus scrolls and other formal ornament. Wares of particular late Ming reigns are most readily recognised by the colours rather than the style of their decoration.

The Hongzhi era is best known for green and white wares, on which the decoration was reserved on the biscuit porcelain by means of a resist, then painted in green enamel before being fired for a second time. Several pieces are known with uncoloured biscuit ornament reserved against a

147 *Meiping* vase, porcelain with green enamel decoration. Most of the decoration on this vase was reserved against the white glaze for the first firing, after which it was coloured with green enamel glaze. The dragons' claws and whiskers are painted over the glaze, as are the single lines dividing the vase horizontally. Additional incised decoration of flaming pearl appears between the dragons. The base is unglazed. Ming dynasty, Hongzhi mark and period (1488–1505). HT 36cm. OA 1924.12–16.1, given by H. Sinclair.

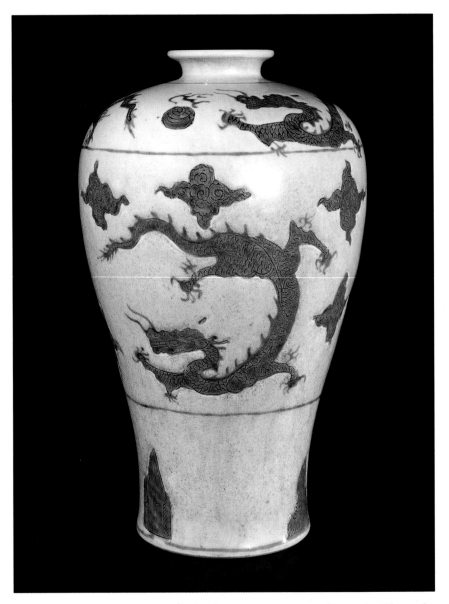

white glazed ground. Green and white wares continued into the Zhengde period, though blue-and-white porcelains were more numerous during that reign. The Zhengde blue has a watery tone and often tends towards grey. The period is perhaps best known for the blue-and-white wares in Islamic shapes, bearing Arabic inscriptions. The poorly written Persian proverbs and verses from the Koran are not indications that the pieces were made for export to the Middle East; rather they show in what high esteem the Zhengde emperor held Islam, even to the extent that he wore Arab dress occasionally, and banned the consumption of pork. 148

The blue-and-white wares of the following Jiajing reign are, by contrast, renowned for the strong, vibrant tones of their imported cobalt

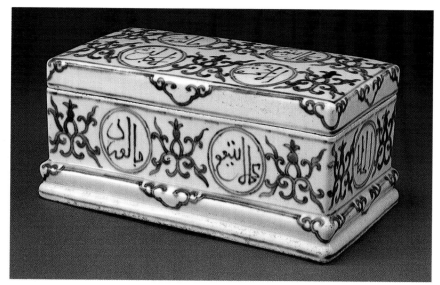

148 Blue-and-white porcelain writing-box. The Arabic inscriptions in the roundels mean 'A fool finds no contentment' and 'The reins are of no use to a blind man'. The Arabic script is shaky and the quality of blue is poor. Arabic inscribed wares were made for the Zhengde emperor, who favoured Islam, and also for Muslim merchants resident in the ports of south China. Ming dynasty, Zhengde period (1506–21). HT (with cover) 9cm, L 20.5cm. OA 1973.7–26.364, Seligman Bequest.

pigment, long known as 'Mohammedan blue'. Jiajing ornament includes pictorial designs and stylised calligraphy. The porcelains produced during the short reign of Longqing anticipate the combination of underglaze blue and overglaze enamel decoration more closely associated with wares of the succeeding Wanli period known as *wucai* ('five colour'). Some examples of porcelain from these two periods are quite fine, but most of the wares are coarse-bodied with rather clumsy decoration.

The constraints of imperial style were not, of course, felt at the privately operated kilns of Jingdezhen, which produced large quantities of more vigorously decorated porcelain for sale throughout the empire. The figure and landscape decoration developed during the period after the withdrawal of imperial patronage at Jingdezhen in the 1620s had probably already existed for some time at the city's non-imperial kilns.

There is literary evidence to suggest that porcelain cost very little in the late Ming period during the sixteenth and early seventeenth centuries, and that it was used as tableware only by those who could not afford gold, silver or jade. The fine ceramics of Jingdezhen were still only affordable to the well-off yet, as Craig Clunas has pointed out, they were cheap in comparison with the other accoutrements of late Ming elegance, such as fine silk and printed books. The low value of porcelain is vividly illustrated by the inventory compiled in 1562 of the possessions of the discredited official Yan Song. His fine items and antiques were confiscated by the palace while his household effects were valued and sold. Amongst the latter were listed 45,000 ceramics.

The low status accorded to porcelain in the late Ming may equally have applied to contemporary ceramics earlier in the dynasty, particularly to those made at the private kilns of Jingdezhen. The status of older porcelain was quite different. The *Ye huo bian*, published in 1606 during the Wanli period, records that a pair of Chenghua wine cups cost 'quantities of silver and lots of gold', indicating that within as little as a

hundred years after its production, Chenghua porcelain already commanded high prices. Wares of the Chenghua period clearly became esteemed and valuable quite quickly. Not only is there ample literary evidence earlier in the Ming, such as the *Ge gu yao lun*, that ceramics of previous periods were prized, but in some cases the objects themselves incorporate references to porcelains of relatively recent manufacture. A unique piece belonging to the British Museum bears a genuine Xuande mark (AD 1426–35), but it is an imitation of Ge ware produced in the Yuan dynasty (AD 1279–1368). Ge ware, now shown to be a Yuan dynasty product, has for century after century been considered one of the five major Chinese ceramic types of the Song dynasty. Thus do the complexities and contradictions of connoisseurship and collecting reveal themselves.

150

The continuous regard for the antique gave rise in the late Ming to some dubious practices, one of which concerns Ding ware incense burners. Ding being a classical Song ware, and incense burners a derivative of a truly antique bronze form, such pieces were obvious candidates for fabulous prices, which at least two examples are known to have achieved. Yet Ding wares, though imperial pieces themselves, pre-date

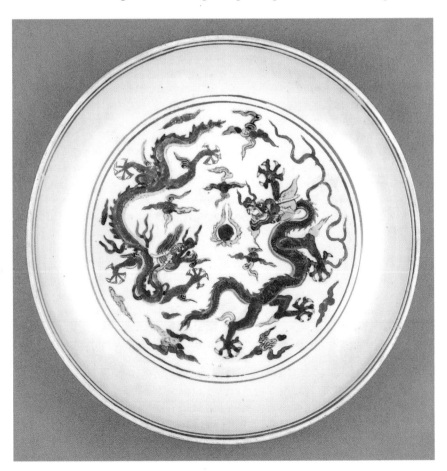

149 Porcelain dish decorated with two dragons chasing the flaming pearl, in underglaze blue and overglaze enamels. Although the Longqing reign was itself short-lived, the style of porcelain decoration is part of an enduring late Ming tradition. Longqing mark and period (1567–72). D 32.5cm. OA 1945.10–16.11, Paget Bequest.

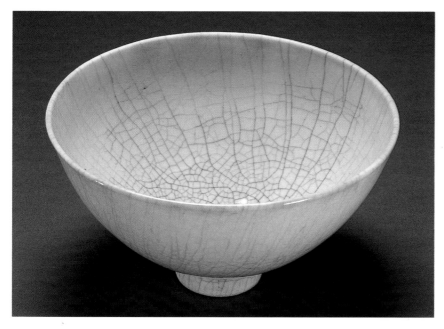

150 Bowl, imitation of Yuan dynasty Ge ware. The ivory glaze has two crackles, known as 'golden thread and iron line'. The golden crackle is fine and closely crazed while the dark grey is on a larger scale. The mark is executed in underglaze blue within a double circle on the base. Ming dynasty, Xuande mark and period (1426–35). HT 8.7cm, D 16.2cm. OA 1968.4–22.38, Sedgwick Bequest.

the Song interest in archaism, and no vessels in the shapes of bronzes were ever produced at the Ding kilns. The late Ming potter and dealer Zhou Danquan himself admitted to having had one made. It seems, then, that the scholarly pursuits which in the Song dynasty had dictated high quality production for a specific and sophisticated clientele had, by the mid Ming dynasty, become the means by which numerous potters and still more dealers deceived aspiring literati.

The continued transformation of the contemporary into the collectable is the point which foils any attempt to identify a scholarly tradition in Ming ceramics. Early Ming monochromes rely for their aesthetic success on some of the principles of form and colour that grace the classic wares of the Song. Either because the court retained exclusive control over porcelain production in the early Ming, or because later Ming gentry lacked the confidence to define their taste and dictate its expression, fine porcelain of the dynasty was concerned with ornament and colour in place of the less transient qualities of form and texture. The interest in the antique and the practice of collecting were sufficiently widespread in the Ming that the pursuits of one dynasty's scholars may be said to have become the habits of another's well-to-do. In this self-conscious atmosphere, fine wares of relatively recent manufacture, such as Xuande and Chenghua porcelain, were worth considerable sums while the truly
152 antique fetched fortunes. Red stoneware teapots and desk accoutrements, which were often in plant shapes such as lotus pods, from Yixing in Jiangsu province are an example of scholarly rather than fine late Ming ceramics highly regarded in their own time. These too were soon faked. The most famous Yixing potter was Shi Dabin, whose signed teapots commanded high prices even during his own lifetime in the late sixteenth and early seventeenth centuries. Already in the early Qing period,

doubts were expressed by the dramatist and collector Kong Shangren (1648–1718) about the authenticity of a Shi Dabin teapot in his collection.

The Transitional period

151 There was good reason for the relatively low value of contemporary ceramics during the sixteenth and early seventeenth centuries, for the great majority of Wanli wares from Jingdezhen were roughly potted from poorly prepared paste. The Wanli emperor enjoyed a luxurious life amid his corrupt court for almost fifty years, but the son who succeeded him ruled for only a month before being poisoned. This happened in 1620, and afterwards so much imperial money was spent on supporting Ming armies to ward off the Manchu threat that the imperial kilns were no longer funded. The lack of imperial funding continued until 1683, the twenty-second year of the reign of Kangxi (1662–1722), second emperor of the Qing dynasty. This interval of some sixty years has been called by Western writers on ceramics the Transitional period.

The lack of support from the Emperors Tianqi (1621–7), Chongzhen (1627–44), Shunzhi (1644–61) and initially Kangxi, had a liberating effect on the Jingdezhen potters. Compelled to seek new markets, they sought new shapes and decoration. Japan and Europe were the main markets during the Transitional period, but large quantities of porcelain were produced for domestic consumption as well. With the establishment of the new markets, the quality of the porcelain body material quickly improved. At first, in the Tianqi period, the blue-and-white wares departed only a little from Wanli styles, but some extant dated Tianqi

153 pieces display the round forms and narrative ornament which developed so quickly in the Transitional period, and on which much Qing porcelain is based.

The use of scenes from poems, plays and novels to decorate the new and improved porcelain had much to do with the greatly increased circulation of printed books during the Wanli period. Narrative decoration is often identifiable with particular incidents in literature, and the most widely used literary sources were the novels *Romance of the Three Kingdoms* and *The West Chamber*. Landscape painting emerged from its subordinate role to become a principal design. This prominence was made possible by an improvement in the preparation of cobalt ore, probably still mined locally, which could give fine gradations of wash. The rich purplish tone of the Transitional blue contrasted well with the milky white body. The paintings were applied to round forms such as vases, censers and the new cylindrical brush-pot, all of which presented the problem of how to link scenes on opposite sides of the piece. The two devices of steep cliffs and banks of cloud solved the problem and are often to be seen on Transitional blue-and-white.

It is sometimes possible to identify the very edition from which a ceramic design was drawn. It is hard not to notice the adoption of certain devices, such as trees, flowers and particularly grass, which is represented by a neat tick or 'v' shape. The most useful practice adapted for porcelain from printing and painting was that of the colophon, lines of verse

151 OPPOSITE (ABOVE LEFT) Porcelain box and cover, decorated with underglaze blue and overglaze enamels. The lobed hexagonal sections of this box suggest a shape more usual in lacquer than porcelain. Late Ming dynasty, Wanli mark and period (1573–1619). HT 13.2cm. OA F1606.

152 OPPOSITE (ABOVE RIGHT) Jar, Yixing *zisha* stoneware. The jar is small, a common feature of wares for the scholar's studio, and the largest inscription is incised in the most formal style of Chinese calligraphy. An inscription on the base dates the jar Wanli *dingyu* year, AD 1597. HT 10.3cm. OA 1981.2–6.1.

153 OPPOSITE (BELOW) Porcelain censer with underglaze blue decoration, inscribed 'Wu, called Dongxiang'. The scenes are from the *San Guo zhi yanyi (Romance of the Three Kingdoms)*, an epic of the struggle for state power in the late 2nd and 3rd centuries AD, following the collapse of the Eastern Han dynasty. The story is best known through the 17th-century historical novel by Mao Zonggang, an illustrated edition of which must have provided the source for the designs on this censer. Dated 5th year of Tianqi, AD 1625. HT 12cm. OA 1971.6–22.1.

describing the narrative subject and ending with the date and sometimes the artist's name. The porcelain painters copied the lines but added their own dates, using the sixty-year cyclical form. This practice meant that an existing body of porcelain can be dated either to the middle or the end of the seventeenth century, the earlier date now being generally agreed. Surprisingly, a significant number of Transitional wares bear reign marks even though the kilns operated privately.

These great departures from the late Ming court style did not occur in enamelled wares until sometime after 1640. Towards the end of the Transitional period, the earliest type of *famille verte* enamel palette was introduced. The term *famille verte* denotes porcelains on which the principal enamel colour is green, just as the term *famille rose* describes a slightly later ware with predominantly pink decoration. These terms, along with the phrases *famille noire* and *famille jaune*, were coined by a mid-nineteenth-century French collector of ceramics, Albert Jacquemart, and have been used ever since to refer to the various enamelled porcelains of the Qing dynasty.

154, 156, 157
158, 159

The styles developed in the Chongzhen period continued throughout the Shunzhi period and even into the early years of Kangxi. The early Qing period saw the cessation of export orders and the subsequent application of certain export characteristics, such as multiple borders, to domestic wares. The period was dogged by intermittent fighting between the new Manchu rulers and Chinese rebels in the south, and in 1674 Jingdezhen was pillaged and burnt.

The Qing dynasty: Kangxi

The Jingdezhen factories were rebuilt in 1677 and their new products included the *famille verte* porcelains, wares combining underglaze designs in both blue and red, and pieces displaying a new textured style of underglaze blue painting. Household ceramics such as dishes, bowls and cups were added to the range of forms these designs ornamented. The supervisor of the rebuilt factories was Zhang Qizhong, a magistrate to whom the banning of Kangxi's reign mark has been attributed. The emperor's name was regarded as too sacred to be put on porcelain. This is not so unusual, given the long practice of 'taboos' in which written characters of identical sound replaced those of the emperor's name for the duration of his rule. Emblems were used instead of the reign mark, and these include the conch shell, artemisia leaf and various flowers. The practice was adhered to until 1683, after which some symbols continued in use, but the mark *Da Qing Kangxi nian zhi* ('made in the years of Kangxi of the Great Qing') also appeared regularly on porcelain wares. It was in 1683 that Zang Yingxuan, the first of the three celebrated Qing dynasty imperial supervisors, was appointed at Jingdezhen. He heralded the last great age of porcelain production.

The imperial kilns were a few amongst scores at Jingdezhen but they occupied the best positions, enjoyed the best of the raw materials and employed the most skilled craftspeople. There were six kilns devoted to producing wares for imperial use and twenty-three workshops, each one

devoted to a particular part of the production process. The imperial palace in Beijing required huge amounts of porcelain. In addition to ceremonial wares, which were required for at least six temples and numerous small altars, porcelain was needed for the emperor's official and personal use, and for all the concubines, children and other nobles who inhabited the thirty-seven acres of buildings comprising the imperial palace.

The other kilns were all privately operated and known as popular kilns, except for those manufacturing high-quality wares for the nobility. These were called 'official old kilns'. Their wares were often as fine as the imperial pieces and had the added attraction of more adventurous decoration since court styles were prescribed and rather formal. These private kilns at Jingdezhen supplied the rest of China and the export markets. It is therefore not surprising that, quite early in the Qing dynasty, the clay from the traditional source at Macang hill in Xinzhengdu, Fouliang county, was exhausted. New clay was transported to Jingdezhen from Wumen, also in Fouliang county.

Zang Yingxuan supervised the imperial factory from 1683 to 1688, a period which is most renowned for its monochrome glazes. It is hard to ascribe particular pieces to this short period, yet there can be no doubt that the monochrome wares of the Kangxi and later periods are some of the most stunning of all Qing porcelains. They are typical of this last great phase of Chinese ceramics in that they are not innovative but their technology is extraordinarily fine. In addition to the red, white and blue monochromes of the Ming dynasty, the Qing potters produced turquoise, bright green and various types of yellow glazed pieces. Turquoise and green glazes were coloured with copper in alkaline and lead-rich bases respectively and could not be fired at high temperatures, so they were applied to fired porcelains already covered with a trans-

154 Pair of porcelain bowls with incised decoration and overglaze enamels. The dragons incised beneath the flowering branches and butterflies distinguish these bowls as imperial pieces. Many late imitations of this type were produced. Qing dynasty, Kangxi mark and period (1662–1722). OA F539+.

parent glaze. The same technique was used for the iron-yellow decoration, but this colour was also sometimes applied directly to the biscuit-fired body with no clear glaze layer in between.

The rediscovery of copper-red glaze was the great contribution of another controller of the kilns, Lang Tingji (1705–12), who gave his name to the bright red wares. The glaze composition and the longer firings used in Qing kilns meant that these later copper reds lacked the resonance of the Xuande pieces, but they are nonetheless a fine achievement. Monochromes, as the ceremonial wares of the emperor, had to be of the finest quality.

Blue-and-white wares were not prominent amongst palace porcelains, but were important in the 'official old kilns' output and dominated the export market. The Kangxi period is renowned in the history of blue-and-white for clear colour and painterly decoration. The purple 155 hues of Transitional ware were replaced by the lighter tones of cobalt from Zhejiang province to the north of Jiangxi. These blues were enhanced by the development of a new body material which is mentioned by Père d'Entrecolles and indeed found in some Kangxi wares, but which become more widely used later in the eighteenth century. Talc replaced kaolin in the new material, which is known in Chinese as *huashi* ('slippery stone') and in the West, slightly inaccurately, as 'soft paste'. The talc and porcelain stone mix gave a body still whiter and lighter than the kaolin and porcelain stone mix, despite the approximate 60-40 proportions. *Huashi* paste was so fine and costly that it was often used only to coat standard body material.

Large forms did not shy from monumental landscapes, while medium-sized jars and bowls displayed more intimate garden scenes depicting scholars, ladies or children at leisure. The imperial wares were mostly dishes, bowls and vases decorated with dragon, phoenix, pine, bamboo and flowers. The more elaborate forms are usually the products of private kilns and their decoration is complex. Some popular themes are the eight immortals, the eight auspicious objects and the myriad children, as well as themes from the popular novels *Water Margin, The West Chamber* and *Journey to the West*.

During the early part of Kangxi's reign in the late seventeenth century, the first form of *famille verte* decoration appeared. Because the blue was 156 under the glaze and the other enamels were painted over it, this scheme is distinct from the mature *famille verte* palette and is often described as *wucai* or 'five colour'. In fact, this differed little from the underglaze blue and overglaze enamel decorated wares of the late Ming in choice and combination of colours, though it must be said that a bright apple green did dominate the Kangxi *famille verte* wares.

The true *famille verte* palette, invented at the very end of the seventeenth century or the very beginning of the eighteenth, is distinguished by the use of blue overglaze enamel colour. The search for a blue enamel that could be used over the glaze was probably prompted by the seventeenth-century invention of a white glaze, against which the enamel colours were greatly enhanced. Traditional underglaze blue was obscured by the

155 Large blue-and-white porcelain brush pot. Qing dynasty, Kangxi period (1662–1722). HT 14.6cm, D 17.6cm.
OA 1957.12–16.5, given by A. D. Passmore.

new white, yet when the same pigment was used on top of the glaze and fired at a low temperature, an overglaze purple colour resulted from manganese in the native Chinese cobalt ore. A new blue glaze composition was therefore required, and recent research at Oxford suggests that it may have been found by turning to cloisonné enamel technology.

In the second quarter of the seventeenth century, cobalt-blue enamel similar to that used over the glaze on Kangxi porcelain was already being painted on to copper. Early in the Qing dynasty a cloisonné enamel workshop existed within the palace, and it is known that enamel colours for Jingdezhen were also prepared within the palace; so it is reasonable to regard the overglaze blue enamel of the late seventeenth or early eighteenth century as deriving from cloisonné technology.

In common with the green, brown, grey and aubergine of *famille verte*, the blue enamel was transparent. All these colours flowed when they melted and were therefore not good for shading or outlining. The black and red colours, on the other hand, were opaque and useful for fine outlines or texture detail. Both were applied over the glaze. The red enamel could be used alone, but the black was simply a pigment and needed to be overlaid with enamel if it were not to rub off after firing.

Early eighteenth-century *famille verte* porcelains are fine wares indeed and similar in purpose to the blue-and-white wares, though the bright colours tended to be used for more detailed styles rather than for
157 monumental landscapes. The wares were embellished with the first gold

156 Porcelain dish. The combination of underglaze blue with overglaze enamel decoration is technically the same as late Ming *wucai* ('five colours'). The scene depicts the Eight Immortals visiting Shoulao, the God of Longevity. The base is marked *yu tang jia qi*. Qing dynasty, Kangxi period, before 1683. D 28.7cm. OA F493+.

pigments fired on to porcelain in China, previous examples having used the far less durable forms of gold leaf or mercury gilding.

Yongzheng

The porcelains known as *famille rose* represent the next major technological breakthrough, and also Jingdezhen's last. The distinctive pink enamel from which they take their name was developed at the end of Kangxi's reign, probably in or around the year 1720, two years before the emperor's death. The type is more closely associated with the subsequent reign of Yongzheng (1723–36), during which the most delicate enamelled wares were produced. There has been much discussion regarding the origin of pink enamel in China, thought by many to have been introduced from Europe. While there can be no doubt that Jesuit artistic influence

158

159

157 Large porcelain dish decorated with pheasants and flowers in overglaze enamels and extensive gilding. Heavily decorated wares of this size were primarily made for export to Europe. Qing dynasty, Kangxi period (1662–1722). D 57.8cm. OA F407, given by A. W. Franks.

at the Qing court was strong, even extending to painted enamel wares, there is equally little doubt that Chinese pink enamel technology is quite different from European.

The pink is provided by gold in both cases, but is prepared by different means. French pink contained tin as well as gold, while the Chinese red contained little or no tin. The ruby glass that resulted was ground up as a pigment to be dispersed in clear enamel. The ground ruby glass method was cheaper as it used far less gold. Kingery and Vandiver have shown the percentage weight of gold in Chinese pink enamel to reach a maximum of 0.31 per cent, a small amount indeed. The enamel was opaque, and its introduction coincided with the appearance of two more opaque enamels in addition to the black and red ones of the *famille verte*: a yellow containing lead stannite in place of the iron oxide in *famille verte* yellows, and a lead arsenate white. The Oxford research showed that the *famille rose* yellow and white enamels are found in early seventeenth-century Chinese cloisonné, which may have been their original source for the Jingdezhen potters. The opaque colours are composed of lead-alkali-silicates, like cloisonné enamels, while the earlier transparent enamels are usually simple lead silicates. The *famille rose* palette included black and brown enamels which could be used without an enamel overlay, because they contained their own fluxes.

The outstanding advantage of opaque colours was that they could be mixed with other pigments to produce new colours, thereby enormously increasing the porcelain painter's palette. White was naturally the most useful enamel from this point of view, and provided the many pastel

158 ABOVE Pair of wine cups. This type of pink enamel glaze, only introduced in the last two years of Kangxi's reign, was applied to the exteriors of these cups by blowing it through a bamboo tube covered with a fine silk gauze at one end. This accounts for the even tone of the glaze. The interiors are glazed white. Qing dynasty, Kangxi mark and period (1662–1722). HT 4.3cm, D 8.4cm. OA 1945.10–16.8, 9.

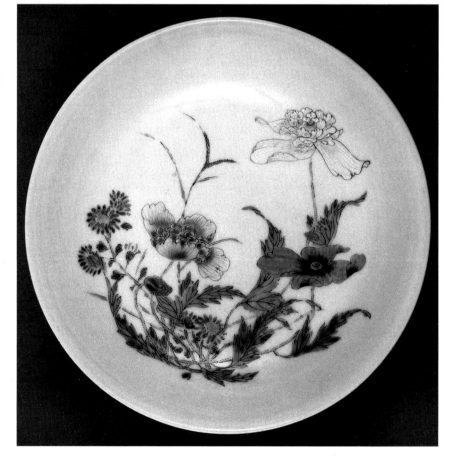

159 RIGHT Porcelain dish decorated in *famille rose* enamels with peony, Michaelmas daisy and poppy. Qing dynasty, Yongzheng mark and period (1723–36). D 14.9cm. OA 1953.10–15.7b, given by the Hon. Mrs Basil Ionides.

shades to be seen on *famille rose* porcelain. The increased range of colours refined the detail on porcelain painting, and Yongzheng wares with delicately painted ornament on a superbly clear white ground are amongst the most exquisite Chinese porcelains. The influence of Jesuit painters at the Manchu court is discernible in certain pastoral scenes and details of dress. It is said that Nian Xiyao, porcelain supervisor from 1726 to 1728, who was also a porcelain painter, was a pupil of the Italian artist in Beijing, Giuseppe Castiglione. An additional impetus for the fine decoration made possible by the new enamels was the personal involvement of the Emperor Yongzheng, who is said to have favoured landscape decoration and ink and wash style. It was perhaps this predilection for painting styles that lay behind the couplets, executed in neat black enamel calligraphy and followed by a small red enamel seal, which accompany many small scenes on *famille rose* porcelain. Pink wares with calligraphy have traditionally been known as *gu yue xuan* ('ancient moon terrace'). They were first made in the Yongzheng period, continued into Qianlong's reign (1736–95) and were widely imitated at the turn of the twentieth century.

Qianlong

In the sixth year of Yongzheng's reign, Tang Ying became imperial supervisor at Jingdezhen, a post once more appointed from the imperial palace rather than by the provincial government as it had been since the beginning of the eighteenth century. Tang Ying remained in office until 1756, twenty years after the Qianlong emperor ascended the throne, and many of the porcelain types associated with that emperor actually commenced during the Yongzheng period. Such wares principally include porcelains imitating the great Song wares of the Ding, Ru, Jun, Guan and Ge kilns, enamelled wares, and blue-and-white wares copying early fifteenth-century Ming styles. Imitation did not rest with earlier ceramics, however, for sophisticated manipulation of glazes resulted in porcelains parading as wood, stone, bamboo, lacquer or bronze, sometimes quite successfully. Enamelled wares were decorated with increasingly dense, complex and colourful designs. This impressive variety has caused the Qianlong period to be associated by many with heights of virtuosity and depths of vulgarity.

With so many fine materials at their disposal, and with the knowledge that these could all be fired successfully, the mid-eighteenth-century porcelain designers enjoyed unprecedented creative freedom, but the aesthetically stagnant wares which they produced imply that this technological peak coincided with a decline in artistic innovation. The very perfection of Qianlong porcelains is their main shortcoming. The shapes are well judged, the bodies superbly fine and white, and the decoration immaculately ordered and executed. However, the ornament seldom shows regard for the vessel shape, being either divided into neat fields of decoration or depicted within densely filled borders or background. The chrysanthemum scrolls are a simple motif to compare with the early Ming porcelains from which they derive: those of the fifteenth-century

Xuande period look perfectly graceful, while those of the Qianlong look accurately measured. Some Qianlong wares seem to indulge a temptation to show as many techniques as possible, resulting in an extravagance of coloured glazes and intricate motifs whose total impact is far less than that of the multiple skills they embody. Where these skills are directed towards wares with a single glaze, the effect is greater. Qianlong monochromes are renowned for their range of bright colours reminiscent in some cases of glass vessels, and for the textures and luminous effects of certain other glazes such as 'tea dust' or those resembling lacquer.

The perfection of the highly decorated wares is explained to some degree by the production process. In 1743 Tang Ying, as the foremost ceramic expert in the land, was summoned to the court in Beijing to annotate a series of illustrations of porcelain manufacture in the imperial collection. The headings he provided, summarising the twenty steps involved in producing the pottery, are worth listing:

collection of clay/refinement of clay/making of glaze/making of saggars/ making of prototypes/shaping of circular wares/shaping of non-circular wares/grading of underglaze blue/grading of cobalt mineral/grinding of

160 Hexagonal porcelain vase with olive-green glaze and gilding. The glaze colour resembles bronze patination, but the shape and the use of gilding are perhaps closer to lacquer styles than to metal. The vase was possibly made for use on an altar. The gold decoration applied over the glaze is well preserved and includes auspicious symbols and stylised longevity characters. The base bears the mark, in gold, of Jingde (reigned AD 1004–7), after whom the porcelain city of Jingdezhen is named. Qianlong period (1736–95). HT 38cm. OA F57, given by A. W. Franks.

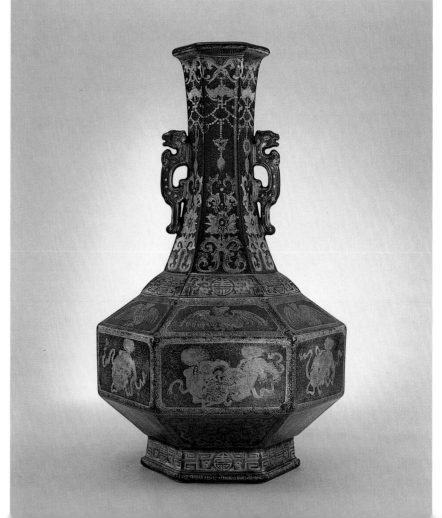

cobalt/application of blue pigment/decorating the wares/application of glaze/finishing of biscuit/filling the kilns/firing/ application of overglaze decoration/baking/grading and packing/thanksgiving to the gods.

No-one, evidently, was responsible for a single piece, but it is clear from the porcelains themselves that each artisan excelled at a particular task. Labour was divided at Jingdezhen early in its history but never so elaborately as under Tang Ying. It is perhaps the narrowness of these skills in executing well-established designs that denies many Qianlong imperial wares the elegance of their Yongzheng precursors or the vigour of the still earlier Kangxi pieces.

The Qianlong emperor clearly took a personal interest in the porcelain produced during his reign. He was also an ardent collector of antiquities and aimed to assimilate every famous old painting, bronze or other object into the imperial collection. This policy led to the commissioning of numerous copies by connoisseurs who did not wish to lose their paintings to a man, however elevated, who would impress his large seal on them in a prominent position. For, as his porcelains suggest, Qianlong was not modest. Individual ceramics were not sufficiently famous to be

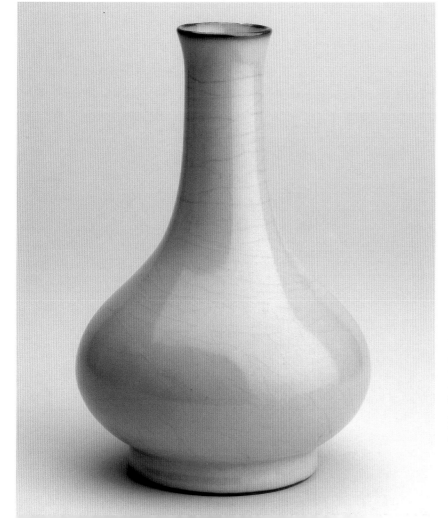

161 Porcelain vase, imitation of Song Guan ware. The rim of the mouth and foot have been painted brown to imitate the 'purple mouth and iron foot' of Song Guan wares (see fig. 77). The base has been inscribed with a poem by the Qianlong emperor extolling the wonders of Guan ware. Qianlong was an avid collector of antiquities. Dated Qianlong *guisi* year, AD 1773. HT 20.9cm. OA 1936.10–12.177.

sought out in this way, but there are several genuine Ru wares whose bases have been inscribed with lengthy verses by Qianlong. Many ceramics were produced in the style of Song pieces, and particularly in imitation of Guan ware. Guan, Ge, Ding and Jun wares were the 161 most reproduced of the Song types, while an unsuccessful attempt to imitate Jun ware prompted the creation of a distinct blue and purple glaze known as 'robin's egg'. Some Southern Song wares had borrowed 129 ancient bronze vessel shapes, but the eighteenth-century imitations were also glazed in bronze colour. Other ceramics copying bronze altar vessels are decorated as ceramics in blue and white, with no regard for the nature of the altar pieces they imitate. Perhaps by the eighteenth century the bronze-derived shapes were so much a part of the porcelain repertoire that it was not necessary to marry the surface with the shape. The great Qing novel of manners, *Hong Lou Meng* ('Dream of the red chamber' or 'The Story of the stone'), includes meticulous descriptions of life in a grand eighteenth-century house and mentions Guan, Ru and Ding wares. The collecting practices of the late Ming were evidently alive and well during the Qing.

In 1756 Tang Ying reliquished his post. He wrote several treatises on porcelain and signed numerous pieces he had produced. He is undoubtedly the most celebrated individual in China's ceramic history, and the porcelains produced during his period in office are often referred to as 'Tang wares'. The period which followed such an able craftsman and administrator was bound to show some decline in the standard of ceramics, and this indeed occurred. The decline was slight in the late Qianlong period but accelerated thereafter. The same types were prod-

162 Porcelain bowl with enamel decoration. The white interior is decorated with five red bats, symbols of happiness because the character *fu* for 'bat' has the same pronunciation as the different character *fu* for 'happiness'. Qianlong mark and period (1736–95). HT 6.1cm. OA F577+.

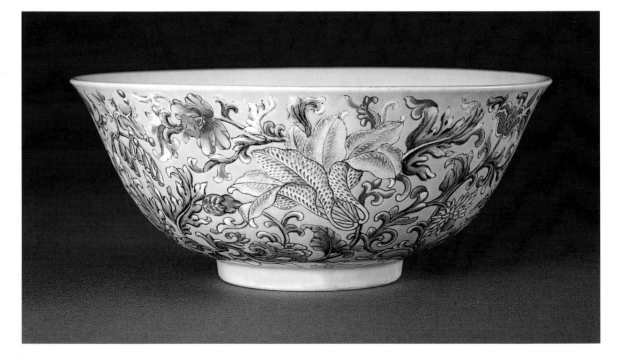

uced, but the materials were less fine and the decoration less skilled. The post-Qianlong era never enjoyed either the artistic or the economic capacity to revive the porcelain industry, and although some fine wares were produced periodically, the nineteenth century was an age of steady deterioration at Jingdezhen.

The regulations for imperial porcelain as defined in 1766 were followed by Qianlong's successors until 1899, at which time they were moderately revised. These rules were in effect for the remaining twelve years of the Qing dynasty. They were minutely detailed, including such matters as the quantities of porcelain allowed for domestic use by different members of the imperial family according to their rank. For example, the Empress Dowager was allowed yellow porcelain totalling 821 pieces; the Empress was allowed yellow porcelain totalling 1,014 pieces; a concubine of the first rank was allowed yellow porcelain with a white interior totalling 121 pieces; concubines of the second rank, yellow porcelain with green dragon decoration, and so forth. These allocations are set out in the *Huangchao liqi tushi* ('Illustrated regulations for ceremonial paraphernalia'). Ceremonial wares were, as ever, monochrome, and different colours were assigned to different temples as follows: red wares for the Temple of the Sun; yellow for the Temple of the Earth; bluish white for the Temple of the Moon; blue for the Temple of Heaven.

Nineteenth century onwards

The Emperor Jiaqing (1796–1820) did not share his father Qianlong's enthusiasm for fine objects and paintings, nor was he as extravagant. 163 The porcelain designs of the Qianlong period therefore continued with

163 Pair of porcelain 'medallion bowls' with enamel decoration and gilding. The term refers to the reserved roundels of decoration. Bowls very similar to this Jiaqing pair were also made in the preceding Qianlong period (1736–95) and the succeeding Daoguang period (1821–50). Jiaqing mark and period (1796–1820). HT 6.9cm. OA F637+.

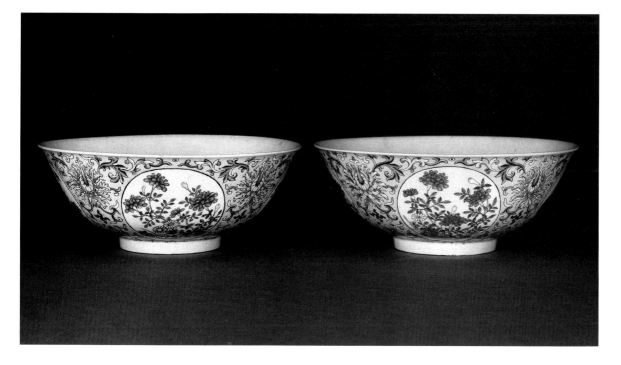

little alteration, and it is thought that those made in the early years of Jiaqing even carried the reign mark of the earlier emperor. The frugality of Jiaqing meant that patronage for the kilns declined. It was not revived by his successor Daoguang (1821–50), who in the last year of his reign ordered the permanent cancellation of sixteen pottery types from the regular list. At the beginning of Daoguang's reign, the heavily decorated ornate styles of the Jiaqing period prevailed. Bowls with roundels of decoration against incised coloured backgrounds covered with floral motifs are a distinctive Daoguang type, known as medallion bowls. They are frequently embellished with *famille rose* decoration and gilding, giving an effect similar to that of cloisonné enamels. Landscapes and garden scenes are prominent amongst the panels of decoration on Daoguang porcelain, and it has been suggested that all the scenes were copied from one particular *hua pu* (illustrated book). The quality of Daoguang wares is variable. A few pieces are fine but even these are rather thickly potted at the foot, and the majority are heavy in comparison with earlier Qing pieces. The quantity was also reduced considerably. It was recorded both by Père d'Entrecolles in 1712 and the British envoy Sir George Staunton in the 1790s that three thousand kilns operated at Jingdezhen, while another European who visited the city in 1837 wrote that there were only three hundred kilns there.

Daoguang was succeeded in 1851 by Xianfeng, during whose ten-year reign Jingdezhen was razed by the Taiping rebels. Prior to this, some porcelains displaying improved thinness and skill were produced. The brilliant tone of the blue was also superior to the slightly greyish tinge of Daoguang underglaze blue decoration. Such pieces were produced for only a few years of the Xianfeng reign before Jingdezhen's kilns were destroyed, so they are rare. It is possible that coarser wares bearing the Xianfeng mark were supplied by private kilns for the remainder of his reign. The rebuilding of the kilns is said to have started early in the reign of Xianfeng's successor Tongzhi (1862–74) under the supervision of Cai 164 Jinqing. A long list of wares supplied to the Emperor in 1864 implies that production had commenced once more but, although the list specifies fifty-five types of ware, the quantities are not mentioned. The quality of wares was improved slightly compared to the mid-nineteenth-century pieces, perhaps because once more there was imperial interest in the manufacture of porcelain.

During the Guangxu period (1875–1908) that followed the reign of Tongzhi, there is evidence that the far-reaching influence of the Empress Dowager, Zi Xi Tai Hou, finally penetrated Jingdezhen. It is possible that some of the imperial orders from earlier in the century had been instigated by her, but in the Guangxu period she ordered a set of porcelain for her own apartments. In 1889 a further 868 pieces were ordered for the Emperor Guangxu's wedding, in addition to the usual palace quota of almost eight thousand pieces per annum. The reign mark was not widely used at this time, but detailed production lists such as that of the year 1900 do survive, so that Guangxu porcelains can sometimes be identified as easily from written records as from their own marks.

Between 1875 and the early years of the twentieth century, many pieces were made in earlier Qing styles. The absence of the reign mark may imply that such objects were intended to deceive, particularly in view of the large number of foreigners and potential collectors in China at that time. The reign mark, when it was used, was applied at many private kilns and was no longer restricted to the imperial factory. One of the commonest reign marks of the nineteenth century was that of Kangxi.

In 1909 the boy emperor Pu Yi ascended the throne, to be toppled within three years. His reign was called Xuantong and its porcelain is barely distinguishable from late Guangxu production, except when it bears his mark. The Chinese Republic was established in 1912 and was transformed into an empire once more by its president Yuan Shikai in 1915, with short-lived success. Yuan Shikai demonstrated the political significance of ceramics by immediately ordering forty thousand pieces of porcelain bearing the mark 'Hong xian', which he adopted as his reign title. Yuan Shikai's abdication after eighty-two days as emperor, and his death within three months, meant that nothing like that amount was 165 produced, and Hong xian porcelain is quite rare. Its style is reminiscent

164 Porcelain jar with *qianjiang* decoration in overglaze enamels. The term is borrowed from painting and denotes a particular landscape colour scheme. The style marks the beginning of the 'literati school' of porcelain painting which flourished in the early 20th century, in which porcelain was treated as silk by specialist painters rather than as ceramic by artisans. Tongzhi mark and period (1862–74). HT 7.2cm. OA 1926.7–15.1.

165 Porcelain vase, Hong xian type. The fine decoration of ladies in a landscape is typical of these wares. A couplet on the reverse reads: 'They go to Hangzhou and do not return, for whom do the blossoms on the river bank flower?'. The distinction of genuine Hong xian porcelain of 1916 from later copies is much debated. This example entered the British Museum collections in 1925, and, if not genuine, must be a relatively early copy. Mark on base: *Hong xian nian zhi*. HT 14.3cm. OA 1925.7–15.2, given by R. L. Hobson.

of the *gu yue xuan* painted wares of the Yongzheng period and belongs to the 'literati school' of porcelain painting which emerged in the 1860s. Such wares are painted in a way which treats porcelain as silk, with carefully conceived compositions complete with colophon and signature. Together with those pieces produced during the Republic of 1912–15 and marked 'Ju ren tang zhi', the Hong xian porcelains represent a fine group of wares which are increasingly appreciated by collectors and connoisseurs. Unfortunately, they were copied on a considerable scale during the 1920s and 1930s. There can be no doubt, though, that the refinement of the thin 'eggshell' porcelain of the Tongzhi period was a major twentieth-century contribution to ceramic manufacture. Even 166 today it is being taken to new limits, thus continuing the search started

166 'Eggshell' porcelain vase with overglaze enamel decoration. The vase, though tall, weighs only 121g and represents the height of current achievement in the manufacture of thin white porcelain. The decoration is distinguished from earlier pieces by the use of overglaze blue enamel rather than underglaze blue pigment for the border decoration. Marked *Jingdezhen zao* on the base. 1990. HT 26cm. OA 1990.7–31.1.

167 Three blue-and-white porcelain flasks, of the Ming, Qing and modern periods, which were all made at Jingdezhen. From left: early 15th century; Kangxi period (1662–1722); 1980s. HT 25cm; 22.1cm; 27cm. OA 1947.7–12.325, 202, Oppenheim Bequest; OA 1987.3–13.18.

in the sixth century for translucency and whiteness.

The Jiangxi Ceramic Bureau was established in 1921 and supervised production at Jingdezhen until the 1940s. In place of an emperor's mark, studio marks or the city's name were added to the bases of the wares. Production has continued throughout the years since 1949, and today Jingdezhen employs 29,000 people in the porcelain industry, producing hundreds of thousands of items annually. The wares are used within China and are widely available abroad; some are marked 'Jingdezhen' and others plainly state 'Made in China'. Kilns in northern and eastern China have in recent years engaged in recreating the wares they produced in the Song dynasty. Such projects have involved Ding, Ru, Jun, Guan and Longquan wares as well as both northern and southern black wares. Although the secret of some glazes remains elusive, the colours and textures of others have been recreated with considerable success. In Shanghai, the Silicate Research Institute creates new ceramic materials for use in items of advanced technology, as well as carrying out analyses of ancient clays and glazes. In Jingdezhen, the Ceramic Research Institute produces fine experimental porcelains which uphold a national tradition begun some eight thousand years ago.

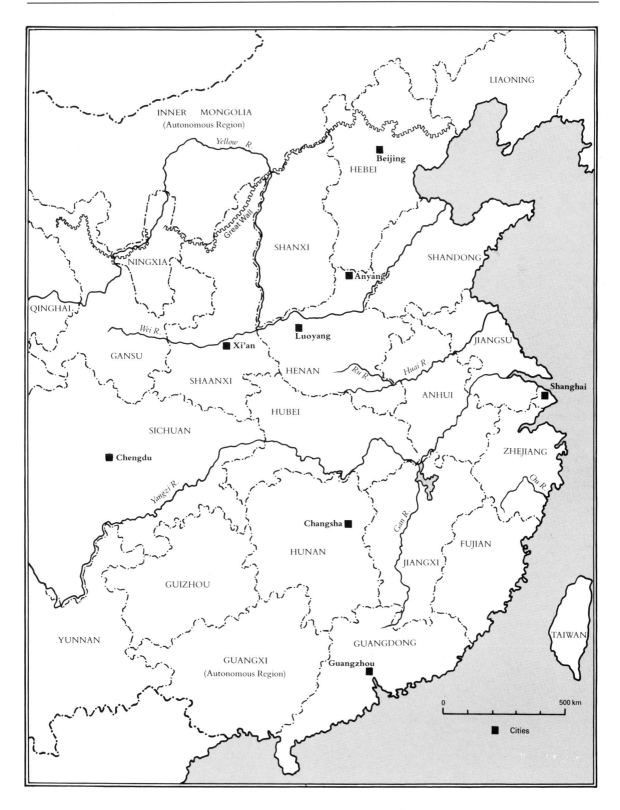

LIAONING

INNER MONGOLIA
(Autonomous Region)

Yellow R.

■ **Beijing**

HEBEI

Great Wall

NINGXIA

SHANXI

■ **Anyang**

SHANDONG

QINGHAI

Wei R.

GANSU

■ **Xi'an**

Luoyang ■

SHAANXI

HENAN

Ru R.

Huai R.

JIANGSU

ANHUI

■ **Shanghai**

HUBEI

SICHUAN

ZHEJIANG

■ **Chengdu**

Yangzi R.

Ou R.

Changsha ■

Gan R.

HUNAN

FUJIAN

JIANGXI

GUIZHOU

YUNNAN

TAIWAN

GUANGDONG

GUANGXI
(Autonomous Region)

Guangzhou ■

0 500 km

■ Cities

APPENDIX I
Clays

China's success in producing fine ceramics is due in large measure to the variety and quality of the raw materials available throughout the country. Some of the characteristics peculiar to Chinese clays are outlined below.

Earthenware
Earthenwares are fired at temperatures below about 1000°C and are soft and porous in comparison with higher-fired ceramics. In China, most vessels produced before the Tang dynasty (AD 618–906) are made of earthenware, as are the majority of burial figures and architectural ceramics.

Stoneware
Stoneware is the term used to describe ceramics whose hardness lies between that of earthenware and porcelain. It may be used to describe early Chinese high-fired wares of the Shang (*c*. 1700 –1027 BC) to the Song (AD 960–1279) dynasties. Stonewares produced before that period are often referred to in China as 'proto-porcelains'. High-quality Song wares not made from secondary kaolin (see below) may be regarded as stonewares, as may some lower-quality Ming and Qing wares.

Porcelain
The term porcelain is usually used to describe ceramics which are hard, white and translucent, though precise definitions have been much debated. The essential requirements are purity of body material and high firing temperature. High-quality clay fired at low temperature would usually constitute stoneware, as would an average clay fired at high temperature. The earliest porcelains in the world are those produced in Hebei and Henan provinces in north China during the sixth and seventh centuries AD. In the tenth century, porcelain was made in Jiangxi province in south China, and this is the basis for the long-term association of porcelain with China. Porcelain was not manufactured in Europe until the eighteenth century.

Porcelain stone
Porcelain stone is the result of the alteration of quartz-feldspar rock by high-temperature fluids in late-stage volcanic processes. It is deposited across south China from Zhejiang in the east to Yunnan in the west, and continues on into north Vietnam. Porcelain stone also occurs in Japan and Korea. The highest-quality deposits are located in Jiangxi province around Jingdezhen and Boyang lake, and this is the only region in which porcelain stone was mixed with kaolin. It was occasionally mixed with a little local clay to produce Longquan wares in Zhejiang and 'Swatow' and Dehua wares in Fujian. Porcelain stone consists mainly of quartz, secondary mica and a little clay. Primary kaolin deposits (see below) often occur in association with porcelain stone.

Kaolin, primary
Primary kaolin is a pure, white-firing, iron-poor clay associated with igneous rocks which have been subjected to alteration by high-temperature solutions. Kaolin is white and plastic and its main function in south China's ceramic industry was as a clay-rich material for mixing with porcelain stone (see above). Porcelain stone has a low clay content, and the addition of kaolin not only renders the material easier to work, but also increases the firing temperature range and provides a smoother, whiter ground for painted decoration. Kaolin seems first to have been used with porcelain stone in the Yuan dynasty (AD 1280–1368) and was added in increasing quanti-

168 Loess magnified and photographed in the scanning electron microscope.

169 Clay-rich loess similarly magnified in the scanning electron microscope.

ties until the eighteenth century, when a maximum was reached of around 50 per cent of the body material.

Kaolin, secondary

Secondary kaolin is derived from primary kaolin deposits (see above) after prolonged sedimentary transport and deposition. It lies in a swathe across north China beneath thick deposits of loess (see below). Along the foothills of the Taihang mountain range, which runs across Henan and Hebei provinces, the loess beds are thinner and the kaolin more accessible, and in these regions kaolin was used to produce ceramics. The earliest known examples were made in the later part of the Shang dynasty between the thirteenth and eleventh centuries BC and have been excavated at the then capital, Anyang. They appear to have been fired at about 1050–1150°C. The next known examples of kaolinitic white ware also occur at Anyang, in the tomb of Fan Cui, dated AD 575. In the Sui and Tang dynasties during the late sixth and seventh centuries AD, kaolin clays were fired at high temperatures to produce the world's earliest porcelain (see above) at the Gongxian kilns in Henan and at the Xing kilns in Hebei. In the late Tang and Song, from the ninth century, the same clay types were used to produce the famous Ding wares of Hebei province.

Loess, primary

Loess is barely a clay at all, with less than 15 per cent of its composition accounted for by true clay minerals. It consists mainly of quartz, feldspar and mica. It was produced by the alternate freez-ing and thawing of igneous rocks in the Tibetan plateau. Once broken, the rocks were pulverised by glaciers, and the dust eventually carried by wind to the north China plains. In places it lies 300 m deep. Primary loess was used for making the ceramic piece moulds from which elaborate bronze vessels were cast during the Shang dynasty (c. 1700–1027 BC). Its low clay content limited shrinkage during drying or firing, thus allowing the construction of complex interlocking mould forms, and its small particle size allowed the loess to retain the high detail of fine ornament. The rammed earth walls surrounding the middle Shang capital of Zhengzhou in Henan province were made of loess, stamped down hard in layers only a few centimetres thick.

Loess, clay-rich

Some loess (see above) is enriched with clay as a result of weathering and transportation by water. Clay-rich loess provided the body material for ceramics produced in the Yangshao Neolithic culture as early as 5000 BC. The same material was used for the terracotta army of the first Qin emperor (221–206 BC), and for lead-glazed earthenware burial vessels of the Han dynasty (206 BC–AD 220).

Iron oxide

Iron oxide is the most widespread contaminant in clay. Northern Chinese clay and southern porcelain stone have unusually low iron oxide contents, which is one reason they produce white-bodied wares. As such they are amongst the rarest types of ceramic body material.

Appendix II

Glazes

A glaze is a glassy coating applied to the exterior or interior surface of a ceramic. Glazes render ceramics non-porous and enhance their appearance. The major glaze types and constituents are outlined below.

Silica

Silica is the main constituent of any glaze. Pure silica provides the hardest possible material in the ceramic spectrum and fuses to glass at about 1700°C. Common forms of silica are quartz and sandstone.

Flux

Flux is the term for any material added to silica (see above) to lower its melting temperature. The flux dictates the character of a glaze; lead oxide and calcium oxide are the major fluxes used in Chinese ceramics.

Alumina

Alumina (aluminium oxide) occurs widely in clays together with silica (see above). It is the third major ingredient of most Chinese glazes.

Lead glazes

Glazes fluxed (see above) with lead have a high refractive index and a very smooth, glossy surface texture. Raw lead, or lead sulphide in its natural form (galena), can be applied directly to a clay body to create a glaze on reaction with the silica content (see above) of the clay. Lead glazes first occur in China in the third century BC and became widely used during the course of the Han dynasty (206 BC–AD 221). In the Northern Qi dynasty (386–581) a superior lead glaze was used, comprising 50–60 per cent lead oxide together with silica and alumina (see above), and fired at 700–800°C. Lead glazes respond well to colouring oxides and are relatively viscous. Tang *sancai* burial wares are decorated with lead glazes, coloured with copper oxide to give green and with iron oxide to give yellow.

High-temperature glazes

High-temperature glazes are those which use calcium oxide as a flux (see above). Calcium oxide occurs widely as chalk and woodash and is therefore both cheaper and safer to use than lead, but it requires a higher firing temperature of around 1170°C. The earliest Chinese glazes, those of the Shang dynasty (c. 1700–1027 BC), are composed of woodash, and numerous high-fired glazes of the Shang, Zhou and Han dynasties appear to be the result of ash sifted on to the shoulder of a vessel. When the ash is very thick, an opalescent blue occurs due to the presence of concentrated phosphorus. This phenomenon may also be seen on certain greenwares of the Sui dynasty (AD 589–618). Porcelain glazes are composed of porcelain stone (see Appendix I) and burnt limestone (calcium carbonate).

Alkaline glazes

Alkaline glazes are those fluxed (see above) with potassium and/or sodium oxide. Such glazes are central to Near and Middle Eastern ceramic technology but are less common within the Chinese tradition. Their earliest occurrence in China is in the Tang dynasty (AD 618–906), at the Qionglai kilns in Sichuan and the Changsha kilns in Hunan. The most prominent use of alkaline glazes in China, however, occurs in the Ming dynasty (1368–1644), on temple ceramics and *fahua* wares made principally in Shaanxi province in north China. The most easily recognised alkaline glaze is the brilliant turquoise blue which can be seen on both of these types.

Oxidation

Oxidation occurs when the firing atmosphere inside a kiln is rich in oxygen and the air is clean and bright. Earthenware clays fired in an oxidising atmosphere are red in colour, like those of the Yangshao Neolithic phase, for example; those fired in a reducing atmosphere (see below) are grey. Oxidised firings produce warm-looking glaze colours.

Reduction

The term reduction refers to the exclusion of oxygen from a kiln atmosphere, rendering it dark and smoky. Such firings reduce the quantity of oxygen atoms in iron or copper oxides present in clays and glazes, and this can change their colour. Firing temperature can also influence colour. All greenware glazes are the result of iron fired in reduction. Earthenware fired in reduction is grey, and much tougher than the red body produced by an oxidised firing (see above). Reduction firings produce cool-toned glaze colours.

APPENDIX III
Kilns and Firing

Kilns are almost as important a part of China's success in producing ceramics as the raw materials themselves. The four major kiln designs are outlined below.

Yangshao Neolithic kilns

Kilns used in north-west China between 4000 and 2000 BC could fire at temperatures of up to 1000°C. The design is that of an updraft kiln, with the firebox situated at some distance from and at a lower level than the firing chamber containing the ceramic vessels. This design allowed heat to build up gradually in the early stages of firing, when the ceramics are still drying out and prone to collapse, and to reach a higher temperature when the firing was nearing completion and more heat was required. The heat entered the firing chamber from beneath, through a circle of perforations in the firing chamber floor. This arrangement allowed the heat to be evenly distributed throughout the firing chamber, preventing the over- or under-firing of pots in different positions within the kiln. Many Neolithic kilns in north China were built of loess (see Appendix I), sometimes on the ground and sometimes into it. Examples of this type of ancient kiln may be seen at Banpo in Xi'an in Shaanxi province.

Mantou kilns

The dome-topped mantou kiln is peculiar to north China, as are the steamed bread rolls from which it takes its name. In section the shape resembles a horseshoe, with firebox and chimneys positioned opposite each other. They are thus cross-draft kilns. Mantou kilns are small in diameter – typically 3–4m – and often quite high. They were either dug into the loess earth, with only dome and chimneys apparent, or they were built of brick. In either case the kiln was lined with a highly refractory clay, abundant throughout north China in the form of fireclay. There are two reasons for the small dimensions of northern Chinese kilns: the fuel used from the tenth century onwards was coal, which has a short flame length; and northern clays require firing temperatures as high as 1350°C, which are more easily achieved in a small kiln.

Dragon kilns

The dragon kiln, so called because it is long and sinuous and stretches up hillsides, is the major kiln type of south China. The long sloping brick tunnels, which reached lengths of up to 60m, had a single wood-burning firebox at the lower end, and fireholes for side-stoking at intervals along their length. The design made it possible to fire large quantities of porcelain in a single firing, and indeed such kilns in Zhejiang during the Southern Song dynasty (AD 1127–1279) fired tens of thousands of greenwares at once. Occasionally the kilns were divided into a succession of firing chambers. Most dragon kilns rise up a hillside at an angle of between ten and sixteen degrees. At Dehua in Fujian province, each chamber could be individually stoked.

Egg-shaped kilns

The egg-shaped kiln is peculiar to Jingdezhen, where it was devised towards the end of the Ming dynasty (AD 1368–1644). The oval construction was usually 7–10m in length, with a tapering chimney of the same height. The door and the wood-burning firebox were situated at the wider end, opposite the chimney. The great advantage of this design was that it allowed different ceramic bodies and glazes to be fired to different temperatures simultaneously.

Kiln furniture

Kiln furniture is the term for all the pieces which go into the kiln apart from the wares themselves, including rings and spurs for setting the wares and saggars to encase them as a protection against the dirt produced in coal firings.

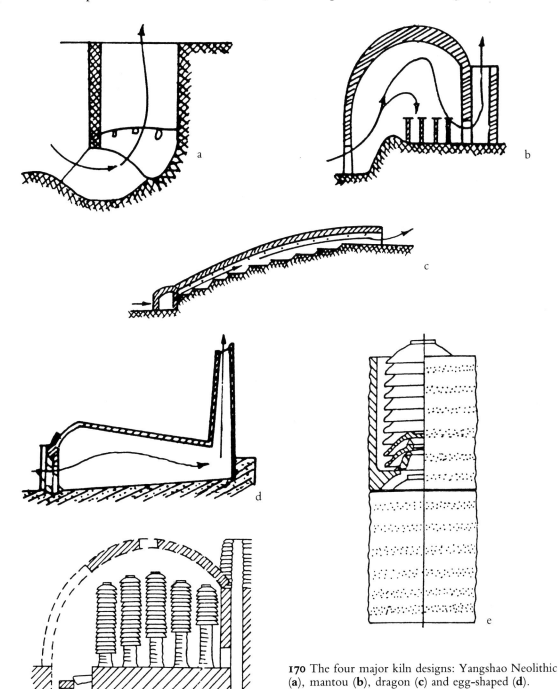

170 The four major kiln designs: Yangshao Neolithic (**a**), mantou (**b**), dragon (**c**) and egg-shaped (**d**). Figure **e** shows dishes encased in a large saggar, and figure **f** shows them stacked on fireclay pillars.

GLOSSARY

bai tunzi Literally, 'little white bricks', previously known as *petuntse*. The term refers to kaolin and porcelain stone, which were transported to Jingdezhen from other regions of Jiangxi province in the form of small bricks.

bianhu Literally, 'flattened flask', the name for vessels of round form but narrow profile, better known as pilgrim flasks.

cong Neolithic jade object of square outer and circular inner section, with carved ornament which also appears on certain Neolithic ceramics.

CRACKLE Appears in glazes as fine lines, and is a deliberate effect.

ding Tripod vessel which occurs in earthenware during the Neolithic period and in bronze during the Shang dynasty.

dou Vessel in the shape of a bowl on a high stem foot. Known in earthenware during the Neolithic period, particularly from the eastern culture of Dawenkou, and later, in the Eastern Zhou, in both bronze and earthenware.

doucai Literally, 'fitted colours', a reference to decoration outlined in blue under the glaze, and coloured in over the glaze with enamel colours. *Doucai* wares are associated with the Chenghua period (1465–87) of the Ming dynasty, and are typically small, thin-walled porcelains.

ENAMELLED PORCELAIN Decorated over the glaze with enamel glaze colours. First occurs at Jingdezhen in the fifteenth century but best known in the form of *famille verte* and *famille rose* wares of the eighteenth and nineteenth centuries which were exported to Europe in large quantities.

fahua Literally, 'bounded designs', in which the motifs are outlined in a raised trail of slip. *Fahua* wares were made from the fourteenth to the sixteenth century, principally in Shanxi province.

gu Tall narrow beaker-shaped vessel. Known in eastern Neolithic pottery but most closely associated with Shang bronze vessels, and reproduced in archaistic porcelain of the Song, Ming and Qing dynasties.

guan A form of wide-shouldered jar, usually large.

gui Ritual bronze food vessel form of the Shang and Zhou dynasties. Reappears amongst archaistic porcelain vessels of the Song, Ming and Qing dynasties, when it generally served as an incense burner.

he Spouted vessel, made in both pottery and bronze in the late Neolithic/early dynastic period.

hu Vessel resembling a vase in shape. Made primarily in bronze but also in pottery, particularly in the Warring States and Han periods.

huashi Literally, 'slippery stone', a fine white powder added to porcelain stone in the eighteenth century to provide a body of exceptional smoothness and whiteness. *Huashi* wares are also known as 'Chinese soft-paste' porcelain.

Imari The name of a port in southern Japan, from which porcelain from the Arita kilns was exported on a large scale in the seventeenth and eighteenth centuries. The word is used to refer to a type of porcelain usually decorated with underglaze blue and a predominantly red overglaze enamel palette with gilding, exported in large quantity from that city.

jia One of the earliest bronze vessel forms, with a cup-shaped body supported on three blade-like legs. Occasionally produced in pottery during the Shang dynasty.

jue Wine vessel on three legs. One of the earliest bronze shapes, together with *he* and *jia*. It ap-

pears in pottery during the Shang dynasty, and later in the archaistic porcelain of the Song, Ming and Qing dynasties.

LEATHERHARD Term used to describe the state of ceramic which has been modelled and has dried out, but not yet entered the kiln.

li Neolithic pottery vessel on three bag-shaped legs.

lokapāla Sanskrit term for the guardians of the four quarters, called *tianwang* in Chinese. Best known in the form of Tang dynasty earthenware tomb figures with *sancai* lead glazes.

LUTING Method of joining the components of an unfired vessel or sculpture using a dilute slip.

meiping Literally, 'plum blossom vase', a tall vase with a wide shoulder and small mouth. The shape was first made in the Song dynasty and became a standard form in the Ming.

OVERGLAZE PAINTING Executed on top of a glaze which has already been fired. Once painted, the vessel would be given a second firing, usually at a lower temperature.

pou Vessel of large, wide proportions, resembling a basin or flattened jar in shape. First made in bronze during the Shang dynasty, it occurs in ceramic amongst the high-fired wares of the Han dynasty.

qingbai Literally, 'blue-white'. The term is used for southern porcelains produced between the tenth and fourteenth centuries, on which the transparent glaze has a blue tinge as the result of titanium impurity. The term *yingqing* (shadow-blue) is sometimes used to denote the same type.

RESIST Substance applied to the surface of any material in order to prevent the action of a colouring agent. On Chinese ceramics, resists were used principally to execute ornament on Tang *sancai* ware, but also constituted a process in certain types of Ming dynasty enamelled wares.

SAGGAR Earthenware or stoneware box for encasing ceramics in the kiln, to prevent any dirt in a kiln atmosphere from blemishing the ceramics and to ensure even temperature during firing.

sancai Literally, 'three colours'. This term refers to the green, amber and cream glazes used on burial pottery of the Tang dynasty, and is the name by which such wares are known.

SGRAFFITO Technique of decoration used on Cizhou wares, consisting of incising a top layer of slip to create a design in the exposed underlying slip layer.

shufu Literally, 'privy council', the term denotes a class of white ware on which these two characters are moulded. A further distinguishing feature is the opacity of the thick glaze.

SLIP Dilute clay mixture applied to the surface of a pot before glazing, to enhance the smoothness and disguise an unsuitable clay body colour. Slip was not much used in this way after the Song dynasty, but during the Song and in the Ming it was used for producing painted decoration.

SOFT PASTE Term used to denote *huashi* wares of the eighteenth century, but otherwise not applicable to Chinese ceramics. Hard-paste porcelain is a European product which matches the hardness and translucency of Chinese porcelain, while soft paste generally refers to unsuccessful attempts to produce the same result.

UNDERGLAZE PAINTING Decoration applied to the body of an unfired ceramic before it is glazed. Underglaze painting may also be applied to a piece which has been covered with slip but not yet glazed.

wucai Literally, 'five colours', a reference to the late Ming palette of underglaze blue and overglaze enamels.

yingqing see *qingbai*

zisha Literally, 'purple sand', a reference to the brown stonewares produced at Yixing in Jiangsu province.

zun Bronze vessel of vase form, usually with a wide flaring mouth. The shape belongs to the Shang dynasty bronze repertoire, but was produced in porcelain in the Song, Ming and Qing dynasties.

CHRONOLOGY

NEOLITHIC CULTURES

Peiligang	c.6500–5000 BC
Cishan	c.6500–5500 BC
Central Yangshao	c.5000–3000 BC
Gansu Yangshao	c.3000–1500 BC
Dawenkou	c.5800–1500 BC
Hongshan	c.4000–2700 BC
Majiabang	c.5500–3000 BC
Songze	c.3500–2500 BC
Hemudu	c.5200–3000 BC
Daxi	c.5500–3500 BC
Longshan	c.3000–1700 BC

EARLY DYNASTIES

Shang	c.1700–1027 BC
Western Zhou	1027–771 BC
Eastern Zhou	
Spring and Autumn period	771–481 BC
Warring States period	480–221 BC

IMPERIAL CHINA

Qin	221–207 BC
Han	
Western Han	206 BC–AD 9
Xin	AD 9–25
Eastern Han	AD 25–220

Three Kingdoms	
Shu (Han)	221–263
Wei	220–265
Wu	222–280
Southern dynasties (Six Dynasties)	
Western Jin	265–316
Eastern Jin	317–420
Liu Song	420–479
Southern Qi	479–502
Liang	502–557
Chen	557–589
Northern dynasties	
Northern Wei	386–535
Eastern Wei	534–550
Western Wei	535–557
Northern Qi	550–577
Northern Zhou	557–581
Sui	581–618
Tang	618–906
Liao	907–1125
Five Dynasties	907–960
Song	
Northern Song	960–1126
Southern Song	1127–1279
Jin	1115–1234
Yuan	1279–1368

Ming	1368–1644	Qing	1644–1911
EMPERORS		EMPERORS	
Hongwu	1368–98	*Shunzhi*	1644–61
Jianwen	1399–1402	*Kangxi*	1662–1722
Yongle	1403–25	*Yongzheng*	1723–35
Xuande	1426–35	*Qianlong*	1736–95
Zhengtong	1436–49	*Jiaqing*	1796–1820
Jingtai	1450–57	*Daoguang*	1821–50
Tianshun	1457–64	*Xianfeng*	1851–61
Chenghua	1465–87	*Tongzhi*	1862–74
Hongzhi	1488–1505	*Guangxu*	1875–1908
Zhengde	1506–21	*Xuantong*	1909–11
Jiajing	1522–66		
Longqing	1567–72	REPUBLICAN CHINA	
Wanli	1573–1620	Republic	1912–49
Tianqi	1621–27	People's Republic	1949–
Chongzhen	1628–44		

BIBLIOGRAPHY

General

AYERS, J. *The Baur Collection* (4 vols). Geneva, 1968

FENG XIANMING. *Essays on Chinese Old Ceramics by Feng Xianming* (in Chinese). Hong Kong, 1987

HE LI. *Chinese Ceramics: The New Standard Guide.* San Francisco and London, 1996

HUGHES-STANTON, P. AND KERR, R. *Kiln Sites of Ancient China.* London, 1982

KRAHL, R. *Chinese Ceramics from the Meiyintang Collection* (2 vols). London, 1994

LI ZHIYAN AND CHENG WEN. *Chinese Pottery and Porcelain.* Beijing, 1984

MEDLEY, M. *The Chinese Potter: A Practical History of Chinese Ceramics.* Oxford, 1976

SATO MASAHIKO. *Chinese Ceramics: A Short History.* New York, 1981

SCOTT, R. E. *Percival David Foundation of Chinese Art: A Guide to the Collection.* London, 1989

Taoci Shihua, in series *Zhongguo Keji Shihua Congshu.* Shanghai, 1982

VALENSTEIN, S. G. *A Handbook of Chinese Ceramics.* New York and London, 1975 (2nd edn 1989)

WU RENJING AND XIN ANHU. *Zhongguo taoci shi.* China, 1936

YANG GEN ET AL. *The Ceramics of China: The Yangshao Culture to the Song Dynasty.* Beijing and London, 1985

YE ZHIMIN. *Zhongguo taoci shi wangyao.* Beijing, 1989

Zhongguo gudai yaozhi diaocha fajue baogao ji. Beijing, 1984

Chapter 1

CHANG, K. C. *The Archaeology of Ancient China.* New Haven and London (4th edn), 1986

CHANG, K. C. *Shang Civilization.* New Haven and London, 1980

CHENG TÊ-K'UN AND SHEN WEI-CHÜN. *A brief history of Chinese mortuary objects.* Peiping, 1933

GAN BAO (4th century AD). *Sou Shen ji.* Hubei, 1875

RAWSON, J. *Ancient China: Art and Archaeology.* London, 1980

Songze: Xin shiqi shidai yizhi fajue baogao. Beijing, 1987

WATSON, W. *Cultural Frontiers in Ancient East Asia.* Edinburgh, 1971

YANG XIAONENG. *Sculpture of Prehistoric China.* Hong Kong, n.d.

ZHONGGUO SHEHUI KEXUEYUAN KAOGU YANJIUSUO (ed.). *Xin Zhongguo de kaogu faxian he yanjiu.* Beijing, 1984

Zuo zhuan (4th century BC). *Chunqiu zuozhuan zhu* (ed. Yang Bojun). Beijing, 1981

Chapter 2

CHENG TÊ-K'UN. *Studies in Chinese Archaeology.* Hong Kong, 1982

CHINESE UNIVERSITY OF HONG KONG, ART GALLERY. *Archaeological Finds from the Jin to the Tang periods in Guangdong.* Hong Kong, 1986

LIM, L. ET AL. *Stories from China's Past: Han Dynasty Pictorial Tomb Reliefs and Archaeological Objects from Sichuan Province, People's Republic of China.* San Francisco, 1987

LOEWE, M. *Chinese Ideas of Life and Death: Faith, myth and reason in the Han dynasty (202 BC–AD220).* London, 1982

LOS ANGELES COUNTY MUSEUM OF ART. *The Quest for Eternity.* Los Angeles, 1987

MINO, Y. AND TSIANG, K. *Ice and Green Clouds* (exhibition catalogue). Indianapolis, 1986

TREGEAR, M. *Catalogue of Chinese Greenware in the Ashmolean Museum, Oxford.* Oxford, 1976

WATSON, W. *Pre-Tang Ceramics of China: Chinese pottery from 4,000 BC to 600 AD.* London, 1991

Chapter 3

LU YU (Tang dynasty). *Cha jing,* in *Wuchao xiaoshuo daguan.* Shanghai, 1926

MEDLEY, M. *Tang Pottery and Porcelain.* London, 1981

MINO, Y. *Pre-Sung Dynasty Chinese Stonewares in the Royal Ontario Museum.* Toronto, 1974

WATSON, W. *Tang and Liao Ceramics.* London, 1984

WECHSLER, H. J. *Offerings of Jade and Silk: Ritual and Symbol in the Legitimation of the Tang dynasty.* New Haven, 1985

Chapter 4

CAI XIANG (Song dynasty). *Cha Lu,* in *Wuchao Xiaoshuo daguan.* Shanghai, 1926

HYMES, R. P. *Statesmen and Gentlemen: The elite of Fu-Chou, Chiang-hsi, in Northern and Southern Song.* Cambridge, 1986

KERR, R. *Song Ceramics.* London, 2004

LU YU (Song dynasty). *Lao Xue an biji.* Reprinted Beijing, 1979

MINO, Y. *Freedom of Clay and Brush through Seven Centuries in Northern China: Tz'u-chou type Wares 960–1600 AD* (exhibition catalogue). Indianapolis, 1980

MOWRY, R. WITH FARRELL, E. AND ROUSMANIERE, N. *Hare's Fur, Tortoiseshell and Partridge Feathers: Chinese brown- and black-glazed ceramics, 400–1400 AD.* Cambridge, Mass., 1996

Nanyao Biji (Qing dynasty), in *Meishu congshu siji yi qi.* Shanghai, 1947

TAO ZONGYI (Yuan dynasty). *Shushi huiyao.* Reprinted Shanghai, 1979

SOUTHEAST ASIAN CERAMIC SOCIETY (West Malaysia Chapter). *A Ceramic Legacy of Asia's Maritime Trade: Song dynasty Guangdong wares and other 11th–19th century Trade Ceramics.* Kuala Lumpur, 1985

TREGEAR, M. *Song Ceramics.* Fribourg and London, 1982

WANG CUN (Song dynasty). *Yuanfeng jiu cheng zhi.* Reprinted Shanghai, 1935–7

WANG QINGZHENG, FAN DONGQING AND ZHOU LILI. *The Discovery of Ru kiln.* Shanghai, 1987

WIRGIN, J. *Sung Ceramic Designs.* London, 1979

ZHAO YANWEI (Song dynasty). *Yun lu man chao.* Reprinted Shanghai, 1935–7

ZHOU MI (Song dynasty). *Wulin jiu shu.* Reprinted Shanghai, 1956

Chapter 5

ABRU, HAFIZ: *see* MAITRA, K. M.

CARSWELL, J. *Blue & White: Chinese porcelain around the world.* London, 2000

CARSWELL, J. *Blue and White: Chinese porcelain and its impact on the Western World.* Chicago, 1985

CONNER, P. *Oriental Architecture in the West.* London, 1979

GRAY, B. 'The Export of Chinese porcelain to India', in *Transactions of the Oriental Ceramic Society,* vol. 36, 1964–6. London, 1967

HARRISON-HALL, J. *Catalogue of late Yuan and Ming Ceramics in the British Museum.* London, 2001

HOWARD, D. S. AND AYERS, J. *China for the West* (2 vols). London and New York, 1978

HOWARD, D. S. *Chinese Armorial Porcelain.* London, 1974

JÖRG, C. J. A. *The Geldermalsen: History and Porcelain.* Groningen, 1986

JÖRG, C. J. A. *Porcelain and the Dutch China Trade.* The Hague, 1982

KRAHL, R. *Chinese Ceramics in the Topkapi Saray Museum, Istanbul* (3 vols). London, 1986

LANE, A. *Later Islamic Pottery.* London, 1957

MAITRA, K. M. (trans.). *A Persian Embassy to China: An extract from Zubdatu't Tawarikh of Hafiz Abru.* New York, 1970 (first published Lahore, 1934)

PIJL-KETEL, C. L. VAN DER (ed.). *The Ceramic Load of the 'Witte Leeuw' (1613).* Amsterdam, 1982

POPE, J. A. *Chinese Porcelains from the Ardebil Shrine.* Washington, 1956

RAWSON, J. *Chinese Ornament: The Lotus and the Dragon.* London, 1984 (2nd edn 1990)

RINALDI, M. *Kraak Porcelain: A Moment in the History of Trade.* London, 1989

SCHEURLEER, D. F. L. *Chinese Export Porcelain: Chine de Commande.* London, 1974

SHEAF, C. AND KILBURN, R. *The Hatcher Porcelain Cargoes: The Complete Record.* Oxford, 1988

SOUTHEAST ASIAN CERAMIC SOCIETY (Singapore). *Chinese Celadons and other related wares in Southeast Asia.* Singapore, 1979

WILSON, T. *Ceramic Art of the Italian Renaissance.* London, 1987

Chapter 6

DONNELLY, P. S. *Blanc de Chine: The Porcelain of Têhua in Fukien.* London, 1969

Exhibition of Shiwan Wares (exhibition catalogue). Hong Kong, 1979

FLAGSTAFF HOUSE MUSEUM OF TEA WARE. *The Art of the Yixing Potter.* Hong Kong, 1990

LIANG SICHENG (ed.). *Qingshi yingzao zelie.* Beijing, 1981 (first published 1934)

PALUDAN, A. *The Imperial Ming Tombs.* London, 1981

PORTAL, J. 'A Tang dynasty tile in the British Museum', in *Orientations,* March 1990

WU QIAN (Qing dynasty). *Yangxian ming taolu,* in *Meishu congshu* (1st collection). Shanghai, 1947

ZHOU GAOQI (Ming dynasty). *Yangxian ming hu xi.* 1695

Chapter 7

ADDIS, J. M. *Chinese Ceramics from Datable Tombs and Some Other Dated Material.* London and New York, 1978.

ADDIS, J. M. *Chinese Porcelain from the Addis Collection: Twenty-two pieces of Chingtechen Porcelain presented to the British Museum.* London, 1979

CHEN LU. *Tao Ya* (Pottery Refinements). 1910. Reprinted (trans. G. R. Sayer) London, 1959

CHINESE UNIVERSITY OF HONG KONG. *Imperial Porcelain of Later Qing.* Hong Kong, 1983

CLUNAS, C. 'The Cost of Ceramics and the Cost of Collecting Ceramics in the Ming period', in *Transactions of the Oriental Ceramic Society of Hong Kong* (forthcoming)

DAVID, SIR PERCIVAL. *Chinese Connoisseurship: The Ko Ku Yao Lun, The Essential Criteria of Antiquities.* London, 1971

HONG KONG MUSEUM OF ART. *Brush and Clay: Chinese Porcelain of the Early 20th century.* Hong Kong, 1990

Imperial Taste: Chinese Ceramics from the Percival David Foundation. Los Angeles and London, 1989

JENYNS, R. S. *Ming Pottery and Porcelain.* London, 1953

JENYNS, R. S. *Later Chinese Porcelain.* London, 1965 (4th edn 1971)

KERR, R. *Chinese Ceramics: Porcelain of the Qing Dynasty 1644–1911.* London, 1986

LAM, P. (ed.). *Qing Imperial Porcelain of the Kangxi, Yongzheng and Qianlong Reigns.* Hong Kong, 1995

LAN PU. *Jingdezhen Taolu* (The Potteries of Jingdezhen) (ed. Zheng Tinggui). 1815. Reprinted (*Ching-te-chen t'ao lu*, trans. G. R. Sayer) London, 1951

LION-GOLDSCHMIDT, D. *Ming Porcelain*. London, 1978

LITTLE, S. *Chinese Ceramics of the Transitional Period: 1620–1683*. New York, 1983

LIU XINYUAN. *Imperial Porcelain of the Yongle and Xuande Periods Excavated from the Site of the Ming Imperial Factory at Jingdezhen* (exhibition catalogue). Hong Kong, 1989

MEDLEY, M. *Yuan Porcelain and Stoneware*. London, 1974

ORIENTAL CERAMIC SOCIETY OF HONG KONG. *Jingdezhen Wares: The Yuan Evolution*. Hong Kong, 1984

ORIENTAL CERAMIC SOCIETY OF HONG KONG. *Transitional Wares and their Forerunners*. Hong Kong, 1981

Qing Porcelain of Kangxi, Yongzheng and Qianlong periods from the Palace Museum Collection. Hong Kong, 1989

SCOTT, R. E. '18th Century Overglaze Enamels: The influence of technological development on painting style', in *Style in the East Asian Tradition* (eds R. Scott and G. Hutt). London, 1987, pp. 149–68

SHANGHAI RENMIN MEISHU CHUBANSHE (ed.). *Taoci 1949–1959*. Shanghai, 1961

TICHANE, R. *Ching-te-chen: Views of a Porcelain City*. New York, 1983

VAN OORT, H. A. *Chinese Porcelain of the 19th and 20th Centuries*. Lochem, 1977

VAN OORT, H. A. *The Porcelain of Hung-hsien*. Lochem, 1970

Technology

KERR, R. AND WOOD, N. with contributions by TS'AI MEI-FEN AND ZHANG FUKANG. *Science and Civilisation in China, Joseph Needham, vol. 5 (Chemistry and Chemical Technology), Pt 12 Ceramic Technology*. Cambridge, 2004

KINGERY, W. D. AND VANDIVER, P. B. *Ceramic Masterpieces: Art, Structure, Technology*. New York, 1986

LI JIAZHI AND CHEN XIANQIU. *Proceedings of the 1989 International Symposium on Ancient Ceramics*. Shanghai, 1989

LI JIAZHI ET AL. *Zhongguo gudai taoci kexue jishu chengjiu*. Shanghai, 1985

ORIENTAL CERAMIC SOCIETY (LONDON). *Iron in the Fire*. London, 1988

SHANGHAI INSTITUTE OF CERAMICS, ACADEMIA SINICA (ed.). *Scientific and technological insights on ancient Chinese pottery and porcelain: Proceedings of the International conference on Ancient Chinese Pottery and Porcelain held in Shanghai, November 1–5, 1982*. Beijing, 1986

TICHANE, R. *Ash Glazes*. New York, 1987

TICHANE, R. *Reds, Reds, Copper Reds*. London, 1985

TICHANE, R. *Those Celadon Blues*. New York, 1978

WOOD, N. *Chinese Glazes: Their Origins, Chemistry and Recreation*. London, 1999

WOOD, N. *Oriental Glazes*. London, 1978

WOOD, N. *Recent Researches into the Technology of Chinese Ceramics*, in the proceedings of a symposium on the ceramic art of China held at Los Angeles County Museum in September 1989 (forthcoming)

Early Works on Chinese Ceramics

An Illustrated Catalogue of Chinese Porcelain and Pottery Forming the Collection of Mr Alfred Trapnell. Bristol, 1901

BLACKER, J. F. *Chats on Oriental China*. London, 1908

BRANKSTON, A. D. *Early Ming Wares from Ching-te-chen*. Peking, 1938 (reprinted 1970)

BRITISH MUSEUM. *A Guide to the Pottery and Porcelain of the Far East in the Department of Ceramics and Ethnography*. London, 1924

BUSHELL, S. W. *Description of Chinese Pottery and Porcelain: Being a translation of the T'ao Shuo*. Oxford, 1910

BUSHELL, S. W. *Oriental Ceramic Art*. London, 1896 (reprinted 1981)

GRANDIDIER, E. *La Céramique Chinoise*. Paris, 1894

HENTZE, C. *Chinese Tomb Figures*. London, 1928

HETHERINGTON, A. L. *Chinese Ceramic Glazes*. Cambridge, 1937

HETHERINGTON, A. L. *The Early Ceramic Wares of China*. London, 1922

HOBSON, R. L. *A Catalogue of Chinese Pottery and Porcelain in the Collection of Sir Percival David, Bt*. London, 1934

HOBSON, R. L. *Chinese Pottery and Porcelain* (2 vols). London, 1915

HOBSON, R. L. *The Later Ceramic Wares of China*. London, 1925

HOBSON, R. L. *The Wares of the Ming Dynasty*. London, 1923

HOBSON, R. L. AND HETHERINGTON, A. L. *The Art of the Chinese Potter*. London, 1923

HONEY, W. B. *The Ceramic Art of China*. London, 1945

LAUFER, B. *Chinese Clay Figures* (2 vols). Chicago, 1914

LAUFER, B. *Chinese Pottery of the Han Dynasty*. Leiden, 1909

DU SARTEL, O. *La Porcelaine de Chine*. Paris, 1881

Articles and Kiln Site Reports
in Chinese Periodicals

Abbreviations

GGBWYYK Gugong Bowuyuan Yuankan
JHKG Jianghan Kaogu
KG Kaogu
KGTX Kaogu Tongxun

KGXB Kaogu Xuebao
KGYWW Kaogu yu Wenwu
WW Wenwu
WWCKZL Wenwu Cankao Ziliao
ZYWW Zhongyuan Wenwu

Neolithic
PEILIGANG KG 1978.2 p.73; KG 1979.3 p.197; KG
 1983.12 pp.1057–65; KGXB 1984.1 p.23
YANGSHAO ZYWW 1984.1 pp.53–9; KGTX 1956.6 p.9;
 WW 1979.11 pp.52–5. Banshan: KG 1980.1 pp.7–10;
 KGXJK 1982. Majiayao: KG 1983.12 p.1066.
 Machang: KGXB 1983.2 p.191; KG 1965.7 p.321
QIJIA KGXB 1975.2 p.57; KGXB 1974.2 p.29; KGXB
 1980.2 p.187
LONGSHAN KGXB 1954.8 p.65. Teng xian Beixin:
 KGXB 1984.2 p.159. Weifang Yaoguanzhuang: KG
 1963.7 p.347. Rizhao Liangchengzhen: KGXB
 1958.1 p.25; KG 1960.9 p.10. Jiao xian Sanlihe: KG
 1977.4 p.262; WW 1981.7 p.64
DAWENKOU WW 1960.2 p.61. Wangyan: KG 1979.1
 p.5
HEMUDU WW 1976.8 p.6; WW 1980.5 p.1; WW
 1982.7 pp.61–9; KGXB 1978.1 p.39
SONGZE KGXB 1962.2 p.1; KGXB 1980.1 p.29
DAXI WW 1961.11 pp.15–22; KGXB 1981.4 p.461;
 JHKG 1982.2 pp.13–19
XINLE KGXB 1985.2 p.209

Shang and Zhou Dynasties
White ware WWCKZL 1954.1 pp.103–7
High-fired wares WW 1960.8/9 pp.68–70; WW
 1972.10 p.20; WW 1973.2 pp.38–45; WW 1975.7
 pp.77–83; WW 1979.3 pp.56–7; WW 1982.4
 pp.53–7; WW 1985.8 pp.66–72; KG 1984.2
 pp.130–34; KG 1985.7 pp.608–13; KG 1985.11
 p.985

Han Dynasty
Architecture and hollow bricks ZYWW 1983 *te kan*
 pp.74–8; KG 1964.4 pp.180–81; WW 1981.4
 pp.107–10; WW 1978.8 pp.46–50; KGYWW 1983.4
 pp.94–9; KG 1962.9 pp.484–92; ZYWW 1982.1
 pp.24–5; KG 1964.2 pp.90–93; WW 1980.2
 pp.56–7
High-fired wares KGYWW 1984.2 pp.91–5; KGXB
 1958.1 p.111; WW 1960.2 pp.37–8; KG 1980.4
 pp.343–6; WWCKZL 1956.11 pp.1–7; WW 1981.10
 pp.33–5; WW 1984.11 p.62
Burial pottery KGYWW 1983.3 pp.80–83; KG 1966.2
 p.66; ZYWW 1981.1 p.62; WW 1985.1 p.8; KGYWW
 1982.1 p.40; KG 1966.1 p.14

Six Dynasties
Greenwares Zibo: WW 1984.12 pp.64–7. South-east
 China: KG 1963.2 p.108; WW 1976.3 p.55; KG 1983.4
 pp.347–53; WW 1975.2 pp.92–4; KGXB 1957.4
 pp.83–106; KG 1974.1 p.27; KG 1966.3 p.152;
 WW 1959.6 pp.18–19
Burial wares KG 1973.4 p.218; KG 1983.7 p.612; WW
 1977.5 p.38; WW 1975.4 p.64; KG 1972.5 p.33; KG
 1966.4 p.197; KG 1965.4 p.176; KGXB 1959.3 p.75

Tang Dynasty
White wares WW 1959.3 p.58; WW 1981.9 pp.37–50;
 WW 1984.12 pp.51–7 & 58–63; WWCKZL 1953.9; KG
 1959.10; GGBWYYK 1981.4; KGYWW 1984.3
Greenwares Zhejiang: WWCKZL 1953.9; WWCKZL
 1955.3; WWCKZL 1958.8; KGXB 1959.3; WW
 1963.1; WW 1981.10 pp.43–7; KGYWW 1982.4.
 Northern: KG 1962.6
Black wares GGBWYYK no.2; WW 1965.11; WW
 1966.11; WW 1978.6; WW 1980.5 pp.52–60
Sancai WW 1959.3; WW 1961.3; WW 1979.2; KG
 1964.4; KG 1972.3; KG 1983.5; KG 1985.5; KG
 1985.9; KGYWW 1985.2; ZYWW 1981.3; ZYWW
 1984.2
Changsha WW 1960.3; WW 1972.1; KGXB 1980.1
 pp.67–96
Qionglai WWCKZL 1958.2; WWCKZL 1955.10
Yangzhou blue-and-white WW 1977.9 p.94
Liao KG 1973.7; KGXB 1984.3 p.361; WW 1978.5
 pp.26–32; WW 1981.8 pp.65–70; WWCKZL
 1958.2 pp.10–22

Song Dynasty
Ding ware KG 1965.8 pp.394–412; WW 1980.10
 pp.95–6; GGBWYYK 1983.3 pp.70–77; WW 1984.5
 pp.86–8; KG 1985.7 pp.623–6; WW 1985.8
 pp.93–4
Fang ding Anhui: KG 1962.3 pp.134–8; KG 1963.12
 pp.662–7
Ru ware WW 1964.8 pp.15–27
Jun ware WW 1964.8 pp.27–37; WW 1974.12; WW
 1975.6 pp.57–64; GGBWYYK no.2
Guan ware KGYWW 1985.6 pp.105–6
Ge ware GGBWYYK 1981.3 pp.33–5 & 36–9
Longquan ware KG 1962.10 pp.535–8; WW 1963.1
 pp.27–43; KGXB 1973.1 pp.131–56; WW 1981.10

pp.36–42; KG 1981.6 pp.504–10; GGBWYYK 1982.2 pp.59–61

Cizhou ware Cizhou: WW 1959.6 pp.159–61; WW 1964.8 pp.37–49; ZYWW 1983.2 p.86. Dangyangyu: WWCKZL 1952.1; WWCKZL 1952.4. Dengfeng: WW 1964.2 pp.154–62; WW 1964.3 pp.47–55

Jianyang WWCKZL 1953.9; WWCKZL 1955.9; KG 1964.4 pp.191–4

Jingdezhen WWCKZL 1953.9; WW 1984.8 pp.94–6; WW 1981.6 p.87; GGBWYYK 1979.2 pp.74–5

Dehua WWCKZL 1957.9; WWCKZL 1954.5; WWCKZL 1955.4 pp.55–71; WW 1965.2 pp.26–35; WW 1979.5 pp.62–5

Guangdong Chaozhou: WWCKZL 1957.3; KG 1964.4. Huizhou: WWCKZL 1955.2 p.157; KG 1964.4 pp.196–200; WW 1977.8 pp.46–56. Xicun: KGTX 1957.3 pp.70–71

LIST OF ILLUSTRATIONS

Except for line drawings and where otherwise noted, all of the ceramics illustrated are in the collections of the Department of Oriental Antiquities, British Museum.

1 Earthenware bowl and amphora, Yangshao culture, from Banpo, *c.* 4500 BC. OA 1959. 2–6.3,4

2 Four vessels, Peiligang culture, *c.* 5000 BC

3 Three painted urns, Gansu Yangshao culture, *c.* 2500 BC. OA 1929.6–13.1, 2; OA 1966. 2–23.1

4 Painted fish designs from Banpo

5 Painted cormorant design from Yancun

6 Urn from Sanping, Majiayao phase, *c.* 3000 BC

7 Painted bowl, Banshan phase, *c.* 2500 BC

8 Painted urn, Machang phase, *c.* 2000 BC

9 Painted vase, Qijia culture, *c.* 2000 BC

10 Clay figurine, Hongshan culture, *c.* 3500 BC

11 Five vessels, Dawenkou culture, *c.* 4300–2400 BC

12 Incised jar, Songze phase, *c.* 3500 BC

13 Incised bowl, Hemudu culture, *c.* 4500 BC

14 Stem bowl, Daxi culture, *c.* 4000 BC

15 Two vessels, Longshan culture, *c.* 2000 BC

16 *Ding* tripod, Longshan culture, *c.* 2500–2000 BC

17 Three bronze-casting moulds, 13th–11th century BC. OA 1939.6–16.1,2,3

18 Four white ware fragments, 13th–11th century BC. OA 1940.4–13.34,39,64,70

19 Glazed stoneware sherd, 15th–14th century BC. OA 1959.2–16.24

20 Earthenware *jue* vessel, 13th–11th century BC. OA 1937.5–15.2

21 Earthenware *li* vessel from Puducun, 10th century BC. OA 1959.2–16.1

22 Glazed stoneware jar, 8th–7th century BC. Asian Art Museum, San Francisco, Avery Brundage Collection, B60 P223

23 Earthenware bowl with glass, 4th–3rd century BC. OA 1968.4–22.18

24 Impressed earthenware jar and bowl, 8th–3rd century BC. OA 1940.4–13.31; OA 1940.12–14.306

25 Painted earthenware wine jar, 1st century BC–1st century AD. OA 1936.10–12.233

26 Two terracotta soldiers, 3rd century BC

27 Lead-glazed burial figures, 1st–2nd century AD. OA 1933.11–14.1

28 Lead-glazed burial model, 1st–2nd century AD. OA 1929.7–16.1

29 Lead-glazed wine vessel, *c.* 1st century AD. OA 1915.4–9.90

30 Black earthenware jar, 2nd century BC–2nd century AD. OA 1932.2–16.1

31 Earthenware roof support bricks, 2nd century BC–2nd century AD. OA +933

32 Detail of hollow brick, 2nd century BC–2nd century AD. OA 1937.7–16.5

33 Earthenware tomb pilaster, 1st century BC–1st century AD. OA 1942.10–10.1

34 Stoneware *pou* with green glaze, *c.* 1st century AD. OA 1924.12–15.35

35 Two glazed stoneware jars, *c.* 1st century BC–1st century AD. OA 1973.7–26.167,173

36 Bowl, Yue ware, 3rd–4th century AD. OA 1971.9–22.1

37 Desk ornaments, Yue ware, 3rd–4th century AD. OA 1943.2–15.7; OA 1968.4–22.20; OA 1973.1–23.1; OA 1973.7–26.174

38 Burial urn, Yue ware, 3rd–4th century AD

39 Chicken-head ewer, Yue ware, late 4th century AD. OA 1972.1–26.1

40 Jar, Yue ware, 5th–6th century AD. OA 1924.12–15.42

41 Lead-glazed reliquary urn, 7th century AD. OA 1930.7–19.58

42 Greenware vase, 6th century AD. Ashmolean Museum, Oxford, 1956.964

43 *Sancai* bottle vase, 8th century AD. OA 1968.4–22.22

44 White porcelain cup, 7th century AD. OA 1909.6–5.4

45 Glazed pilgrim flask, 7th–8th century AD. OA 1936.10–12.253

46 White porcelain rhyton, 7th century AD. OA 1968.4–22.21

47 White porcellanous stoneware jar, 7th century AD. OA 1968.4–22.23

48 White porcelain water-dropper, 10th century AD. OA 1947.7–12.50

49 Group of Buddhist vessels, 7th–9th century AD. OA 1909.4–1.76; OA 1931.12–15.1; OA 1936.10–12.120, 145, 146, 147; OA 1937.7–16.41; OA 1938.5–24.104

50 Globular jar, Yue ware, 9th–10th century AD. OA 1936.10–12.70

51 Covered box, Yue ware, early 10th century AD. OA 1947.7–12.47

52 Vase, Yue ware, early 10th century AD. OA 1924.6–16.1

53 Stoneware ewer with black glaze, 8th–9th century AD. OA 1936.10–12.215

54 Stoneware dish, Huangdao ware, 8th century AD. OA 1967.12–12.2

55 *Sancai* lidded jar, 8th century AD. OA 1946.7–15.1

56 *Sancai* dish, 8th century AD. OA 1936.10–12.211

57 Three *sancai* boxes, 8th–9th century AD. OA 1936.10–12.116; OA 1947.7–12.30,32

58 Ring-handled cup, *c.*8th century AD. OA 1947.7–12.24

59 Group of six *sancai* tomb figures, 8th century AD. OA 1936.10–12.220–25

60 Tomb figure of a horse, 8th century AD. OA 1940.7–15.1

61 Three marbled wares, 8th–9th century AD. OA 1925.10–12.2; OA 1936.4–13.1; OA 1937.7–16.44

62 Three jars, Tongguan ware, 8th–9th century AD

63 Ewer, Tongguan ware, 8th–9th century AD. OA 1961.5–15.3

64 Bowl, Qionglai ware, 8th–9th century AD. OA 1909.12–14.25

65 White vase, Liao ware, 10th–11th century AD. OA 1936.10–12.186

66 Vase, Ding ware, 11th–12th century AD. OA 1936.10–12.26

67 Black ware vase, 12th–13th century AD. OA 1947.7–12.148

68 White porcelain bowl, 9th century AD. OA 1956.12–10.22

69 White porcelain jar, 10th century AD. OA 1947.7–12.56

70 Stoneware mould and saggar, 12th century AD. OA 1926.4–21.1; OA 1938.5–16.3

71 Porcelain bowl, Ding ware, 12th–13th century AD. OA 1947.7–12.62

72 Porcelain dish, Ding ware, 12th century AD. OA 1947.7–12.61

73 Vase, Ru ware, 11th–12th century AD. OA 1978.5–22.1

74 Dish, Ru ware, 11th–12th century AD. OA 1936.10–19.1

75 Jar, Jun ware, 12th century AD. OA 1936.10–12.151

76 Dish, Jun ware, *c.* 12th century AD. OA 1925.7–17.1

77 Vase, Guan ware, 12th–13th century AD. Percival David Foundation, London, PDF4

78 Vase, Longquan ware, 12th–13th century AD. OA 1936.10–12.66

79 Stoneware ewer, Zhejiang greenware, 11th–12th century AD. OA 1973.7–26.293

80 Lidded vase, Longquan ware, 12th century AD. OA 1972.5–17.1

81 Vase and incense burner, Longquan ware, 12th–13th century AD. OA 1929.7–22.6; OA 1938.5–24.9

82 Ewer, Yaozhou ware, 11th–12th century AD. OA 1936.10–12.69

83 Bowl, Yaozhou ware, 11th–12th century AD. OA 1973.7–26.285

84 Stoneware moulds and kiln furniture, 11th–12th century AD. OA 1933.5–18.1(a,b); OA 1933.7–11.17; OA 1937.7–16.138

85 Pillow, Cizhou type ware, 11th–12th century AD. OA 1936.10–12.169

86 Stoneware pillow, Cizhou type ware, 13th century AD. OA 1936.10–12.165

87 Stoneware bowl, Cizhou type ware, 13th century AD. OA 1973.7–26.255

88 Vase, Cizhou type ware, 11th–12th century AD. OA 1936.10–12.175

89 Stoneware bowl, Jian ware, 12th–13th century AD. OA 1947.7–12.142

90 Stoneware bowl, Jian ware, 12th–13th century AD. OA 1936.10–12.156

91 Tripod censer, Jizhou ware, 13th century AD. OA 1926.4–14.1

92 Painted vase, Jizhou ware, 13th–14th century AD. OA 1936.10–12.85

93 Porcelain ewer and basin, 11th century AD. OA 1936.10–12.153

94 Tomb models, *qingbai* ware, 11th century AD. OA 1983.7–29.2,3,4

95 Porcelain box, *qingbai* ware, 13th century AD. OA 1933.10–18.1

96 White porcelain dish fragment, 10th century AD. OA 1938.4–12.41

97 Phoenix-head ewer, 10th–11th century AD. OA 1936.10–12.206

98 Porcelain vase, *qingbai* ware, 11th–12th century AD. OA 1947.7–12.73

99 Blue-and-white *guan* jar, *c.* AD 1350. OA 1960.7–28.1

100 Greenware dish, 14th–15th century AD. OA 1936.12–19.9

101 Five bottle vases, 14th century AD. OA 1924.1–14.1; OA 1947.7–12.162; OA 1961.2–16.3; OA 1975.10–28.2,3

102 Blue-and-white dish, 14th century AD. OA F1670

103 Blue-and-white dish, early 15th century AD. OA 1968.4–22.27

104 Blue-and-white lidded jug, early 15th century AD. The Burrell Collection, Glasgow

105 Vase, *qingbai* ware, *c.*AD 1300. OA 1961.10–21.1

106 Blue-and-white flask, late 16th century AD. OA F778+

107 Dish, Swatow ware, *c.*AD 1600. OA F486+

108 Martaban jar, 15th–17th century AD. OA 1973.4–16.1

109 Blue-and-white dish, Kraak ware, late 16th century AD. OA 1984.2–2.33

110 Blue-and-white *kendi*, 16th century AD. OA 1948.4–15.1

111 Censer bowl, Swatow ware, 17th century AD. OA 1984.2–2.50

112 Enamelled ewer, late 17th–early 18th century AD. OA F493+

113 *Famille rose* plate, c.AD 1756. OA F598

114 Material from a shipwreck, mid-17th century AD. OA 1985.11–19.2,22,36,38

115 *Famille rose* armorial dish, c.AD 1735. OA F733+

116 Punch bowl, AD 1786–90. Marylebone Cricket Club Museum, Lord's

117 Teapot, Yixing ware, 18th century AD. OA 1927.2–19.1

118 Teapot, *famille rose* porcelain, c.AD 1760. OA F597+

119 Daoist shrine, Longquan ware, AD 1406. OA 1929.1–14.1

120 Earthenware tile, early 7th century AD. OA 1983.7–25.1

121 Designs for roof tiles, Qing dynasty

122 Stoneware roof finial, 16th century AD. OA 1938.5–24.133

123 Stoneware vase, *fahua* ware, 15th century AD. OA F67

124 *Lohan* sculpture, 10th–12th century AD. OA 1913.11–21.1

125 Funerary model of a house complex, 14th–15th century AD. OA 1937.7–16.6–12

126 Altar vase and candlesticks, late 16th–early 17th century AD. OA 1930.10–17.1,2,3

127 Roof ornament, 15th–16th century AD. OA 1907.11–5.4

128 Figure, Dehua porcelain, AD 1610. OA 1930.11–13.1

129 Vase, Shiwan ware, 18th century AD. The Burrell Collection, Glasgow, 38/342

130 Teapot, Yixing ware, late 17th–early 18th century AD. OA F2458

131 Detail of fig.130

132 Blue-and-white *meiping* vase, 14th century AD. OA 1972.6–20.1

133 Vase, *qingbai* ware, early 14th century AD. OA 1975.10–28.1

134 Underglaze red painted bowl, late 14th century AD. On loan

135 Stem-cup with blue and brown glazes, late 14th century AD. OA 1968.4–23.1

136 Bowl with copper-red glaze, late 14th century AD. OA 1936.10–12.107

137 White porcelain dish, late 14th century AD. OA 1930.2–15.1

138 White 'monk's cap' ewer, early 15th century AD. OA 1952.5–12.1

139 Stem-cup with red and white decoration, early 15th century AD. OA 1968.4–23.2

140 Yongle mark in seal script, early 15th century AD

141 Bowl with copper-red glaze, early 15th century AD. OA 1947.7–12.321

142 Blue-and-white flask, early 15th century AD. OA 1975.10–28.19

143 Blue-and-white vase, mid 15th century AD. OA 1973.7–26.359

144 Blue-and-white 'palace' bowl, late 15th century AD. OA 1947.7–12.182

145 Vase with green enamel decoration, late 15th century AD. OA 1953.5–9.1

146 Box with blue enamel glazes, late 15th century AD. OA 1979.7–22.10

147 Vase with green enamel decoration, late 15th century AD. OA 1924.12–16.1

148 Blue-and-white writing box, early 16th century AD. OA 1973.7–26.364

149 Dish with *wucai* decoration, late 16th century AD. OA 1945.10–16.11

150 Bowl, Ge type ware, early 15th century AD. OA 1968.4–22.38

151 Box with *wucai* decoration, late 16th–early 17th century AD. OA F1606

152 Jar, Yixing ware, AD 1597. OA 1981.2–6.1

153 Blue-and-white censer, AD 1625. OA 1971.6–22.1

154 Pair of enamelled bowls, late 17th–early 18th century AD. OA F539+

155 Blue-and-white brush pot, late 17th–early 18th century AD. OA 1957.12–16.5

156 Dish with enamel decoration, late 17th century AD. OA F493+

157 *Famille verte* dish, late 17th–early 18th century AD. OA F407

158 Pair of *famille rose* wine cups, early 18th century AD. OA 1945.10–16.8,9

159 *Famille rose* dish, early 18th century AD. OA 1953.10–15.7b

160 Hexagonal vase, green glaze with gilding, mid–late 18th century AD. OA F57

161 Vase imitating Guan ware, AD 1773. OA 1936.10–12.177

162 Bowl with enamel decoration, mid–late 18th century AD. OA F577+

163 Pair of 'medallion bowls', early 19th century AD. OA F637+

164 Jar with landscape decoration, late 19th century AD. OA 1926.7–15.1

165 Vase, Hong xian type, AD 1916–25. OA 1925.7–15.2

166 'Eggshell' porcelain painted vase, AD 1990. OA 1990.7–31.1

167 Three blue-and-white flasks, early 15th, early 18th and late 20th centuries AD. OA 1947.7–12.202, 325; OA 1987.3–13.18

168 Loess under magnification

169 Clay-rich loess under magnification

170 Kiln designs

INDEX

Figures in bold refer to illustration numbers

acroteria, 164–5, **121**, **127**
Africa, 81, 82, 88, 94, 128, 129
agate, 100
Alexandria, 145
alkaline glazes, 220
altar vessels, 91, 110, 140, 166, 168, 170, **126**, 210
alumina, 46, 96, 220
aluminium oxide, 180
America, 152, 153
An Lushan rebellion, 80, 81, 88
Anhui, 33, 34, 52, 96, 98, 125
antiques, 91, 109, 195, 196, 197
Anyang, 27, 30, **20**, 37, 55, 59, 117, 162
archaism, 91, 109, 110, 111, **81**, 168, 170, 184, 186, 197, 207, 210
architecture, 23, **28**, 44, **31**, **32**, 45, 46, **33**, 55, 144, 160–5, **121**, **122**, 166, **125**, **127**, 184
Ardebil, **99**, 137
Arita, 150
armorial porcelain, 144, **106**, 154–5, **115**
ash, in glazes, 29, 46, **34**, 180

bai tunzi, 124
Banpo, Xi'an, **1**, **4**, 16
Banshan, 18, **7**, 19
Bao'en temple, 184
Baofeng, Henan, 87, 100, 101, 102, 112
beaded ornament, 55, 59, **42**, **46**, 68, 140, **105**, 180
Beijing, 86, 138, 176, 201, 208
Beixin, Shandong, Teng xian, 20
bianhu, 59, **45**, **106**
black wares, 50, 53, 55, 73–4, **53**, **54**, 82, 87, **67**, 91, 99, 101, 102, 115, 118–24, 128
blanc-de-chine, 66, 168–72, **128**
blue-and-white, 81, 82, 134, **99**, 136, 137, 138, 139, **102**, 140, 141, **103**, 143, **104**, **106**, 145, 147, **109**, **110**, **111**, 150, **114**, 154, 155, **132**, 180, 181, 183, 188, **142**, **143**, **144**, 191, 194, **148**, **153**, 202, 203, **155**, 207, **167**
Böttger, Johann Friedrich, 157
boxes, 25, 73, **57**, 99, 126, **95**, **146**, **151**
Boyang lake, Jiangxi, 176
bracketed rim, **72**, 147
Brahminabad, 71, 82

bricks, 23, 44, **31**, **32**, 45, **33**, 160, 162, **120**
Brighton, Royal Pavilion, 158
Bristol, 157
bronze, 14, 42, 65, 68, 168, 173, 207
vessels, 25, 26, 27, 30, 36, 41, 46, 47, 91, 108, 109, 110, 168, 186, 196, 209, 210
Budai, 166, 173
Buddhism, 49, 53, 55, **41**, 59, **43**, 62, 67, **49**, **50**, 71, 91, 94, 121, 127, 140, 165, 166, 168, 171, 180, 184, 192
burial
figures, 37, 38, 40, **26**, **27**, 42, 59, 63, 76, 78–81, **59**, **60**, 127, 160, 166
objects, 40, 42, 52, **38**, 81, 110
pottery, 36, **25**, 41, 42, **28**, **29**, **30**, 44, 46, 117, 124, 125, 126, 127, **94**, 168, **125**

Cai Jinqing, 212
Cai Xiang, 120
calcium oxide, 46, 180, 184
calligraphy, 82, 84, 117, **101**, 142, 186–7, 191, 192, 195, 207
candlesticks, 168, **126**
Canton *see* Guangzhou
Castiglione, Giuseppe, 207
Central Asia, 55, **43**, 62, 88
Cha jing see Tea Classic
Cha lu, 120
Chai ware, 101
Chang river, 176
Chang'an *see* Xi'an
Changsha, Hunan, 60, 73, 104
Changsha ware *see* Tongguan ware
Changzhi, Fengshuiling, Shanxi, 37
Chaozhou, Guangdong, 129
characters, 19, 46, 103, 123, **94**, **112**, 179, 186
Chen Lu, 178
Chen Mingyuan, 175, **130**, **131**
Cheng Dacheng, 120
Chengdu, Sichuan, 85
Chenghua, Emperor, 145, 188, 190, 191–3, **144**, **145**, **146**, 196, 197
Chenjiazhuang, 102
chinoiserie, 141, 155–8
Chongzhen, Emperor, 175, 199, 209
Ci xian, Hebei, 115
Cishan *see* Wu'an

Cizhou wares, 102, 115–18, **85**, **86**, **87**, **88**, 121, 124, 127, 129, 133, 146, 172, 179, 181
cloisonné, 166, 168, 191, 203, 205, 212
coal, 67, 124
cobalt, 76, **57**, **60**, 82, 138, 139, 150, 168, 180, 181, 185, 188, 191, 194, 199, 202, 203, 208
coiling, 18, 19
collecting, 91, 110, 173, 196, 197, 209, 210
collections, 91, 150, 208
collectors, 110, 127, 139, 209, 213, 214
Confucius, 37, 60, 62, 88, 91, **119**
cong, 25
connoisseurs, 64, 70, 88, 91, 99, 102, 127, 188, 209
copper, 42, 95, 117, 121, 203
copper oxide, 76, 82, 84, **75**, 133, 181, 187, 201
copper-red wares, 82, 104, 117, **101**, 140, **134**, 181, **136**, 183, 184, **139**, 187, **141**, 188, 202
corded decoration, **1**, 15, 22, 30
crackle, in glazes, 101, **77**, **78**, 107, 108, **150**
cricket, **116**
currency, 44, 65, 85
cut-glaze, 116, 117

Damascus, 142, 145
Daming Palace, 64, 67
Daoguang, Emperor, 212
Datong, Qinghai province, 17
Datong, Shanxi province, 49, 59, 163
Dawenkou culture, 20, 21, **11**, 30
Daxi culture, 22, **14**, 23
Dayao, 109
Dehua, Fujian, 96, 168–72, **128**, 172, 173
Delft, 153, 157
Dengfeng, 117
D'Entrecolles, Père, 178, 202, 212
Deqing, Zhejiang, 51
desk ornaments, 49, **37**, 52, **48**, 84, 175, 197
ding, 20, 21, 25, **16**, 207
Ding wares, 87, **66**, 93–9, **69**, **70**, **71**, **72**, 102, 109, 112, 113, 124, 129, 130, 133, 196, 197, 210, 216
dinner services, 154
dipping, 34, **47**, 95, 108

Donggou, 102
Dongsiling, Jingdezhen, 178
dou, 20, 21, **15**
doucai, 190, 193
dragon, 44, 141, 146, **108**, 163, **133**, **135**, **136**, **137**, 184, 186, **139**, 188, 193, **147**, **154**, 202
dragon kiln, 51, 72, 84, 222, **170b**
Du Fu, 85
Du Wan, 100
Dutch, 147, 150, 151, 152, 157

earthenware, 145, 157, 158, 160, 162, **120**, 165, **125**, 218
East India Company
 Dutch *see* VOC
 English, 152, 153, 154, 157, 158
'eggshell' porcelain, 214, **166**
Egypt, 140, 141
enamel on biscuit, 165, 166, **126**, 193, **147**
enamels, **87**, 133, 146, **107**, **112**, 150, 154, 166, 171, 175, 181, 188, 190, **145**, **146**, 193, 195, **149**, **154**, 202–3, 204–7
English Delft, 157
Erligang, Henan, **19**
Erlitou, Henan, 25, 26, 30
Europe, 142, 143–5, 147, 151–9, 176, 199, 205
ewer, 82, **63**, 84, 87, **93**
 chicken-head, 52–3, 55
 monk's cap, 168, 184, **138**
 phoenix-head, 130, **97**
export, 81–2, 88, 109, 111, 112, 125, 128–9, **95**, 134–59, **99–118**, 173, 182, 201, 202, **157**

fahua, 165–8, **122**, **123**
Famen temple, 70, 73
famille rose, **113**, 154, **115**, **118**, 200, 204–5, **158**, **159**, 212
famille verte, 154, 200, 202–4, 205, **157**
Fan Cui, 59
feldspar, 66
Fengshuiling *see* Changzhi
fireclay, 67, 222
firing temperatures, 21, 22, 33, 72, 75, 84, 105, 133, 134, 145, 180
'Five great wares', 93, 196
flux, 205, 220
Fonthill Vase, 143
Forbidden City, 163
Foshan, Guangzhou, 173
Fouliang, Jiangxi, 176, 178, 201
Fouliang Porcelain Bureau, 179
France, 153, 154, 156
fuel, 94, 124
Fufeng, Shaanxi, 33
 see also Famen temple
Fujian province, 35, 52, 66, 120, **89**, 121, **90**, 129, 145, **107**, 150, 160, 168–72, **128**

Fustāt, 71, 81, 129
Fuzhou, Fujian, 90

Gan river, 176
Gansu province, 17, **3**, **6**, 19, **9**, 20, 42
Gaozong, Emperor, 99, 128
Gaozu, Emperor, 75
gazetteers, 64, 65, 90, 176, 178
Ge Gu Yaolun, 196
Ge wares, 93, 108, 196, **150**, 207, 210
Geldermalsen, 155
Germany, 134, 152, 156
gilding, 95, 117, 154, **118**, **119**, 168, 204, **157**, **160**
glass, **23**, 42, 63, 68, 109, 207, 208
glaze, 29, 33, 34, 48, 76, 104, 166
gold, 32, 36, 94, 95, 126, 150, 186, 195, 203, 205
Gongchun, 174
Gongwayao, 86
Gongxian, Henan, 59, 65, 66, 67, 75, 81, 82
Gongyao, Zhejiang, 71
Great Wall, 46
greenwares, **22**, **34–40**, 50, 53, 54, 55, 59, **42**, 63, 68–72, **50**, **51**, **52**, 73, 74, 82, 87, 91, 101, 102, **77–83**, 108, 112, 120, 127, 128, 129, 130, 134, 136, 137, **100**, 140, **119**, 178
gu, 20, 110, 170
Guan wares, 93, 105–8, **77**, **78**, 109, 111, 115, 130, 207, **161**, 210, 216
Guangdong province, 35, 46, 51, 52, 129, 145, **108**, 160
Guangxi Autonomous Region, 14, 46, 104
Guangxu, Emperor, 212, 213
Guangzhou (Canton), 128, 138, 139, 143, 147, **108**, 152, 153, 154, 158, 164, 173, 176
Guanyin, 171, 172
gui, 21, 168, 170
Guilin Zengpiyan, Guangxi, 14
Guizhou province, 51, 52

Halima, 184
Hangzhou, 22, 99, 105, 108, 109, 115, 128, 130
Haobi, Henan, 74, 117
hare's fur glaze, 120, **89**
He Chaozong, 172
Hebei province, 14, 20, 23, 25, 34, **42**, **44**, **47**, 66, 67, 74, 75, 81, 86, 93, **68**, **69**, **70**, **71**, **72**, 115, **85**, **86**, **88**, 124, 127, 166, **124**
Hemudu, 22, **13**
Henan province, 14, 16, 23, 25, 34, 42, 46, 55, 59, 60, **44**, 65, **47**, 66, 67, **53**, 74, 75, **59**, 81, 84, 87, 101, **73–6**, 105, 112, 115, 117, 118, 120, 121, 123, 127, 130, 162, **120**

Hetaozhuang, 17
Hong xian porcelain, 213–14, **165**
Hongshan, 20, **10**
Hongwu, Emperor, 140, 163, **134**, 182–3, **135–7**, 184
Hongzhi, Emperor, 193, **147**
Hu'an, 127
Huai river, 105
Huangbaozhen, 73, 112
Huangdao, **54**
Huangniangniangtai, **9**
huashi, 202
Hubei province, 22, 23, 30, 34, 125
Hui xian, Henan, 74
Huizhou, Guangdong, 129
Huizong, Emperor, 99, 101, 120
Hunan province, 42, 46, 51, 52, 73, 104, 117, 125
Huo xian, Shanxi, 99
Hutian, Jingdezhen, 178

Imari, 150, 154
imperial
 buildings, 38, 44, 160, 162, 163, 164, 201
 factory, 186, 190, 191, 195, 200–1, 213
 taste, 91, 93, 99, 120, 188
 tribute, 64, 66, 91, 93, 112, 120, 140
India, 55, 128, 129, **99**, **110**
Indonesia, 71
Inner Mongolia Autonomous Region, 20, 86, 87, 125
inscriptions, 67, 71, 94, **70**, 102, 103, **76**, 126, **119**, 170, **128**, 175, **131**, 184, 192, 194, **148**, **152**
'Interregnum', 190, **143**
inventories, 136, 137
Ireland, 143, 152
iron, 46, 59, 67, 79, 85, 98, 108, 192
iron oxide, 33, **29**, 53, **39**, 54, 55, **53**, 76, 82, 84, 101, 105, 115, 117, 118, 120, **90**, 127, 129, 130, 133, 146, 154, **135**, 202, 219
Islamic, 139, 183, 184, 194, **148**
Italy, 134, 145, 152
Iznik, 145

jade, 20, 25, 26, 67, 70, 91, 95, 99, 109, 110, 126, 173, 195
Japan, 81, 82, 111, 121, 128, 129, 134, 136, 145, 147–50, **112**, 152, 199
Jesuits, 164, 178, 204, 207
Jiajing, Emperor, 193, 194
Jian wares, 120–1, **89**, **90**
Jiancicun *see* Quyang
Jiang Qi, 176, 178
Jiangsu province, 21, **11**, 30, 34, 35, 46, **34**, 49, 51, 60, 81, 96, 125, 160, 173–5, **130**, **131**
Jiangxi province, 34, 35, 42, 51, 52, 84, 87, 91, 98, 108, 121, **91**, **92**, 124, 125, 127, 147, 176–216

Jianyang, Fujian, 120, 121, 129
Jiaotanxia, 106, 109
Jiaqing, Emperor, 211, **163**, 212
Jiaxing Majiabang, Jiangsu, 21
Jilin, 125
Jincun, 109
Jingdezhen, 66, 96, 124, 127, 129,
 133, 134, 136, 138, 139, 144, 145,
 146, 152, 154, 158, 162, 166, 168,
 176–216
Jingtai, Emperor, 190–1
Jingzhi pagoda, 94
Jinzhong pagoda, 94
Jiuyan see Shaoxing
Jizhou, 121–4, **91**, **92**, 129
jue, 25, 26, 30, **20**, 168, 170, 184
Jun ware, 93, 101–5, **75**, **76**, 115,
 173, 207, 210, 216
Junshan see Yixing
Jürchen, 115

Kangxi, Emperor, 152, 199, 200–4,
 154–8, 208, 213
kaolin, 27, 28, **18**, 33, 66, 76, 124,
 133, 180, 202
 primary, 218
 secondary, 47, 67, 219
Karachi, 71
kendi, **110**
kilns, 222–3
 private, 201, 202, 212
kiln fuel, 94, 124
ko-sometsuke, 158
Kong Shangren, 199
Koran, 142, 194
Korea, 82, 111, 128, 129, 134, 136,
 164, 173, 192
kraak, 147, **109**, 151, **114**
Kütahya, 141

lacquer, 14, 26, 32, 36, 49, 109, 126,
 151, **119**, 207
Lambeth, 157
Lan Pu, 178
landscape, 181, 188, 193, 195, 199,
 202, 207, 212
Lang Tingji, 202
Langjiazhuang see Linzi
Lao xue an biji, 112
lead, 42
 glaze, **27**, 42, **29**, 44, 46, **41**, 59,
 43, 63, 75–8, **61**, 86, 87, **88**, 160,
 201, 220
Ledu Liuwan, Qinghai, 19, **8**
Li Feng, Prince, 75
Liangchengzhen see Rizhao
Liao wares, 86–7, **65**, 166
Liaoning province, 20, **10**, 86, 125, 164
Liaoyang, 86
Lifan, Sichuan, **30**
Lincheng, Hebei, 66
Lingshan, Hebei, 96
Linru, Henan, 16, **5**, 101, 102, 105,
 112, 129

Lintao Majiayao, Gansu, 17
Linzi Langjiazhuang, Shandong, 37
literati, 111, 127, 173, 188, **164**, 214
Liuwan see Ledu
Liverpool, 157
loess, 19, 26, 27, **17**, 38, 46, 67
 clay-rich, 219, **169**
 primary, 219, **168**
lohan, 166, **124**
lokapāla, **59**, 79, 80, 165
Longmen, 49, 59
Longqing, Emperor, 195, **149**
Longquan ware, 55, 106, **78**, 108–12,
 80, **81**, 115, 127, 129, 133, 136,
 141, **119**, 179, 216
Longquanwucun, 86, **65**, 87
Longshan Chengziya, Shandong, 23
Longshan culture, 23, 25
lotus, 55, **51**, 94, 109, 113, **102**, 141,
 146, 163, 193
Lu Jiuyuan, 91
Lu You, 99, 112
Lu Yu, 70
Luoyang, 33, 49, 59, 65
Lushan, **54**, 105
luting, 80

Machang, 19, **8**
magnesia, 96
Majiabang, 21, 22, **12**
Majiayao, 17, 18, **6**, 19
Manchuria, 20
manganese, 82, 203
Mantai, 81, 82
marble, 109
marbled wares, **61**
marks, 19, 22, 30, 33, 44, 46, 82, 99,
 86, 117, 126, 157, **117**, 178, 214,
 216
martaban, 146, **108**, 151, 164
mass production, 40, 134, 136, 141,
 154, 156, 209, 216
medallion bowls, **163**, 212
Medici porcelain, 134, 145
meiping, 102, **88**, 166, **123**, **132**, **133**,
 180, **143**, **147**
Meissen, 157
Mencius, 37
Meshed, 141
metalwork, 26, 49, **43**, 68, 76, 102,
 124, 139, 184
mi se, 70–2, 130
Mianchi Yangshao, Henan, 16
Miaodigou, 16
mica, 20, 124
Middle East, 66, 81, 82, 134, 136–43,
 145, 180, 188, 194
Minghuang, Emperor, 62, 80
monk's cap see ewer
monks, 120, 121, 128, **124**
monochrome, 201, 202, 208, 211
moulds, 26, **17**, 36, 46, **70**, 96, 113,
 84, 127, 129, 145
Mozi, 37

Muslim, 138, 140, 143
mythology, 12, 44, **127**

Nanfeng, Jiangxi, 91, 124
Nanjing, 51, 52, **39**, 162, 174, 183, 184
Nanyao biji, 103
Neiqiu, Hebei, 66, 75, 93
Nian Xiyao, 207
Ning Feng, 12
Ningbo, Zhejiang, 48, 128, 136, 138
novels, 202, 210

official wares, 94, **69**, 105, 179
oil-spot glaze, 120
opaque glazes, 82, 85, 173, 180, 205
openwork, 20, 22, 180
Ou river, 109
Oxford, 203, 205
oxidation, 46, 94, 221

pagodas, 94, 162, **120**, 184
painted decoration, 117, 129, 188
 on burial pottery, 36, **25**, 40, **31**,
 76, 79
 Neolithic, **3**, 16, 17, 18, 20, 23, 30
 overglaze, **87**, 133, **107**, 154, 156,
 116, 180, 181, 187, 190, **145**, **146**,
 193, 202–4, 205–7
 underglaze, 82, **62**, 84, 85, 117,
 133, 138, **101**, 140, **103**, **104**, 179,
 181, 187
painting, 188
Pakistan, 71, 82, 129
Panlongcheng, Hubei, 30
paper-cut, 123
paper patterns, 150, 153, 154
Peiligang, 14, 15, 16, 20
Peng xian, Sichuan, 99
Persia, 82, **99**, 137, 140, 141, 142,
 152, 162, 185
phase separation, 82, 104, 105, 117
phoenixes, 44, 96, **99**, 141, 186, 193,
 202
pilgrim flask, 59, **45**, **106**, **167**
Pingding xian, Shanxi, 99
Pingliangtai, 23
poetry, 70, 84, 85, 175, 207, **161**
poison, 136, 199
porcelain, 27, 66–8, 95, 108, 124,
 133, 134, 140, 145, 154, 157, 162,
 176–216, 218
porcelain stone, 124, 146, 159, 171,
 173, 176, 180, 202, 218
Portuguese, 143, 144, 150, 151, 152
potter's wheel, 12, 20, 34
pou, 47, **34**
printed books, 91, 109, 195, 199,
 153, 212
Pronk, Cornelis, 153, 154
Pu Yi, Emperor, 213
Puducun, Shaanxi, 21

Qianlong, Emperor, 164, 207–11,
 160–2

Qidan, 86
Qin Shihuang, 38, 40, **26**
qingbai wares, 98, 124–9, **94**, **95**, 133,
 98, 138, **105**, 143, 168, 178, 179,
 133, 180, 184
Qinghai province, 17, 19
Qingliangsi, Henan, 100, 101
Qionglai, Sichuan, 84–5, **64**, 129
Quanzhou, 128, 138, 143
quartz, 84, 141
Qujialing, Hubei Jingshan, 23
Quyang, Hebei, 74, 93, 95

Raozhou, Jiangxi, 176, 191
Raqqa, 141
raw materials, 93, 98, 112, 124, 134,
 158, 173, 200
reduction, **32**, 46, **35**, 54, 72, 95, 98,
 101, 108, 124, 221
reign marks, 186, 187, 190, 191, 192,
 196, 200, 212, 213
religion, 20, 41, 46, 49, 71, 137, 160,
 119, 166
resist decoration, **55–7**, 76, 81, 121,
 91, 193
ring punching, 117
ritual, 41, 71
 vessels, 25, 26, 27, 28, 32, 41
Rizhao, Liangchengzhen, Shandong,
 16
'robin's egg' glaze, **129**
Ru river, 101
Ru ware, 93, 99–101, **73**, **74**, 102,
 105, 107, 112, 129, 130, 133, 192,
 207, 210, 216

saggar, 95, **70**, 97, 105, 178, 208
Samarra, 67, 71, 81, 82, **68**
sancai, **43**, 75–8, **55–7**, **59**, 84, 86, 87,
 101, 165, **124**
Sanlihe, 21, **15**
Santos Palace, 144, 156
Sasanian, 59, 63, 78
scholars, 91, 111, 133, 146, 173, 175,
 197
sculpture, 15, **10**, 21, 22, 23, 37, 40,
 59, 78, 84, **119**, 164, 165, 166, 170,
 171, 172
sgraffito, 116
Shaanxi province, 14, 23, 33, 34, 42,
 46, 55, 60, 70, 73, 74, 75, 84, 87,
 112, **82**, **83**, 115, 125
Shan xian, Miaodigou, Henan, 16
Shandong province, 20, **11**, 23, **15**,
 16, 34, 37, 42, 49, 55, 74
Shanghai, **24**, 94, 187, 216
Shangjing, 86
Shanglinhu, Zhejiang, **50**, 71, 72, **52**
Shangyu, Zhejiang, 48, 50, 51
Shanxi province, 14, 23, 34, 37, 46,
 59, 99, 117, 124, 163, 166, **123**
Shaoxing Jiuyan, Zhejiang, 51
Shen Du, 186–7, **140**

sherds, 47, 64, 67, 82, 106, 107, 120,
 121, 172, 178
Shi Dabin, 175, 197, 199
shipwrecks, 136, 138, 146, 151, **114**,
 155
Shiwan, 147, 164, 173, **129**
Shonzui, 150
Shoulao, 171, 172, **156**
shufu, 179–80, 184
Shunzhi, Emperor, 199, 200
Sichuan province, 22, **14**, **30**, 45, 49,
 84–5, **64**, 99, 125, 129
signatures, 157, 172, 173, 175, 200,
 214
silica, 29, 46, 221
silk, 16, 128, 140, 150, 151, 195
Silk Route, 62, 63, 88
silver, 32, 36, 55, 63, 67, 70, 81, 86,
 87, 94, 95, 109, 121, 126, **99**, 151,
 180, 195
Sima Jinlong, 59, 75
Sinan *see* shipwrecks
Siraf, 67, 71
slip, 17, 23, **23**, 66, 73, 85, **64**, **85**,
 116, **86**, 117, 129, 133, 166
slip-painted, 73, **86**, 117, 118, 121,
 92, 123, 133, 146, **111**, 181
soft-paste, 145, 202
Sogdian, 62, 78, **58**, 80
Songze, Shanghai, 22, **12**
South-east Asia, 81, 82, 128, 129,
 140, 146, 173
Southern Ding, 97
Spain, 151
splashed wares, 74, **54**, 76, **57**, 84,
 104, 105, 120
Sri Lanka, 71, 81, 82
Staffordshire, 157
stone, 12, 14, 15, 168, 207
stoneware, 29, 46, 82, **70**, 105, **79**,
 84, **85**, **91**, 133, 165, **123**, 218, **124**,
 182
Swatow, 145–6, **107**, **111**
sweet white wares, 184, **138**
symbols, 19, 140, 200
Syria, 140

Taiwan, 150, 152
Tang Ying, 178, 207, 208, 209, 210
Tao Zongyi, 105
Taoya, 103
tax, 90, 91, 178
tea, 66, 86, 120, 150, 155, 174, 175
'Tea Classic', 66, 68, 93
teapot, 157, **117**, **118**
temmoku, 121
textiles, 14, 16, 23, 27, 63, 76, **96**
Thailand, 82, **99**, 146, 164
Tianqi, Emperor, 199, **153**
Tianshun, Emperor, 190
Tibet, 184
tiles, 45–6, 160, 162, 163, 164, **120**,
 121, 166, **127**, 172
Timurid, 141, **104**

titanium, 67, 72, 85, 98, 112
Tongchuan, Shaanxi, 73, 75, 112
Tongguan, Hunan, 73, 82–4, **62**, **63**,
 85, 104, 105, 117, 133, 181
Tongzhi, Emperor, 212, **164**, 214
Topkapi Saray, 136, 142
toys, 73, 84
Transitional wares, 199–200
Tunxi, 33
Turkey, **99**, 140, 141, 142

utilitarian wares, 16, 49, 115–18,
 146, 159, 186, 200

VOC, 151, 152, **113**, 153, 154

Wang Cun, 112
Wang Zhaojun, **86**
Wanggu, **11**
Wanli, Emperor, 168, **126**, **128**, 145,
 147, 150, 193, 195, 199, **151**, **152**
Wedgwood, Josiah, 158
Wen, Emperor, 60, 62
Wenzhou, Zhejiang, 48, 51
white wares, 27, 28, **18**, 50, 59, 60,
 44, 63, 64–8, **46–9**, 79, 82, **65**, 87,
 66, **91**, 93–5, **68**, **69**, **71**, **72**, 112,
 120, 124, **93**, 127, 128, 129, 130,
 96, **97**, 162, 168–72, 178, **137**, 183,
 184, **138**, 186, 187
willow pattern, 158
Witte Leeuw, 151
wood, 14, 20, 49, 160, 207
Wu, Empress, 65
Wu and Yue, states of, 30, 35, 50
Wu Jing, 174
Wu xian, 173
wucai, 195, 202, **156**
Wudi, Emperor, 41, 42
Wugongshan, 102
Wuguishan, Hangzhou, 106–7, 109
Wushan, Sichuan, Daxi, 22, **14**
Wuxi, Jiangsu, 175

xeroradiography, 18
Xia dynasty, 26
Xi'an, 33, 38, 62, 64, 65
Xianfeng, Emperor, 212
Xianyang, 44
Xiao xian, Anhui, 98
Xiaoshan, Zhejiang, 51
Xicun, Guangzhou, 129
Xiguan, Henan, 74
Xing ware, 66, 67, 68, 70, 93, **68**,
 125
Xinle, 20
Xiongnu, 40
Xiuding temple, 162, **120**
Xiuneisi, 105, 106
Xuande, Emperor, 137, 178, 187–91,
 141, **142**, 191, 196, 197, **150**, 208
Xuandi, 42
Xuantong, Emperor, 213

Yan Song, 195
Yancun, 16, **5**
Yangcheng, Shanxi, 99
Yangshao, **1**, **3**, 16, 17, 18, **6**, 19, 20
Yangzhou, Jiangsu, **40**, 81, 82
Yangzhou, Wanggu, Shandong, **11**
Yangzi river, 22, 23, 30, 33, 34, 35, 49, 85, 176
Yanshi *see* Erlitou
Yaozhou ware, 73, 74, 75, 109, 112–15, **82, 83**, 124, 129, 175
Yellow river, 27, 35
Yemen, 142
yingqing see qingbai
Yinliu zhai shuo ci, 103
Yixing Junshan, Jiangsu, 51
Yixing ware, 157, **117**, 172, 173–5, **130, 131**, 197, **152**
Yizhou, Hebei, 166, **124**
Yizong, Emperor, 71
Yongjing Sanping, Qinghai, **6**

Yongle, Emperor, 140, 162, 184–7, **138–40**, 188, 191
Yongzheng, Emperor, 204–7, **159**, 208, 214
You Efu, 32
Yu xian, Henan, 101, 102, 103, 104
Yuan feng jiu cheng zhi, 112
Yuan Shikai, 213
Yue, state of *see* Wu
Yue ware, **36–40**, 51, 68, 70, **50–2**, 72, 73, 82, 108, 112, 113, 129, 130, 178
Yun lu man zhao, 108
Yungang, 49, 59
Yunnan, 140
Yuyao, Zhejiang, **13**, 51, 112

Zang Yingxuan, 200, 201
Zengpiyan Guilin, 14
Zhang family, **86**, 117, 127
Zhang Qizhong, 200
Zhantou *see* Swatow
Zhao Rushi, 128

Zhao Yanwei, 108
Zhejiang province, 22, **13**, 30, **22**, 34, 35, 46, 48, **35**, 50, 51, 52, 60, 68, **50**, 84, 87, 105, 108, 109, **80**, **81**, 112, 115, 120, **100**
Zheng He, 140
Zhengde, Emperor, 142, 143, 174, 193, 194, **148**
Zhengtong, Emperor, 190, 191
Zhengzhou, Henan, 29, **19**, 30
Zhenjiang, Jiangsu province, 53
Zhezong, 101
Zhou Gaoqi, 173
Zhou Hui, 98, 100
Zhou Mi, 99
Zhu Yan, 178
Zhu Yuanzhang, 182
Zhushan, Jingdezhen, 183
Zibo, Shandong, 55, 74
zisha ware, 173–5, **152**
Zu Tangju, 172
Zuo zhuan, 32, 37